HOPE DRAPED IN BLACK

RELIGIOUS CULTURES OF AFRICAN AND AFRICAN DIASPORA PEOPLE

SERIES EDITORS:

JACOB K. OLUPONA, HARVARD UNIVERSITY

DIANNE M. STEWART, EMORY UNIVERSITY

AND TERRENCE L. JOHNSON, GEORGETOWN UNIVERSITY

The book series examines the religious, cultural, and political expressions of African, African American, and African Caribbean traditions. Through transnational, cross-cultural, and multidisciplinary approaches to the study of religion, the series investigates the epistemic boundaries of continental and diasporic religious practices and thought and explores the diverse and distinct ways African-derived religions inform culture and politics. The series aims to establish a forum for imagining the centrality of black religions in the formation of the "New World."

HOPE DRAPED IN BLACK

Race, Melancholy, and the Agony of Progress

JOSEPH R. WINTERS

DUKE UNIVERSITY PRESS DURHAM AND LONDON 2016

Book and cover design by Natalie F. Smith
Typeset in Whitman by Westchester Book Group

Library of Congress Cataloging-in-Publication Data
Names: Winters, Joseph Richard, [date]–author.
Title: Hope draped in black : race, melancholy, and the agony of
progress / Joseph R. Winters.
Other titles: Religious cultures of African and African diaspora
people.
Description: Durham : Duke University Press, 2016. | Series:
The religious cultures of African and African diaspora people |
Includes bibliographical references and index.
Identifiers: LCCN 2015043615
ISBN 9780822361534 (hardcover : alk. paper)
ISBN 9780822361732 (pbk. : alk. paper)
ISBN 9780822374084 (e-book)
Subjects: LCSH: United States—Race relations—Philosophy. |
United States—Race relations—Political aspects. | Racism—
United States. | African Americans—Race identity—United
States. | African Americans—United States. Classification: LCC
E185.615 .W568 2016 | DDC 305.800973—dc23
LC recordavailableathttp:// lccn.loc.gov/2015043615

Duke University Press gratefully acknowledges the support of
The Barney Jones Endowment Fund, which provided funds
toward the publication of this book.

CONTENTS

Acknowledgments ix

Introduction 1

ONE. Unreconciled Strivings: Du Bois, the Seduction of
Optimism, and the Legacy of Sorrow 31

TWO. Unhopeful but Not Hopeless: Melancholic Interpretations
of Progress and Freedom 57

THREE. Hearing the Breaks and Cuts of History: Ellison,
Morrison, and the Uses of Literary Jazz 85

FOUR. Reel Progress: Race, Film, and Cinematic Melancholy 137

FIVE. Figures of the Postracial: Race, Nation, and Violence in
the Age of Obama and Morrison 187

Conclusion 237

Notes 253 Select Bibliography 287 Index 297

ACKNOWLEDGMENTS

I have been thinking about the themes of melancholy, remembrance, and trauma for a while. Part of my investment can be traced back to personal experiences and losses; another source of this interest is my immersion in African American literature and culture and my passion for critical and literary theory. This book is motivated by a suspicion that many of our influential narratives, images, and cultural symbols minimize the intensity of loss and injury in our world. More specifically, this project is animated by the dangers and limitations of interpreting black freedom struggles and the legacy of racism within logics of progress and national exceptionalism. My sense is that a different kind of hope and set of possibilities emerge through melancholy, remembrance, and a heightened understanding of history's tragic features.

I completed the penultimate draft of this book a month before the Ferguson uprising and the re-emergence of the Black Lives Matter movement. While time and space did not permit me to write about this insurgent set of practices, struggles, and aspirations, much of my analysis resonates with the concerns and overall energy of this movement. This book is also

very much concerned about the ways in which black death and suffering have become normalized and widely acceptable.

While writing (and academic life more generally) often seems like a solitary practice, this project would not have been possible without the support, love, friendship, and interventions of others. At the same time, an acknowledgments or "shout out" section cannot do justice to one's indebtedness to other people. But I will make an attempt. First, I am very grateful to the editors of the *Religious Cultures of African and African Diaspora People* series—Dianne Diakité, Terrence Johnson, and Jacob Olupona—for their welcoming embrace of my project. I owe a special debt of gratitude to Terrence Johnson, who initially had more faith in this book project than I did. I want to also thank my editor, Miriam Angress, and the staff at DUP (especially Susan Albury) for their support, hard work, and patience throughout this process. Miriam Angress's generous encouragement throughout the editing process was invaluable.

To my Princeton people, thank you for pushing me to be more clear and confident with my ideas. Jeff Stout has always encouraged me to write lucidly and be more generous toward interlocutors. Eddie Glaude encouraged me to find my own voice. Cornel West, who continues to be the main source of motivation for my work, taught me that reading Adorno and Morrison together is not so strange. To my fellow students in religion, ethics, and politics, especially Kevin Wolfe, Terrence Wiley, Molly Farneth, Fannie Bialek, Stephen Bush, and Andrea Sun Mee Jones, thank you for pushing and challenging me.

I would not have kept my sanity if it were not for friends and colleagues like Ken Walden and Jamil Drake. I want to thank them for showing me how to balance the life of the mind with responsibilities in the "real world."

This project would not have been possible without the support and intellectual brilliance of my early mentors—Romand Coles, Ken Surin, Nelson Maldonado-Torres, and Bill Hart. I especially want to acknowledge Bill Hart, a colleague and friend, who first introduced me to the possibility of approaching black religion and African American studies in an eccentric manner.

My colleagues and students in the Department of Religious Studies at UNC at Charlotte inspired and enabled me to finish this project. Dave Mozina, Julia Marie Robinson, and Sean McCloud offered insightful feedback on my project during conversations and discussions. I want to single out Kent Brintnall, my good friend and colleague, who read several versions of the manuscript and offered extremely helpful comments and

suggestions. To other colleagues and students at UNC at Charlotte who offered generous and critical feedback on my project—Mark Sanders, Dan Grano, John Cox, Travis Jones, Carrie Jones, Ilya Merlin, and Julie Hawks—I am truly grateful.

I am also very indebted to the support and encouragement of Sharon Watson Fluker and FTE (Fund for Theological Exploration). When my ideas were at the dissertation phase, Sharon looked out for me when others did not understand my project. Thank you.

Over the past five years, I have had the opportunity to present sections of the book project at various colloquia and public lectures. I would like to thank Lawrie Balfour and Melvin Rogers for inviting me to the University of Virginia's political theory colloquium to discuss Adorno and critical theory. Terrence Johnson invited me to Haverford's humanities center to discuss Ralph Ellison, jazz, and democracy. I also presented a paper on Toni Morrison and jazz in an Africana Studies colloquium at UNC at Charlotte thanks to an invitation by Akin Ogundiran. And Ian Ward invited me to the political theory colloquium at the University of Maryland to discuss Du Bois and melancholy. These forums encouraged me to make my ideas and arguments more lucid and persuasive.

Even though many of the people closest to me do not always understand what it is that I do for a living, I do not know how I would survive without them. To my extended family—my cousins, aunts, uncles, in-laws—thank you for putting up with my idiosyncrasies, quirks, and occasional absence (not answering phone calls, for instance). Winterses, Karims, and Smiths—I truly love and appreciate you. I want to send a special shout out to Jamillah Karim, whose dedication to writing and the life of the mind provides a beacon for me to try to follow.

To my sister, Mareisha, thank you for being the little sister that I could look up to and emulate. I hope you (and Byron) find something in this project that makes sense.

To my mother (mom), thanks for teaching me how to write, how to think critically, how to be generous, and thanks for always supporting my pursuits and aspirations. I hope that you (and Ken) find something in this book that resonates.

I reserve the final acknowledgment to my partner, Kamilah Legette. I only wish that I had your work ethic, dedication to learning, and unwavering commitment to social justice. Without you in my life, I am greatly diminished.

Introduction

On the evening of November 4, 2008, the Republican presidential candidate, John McCain, conceded victory to his opponent, Barack Obama. McCain's concession speech encompassed many of the familiar elements associated with this genre of political oratory, including successive attempts to urge his Republican-dominated audience to overlook partisan differences and redirect their energy and commitment to overcoming common problems. What made this situation historically unique, of course, was the fact that the Democratic opponent and victor was a black American. Understanding the significance and import of "the first black President," McCain began his speech by situating Obama's victory within a broader historical trajectory, by connecting the present moment to the nation's past:

> This is an historic election, and I recognize the special significance it has for African Americans and for the special pride that must be theirs tonight. I've always believed that America offers opportunities to all who have the industry and will to seize it. Senator Obama believes that

too. But we both recognize that, though we have come a long way from the old injustices that once stained our nation's reputation and denied some Americans the blessings of American citizenship, the memory of them still had the power to wound. A century ago, President Theodore Roosevelt's invitation of Booker T. Washington to dine at the White House was taken as an outrage in many quarters. America today is a world away from the cruel and frightful bigotry of that time. There is no better evidence of this than the election of an African American to the presidency of the United States. Let there be no reason now for any American to fail to cherish their citizenship in this, the greatest nation on Earth.[1]

McCain makes several important rhetorical moves in the opening segment. He acknowledges that Obama's victory is especially significant for black Americans, a group that has endured various kinds of injustice since the seventeenth century. Even though he suggests that black people might value and interpret this event differently than other Americans, McCain underscores the relevance of this event for America as a whole (which resembles his insistence that common goals and ideals should trump partisan disagreements). For the Republican candidate, Obama's triumph confirms his belief that "America offers opportunities to all who have the industry to seize it," a belief that Obama apparently shares. After this election, according to McCain, there is no reason to doubt America's supremacy vis-à-vis the rest of the world. Similarly, there is no reason for citizens to feel ambivalent about their relationship to the nation-state, their identity as Americans. In other words, Obama's victory is meaningful and significant because it reinforces America's collective self-image as an exceptional nation, as a place unequivocally defined by opportunity, tolerance, and freedom. His ascendancy illustrates and confirms the nation's democratic ideals.

As McCain identifies Obama's impending victory as "evidence" of American supremacy, he also invokes America's racialized past in a specific manner. Think, for instance, of his reference to Booker T. Washington, the late-nineteenth-century black leader who urged black people to develop industrial skills, rather than strive for political enfranchisement, as a way to secure acceptance and respect.[2] McCain suggests that Washington, the first black to be formally invited to a White House dinner, anticipates and foreshadows the election of the first black president. By referring to

a black leader widely known for his tendency to cater to the interests of white elites, McCain directs the audience's memory to the more acceptable and palatable dimensions of black freedom struggles. Black activists like W. E. B. Du Bois or Ida B. Wells, contemporaries of Washington who rejected his conservatism, might not fit so easily into McCain's speech or into a triumphant vision of American history.

Even though McCain refers to the more palatable side of the nation's racial history, he knows that any reference to this history involves memories of injustice and suffering. Yet McCain seems to relegate this memory to a past that the nation has moved beyond and transcended. He claims, for instance, that "we have come a long way from the old injustices that once stained the nation's reputation" and that "America today is a world away from the cruel and frightful bigotry of that time." He also points out that the memory of racial injustice "had" the power to wound and unsettle people, suggesting that what Wendell Berry refers to as America's "hidden wound" has been mended. McCain is right to proclaim that there have been significant changes and shifts in America's racial arrangements in the past century, including the elimination of laws that prohibited blacks from entering and participating in designated public spaces. To deny these changes and improvements would be disingenuous. At the same time, it is important to remember that these changes are the result of long, tortuous struggles against white supremacist practices. Altering the state of things, as these struggles demonstrate, requires people to put their bodies on the line, to expose their bodies to danger, violence, injury, and State repression. The victorious tone of McCain's terse recapitulation of the past obscures this painful side of progress. In addition, McCain's rhetoric deflects attention from the ways that "old injustices" linger on in the present, even if these injustices target black bodies in new and subtler ways. The assumption that the nation has moved beyond the cruelty and bigotry of the past overlooks the ways in which these forces get redirected toward other racialized groups—Arabs, Latinos, Asians, and so forth. What is crucial here is the relationship between the significance/meaning ascribed to Obama's victory and memory of racial loss, violence, and cruelty. For McCain, the election of the first black president not only illustrates the nation's greatness but it also enables us to locate "old injustices" in a distant past, a past that is a "world away" from us. Because of the nation's recent triumph, we should no longer be disturbed by anguished memories of racial exclusion.

In response to Obama's victory, many publicly recognized figures echoed McCain's enthusiasm about racial progress. For instance, Rudolph Giuliani proclaimed, "We've achieved history tonight and we've moved beyond . . . the whole idea of race and racial separation and unfairness."[3] For the former mayor of New York City, the election of the first black president signified the end of racial inequality; similarly, this momentous event proved that race was no longer a relevant factor or social category. America, according to Giuliani's assessment, is undeniably postracial; we have arrived. In line with the former mayor's optimism, the Pulitzer Prize–winning columnist George Will stated that the 2008 election should put an end to racial narratives defined by "strife and oppression," tired discourses that deny "fifty years of stunning progress."[4] Perhaps more surprising, black American celebrities like Will Smith claimed that Obama's ascendancy prevented black people from making any more excuses regarding their inability to thrive and prosper in America.[5] The irony here is that these public figures employed classic racial thinking—the notion that one individual's success represents the achievement of a racial group as a whole—to deny the ongoing significance of race.[6]

One might dismiss this postelection excitement as a fleeting moment. The rhetoric of a postracial nation might simply be the result of collective fervor around a historic event that many thought they would never experience in their lifetime. According to this explanation, as the enthusiasm generated by Obama's victory wanes and the postracial fantasy confronts sober realities and stubborn conditions (police surveillance and repression in communities of color, protests in places like Baltimore and Ferguson), the assumption that the nation has moved beyond race will lose validity. Although there may be some truth in this explanation, dismissing the optimism around racial progress as a fleeting response to Obama's ascendancy would neglect the ways postracial rhetoric exemplifies long-established ideologies, narratives, fantasies, and aspirations that heavily influence Americans in particular, and modern denizens more generally.[7] It would neglect the pervasive commitment to the idea of progress in American culture, an idea that, when invoked, mitigates experiences and memories of racial trauma and loss.

Even individuals and figures who might reject the postracial fervor tend to cling to the proverbial idea of progress, invoking this trope to make sense of present and past struggles, achievements, and losses. Think, for instance,

of President Obama's poignant speech in response to the acquittal of George Zimmerman and the collective frustration and anger over the death of Trayvon Martin.[8] In July 2013, Obama began this speech by identifying with the deceased victim of Florida's stand-your-ground law. The deceased black subject, Obama tells the listener, could have been him thirty-five years ago, or even his son. This identification with Trayvon has generated criticisms in the past, accusations of Obama's playing the race card, being divisive, and so forth. After lauding the overall efficiency of the American legal process (he tells us that the system works), Obama reminds his audience of a history of racial disparities in the justice and legal systems. Black communities, he suggests, experience racial profiling, police brutality with police impunity, excessive surveillance, and unfair drug laws more frequently than other groups. But as a good politician, he quickly shifts from discussing the problems to delineating some concrete proposals to redress these lingering racial inequities and divisions. In addition to mentioning local and federal policies that might defuse mistrust and fear, he stresses the importance of starting a national conversation about race. He recommends that we begin these serious and difficult talks at the local level, in churches, families, and workplaces, in spaces that are supposedly less "stilted" than formal political realms. He ends the speech in an upbeat and buoyant manner. Talking about his daughters and their promising relationships with diverse groups of friends, he reassures the audience that the nation is progressing and getting better on the problem of race. He consoles us that the nation, despite recent events, is becoming a more perfect union, thereby connecting this speech to the famous Philadelphia address in 2008. (This conclusion also resonates with Obama's claim, made during a BET interview in response to protests in American cities against police violence and State repression, that we have to believe in progress because this belief gives us hope that we can make more progress in the future.[9]) Why is the president compelled to comfort citizens in the face of tragedy with the idea that each successive generation is advancing as a whole? What does this rhetorical move accomplish for us and why do we desire this consolation? How does a sweeping, unifying notion of progress serve as an imaginary buffer against instances of tragedy, violence, and loss? How does Obama's concluding optimism in the speech about Trayvon Martin and George Zimmerman thwart more unsettling ways of remembering, interpreting, and contemplating violence and suffering? How does this

attempt to sustain optimism around the subject of race foreclose a different kind of hope, a more melancholic kind of hope that Obama both gestures toward and immediately stifles for the sake of the order of things?[10]

Obama's speech, similar to McCain's, articulates a logic and grammar of progress that resonates with many. It has become quite commonplace to assume that Americans are situated on a progressive trajectory that continues to unfold through time.[11] In other words, with more progress, the nation will continue to approach a state of racial reconciliation (and perhaps even reach a juncture where race no longer matters). Even if people quibble about how to measure this progress, they typically leave unexamined the limitations and dangers internal to the rubric of progress as it applies to racial difference, black American strivings, struggle, loss, and forms of remembrance. In this book, I critically examine this trope, the effects it has had on the nation's imagination of its racial history, and the ways it has been used, invoked, and troubled by black writers and artists. Like many authors before me, I contend that the category of progress— even as it has been used in different contexts to galvanize struggles for a better, more just world—harbors a pernicious side. This all-too-familiar concept often functions in public discourse to downplay tensions, conflicts, and contradictions in the present for the sake of a more unified and harmonious image of the future. As McCain's concession speech demonstrates, progress is often aligned with triumphant accounts of history and the nation-state that too easily reconcile historical losses with current achievements. Similarly, the rhetoric of progress aligns itself with other reassuring tropes, ideals, and fantasies that seduce us into imagining a future that can protect us from loss, tragedy, and other conditions that are unavoidable for human subjects. As I argue throughout the book, the discursive reproduction of this concept results in the conflation of hope and optimism, a process that cultivates expectations of a better future by marginalizing or downplaying dissonant memories and attachments. These dissonant attachments—to traumatic events, unfinished struggles, neglected histories, and the recalcitrant dimensions of that past and present that resist closure and the eagerness to "move forward"—are necessary to challenge current configurations of power, especially since the effectiveness of power depends partly on its ability to produce forgetful subjects.

In this book, I draw attention to the black literary tradition as a discursive site that both troubles collective attachments to progress and that puts forth conceptions of hope and futurity that are mediated by melancholy,

loss, and a recalcitrant sense of tragedy. (Certainly other groups, communities, and traditions, some of which include black people, demonstrate how narratives of progress undermine themselves—Native Americans, immigrants, LGBT communities, and working-class subjects are examples. Yet in light of the ways black people's diverse strivings, experiences, and struggles consistently get assimilated into ascendant national narratives and because black bodies become readily available signifiers of progress, optimism, and American supremacy, it is important to reconsider the fraught relationship between black strivings and progress.) The authors and artists that I examine in this book, including W. E. B. Du Bois, Ralph Ellison, and Toni Morrison, suggest that the possibility of a better world involves a heightened capacity to remember, register, and contemplate the damages, losses, and erasures of the past and present. While progress tends to function as a consoling and conciliatory narrative, this book contends that a better world, a more generous world, involves being more receptive to those dissonant, uncomfortable dimensions of life and history that threaten our sense of stability, coherence, and achievement.

THE AMBIVALENCE AND AGONY OF PROGRESS

The idea and promise of progress, an idea that is connected to values such as recognition, equality, and freedom, has always been a fraught object of discussion and interest for black writers, artists, and thinkers. This is especially the case for the philosopher, social critic, and activist W. E. B. Du Bois. In "The Souls of White Folk," a scathing essay written in the aftermath of World War I, Du Bois radically undercuts the pervasive faith that the world is moving steadily on a path toward increased freedom and equality. In this essay, he suggests that the rhetoric of civilization and progress denies a traumatic underside that consists of slavery, the colonization of people of color, war, and conquest. In an expression that resembles a prayer, Du Bois exclaims: "We have seen—Oh Merciful God! in these wild days and in the name of Civilization, Justice, and Motherhood—what have we not seen, right here in America, of orgy, cruelty, barbarism, and murder done to men and women of Negro descent."[12] While Du Bois underscores the specific struggles of black Americans during the so-called nadir of American race relationships (a post-Reconstruction period marked by the establishment of Jim Crow segregation and the ritualized lynching of black bodies), he is also thinking broadly about the relationship between

civilization, progress, and race-inflected domination within modern life. Similar to Karl Marx, Du Bois contends that many of the material freedoms, advancements, and enjoyments that the modern world introduces rely on systems of exploitation and exclusion. As Du Bois puts it, "High wages in the United States and England might be the skillfully manipulated result of slavery in Africa and peonage in Asia."[13] What is important here is that Du Bois can be interpreted in this essay as saying that modern notions of progress and freedom are inherently flawed and problematic because they rely on and are intertwined with practices and conditions—capitalism, colonial expansion, racial hierarchies, endeavors, and incentives to usurp and possess the earth—that are harmful to non-Europeans, working-class bodies, women, and other groups. At the same time, he can be read as suggesting that these notions of freedom and progress are not necessarily flawed or attached to pernicious desires, endeavors, and projects; rather, these ideals have just not been embodied or practiced properly. If the latter position is taken, then progress and the practices and arrangements associated with this ideal should be embraced and simply expanded to include groups, communities, and collective bodies that are presently marginalized.[14]

This ambivalence haunts Du Bois's writing and thought. (But, of course, he is not unique; he inherits, and bequeaths, this ambivalence.) As many commentators have noted, Du Bois occasionally identifies with and adopts rather simplistic notions of progress and civilization. Like other black intellectuals and black people more generally, Du Bois articulates a commitment to something like racial progress or uplift. While historical efforts to uplift the race seem necessary and laudatory, these efforts carry troubling implications and consequences, especially when uplifting black people is defined as civilizing the black masses. As Kevin Gaines points out, the proverbial uplift paradigm, adopted by many black intellectuals and activists since the nineteenth century, calls for an educated, elite class of black people to liberate the masses of black folk from imposed conditions of poverty, ignorance, and moral depravity.[15] The demand and struggle for recognition has therefore involved the celebration of certain individuals or groups that "embody" and signify progress and advancement; these are figures that have adopted and learned the ideals, values, and practices of the civilized world (Europe and America), middle-class whiteness, enlightened Christianity, and so forth. Du Bois certainly has moments that betray a strong allegiance to progress, to the idea that recognition for black

people requires being inducted into the civilizing process. Here we might think about Du Bois's fascination with charismatic figures like Otto Von Bismarck, a model for black leadership, according to Du Bois, because he embodied a "forward marching spirit" in his endeavor to unite Germany. Or one could cite his enthusiasm during World War I about black soldiers (and black people's patriotism) being conduits for recognition, assimilation, and advancement. But to reduce the possibilities in Du Bois's thought to these moments is to foreclose more ambiguous, and more generative, trajectories and lines of flight as indicated in essays like "The Souls of White Folk." Throughout his corpus, there are fruitful tensions and conflicts around related notions of progress, recognition, and freedom; while he certainly has one foot in the civilizing processes of modernity, he also acknowledges that these processes are pernicious and terrifying for people of color, working-class bodies, and other kinds of subjects. Du Boisian ideas like the color line, the Veil, and double-consciousness, themes that I discuss in chapter 1, suggest that modern life is fractured and broken and that the flourishing of some groups and communities relies on the systemic marginalization, alienation, and death of others—in addition to tendencies to bury and conceal these persistent realities.

To better understand Du Bois's equivocal position, it is helpful to remember that he is responding to ideas, philosophies, and narratives that mark people of color as backward and uncivilized or that locate black bodies outside the movement of history. As Shamoon Zamir reminds us, Du Bois is in conversation with philosophers who adopted and articulated these kinds of narratives, most notably Hegel.[16] Hegel is significant in part because of his attempt to fuse philosophy and history, to offer a coherent, systematic account of the development of Reason and Spirit within history.[17] For Hegel, world Spirit develops in stages and through various conflicts and contradictions, becoming more coherent and mature in the process. Spirit moves from a lower form of consciousness to a higher form, originating in the East and culminating in the West. During this journey, according to Hegel, Spirit "skips over" Africa, meaning that Africa does not participate in the development of reason, truth, and freedom. Africa, in Hegel's vision, "is no historical part of the World; it has no movement or development to exhibit. Historical movements in it—that is in its northern part—belong to the Asiatic or European part of the world."[18] Here my intention is not to simply bash Hegel for his individual blind spots, nor is my intention to neglect the more admirable aspects of his thought and

legacy. What is important here is that Hegel's thought demonstrates how the logic of progress operates to establish and justify racial hierarchies. Because some nations are imagined as more advanced than others (in politics, technology, culture, religion), these advanced nations are able to rationalize and vindicate the violent treatment of inferior nations as part of a civilizing process. Hegel claims, for instance, that civilized nations are entitled to "regard and treat as barbarians other nations which are less advanced than they are."[19] As Hegel indicates, the colonial system, a set of coercive arrangements and policies that heavily shaped current racial formations and hierarchies, was motivated and legitimated by narratives of progress that located Europeans at the forefront of history's movement and black and brown peoples behind, or forever outside, the vanguard of history.[20]

Implicitly responding to this kind of historical imaginary, Du Bois contends that black people have unique gifts to contribute to civilization and humanity.[21] Contra Hegel, he argues that black people's strivings are just as important and significant to the shape of modern and American life as other racialized groups and communities. Furthermore, black people's struggle for recognition has something to do with demonstrating and acknowledging their distinct cultural and political contributions to the modern world—their humility, songs, art, democratic traits, spiritual struggles for freedom, etc. As I argue in chapter 1, by inscribing black people's experiences, struggles, losses, and contributions into the movement of history, Du Bois interrupts, challenges, and "puts the brakes" on Hegel's march of freedom. In other words, while Du Bois initially accepts the terms and conditions for acceptance into an advanced state of humanity, he also introduces themes, motifs, narratives, and strivings that undermine triumphant notions of advancement, progress, and the expansion of freedom.

Other literary figures of the twentieth century, including Ralph Ellison, exposed the limitations, dangers, and erasures of forward-marching schemes. In his celebrated novel *Invisible Man*, Ellison offers a kind of parody of Hegelian and Marxist-inspired conceptions of time and history. The Brotherhood, an interracial, liberationist group that the protagonist joins and later clashes with in the novel, tends to view the past and present in a narrowly instrumental way. According to this organization, past events, struggles, and losses are only significant insofar as they contribute to and help fulfill the goal of human liberation. Those individuals, strivings, and memories that are not immediately relevant to this liberated future, or that

present an obstacle to a unified, harmonious future, are "plunged outside of history." While Ellison insists that the Brotherhood does not represent Marxism per se, some of the qualities associated with the fictional organization remind us of the dangers of Marxism and Marxist interpretations of history and human experience. Recall that Marx, Hegel's dissident disciple, is very aware of the ambivalences at the center of modern life. While Marx occasionally lauds capitalism for the new, valuable things and ideas that it brings into the world—novel forms of communication, travel, commerce, knowledge—he claims that advancements in these areas depend on the global exploitation of workers, the unequal distribution of wealth, and the objectification of human relationships.[22] Although Marx is primarily concerned with class struggle, he is aware that class and race domination are intertwined. The wealth that European capitalists have been able to accumulate, on Marx's reading, is made possible by the exploitation and enslavement of Africans, Asians, and Native Americans as well as the usurpation of indigenous lands.[23] The "rosy dawn of the era of capitalist production" contains a dark underside; progress is a turbulent movement.[24] Even though Marx acknowledges the ambivalence of progress, he remains committed to the idea that history moves, through struggle and conflict, toward a better and more humane future. Capitalism is a penultimate historical stage, a stage that anticipates and enables the workers' revolution and the gradual creation of a classless society, the telos of history. Marx envisions a future society no longer beset by exploitation, inequality, and division. Although this seems on the surface to be a laudable vision, Marx's forward-directed proposal contains notable problems and flaws. The belief that history moves toward one goal trivializes the presence of multiple and conflicting aims, desires, meanings, pasts, and comprehensive visions within our world. This denial of plurality has pernicious consequences. As the legacy of communist regimes demonstrates, the imposition of a universal telos (by the so-called vanguards of history) onto local contexts and communities is a violent process, a process that sacrifices—for the sake of a unified and liberated future—those bodies, cultures, and groups that "lag behind" and resist the movement of history.[25] Therefore Marx's proposal runs into some of the same problems that Hegel's account of history does. In addition, because Marx privileges class identity and the labor struggle, other kinds of struggles—around race and gender, for instance—are either rendered insignificant or seen as ancillary to class conflict. In chapter 3, I discuss how Ellison challenges Marxist conceptions of time and history by

offering a jazz-inspired notion of time and by demonstrating the playful, tension-filled relationship between the past and present.

While Ellison resists Marxism's triumphant account of history, he is much more ambivalent about optimistic versions of America, America's future, and national exceptionalism. Ellison's relationship, like Du Bois's, to the "idea" of America is motivated in part by an insistence that black Americans have always participated in shaping and building American culture. Contra those who would make a stark contrast between black and American identity, Ellison underscores the "intricate network of connections which binds Negros to the larger society."[26] Even though blacks have been historically marginalized and excluded from the mainstreams of American life, they have also created cultures and traditions that both constitute, define, and challenge what we mean by the term *America*. As Ellison puts it, "Negro writers and those of other minorities have their own task of contributing to the total image of the American by depicting the experience of their own groups . . . A people must define itself, and minorities have the responsibility of having their ideals and images recognized as part of the composite image which is that of the still forming American people."[27] Similar to Du Bois, Ellison suggests that black people's struggle for recognition occurs through their various contributions to the evolving idea of America, humanity, and so forth. At the same time, Ellison's fidelity to the evolving idea of America occasionally devolves into a commitment to American exceptionalism and an uncritical celebration of the "frontier" as a site of boundless freedom and creativity, ideas and myths that have had disastrous consequences for America's internal and external others.[28]

As I show especially in chapter 5, American exceptionalism, progress, and empire form a complicated and tortuous constellation, a constellation that has been both formative and destructive of black existence. American-style optimism in a future marked by greater opportunity and freedom for American citizens (and nations that endorse the nation's ideals and principles) is intertwined with the assumption that America is an exceptional nation, a "beacon" to the rest of the world. In his influential book *The American Jeremiad*, Sacvan Bercovitch traces American exceptionalism back to the Puritan-inspired notion that America represents a New Israel, a nation and people that have been chosen by God to redeem the world.[29] The imagined covenant between God and America ensures that the nation's future is one of plenitude on the condition that America strives to fulfill its mission to the other nations, a mission that entails the expansion

of internal and external borders. One example of this missionary attitude is President McKinley's proposal to civilize and Christianize America's "little brown brothers" in the Philippines at the turn of the twentieth century, a proposal that justified America's occupation of the Philippines. According to Bercovitch, as civic rituals and discourses perpetually reenact the idea of chosenness (in religious and secular garb), America increasingly becomes a symbol of progress, freedom, and opportunity.[30] He claims that prominent American writers and critics, including figures of the nineteenth century like Emerson and Whitman, often ascribe these ideals to America as if they are part of its essence, part of its fundamental makeup. America, in fact, has privileged access to these ideals; the world's success depends on America's capacity to embody and spread the spirit of democracy. On Bercovitch's reading, American progress constitutes a unifying and unidirectional trajectory; progress, as he points out, "denies divisiveness."[31] While Ellison seems to have one foot in this all-too-familiar ideal of America and the grammar of progress and optimism that accompanies this ideal, he also pushes back against this framework. He contends that progressive and triumphant narratives rely on the denial of painful and uncomfortable details of the nation's history. As he puts it, "A great part of our optimism, like our progress, has been bought at the cost of ignoring the [troublesome] processes through which we've arrived at any given moment in our national existence."[32] Ellison acknowledges that there is something about our attachment to American-style progress that diminishes our capacity to remember and contemplate the tragic underside of this movement and story.

As Du Bois and Ellison indicate, progressive accounts of history have been complicit with the violence of modern life. These narratives work to rationalize the violence enacted against "less advanced" groups, people who need to be civilized, saved, or brought into the fold of universal history. Similarly, they encourage people to forget, deny, or downplay the violence that happens against people of color in the name of progress. As I show throughout this book, these concerns about the dangers and erasures of progress resonate with the reflections of Walter Benjamin, the literary critic of the twentieth century who is often associated with the Frankfurt School. In his well-known essay "On the Concept of History," Benjamin acknowledges that progress is a "storm," that this idea has justified and been complicit with numerous historical catastrophes.[33] But just as important for my argument, he suggests that progressive narratives vitiate our

ability to remember, contemplate, cite, and mourn these catastrophes. For Benjamin, progress renders history coherent and harmonious by resolving the traumatic dimensions of history, by incorporating history's traumas into affirmative accounts that underwrite the positions of those in power. As he puts it, memory is always in danger of "becoming a tool of the ruling classes," a situation that threatens to "murder the dead twice," to erase and eliminate the dissonant quality of past suffering, injustice, struggle, and loss.[34] Think, for instance, of the way Obama's presidency is often placed in a linear trajectory that begins with chattel slavery, travels through Lincoln and the Emancipation Proclamation, traverses the civil rights movement, and culminates with Obama's election.[35] This kind of story places black American struggles into a transparent, forward-marching story that easily makes sense of and resolves past and present traumas and conflicts. In other words, we don't have to be disturbed by this ponderous racial past because it has been lifted away, or is being lifted away, by the achievements of the present. As McCain's speech shows us, Obama's victory might invoke the memory of racial suffering but this dissonant memory is quickly superseded by an optimistic interpretation of this historic moment that reassures us of American progress and supremacy. The "triumphs" of the present enable us to explain away and buffer ourselves from the unsettling quality of America's racial history. Similarly, overconfident claims about black American advancement and racial progress assume that these achievements have been distributed equally across class and gender lines. This overconfidence screens from view the ways racial fears and anxieties, traditionally directed toward black subjects, can get redirected and attached to other bodies and communities that seemingly pose a threat to the nation's well-being and collective images.

But, as Du Bois and Ellison also demonstrate, it is not easy to simply dismiss the idea of progress in light of the multiple and conflicting ways that this trope has been used, especially in the context of black freedom struggles. I acknowledge that a basic notion of progress has inspired many struggles, acts of resistance, and movements that many of us admire. It is a concept that has been deployed, resignified, and enacted by communities and individuals that have experienced the underside of this concept and process. I think, for instance, of Martin Luther King's faith in a universe that "bends toward justice." I also am reminded of Theodor Adorno's claim that progress provides a preliminary "answer to the doubt and the

hope that things will finally get better, that people will at least be able to breathe a sigh of relief."[36] What would critique, resistance, or political struggle mean apart from a minimal notion of progress, a hope that the quality of life will improve, especially for those groups that have been systematically marginalized? I therefore acknowledge that progress, a trope that facilitates certain ways of interpreting, constructing, and relating to historical change and development, has had different meanings and connotations. (To claim, for instance, that humanity necessarily moves forward, improves, and approaches a state of fulfillment is not necessarily the same thing as claiming that progress is the result of contingent human efforts, interventions, and interactions.) I also take it that this idea is intertwined with other fraught ideas and ideals that many people cherish— freedom, equality, inclusion, recognition, reconciliation, agency, and so forth. Although I take seriously the complexities involved with this category, in what follows I am primarily concerned with progress as a triumphant category, as a tool that helps to reinforce, affirm, and justify the order of things (and conceal the nasty aspects of the existing state of affairs). In other words, this book specifically targets narratives, images, and strategies that rely on the denial or easy resolution of painful tensions and contradictions in the past and present, those facets of life that remind us that the status quo is harsh and cruel for many people under its sway. While attachments to progress are not always explicit, my sense is that it lurks behind and discloses itself in collective commitments to American exceptionalism, the American Dream, a postracial society, leaving the past behind, and spreading democracy and capitalism, even through war, to less "developed" nations. For many people, catastrophic events in the modern age, like the Holocaust, the slow extermination of Native Americans, The Middle Passage, genocide in Rwanda, and perpetual wars and ecological disasters, have shattered the notion that history necessarily moves toward a more complete and fulfilling state. At the same time, this idea of progress episodically flashes up. It operates in both subtle and explicit ways to mitigate and diminish the tragic qualities of history and human existence. The denial of ongoing racial disparity and violence is, in part, a result of our culture's yearning for a future (and a present) that has been liberated from certain kinds of unsettling losses, memories, and conflicts. If progress is the condition of the possibility of hope in our culture, then this is a hope that has little to no room for melancholy.

Du Bois and Ellison make up an important part of what I call the black literary and aesthetic tradition, a tradition that often underscores themes like melancholy, remembrance, loss, and tragedy in ways that gesture toward a different kind of hope. This melancholic hope, in opposition to triumphant, overconfident narratives, tropes, and images, suggests that a better, less pernicious world depends partly on our heightened capacity to remember, contemplate, and be unsettled by race-inflected violence and suffering. When I use the phrase *black literary and aesthetic tradition*, I have in mind authors, artists, and texts that have responded to, articulated, and rendered audible and visible the painful contradictions associated with black subjectivity, modern processes of racialization, and so forth. I am thinking of a variety of texts and discourses that delineate and exemplify the ways black Americans have developed enduring, yet precarious, cultural practices, institutions, and resources, enabling blacks to survive within the tentacles of white supremacy.[37] By *tradition*, I mean something like what Alasdair MacIntyre calls "arguments extended in time," discourses that travel across time and space, elaborating on recurring themes, topics, and conditions while acknowledging historical discontinuities and breaks.[38] In this book, the black literary and aesthetic tradition refers specifically to essays, novels, speeches, music, and films, different kinds of texts that reflect and give meaning, and meanings, to the diverse experiences of being formed as a black subject in America and the modern world more generally. By using the language of tradition, I acknowledge and accept the dangers involved in imposing unity and coherence onto experiences, phenomena, and expressions that are diverse, pluralistic, and scattered. I similarly acknowledge that the qualifier *black* or the phrase *black subjectivity* is unstable and takes on different, conflicting meanings across time. For instance, if Du Bois defined black Americanness or Negroness as "riding in a Jim Crow car" (suggesting that this legal and social condition provided blacks with a common, unifying obstacle), then surely something about being and identifying as black has changed significantly since 1964 and the passing of the Civil Rights Act. Finally, I take it that traditions are imagined and constructed according to certain interests, desires, and aims. For this book, the black literary and aesthetic tradition is a construct that enables me to connect and juxtapose authors and artists that share concerns, ideas, and commitments germane to my investigation.

This "shared" dimension should not obscure the fact that every imagined tradition is defined just as much by disagreement and tension as it is by consensus and overlap.[39]

In what follows, I consider how black thinkers, writers, and artists have articulated the pains, pleasures, and struggles associated with inhabiting a black body in the modern world, experiences that trouble progressive narratives and that invite us to think hope and melancholy together, to imagine vulnerability and heightened receptivity to loss as sites for a different kind of hope. In order to express and articulate this melancholic hope, these writers and artists often draw from black musical practices and styles, such as the spirituals, blues, jazz, and more recently, hip hop. Du Bois, for instance, treats the sorrow songs of slave communities as expressions of "death and disappointment" that simultaneously voice longings for a better, more just existence. As Du Bois pays tribute to the spirituals and sorrow songs in his well-known text *The Souls of Black Folk*, he does this in part by using sorrow as a trope throughout the text, a trope that works to invoke different kinds of emotions and affects in the reader. Writers like Ralph Ellison and Toni Morrison use blues and jazz in their novels and essays to register the "painful details" of black life, the tragic and comic dimensions of human existence, and the breaks, cuts, and wounds that accompany migration, exile, and dislocation. Similarly, filmmakers like Spike Lee and Charles Burnett incorporate jazz and blues songs in their cinematic representations of black communities and cultures. By combining image and sound, these films enable and compel audiences to both see and hear the pleasures and pains, doings and sufferings, struggles and losses experienced by black bodies. For these authors and filmmakers, musical practices like jazz and the blues, especially when incorporated into literature and film, signify different modes of being in the world, different ways of relating to others, time, history, and loss.

Yet the use of the term *melancholy* or the phrase *melancholic hope* to describe these aesthetic expressions might understandably generate questions and concerns. For many people, melancholy invokes images of depression, pathology, and despair. In addition, melancholy usually refers to an exclusively individual state or condition; it therefore does not appear to have implications for ethics, politics, and how we imagine the relationship between self and other. Finally, it might not be clear how this category helps us think about and reimagine modern racial formations, racial difference, and black people's strivings and experiences. While the language

of progress might be too optimistic, the invocation of melancholy goes too far in the opposite direction. In this study, I draw from an array of thinkers who have rekindled interest in the political and ethical implications of loss, trauma, and remembrance. Many of these authors trace the idea of melancholy back to Sigmund Freud's essay "Mourning and Melancholia" (1917), wherein Freud appears to make a stark distinction between these two mental states.[40] Mourning, according to Freud, "is regularly the reaction to the loss of a loved person, or to the loss of some abstraction which has taken the place of one, such as one's country, liberty, an ideal, and so on."[41] Notice that the object of mourning is not always concrete for Freud. Because people are attached to ideals (like freedom or equality), they can experience loss when these ideals are undermined or when these ideals are withheld from certain individuals or communities. It is also important to point out that Freud refers to mourning as a regular response to loss. The mournful subject acts normally when she is able to replace the lost object with a new one, even though this may be a slow and painful process. Melancholia, on the other hand, is a pathological response to the loss of an object. This condition is "not the normal one of a withdrawal of the libido from this [lost] object and a displacement of it on to a new one, but something different, for whose coming-about various conditions seem to be necessary."[42] Because the melancholic subject cannot replace the lost object with a new one, she must incorporate the lost object, a process that leads to a conflation between the self and the lost object. This internalization of loss works to unravel the grieving individual; this internalized loss becomes a recalcitrant wound that "empties" the self and undermines any notion of self-coherence. As Freud puts it, "In mourning it is the world which has become poor and empty; in melancholia it is the ego itself."[43]

Freud seems to be making a neat distinction between healthy and unhealthy ways of responding to loss, between those who are able to successfully move on from a traumatic experience and those who remain stuck in that moment.[44] But anyone who has experienced loss (death, separation, injury) knows that the process of moving on is always incomplete. Past losses have a habit of haunting the present in ways that we cannot control or anticipate. As Judith Butler points out in her reading of Freud's essay, Freud incorrectly assumes that objects are exchangeable, that the new object of attachment can fill in the emptiness caused by the loss of an object. She writes, "Freud's early hope that an attachment might be withdrawn and given anew implied a certain interchangeability of objects as a

sign of hopefulness. . . . I do not think that successful grieving implies that one has forgotten another person or that something else has come along to take its place, as if full substitutability were something for which we might strive."[45] Since objects are never completely exchangeable, Butler contends that the neat distinction between mourning and melancholy does not hold, a conclusion that Freud's 1917 essay actually invites. Whereas Freud suggests that the completion of the work of mourning is a sign of hope, Butler maintains that a different kind of hope is opened up when we confront the intractability of loss or the ways various forms of unrecognized loss both shape and puncture our social worlds and relationships. For Butler, an alternative to violence and perpetual war involves developing forms of solidarity and community that affirm our shared vulnerability to injury, loss, and death, a shared quality that proponents of empire and war tend to disavow. Like Butler, David Eng and David Kazanjian also suggest that melancholy might be unhinged from its exclusively pessimistic connotations.[46] For these authors, melancholy does not simply register lost objects and ideals; it also signifies the remains and leftovers from past experiences of loss. Melancholy, on their reading, is "a continuous engagement with loss and its remains. This engagement generates sites for memory and history, for the rewriting of the past as well as the reimagining of the future."[47] Whereas narratives of progress minimize or explain away the catastrophes of history, melancholy becomes an occasion to be unsettled and opened up by painful, fragmented accounts of war, genocide, and racial and gender violence. This melancholic attachment to the losses and remains of history makes possible a different kind of future than the one imagined by the proponents of progress. Similarly, these attachments reshape our relationship to the past (and the evanescent present).

Amid these recent attempts to draw out the ethical and political dimensions of melancholy, Anne Cheng has used this category to think specifically about racial formations in America. In *The Melancholy of Race*, Cheng uses Freud's category to draw attention to forms of grief experienced by black Americans (and other racialized groups, especially Asian-Americans) that cannot be quantified or "definitively spoken in the language of material grievance."[48] Cheng does not deny the importance of redressing historical injustices in the political and legal realms. She is simply concerned about experiences, struggles, and losses that cannot be resolved or fixed through juridical institutions. Alluding to Ellison's aforementioned novel, Cheng suggests that melancholy registers the experience of being rendered invisible, of

being both assimilated into and excluded from the social order. By setting up an analogy between the melancholic ego and the ideal of whiteness, Cheng claims that "racialization in America may be said to operate through the institutional process of producing a dominant, standard, white national ideal, which is sustained by the exclusion-yet-retention of racialized others."[49] (Racialized others, in this configuration, are akin to lost objects that are integrated into the ego but only because the distinction between the ego and the lost object has been elided.) In addition to describing racial formations in America, melancholy also refers to the ways blacks have responded to rejection and marginalization. As Cheng puts it, "racial melancholia as I am defining it has always existed for raced subjects both as a sign of rejection and as a psychic strategy in response to that rejection."[50] By linking loss and strategy, or melancholy and practice, Cheng's project resonates, to some extent, with Karla Holloway's fascinating work on grieving practices within black American culture. In *Passed On*, Holloway discusses how black Americans have endured a history of untimely deaths. Because of this predicament, they have established practices, rituals, and institutions in response to death and loss that have been crucial to the formation of black American identity.[51] Both Holloway and Cheng allude to the sorrow songs and spirituals as examples of this melancholic mode of being. Referring to Du Bois's aforementioned interpretation of this genre, Cheng suggests that melancholy is a strategy that involves wrestling with death, suffering, and absurdity while also affirming moments of freedom, joy, and pleasure. In fact, the sorrow-song tradition, she suggests, juxtaposes and even fuses feelings, affects, and dispositions that we usually take as opposites—joy and sorrow, pleasure and pain, and melancholy and hope.[52]

In what follows, I take this intimacy, and tension, between melancholy and hope seriously in an attempt to trouble overconfident accounts of history, human experience, collective identity, and racial progress. In this book, melancholy undercuts familiar affirmations of hope, or hopefulness, to gesture toward a different kind of hope, future, and set of possibilities. Melancholy, as the sorrow-song and blues traditions indicate, is one way to register death, tragedy, and loss, including the losses, exclusions, and alienating effects of social existence. It names one way of being unsettled, wounded, and affected by these all-too-human conditions. While these conditions are ineluctable for human beings, they are also mediated and informed by power, sociality, history, and so forth. Certain communities and subjects, in other words, are more susceptible to "untimely" death

and loss because of their positions within the social order. Finally, my use of melancholy suggests that attachment to loss is also an attachment to the remains and traces of past experiences and events. By imagining and relating to the past as a congeries of remainders and fragments, we refuse the tendency of progress to integrate past events, ideas, and possibilities into a coherent, status quo–affirming framework. This refusal potentially allows the past to disrupt, unsettle, and rework our sense of and relationship to the present. As Jonathan Flatley describes it, melancholy is an attitude, form of attunement, and mode of being in the world.[53] It names a way of remembering and being opened up by the often unacknowledged forms of violence and cruelty that social arrangements produce and rely on; it is defined by a difficult vulnerability to the broken features of the world, a kind of vulnerability that threatens coherent identities and narratives.

THE FRANKFURT SCHOOL AND
THE STRANGE-BEDFELLOW APPROACH

While this study mainly draws from black writers and artists who have thought explicitly and substantively about the complexities of racial formations, the book also employs ideas and concepts from members of the Frankfurt School, especially Walter Benjamin and Theodor Adorno. The Frankfurt School and the black literary tradition may appear unlikely bedfellows to some readers. We are usually told that the members of the Frankfurt School, particularly Adorno, were elitist, Eurocentric, and dismissive of popular culture, characteristics that come together in Adorno's infamous critique of jazz music. Because of this, most would not expect Adorno and Benjamin to be relevant or useful for thinking about race, racial history, or what Du Bois refers to as black strivings. In addition, because Adorno and Benjamin are supposedly pessimistic about the possibility of change and transformation in our world, it makes no sense that these authors would be helpful for a book that purports to be about hope, even if this is a hope rendered strange.[54] This book attempts to offer a more creative and refreshing reading of these authors, a reading that enables us to see affinities, as well as vital differences, between the Frankfurt School and the black literary tradition. For instance, as suggested above, it is illuminating to juxtapose Ellison's concerns about instrumentalizing suffering and loss in *Invisible Man* with Benjamin's critique of continuous, progressive accounts of history. Both authors contest the ways ascendant images

and projects erase, minimize, and explain away historical loss and anguish. In addition, one could read Du Bois's implicit engagement with Hegel, his attempt to challenge the sweeping, absorbing quality of Hegel's dialectic in the context of black strivings, alongside Adorno's critique of Hegel's occasional aversion to recalcitrant forms of difference and nonidentity.

More generally, what connects Adorno and Benjamin to authors like Du Bois, Ellison, and Morrison is a sense that melancholy is an ethical attitude and disposition that is not antithetical to hope for a better world. In other words, melancholy doesn't necessarily lead to despair and cynicism; melancholy in the writings of Adorno and Benjamin is implicitly reimagined as a way of thinking about and being affected by the world. It engenders vital dispositions, attitudes, and desires—a critical gaze toward the social order, heightened awareness of those bodies and objects mutilated by the social order, sensitivity to the disavowed relationship between freedom and violence, and hope for a different kind of existence. But this is a hope that, in Adorno's words, finds itself "draped in black."[55] While Adorno and Benjamin might not talk specifically about the conditions that influence and plague black people, they are deeply aware of racial formations that marginalize and persecute Jews, formations that Du Bois becomes increasingly concerned about throughout his life. A final point of intersection between these two discursive legacies is the significance ascribed to art. Like the black literary figures discussed in this book, Adorno and Benjamin imagine art and aesthetics as a site where suffering can be expressed and a better world imagined. In what follows, I take seriously the social ambivalence of art, the ways artworks both reflect social and historical conditions and enable viewers, listeners, and participants to rethink and reimagine these conditions. Similarly, I critically examine Adorno's contention that influential cultural practices and mechanisms (television, film, entertainment industry, radio, popular music) contribute to the fantasy of a coherent, harmonious world that is relatively unscathed by painful events, conditions, and memories.

In many ways, my strange-bedfellows approach is indebted to contemporary thinkers who have attempted to forge dialogues between Africana studies and other discourses, such as continental philosophy and American pragmatism. These approaches provide, among other benefits, nuanced ways of understanding the complexities, erasures, and struggles of modern life, particularly as they pertain to the formation of race and racial hierarchies. Cornel West, for instance, has contributed to this dia-

logical endeavor by uncovering shared democratic concerns and commitments between Du Bois and pragmatists like Emerson and Dewey.[56] At the same time, West's work exposes glaring gaps within American pragmatism concerning the issue of race, racial injustice, and modern colonial power. Furthermore, West's oft-cited notion of the tragic-comic, a concept that registers the tensions and ambiguities, the joys and pains, internal to human life, borrows from and brings together thinkers and artists from diverse traditions—Coltrane, Chekov, Beckett, Morrison, Gramsci, and others. Following West's practice of bricolage, the cultural theorist Paul Gilroy also juxtaposes Africana cultural resources (Du Bois's ideas, black music, black literature) and European discourses (including the Frankfurt School) to make sense of what he calls the "terror of modernity."[57] Gilroy is especially interested in the ways that modern black selves have created trans-national practices in opposition to modernity's more pernicious tendencies. These practices, for Gilroy, develop *within* but are not fundamentally *of* modernity. While this distinction might be too strong, we might simply take Gilroy to be highlighting the ambivalent relationship between blackness and the forces of modernity. West and Gilroy both create what Adorno might call "constellations"—configurations of ideas, concepts, and images from disparate traditions and discourses, configurations marked by both the affinities and the tensions that exist among the collected concepts.[58] A constellation refers to a construction of ideas that is never completely harmonious; the relationships between these juxtaposed ideas include ambiguities, fissures, and tensions, qualities historically associated with selves that have been dislocated, that have experienced ruptures to their communities, and that have been forced to live at the intersection of disparate traditions, practices, and discursive trajectories. A constellation, on my reading, is also one way the remains of the past and present are used and reorganized to create and prepare for a different kind of future. As Eng and Kazanjian suggest, remains signify both erasure and survival, both loss and possibility. While this project, like remains, exists at the intersection of melancholy and hope, it also exists at the intersection of different discourses and traditions that offer provocative resources to reflect and elaborate on the relationship between melancholy and hope. In other words, in this book, I gather the remains of various discourses and practices, particularly the black literary and aesthetic tradition and the Frankfurt School, in the effort to articulate a hope draped in black. This awkward kind of hope is a response to a culture attached to narratives of

progress and eager for a world in which painful racial memories will be left behind, forgotten, or converted into an affirmation of the status quo.

This strange-bedfellow approach is perhaps not so strange depending on how one thinks about tradition and discourse. Discursive traditions are never monads that exist in isolation. Any tradition is always being defined in relationship to other traditions and discourses, even if this relationship is antagonistic. While authors constantly bring together and juxtapose different horizons and ways of thinking, this is faciliated by the fact that traditions (arguments, ideas, practices) always point beyond themselves—they move, travel, transform, borrow, get fragmented, intervene in and get "cut" by other discourses. In the particular context of black literature, the twentieth century Trinidadian thinker C. L. R. James refused the notion that black studies is an isolated discourse and only relevant to black people. James famously defines this fledgling field as a kind of intervention into and within Western civilization, an intervention that is always already a part of Western history and modernity.[59] Many scholars, including the influential Jamaican thinker Sylvia Wynter, have advanced James's ideas. Wynter demonstrates how black literature and thought relate to and contest modern European conceptions of the human being, conceptions that are often defined in opposition to people of color or by locating people of color outside the category of the human.[60] In what follows, I think within black studies and between black studies and critical theory to interrupt self-satisfied commitments to Western civilization and progress.

To accomplish this, each chapter in this book looks at specific sites within the black literary and aesthetic tradition that articulate this relationship between melancholy and hope. At the same time, each chapter incorporates themes and motifs from Adorno and Benjamin (with some chapters accomplishing this in more explicit ways than others). In chapter 1, I revisit Du Bois's classic work, *The Souls of Black Folk*. I suggest that there is a tension in this text around the theme of progress. On the one hand, Du Bois claims that black American strivings and aspirations should reach their destination in the "kingdom of American culture." He seems to express the kind of optimism about American ideals that Bercovitch associates with the jeremiad tradition. In a quasi-Hegelian manner, he suggests that freedom and equality will eventually unfold and expand to include black people. On the other hand, Du Bois draws from the sorrow-song tradition to undo overconfident accounts of freedom and progress, a strategy that enables him to place racial trauma at the heart of American

history and modernity more broadly. In this chapter, I don't try to resolve this tension but rather invite the reader to see what this tension might offer. Since Du Bois demonstrates the critical and ethical dimensions of sorrow in *Souls*, I broach Adorno and Benjamin's ideas in this chapter to flesh out the implications of melancholy. In the second chapter, I continue to read and examine *Souls*, paying attention to the specific work that sorrow performs in the text, how it troubles and complicates notions of freedom, liberation, and agency. In addition, I contend that Du Bois's multigenre work invites the reader to think about the fraught relationship between aesthetics, ethics, and politics, a relationship that I examine in conversation with Adolph Reed's against-the-grain study of Du Bois.

Chapter 3 examines Ralph Ellison's and Toni Morrison's literary use of jazz in their respective novels, *Invisible Man* and *Jazz*. In the same way that Du Bois uses the mourning song as a trope in *Souls*, Ellison and Morrison deploy jazz as way to critique linear, forward-marching conceptions of time, history, and freedom. Both authors agree that jazz "gives one a slightly different sense of time."[61] The discordant, improvisational quality of jazz compels these authors to imagine time as always out of joint, a theme also found in the writings of Benjamin and Jacques Derrida. This disjointed quality means that the past can always haunt and disturb the present. In addition, the present is always the site of potential breaks and ruptures that can signify both dislocation and pain as well as novelty and possibility. In this chapter, I show how Ellison uses a jazz-imbued notion of time to critique quasi-Marxist interpretations of history, especially those that encourage us to forget racial conflicts and struggles for the sake of a unified future. For Ellison, jazz and blues record and capture instances of suffering and loss that traditional Marxist frameworks instrumentalize and explain away. In *Jazz*, Morrison uses jazz tropes and images to reinterpret black American migration narratives, especially those that trace the movements of black bodies from the South to the North in the early part of the twentieth century. Whereas Harlem Renaissance writers, such as Alain Locke, imagined the North as a space of unlimited possibility and progress for blacks, Morrison, with the privilege of hindsight, draws attention to the ways the North became a site where the violence and terror associated with the South was repeated. This condition, as Morrison represents, was experienced differently across gender lines. The concept of repetition, so vital to the jazz tradition and music in general, allows Ellison and Morrison to underscore how past traumas and losses have a

habit of returning in the present. At the same time, repetition signifies novelty and possibility for these authors, since repetition enables the emergence of something different, even if this is a slight difference. It is important, I argue, to keep both connotations in mind. To conclude the third chapter, I use Ellison's and Morrison's reimaginations of jazz to address the limitations in Adorno's controversial critique of this musical tradition.

In chapter 4, I shift to an analysis of visual texts. I invite the reader to think about how films shape cultural memory and influence our relationship to the past and present. While this might seem like a break from the other chapters and my examination of novels and essays, I intend to show how images of progress and forward-marching strategies operate in different kinds of media and contexts.[62] Inspired by Adorno's and Benjamin's understanding of the relationships between culture, art, and power, I argue that the film industry tends to minimize or displace racial conflicts and tensions, a strategy that works to leave the comfort and coherence of the viewer or spectator intact. In this chapter, I examine how this strategy operates in Stanley Kramer's classic film *Guess Who's Coming to Dinner*. To some extent, this film marks a break from previous depictions of black people and interracial intimacy, especially those associated with *The Birth of a Nation*. At the same time, I show how Kramer's film, like its predecessors, betrays an eagerness to transcend and move beyond the contradictions and tensions attached to the historical construction of race and racial difference. Situated in the midst of the *Loving v. Virginia* (1967) case, I interrogate how the film prefigures the postracial ideal and the dominant interpretations of black civil rights struggles that accompany this ideal. In response to *Guess Who's Coming to Dinner*, I look at two post–civil rights films that refuse to do the work of racial progress and optimism. I look, for instance, at Charles Burnett's *Killer of Sheep* (1977), an independent film about a black family enduring harsh conditions in Watts, California. This film, as other commentators note, indirectly invokes the Watts riots, reminding the viewer of the less palatable dimensions of the civil rights movement that cannot be assimilated into reassuring narratives of achievement. At the same time, this film shows how working-class black people discover moments of joy and pleasure (in music, dancing, friendship, laughter, intimacy) amid stark, confining economic conditions. I conclude the chapter with a reading of F. Gary Gray's heist film *Set It Off* (1996), showing how the film troubles gender assumptions in urban action films while showing the failures and erasures involved with the so-called American dream.

Chapter 5 examines two ways of thinking about the postracial idea. On the one hand, the postracial trope reenacts the kind of progressive and forward-marching imagination that black literary figures trouble and contest. On the other hand, it alludes to a more nuanced and tension-filled way of thinking about and imagining racial difference (in opposition to racial authenticity concerns) in the age of Obama. By looking at his speeches and writings, I show how Obama's inspiring message of hope and promise is balanced by a tragic sense of America's racial history. Yet I suggest that this tragic sense is too often diminished by his commitment to American exceptionalism. This all-too-familiar attachment to American uniqueness and progress works to assimilate the complexities of race and history into a coherent, reassuring framework of meaning. This tactic encourages the stronger, victorious sense of the postracial and obscures how the nation-state has been a crucial site of racism, cruelty, and violence. To put forth a critique of this tendency in Obama's writings and speeches, I return to the work of Toni Morrison. Morrison reminds us that the traumatic episodes of history, such as chattel slavery, undo coherent representations of history, nationhood, and identity. This undoing, according to Morrison, is perhaps the best way we can "pay our debts" to those who have perished and suffered unjustly. Her work suggests that "being undone" potentially renders us more vulnerable and attuned to extant forms of suffering and loss. Along these lines, I provide a reading of Toni Morrison's *Paradise* to challenge deeply entrenched commitments to nationalism and exceptionalism and to offer a more nuanced conception of the postracial. In the conclusion, I use my analysis in the previous chapters to respond to contemporary conversations and discussions about race, nation, progress, and the tragic quality of human life.

FINAL, PREPARATORY SKETCHES

While part of my argument is that postracial rhetoric exemplifies familiar notions of progress, I recognize that current resistance to race talk is motivated by other factors, many of them related to epistemological and ethical concerns. For some people, race is not a viable concept because it is no longer scientifically valid.[63] Since the pseudoscientific discourses that helped to underwrite racial classifications and hierarchies have been debunked, we can now dismiss race as an illusory social construct. If race is a fabricated idea, why not deconstruct race to the point of obliteration?

If race is such a divisive category (that isn't even real), why should we hold onto this dubious concept? Why not focus on what we, as humans, have in common? In this book, I accept that race is a social construct but I reject the notion that social constructs are somehow not real or the hidden assumption that we can allude to and make sense of reality apart from language, imagination, and social norms. Like gender, sexuality, or the idea of humanity, race is real because, not despite that fact that, it has been socially constructed, embodied, revised, and performed across space and time. Following scholars like Stuart Hall, I take it that race is a contingent, historical signifier that takes on new meanings and connotations as it migrates across different discursive domains and contexts.[64] Because race is not a fixed, stable category or a category that exists in itself, this book assumes that racial identity becomes intelligible in relationship to other identities and subject positions, including class, gender, sexuality, and citizenship. In what follows, I attempt to take seriously what Kimberlé Crenshaw famously refers to as the "intersection" of these coconstituting identities.[65] I therefore assume that each individual is what Anthony Pinn calls a "complex subject," existing at the fraught, tension-filled intersection of different markers of identity.[66] In addition, I take it that the language of race is an indispensable category that enables us to illumine certain kinds of social arrangements, conflicts, disparities, and exclusions in addition to collective fears, anxieties, and aversions that are directed toward certain bodies.[67] The language of race is indispensable, although not sufficient, to critically examine the hypersexualization of black and brown women within hip hop's visual culture, everyday conversations that stigmatize Mexican and Latino migrants, the excessive State surveillance and repression of working-class black communities, or the Tea Party's attempt to discredit Obama's presidency by insisting on his Muslim and Arab identity (as if Islam is necessarily bad, undesirable, and un-American). As I point out in the concluding chapter, the concept of race enables us to trace how value and recognition gets distributed across communities, how certain subjects and bodies become more "worthy" of life than others and therefore more worthy of compassion, care, protection, and lament.

A final note: Nothing in my analysis suggests that there have not been changes, shifts, and improvements within America's racial arrangements. In fact, what is so slippery about the racial order, or the narratives, practices, conditions, and institutional arrangements that maintain and reproduce patterns of inequality between white people and people of color, is

that it is both precarious and durable, historically contingent and transhistorical, mutable and resilient. In many ways, I am the beneficiary of the gains made by various struggles for racial justice and equality. My book is motivated by a concern that when these changes are interpreted through the lens of progress, something is lost (and progress makes us unaware of this loss). Because progress tends to function as a harmonizing category, it makes us less attuned and responsive to events, bodies, conditions, and losses that we cannot immediately make sense of, explain away, or integrate into a unified narrative. But this book is also motivated by a sense that what is admirable about us is our capacity to be moved, affected, and transformed by others. Melancholy names one way that we are undone by the sufferings and struggles of others, one way that the dismembered haunt and agitate our narratives, memories, and frameworks of meaning. A less violent and cruel world depends, in large part, on our capacity to be figuratively wounded and opened by the dissonant qualities and blue notes of life's many soundtracks. At least this is my wager . . . and hope.

ONE

Unreconciled Strivings

DU BOIS, THE SEDUCTION OF OPTIMISM,

AND THE LEGACY OF SORROW

The twentieth-century philosopher Alfred North Whitehead famously claimed that all philosophy is a footnote to Plato. Sometimes it feels as if African American studies consists of a succession of footnotes to W. E. B. Du Bois.[1] Not only do many genealogies of black intellectual production, to the chagrin of some scholars, begin with Du Bois, but many authors continue to draw from his corpus in order to frame, explain, and put forth solutions to the problems that currently beset black people.[2] Although there are glaring blind spots and omissions within his corpus, he confronted many of the unpleasant realities, conditions, and topics that continue to haunt the social order—the problem of the color line, the subordination of women, the complicated relationship between race and class, Western imperialism, and the pernicious consequences of the capitalist-inspired accumulation of wealth, especially for the darker denizens of the world. In this chapter and chapter 2, I also argue for Du Bois's ongoing relevance, underscoring the capacity of his ideas to illuminate and reconfigure our understanding of the present. I am particularly interested in how the trope of sorrow operates in *The Souls of Black Folk* to challenge

facile notions of racial progress. In this work, Du Bois adopts a melancholic mood or attitude in response to the harrowing dimensions of his recent past (a past that includes chattel slavery and the Civil War) as well as the postbellum arrangements that prevent black bodies from flourishing and living well after the putative triumph of emancipation. As Terrence Johnson suggests, the spirituals, or sorrow-song tradition, constitutes a central part of Du Bois's thought and practice; this musical legacy contributes significantly to his understanding of race, American history, religion, human suffering, and hope.[3]

However, turning to Du Bois to develop a critique of progress is not an easy task. As many commentators have stressed, Du Bois adopts Enlightenment-inspired assumptions about the process and triumph of civilization, an inheritance that influences his conception of racial uplift. In his famous essay on the "Talented Tenth," a term that refers to the educated black elite, Du Bois takes for granted that "the Negro race, like all races will be saved by its exceptional men."[4] These exceptional men will be those who have absorbed the higher ideals and truths of humanity, those who have been trained and acculturated to rescue the masses of black folk from their benighted state. These agents of civilization and uplift, to put it succinctly, will redeem black people. Du Bois's faith in cultural redemption exhibits a troubling elitism.[5] More generally, it betrays a commitment to categories and processes—the civilizing process, for instance—that have had pernicious, if not ambiguous, implications for black people. As Cornel West points out, Du Bois appears to be "seduced by the Enlightenment ethos and enchanted with the American Dream."[6] His optimistic vision of humanity, according to West, prevents Du Bois from wrestling sufficiently with evil, tragedy, and the legacy of white supremacy. Although there is some truth to West's concerns, to simply locate Du Bois within this Enlightenment trajectory flattens the complexities and tensions within Du Bois's corpus. More specifically, this reduction downplays the significance of sorrow, tragedy, and death in his writings, especially in *The Souls of Black Folk*. In this chapter, I argue that *Souls* is a fissured text. Although Du Bois occasionally locates black strivings within an all-too-familiar telos of human advancement, he also draws from the sorrow-song tradition to undermine narratives of progress.[7] I encourage us to read this tension in a productive manner—as a commitment to a better future for blacks and other subjugated groups, but a vision that is mediated and informed by memories of racial loss and trauma.

Lawrie Balfour reminds us that *Souls* was written at a critical and painful juncture in black American history. The powerful concepts and metaphors that Du Bois introduces in this work—double-consciousness, the Veil, the color line—mark a moment in which the new freedoms and opportunities acquired by blacks after the Civil War have been undermined by the emergence of Jim Crow laws and practices. As Balfour describes, "Writing at the turn of the twentieth century, Du Bois uses this language to limn the contours of a world in which long-awaited emancipation and new citizenship gave way to disenfranchisement, debt peonage, and de jure segregation, enforced by terror in the South and inaction in the North."[8] *Souls*, as I argue in this chapter and chapter 2, reflects this broken predicament; it exists in a space between melancholy and hope, disappointment and possibility. Consequently, there are moments when Du Bois contends that the end of black people's strivings and aspirations should be "co-participation" or mutual recognition within existing social and political arrangements, a projected end that invokes Hegel's well-known Master-Slave dialectic. Along this line of thinking, American citizenship is imagined and valorized as an unequivocal ideal and good. Yet there are other moments in this collection when Du Bois suggests that the prevalent arrangements of America and modernity rely on the violent exclusion of certain kinds of bodies and communities, rendering integration a dubious, tension-filled aim. Mutual recognition (between whites and blacks, the oppressors and the subjugated) is a marker and benchmark of racial progress, and Du Bois hints at the losses, constraints, and failures that undermine endeavors to integrate formerly excluded groups into the nation-state, social order, and unstable category of the human. His writing renders us more attuned to those individuals, communities, and experiences that don't quite fit into overconfident narratives of freedom, civilization, and reconciliation. In this chapter and the next, I trace Du Bois's attunement to those bodies and subjects that cannot be easily placed in unifying imaginaries and optimistic frameworks of meaning.

DOUBLE-CONSCIOUSNESS AND
THE DUPLICITY OF RACIAL RECOGNITION

The play between optimism and lament in Du Bois's thought is articulated powerfully in "Of Our Spiritual Strivings," the first chapter of *Souls*. In this chapter, the reader encounters Du Bois's early attempts to wrestle

with self-estrangement, an uncanny mode of existence that reflects black people's marginalized status within the contours of American democracy and the modern world more generally. In this essay, Du Bois invites the reader to confront the harrowing question, what does it mean to be a problem? He begins, "Between me and the other world, there is an unasked question: unasked by some through feelings of delicacy by others through rightly framing it."[9] The word *between* here denotes both separation and proximity. Even as Du Bois is immersed in the other world of white bodies, expectations, and desires, he never feels quite at home. In other words, "being a problem is a strange experience," and this experience, or condition, renders the black subject a stranger to herself. This sense of *Unheimlichkeit* (traumatic uncanniness) is experienced at a young age for Du Bois as he frolics with other (white) children. After being refused by his classmate during an exchange of cards, he realizes "with a certain suddenness that he is different from the others; or like, mayhap, in heart and life and longing, but shut out from their world by a vast veil."[10] Here Du Bois introduces the notion of a veil, which connotes darkness, mystery, concealment, altered vision, as well as mourning and loss. In addition, the veil signifies separation and protection, an appropriate set of meanings since the color line functions to prevent "threatening" black bodies from entering spaces inhabited by white Americans. Several anticipatory questions emerge from this unsettling event in Du Bois's life in which he encounters this vast racial veil. First, does this veil enable black Americans to see and think differently even as it constrains and limits their participation in American life? In other words, what are the auspicious implications of being a "stranger in one's own house" and seeing the world through a dark lens? If there are empowering aspects of seeing through a veil, do these favorable aspects clash with the veil's more debilitating tendency to obscure or conceal similarities between both worlds, the ways blacks and whites are "alike in heart and life and longing"?

Du Bois's conception of double-consciousness is a response to this socially produced veil that, among other effects, alienates blacks from whites and from the broader social world, thereby producing divisions within the black self. In other words, this idea reflects social conditions that prevent black Americans from completely "fitting" into the democratic polity and consequently from becoming coherent selves. Yet his articulation of this double-consciousness also reflects Du Bois's implicit refusal to completely accede to the pressures of the racial and social order, to uncritically vener-

ate a nation founded on theft, dispossession, chattel slavery, and racial injustice. Even as he affirms the principles of American democracy, he is attuned to how the ideals of the so-called founding fathers have historically excluded and failed black bodies and other communities. Consequently Du Bois, through this notion of double-consciousness, attempts to mediate between "tasteless sycophancy [on one hand] and silent hatred of the pale world and mocking distrust of everything white [on the other]."[11] The following well-known passage expresses this experience of living between two separate, yet connected, worlds:

> The Negro is sort of a seventh son, born with a veil, and gifted with a second sight in the American world—a world which yields him no true self-consciousness, but only lets him see himself through the revelation of the other world. It is a peculiar sensation, this double-consciousness, this sense of always looking at one's self through the eyes of others, by measuring one's soul by the tape of the world that looks on in amused contempt and pity. One ever feels this two-ness, an American, a Negro; two souls, two thoughts, two unreconciled strivings; two warring ideals in one dark body, whose dogged strength keeps it from being torn asunder.[12]

In this passage, Du Bois again highlights the peculiarity or strangeness of being a split, fragmented subject. He laments the fact that the racial order prevents the Negro from attaining true self-consciousness, which entails the elimination of debilitating divisions within the black soul. He contends the Negro is out of joint with himself precisely because he is denigrated by the "other world," reduced to a "tertium quid," or an undefinable, illegible object, by the prevailing order. He looks at himself through the so-called normative gaze of white supremacy, which "looks on with amused contempt and pity," feelings that are internalized by black selves. The ideals and practices that define the social order are defined over and against blackness; white supremacy operates by marking the black body as other, deviant, inferior, and not quite human. The black self, at this stage, can only see a distorted, fragmented image of herself in the world dominated by her white counterparts. The true, integrated self, on the other hand, is only possible when black strivings coincide with the collective desires of the nation, or when Negro and white American are not imagined as contending identities.

It is important to keep in mind that the concept of double-consciousness signifies and recalls a legacy of both psychic and physical violence.[13] If the

term *double* connotes a division or a split, then it conjures up a history of black bodies being "torn" from African communities, black flesh being cut or torn open by the lash of the whip, black female slaves being routinely forced to "open" their bodies to the Master, and black body parts being cut off during the ritual of lynching. As Hortense Spillers argues, the distinction between the flesh and the body enables us to track the kinds of injury inflicted on black subjects. Whereas the body is usually imagined as relatively whole and coherent, the flesh, which is prior to the body for Spillers, registers and underscores the routine vulnerability and permeability of black selves within modern regimes of power. As Spillers puts it, "If we think of the 'flesh' as a primary narrative, then we mean its seared, divided, ripped apartness, riveted to the ship's hole, fallen, or escaped overboard."[14] In this allusion to the Middle Passage, Spillers repeats images and tropes associated with the cut or the wound, a repetition designed to underscore the violent tearing that black bodies and flesh endured at the advent of modernity and progress. By drawing attention to the "ripped apartness" of black flesh, Spillers enables us to connect double-consciousness to the physical wounds involved in the formation of modern black selves. Double-consciousness signifies this collective wound.

While double-consciousness marks a division or split in the black self, Du Bois does not necessarily endorse a *simple form* of reconciliation to fix this historical condition and experience. In other words, he does not suggest that black identity should be erased or replaced by a broader, more encompassing category of American identity that would eliminate the tensions, complexities, and possibilities of black existence. He writes, for instance, "The history of the longing to attain self-conscious manhood, to emerge his double self into a better and truer self, in this merging he (the Negro) wishes neither of his older selves to be lost. He would not Africanize America, for America has too much to teach the world and Africa. He would not bleach his Negro soul in a flood of white Americanism, for he knows the Negro blood has a message for the world."[15] For Du Bois, the truer self that emerges in the development of black identity will encompass both of his "older selves," both of his hitherto unreconciled strivings. As Shamoon Zamir rightly points out, it is important to recall the influence of Hegel's dialectic on Du Bois here.[16] Hegel's notion of *aufheben*, which according to Charles Taylor is "Hegel's term for the dialectical transition in which a lower stage is both annulled and preserved in a higher one," helps illumine Du Bois's analysis in "Of Our Spiritual

Strivings."[17] For Du Bois, the Negro's strivings are dialectically related to the aspirations of the broader American nation. This simply means that DuBois's Negro identity is (temporarily) opposed to his American identity, even as each opposing category is only identifiable in relation to its other. What Du Bois means by the truer self, as intimated above, is a black soul that has undergone the proverbial aufheben, a process through which the previous rift between black and American identity is overcome, but in a manner that difference and tension are not completely eliminated. Double-consciousness is therefore the "lower stage" of the self, which is both "annulled and preserved" as the higher self unfolds. It is important to note that, for Du Bois, both black and white American identities are transformed and synthesized in this dialectical progression toward a higher self. The Negro purportedly becomes more attuned to the higher ideals and values of American and Western civilization, while white Americans become more aware of and sympathetic to the losses, sufferings, aspirations, and gifts of black selves—qualities expressed through songs, narratives, church practices, and freedom struggles. We might wonder how this reconciliation occurs, especially without the metaphysical dimensions of Hegel's understanding of history and freedom. Will reconciliation between blacks and whites be the result of a universal history that necessarily bends toward reason, freedom, and equality? Or will blacks become reconciled to the broader nation-state through contingent, fallible institutions that promote equal education, black civic participation, the cessation of racist laws and codes, and the deepening of democracy? Will blacks gradually overcome inequality and division through ongoing political struggles by striving for common democratic goods, and by collectively bearing the memory of those who have vanished behind the veil?

While Hegel's aufheben can sound abstract and metaphysical, we should keep in mind that this dialectical process occurs within the precarious, contingent historical world. One place where this concept materializes is in Hegel's famous account of the master-slave struggle for recognition.[18] While some commentators, most famously Karl Marx, read this section of *The Phenomenology of Spirit* as a metaphor for class struggle, Susan Buck-Morss has recently reminded us that one important source of inspiration for this section was the Haitian Revolution, thereby suggesting that the master-slave dialectic is also an allegory about racial conflict and inequality within modern life.[19] Several aspects of this struggle are relevant for understanding Du Bois's account of black strivings. For one, Hegel begins the

narrative with an encounter between self and other, an interaction in which each self can only see the other as a hostile obstacle to his or her desire, self-certainty, and freedom (and therefore the other becomes an object that must be integrated into the self's narcissistic scheme or agenda). As Hegel puts it, "What is 'other' is an unessential, negatively characterized object."[20] For Hegel, the relationship between self and other at this stage lacks a mediating third term; it lacks a shared set of practices and norms that would allow for mutual recognition. Hegel prepares the reader for a crucial distinction that he makes throughout *Phenomenology*—the distinction between an autonomous self that is defined "by the exclusion from itself of everything else" and a self that is defined by its relationship to others and its coparticipation in a common ethical life.[21] Yet Hegel's narrative also suggests that this coparticipation is an arduous achievement. It emerges through life-and-death struggles between competing selves and communities, oppressive relationships between autonomous masters and dependent slaves, and the redeeming labor of the slave, labor that indirectly gives the bondsman a sense of power and independence with respect to the master (who can only enjoy and rely on what the slave works on and produces).

Hegel's master-slave narrative provides a useful way to frame and interpret the grievances and struggles of historically marginalized groups, including those of black Americans. Using this framework, we would imagine mutual recognition as the end goal or telos of black freedom struggles. While slavery, segregation, and racial inequality constitute examples of nonrecognition, endeavors to challenge and ameliorate these conditions rely on what Axel Honneth refers to as moral grammar, language that includes respect, esteem, and protection of rights.[22] As intimated above, injustice and nonrecognition connote division and conflict within the social order and within the marginalized black self; recognition, as a goal and ideal, contributes to what Hegel would call *Versöhnung* (reconciliation) of these social and individual conflicts.[23] Social progress would therefore involve the expansion of the sphere of recognition, the inclusion of formerly excluded bodies and communities, and the gradual resolution of social tensions and contradictions. On the surface, mutual recognition seems like an unequivocally worthy goal of political struggle. The basic survival of communities and selves relies on the protection of their rights and freedoms, the ability to participate in society's central institutions and practices, and the extension of respect and affirmation—especially

to groups that have been systematically injured and disrespected—from other members of the broader community. At the same time, there is an underside to this desire for recognition. Recognition comes with a price. In order to be recognized and affirmed by those in power, one has to accept and consent to the terms and conditions of power (even as those terms and conditions might change and shift). As Louis Althusser famously argues, the process of becoming an intelligible, recognizable self entails subordination to the status quo.[24] In addition, the Hegelian emphasis placed on reconciling conflicts and divisions, while important and occasionally necessary, overlooks the ways the drive toward unity often reproduces and deflects attention from suffering, conflict, and violence. Although Hegel's notion of reconciliation, as Michael Hardimon points out, takes seriously lingering tensions and conflicts within the social order that cannot be easily eliminated, some interpreters of Hegel have historically accentuated the triumphant side of the dialectic. As Zamir describes, many of Du Bois's American contemporaries in the late nineteenth century used Hegel "as a legitimation of American exceptionalism" and as a way to explain away and resolve the painful contradictions that accompany this imperial attitude and practice.[25]

To some extent, Du Bois inherits the ambiguities of the Hegelian legacy. On the one hand, he suggests that double-consciousness acts as a hindrance and obstacle to a more unified, coherent, black self. He refers to this condition as a "waste of double aims" that has "brought sad havoc" on black selves, preventing them from developing necessary skills and leading them to search for emancipation in the wrong places. Instead of "seeking to satisfy two unreconciled ideals," black Americans, according to Du Bois, should strive "to be co-workers in the kingdom of culture, to escape both death and isolation."[26] In order for blacks to flourish and prosper (and escape death and its various intimations), they must direct their desires and aspirations toward the venerable ideals of American democracy and the broader modern world. They must embrace the "ideal of fostering and developing the traits and talents of the Negro, not in opposition to or contempt for other races, but rather in large conformity to the greater ideals of the American Republic."[27] Du Bois claims, much as optimistic interpreters of Hegel do, that racial struggle and conflict can be resolved by integrating black bodies into the broader body politic, by enabling blacks to become participants within a shared ethical and political life. Through this coparticipation, both blacks and whites would be enriched and transformed.

Yet there is another side of Du Bois that resists this eager drive toward unity and the conciliatory quality of the framework of mutual recognition. This side of Du Bois similarly challenges facile notions of progress that hastily reconcile and explain away past and present forms of suffering and injustice. Following Zamir's analysis, this is the "Du Bois [who] refuses to subsume the negative particularity of African-American experience into historicist teleologies" and who reads double-consciousness as a kind of second sight, a different way of seeing and perceiving the social world.[28] Rather than being a debilitating obstacle to black flourishing, the divided quality of the black self might contribute to a heightened sense of the losses and fissures that optimistic accounts of progress and reconciliation downplay or deny. Seeing within and through a veil draws Du Bois's attention, for instance, to the shadowy side of emancipation and Reconstruction, to the "deep disappointment" that many blacks experienced after "the holocaust of war, the terrors of the Ku Klux Klan, the lies of the carpet baggers, and the contradictory advice of friends and foes."[29] Seeing through and within the more opaque side of things also makes Du Bois attentive to "the recent course of the United States toward weaker and darker peoples in the West Indies, Hawaii, and the Philippines."[30] As these examples suggest, double-consciousness might connote an embattled self with unresolved desires and strivings, but it also betokens a self that is attuned to the fractured quality of the social order, a feature that is often trivialized by our yearnings for a reconciled self and world.

Du Bois's ambivalent relationship to a Hegelian-inspired notion of reconciliation is exemplified by his brief reference to the sorrow songs at the conclusion of the first chapter of *Souls*. In his attempt to delineate the gifts that black and native peoples offer to America and the world in general, he writes, "There are today no truer exponents of the human spirit of the Declaration of Independence than the American Negroes; there is no true American music but the wild sweet melodies of the Negro slave; the American fairy tales and folk-lore are Indian and African . . . Will America be poorer if she replace her brutal dyspeptic blundering with light-hearted but determined Negro humility? Or her coarse and cruel wit with loving jovial good-humor? Or her vulgar music with the soul of the Sorrow Songs?"[31] In this passage, Du Bois valorizes the sorrow-song tradition (in addition to Native American and African storytelling) in order to inscribe black history and experience into the heart of American history.[32] This enables him to rei-

magine groups that have been marginalized and excluded as indispensable contributors to the formation of American democracy and culture. Here Du Bois anticipates Ralph Ellison's insistence, in opposition to those who imagine black and American identity as incompatible, that American culture has always been defined and shaped by black music, art, culture, and vernacular.[33] More generally, the sorrow songs, as Arnold Rampersad describes them, "seemed to Du Bois a reflection in art of a people's essential capacity for grandeur in thought and expression," thereby refuting the well-established assumption that blacks had nothing to contribute to civilization.[34]

As Paul Allen Anderson contends, Du Bois imagines the sorrow songs as a conciliatory gift offered by black people to mainstream America.[35] According to Du Bois, black people, through the beauty and grandeur of the sorrow-song tradition, corroborate their worth and value, qualities that have historically been denied to them. Black folk similarly demonstrate that they comprehend and embody the higher ideals of American democracy, humanity, and civilization. By assuming that these ideals and tenets are intrinsically good and valuable, Du Bois seems to confirm West's suspicion about the former's Enlightenment-inspired optimism. In addition, Du Bois contends that black bodies are the "true proponents" and even benchmarks of democracy. As he puts it, "Merely a concrete test of the underlying principles of the great republic is the Negro Problem."[36] The struggles and achievements of black people, in other words, become a barometer of democracy's success, placing the burden of democratic redemption and hope on black people's progress. But Du Bois does not simply affirm the legacy of sorrow songs as a conciliatory gesture, as a way to assimilate marginalized bodies into the fold of American life and the progressive movement of humanity. He also envisions the sorrow-song tradition as a configuration of cries, expressions, memories, and longings that challenge and undermine certain qualities and characteristics associated with America's collective self-image. Even though Du Bois operates with an essentialist logic that I find untenable (the Negro is humble and jovial while America is coarse and cruel), we can read Du Bois's language of replacement or substitution in a productive manner. Here Du Bois suggests that the "wild, sweet melodies of the Negro slave" don't simply add to and reinforce America's prevalent narratives, practices, and modes of being. The content and style of these

songs also work against and oppose certain tendencies adopted by the nation-state—such as the tendency to downplay racial loss and trauma in the name of progress.[37]

Terrence Johnson points out that the sorrow-song tradition is equally as important to Du Bois's ethical and political imagination as the Hegelian legacy or the discourse of American pragmatism. Not only does Du Bois end his 1903 text with a provocative reading of the spirituals but, as Eric Sundquist suggests, *Souls* as a whole is a musical text, one in which the ideas are inspired and haunted by the rhythmic cries of a subjugated community.[38] In this chapter and chapter 2, I show how sorrow and lament operate throughout *Souls*, as both an indication of the looming presence of the spirituals in the text and as an illustration of what Zamir alludes to as Du Bois's refusal to absorb black strivings into a triumphant account of history. Drawing from Theodor Adorno, I accent the "work of the negative" that lament performs, the ways expressions of sorrow and loss thwart prosaic yearnings for assurance, comfort, and historical closure. Adorno refuses, much as Zamir does in his reading of Du Bois, the teleological tendencies attached to Hegelian reconciliation. Adorno underscores how our dominant narratives and practices foster a false sense of harmony, harmony that is predicated on the denial or assimilation of difference and conflict. When he refers to his philosophical approach as "the consistent sense of non-identity," he attempts to cultivate a heightened sensitivity to the uncomfortable dimensions within our social world (violence, material suffering, alienation, trauma) that cannot be easily integrated into familiar patterns of thought, frameworks of meaning, and narratives of history.[39] At the same time, the nonidentical signifies possibility for Adorno; it reminds us that the present order of things is never total and complete. There is always room, however cramped and constrained, to imagine and construct new ideas, practices, and ways of being together. Yet this hopeful possibility in Adorno's thought is always tethered to a stubborn, tragic sense of human finitude. Hope emerges by working through the opaque dimensions of life, by acknowledging and looking from behind and through the multiple veils in our social worlds. As I argue in the rest of this chapter and in chapter 2, the sorrow-song tradition, on Du Bois's reading, articulates this opaque hope and, like Adorno's philosophy, challenges confident notions of historical progress and reconciliation.

Du Bois's attempt to draw out the ethical dimensions of spirituals is antici-
pated by Frederick Douglass's ode to this musical tradition. In his widely
celebrated slave narrative, Douglass devotes a passage to the slave songs,
emphasizing the affects and emotions that these "strange" melodies and
tones elicit. He writes:

> They would sing, as a chorus, to words which to many would seem un-
> meaning jargon, but which, nevertheless, were full of meaning to them-
> selves. I have sometimes thought that the mere hearing of those songs
> could do more to impress some minds with the horrible character of
> slavery, than the reading of whole volumes of philosophy on the subject
> could do.
>
> I did not, when a slave, understand the deep meaning of those rude
> and incoherent songs. I was myself within the circle; so that I neither
> saw nor heard as those without might see and hear. They told a tale of
> woe which was altogether beyond my feeble comprehension; they were
> tones loud, long, and deep; they breathed the prayer and complaint of
> souls boiling over with the bitterest anguish. Every tone was a testi-
> mony against slavery, and a prayer to God for deliverance from chains.
> The hearing of those wild notes depressed my spirit, and filled me with
> ineffable sadness. I have frequently found myself in tears while hearing
> them. The mere recurrence of those songs, even now, afflicts me; and
> while I am writing these lines, an expression of feeling has found its
> way down my cheek. To those songs, I trace my first glimmering concep-
> tion of the dehumanizing character of slavery. I can never get rid of that
> conception. Those songs will follow me, to deepen my hatred of slavery,
> and quicken my sympathies for my brethren in bonds. If any one wishes
> to be impressed by the soul-killing effects of slavery, let him go to Colo-
> nel Lloyd's plantation, and, on allowance-day, place himself in the deep
> pine woods, and there let him, in silence, analyze the sounds that shall
> pass through the chambers of his soul,—and if he is not thus impressed,
> it will only be because "there is no flesh in his obdurate heart."[40]

Several aspects of this passage help prepare us for Du Bois's more ex-
tended reading of the sorrow songs. For one, Douglass suggests that there
is a play between lack and excess with respect to the meaning articulated

in these "wild notes." They are "full of meaning" even though to many observers and hearers, they "would seem [like] unmeaning jargon." As a slave, Douglass did not understand the "deep meaning" of these songs, which he describes as "rude and incoherent." There is something about these songs that defies immediate interpretation; they possess an ineffable quality that is "beyond comprehension." This passage articulates a relationship between aesthetics and ethics, affect and politics. More than philosophy, according to Douglass, the slave songs "impress" upon the hearer the horror and brutality of American slavery. As Fred Moten suggests in his discussion of this passage in his study, *In the Break*, these cries provoke a response, a hearing, an encounter with the persecuted other.[41] The slave songs, which express woe, anguish, vulnerability, and complaint, unsettle Douglass; they induce sadness and melancholy, draw tears, and elicit rancor toward the institution of slavery. They provide him with the "glimmering conception of the dehumanizing character of slavery," a conception that is etched in his memory and that expands his sympathies for other subjugated bodies. Therefore, while Douglass accentuates the anguish and sorrow expressed by the slave songs, he does not claim that these affective responses necessarily lead to pessimism and despair. Rather, he acknowledges that these "depressing" feelings and emotions heighten his sensitivity to the pain and suffering of others. Melancholy here signifies a kind of wound but a wound that is the result of an excess of painful feelings that "boil over." This wound opens Douglass to the suffering of others, an opening that departs from the kinds of cruelty associated with an "obdurate heart."

According to Douglass, the slave songs inculcate dissonant memories and feelings while articulating desires for liberation. Hope, critique, and resistance are intertwined with vulnerability, sensitivity to the agony of others, and memory of past suffering. These connections are reiterated and expanded by Du Bois in the final chapter of *Souls*. If Du Bois claims that double-consciousness names the strange, uncanny feeling of being a black body in America, then the sorrow songs provided one soundtrack for this experience of two-ness. In "The Sorrow Songs," DuBois offers a provocative analysis of the "rhythmic cries of the slave," rhythmic cries and hollers that have "traveled down" from one generation to the next. Referring to songs such as "Swing Low," "Roll Jordan Roll," and "My Way's Cloudy," Du Bois, similar to Douglass, constantly refers to the strangeness of these songs, to the ways they agitate and unsettle his perceptions and sensibilities. He confesses, "Ever since I was a child these songs have

stirred me strangely."[42] He concomitantly suggests that these slave songs haunt him, indicating the nagging presence of an uncomfortable past in a nation that celebrates progress and the need to move forward.

Du Bois maintains in this essay that the sorrow songs tell a different story about black strivings vis-à-vis popular discourses and narratives about slave life and black people's relationship to this cruel social arrangement. He claims that certain voices "tell us in these eager days that life was joyous to the black slave, careless and happy."[43] Although Du Bois admits that there is some truth to this ascription of happiness and joviality to black folk, he claims that the sorrow songs "are the music of an unhappy people, of the children of disappointment; they tell of death and suffering and unvoiced longing toward a truer world, of misty wanderings and hidden ways."[44] These songs, Du Bois suggests, unveil forms of "death and suffering" that are often concealed and expunged from public memory or that enter public discourse in a palatable manner. Insofar as they enable the slave to "speak to the world," the songs of sorrow give a voice to dimensions of American life that typically go unvoiced, unheard, or that get explained away by sanguine, reassuring interpretations. Thus, when Du Bois claims "there is no true American music but the wild sweet melodies of the Negro slave" he is not merely assimilating these songs into the established narratives about America and its historical development. By suggesting that these songs are the true American songs, he is inscribing a history of racial violence into these entrenched narratives and therefore undoing relatively complacent depictions of the nation's identity, of its past and present formations. He is implying that the cries of the slave—cries in response to exile, loss, separation from loved ones, torture, sexual violence, and the agony and toil of repetitive labor—reveal something central to and traumatic about American life and history.

Du Bois anticipates James Baldwin's claim that "It is only in his music . . . that the Negro in America has been able to tell his story."[45] Baldwin, not unlike Du Bois, attributes racism to various myths of innocence, to the stories and practices that both produce racial hierarchies (because some groups are imagined as more pure than others) and allow people to disentangle themselves from the dirtying effects and messy features of past and present arrangements. For Baldwin, the music made and moaned in black churches, the cry heard through a saxophone or trumpet, or the rhythmic beat of a drum provide an occasion for black bodies to tell, perform, and re-sound a different set of histories and experiences that myths of purity

both exclude and define themselves against. By identifying song as an alternative site of storytelling, Du Bois and Baldwin suggest that there might be something about conventional narratives more generally that cannot register the complexities, depths, gaps, fissures, and anguish of black experience. The cry or the moan is felt as much as it is understood. The cry upsets one's yearning for clarity and coherence. Saidiya Hartman argues something similar in her analysis of slave songs in *Scenes of Subjection*. According to Hartman, the slave songs express an opacity in the slave experience. In slave songs and strivings, Hartman identifies an excess of meaning that undermines attempts to make the anguish of slavery transparent and easily accessible. These songs, according to Hartman, consequently trouble easy distinctions between pleasure and pain, or joy and melancholy.[46]

The play between anguish and pleasure in the sorrow songs explains why Du Bois insists that these cries of subjugated black bodies also express a yearning for a better world. As Du Bois puts it, "Through all the Sorrow Songs there breathes a hope—a faith in the ultimate justice of things. The minor cadences of despair change often to triumph and calm confidence."[47] The use of the preposition *through* indicates that hope is not acquired easily. The sorrow songs compel the listener (and performer) to make a passage through the moans and cries. In other words, the "longing for a truer world" must traverse the sorrow and loss that has accumulated in black communities. Hope, according to this view, must be inflected and even constrained by our attunement to ongoing modes of suffering and injustice. Du Bois claims that this breath of hope throughout the sorrow songs springs from several sources: "Sometimes it is a faith in life, sometimes a faith in death, sometimes assurance of boundless justice in some fair world beyond."[48] The source of boundless justice resonates with Du Bois's claim that black Americans have found occasional moments of peace in the "altars of the God of Right."[49] In many of the sorrow songs, we hear references to Jordan, the Promised Land, a symbol for earthly freedom and an image of a reunion with God in the afterlife. As many authors have pointed out, most notably Eddie Glaude, the themes and promises of the book of Exodus were incorporated and reinterpreted by many antebellum black communities. These communities were understandably attracted to the depiction of a God who identifies with an enslaved group, the Israelites, eventually delivering them from Egypt and guiding his chosen people into the promised land of Canaan.[50] The yearning for a better world that is heard in the sorrow songs is often emboldened by a com-

mitment to a God who is moved by the tears of the dispossessed. At the same time, Du Bois reminds us that for some enslaved blacks, death itself, apart from the promise of otherworldly bliss or an earthly haven, provided a kind of hope insofar as it signified liberation and escape from worldly cruelty and torment.

It is important to keep in mind that while Du Bois links the sorrow songs with hope for a time and place where humans will be judged by "their souls and not by their skins," he also questions the tenability of this hope. He asks, "Is such a hope justified? Do the Sorrow Songs sing true?"[51] These questions insert doubt and uncertainty into our aspirations for a world in which race does not matter. They remind us that even as some of us place our faith and hope in God, boundless justice, or some utopian vision of a transformed world, these commitments must take seriously conditions, realities, and historical events that should make us skeptical and ambivalent about claims that the world is steadily drifting toward truth, justice, and equality. As Anthony Pinn points out in his insightful study of black theodicy, the spirituals often make sense of and redeem black suffering by interpreting that suffering through a redemptive telos.[52] Agony and injustice can be endured on earth because heaven or an earthly paradise is promised in the future. In addition, suffering within this redemptive logic can be turned into a positive, it can be valorized and justified as a means to some future good. Pinn rejects this redemptive logic in addition to the theological assumptions behind it, particularly the idea of a benevolent God that exists outside of human powers and aspirations. Pinn's concerns resemble those of Marx, who famously describes religion as the "opiate" of the people; religious traditions offer oppressed communities visions of a blissful afterlife, thereby vitiating the kinds of struggles and efforts needed to transform the world of the here and now. Yet if Du Bois is right, the sorrow songs don't always place hope in some heavenly beyond that will redeem temporal suffering. Furthermore, by asking questions like "is the hope justified," Du Bois introduces doubt into his appreciation of the better world that the sorrow songs adumbrate.

But Du Bois, and Pinn as well, offers a much more nuanced understanding of religion than Marx. On the one hand, Du Bois agrees with Marx that Christian ideas and practices functioned to cultivate submissive, obedient slaves. While providing a history of black religion in "Of the Faith of the Fathers," Du Bois writes, "Nothing suited [the slave's] condition better than the doctrines of passive submission embodied in the newly learned

Christianity."[53] In addition, the postbellum church, for Du Bois, is often a breeding ground for passivity, resignation, and certain moral vices. At the same time, Du Bois stresses the importance of the black church as a "social center" for black people, as a gathering space for black Americans excluded from public goods and social spaces by Jim Crow laws and practices of racial inequality. For Du Bois, black religion, with its emotional, passionate ethos and musical expressions, enables black people to articulate "a people's sorrow, despair, and hope."[54] Or, in agreement with Marx's more generous views on religion, Du Bois would say that black religious life provides a "soul in soulless conditions."[55] While most readers of Du Bois either omit or underestimate the significance of religion within Du Bois's thought, recent work on Du Bois has addressed this blind spot.[56] Authors like Manning Marable and Edward Blum, for instance, see Du Bois as a kind of prophet who connects Jesus's teachings with the "spiritual" struggles of black people against racism. Blum even suggests that Du Bois's black Christ parables, one of which I discuss in chapter 2, anticipate black theology and the general rejection of the traditional assumption that whiteness and sacred value are equivalent. For my purposes, Jonathon Khan provides the most useful account of Du Bois's religious views when he associates Du Bois with the tradition of religious naturalism, a tradition that includes Williams James, John Dewey, and George Santayana. For this tradition, one can be religious or pious without expressing a commitment to supernatural powers. Natural piety suggests that the experiential and historical world is a site of wonder, surprise, and transformation (in addition to evil, suffering, and tragedy). One shows piety not necessarily by praying to a supernatural being—even though Du Bois ends *Souls* with a prayer—but by acknowledging the immanent sources of one's existence. Community, family, ancestors, nature, anonymous others who have been erased from official narratives and histories become the objects of desire and remembrance for religious naturalists. While natural piety provides a helpful framework to think about Du Bois's relationship to black traditions of struggle and creativity, it is important to remember that many of the religious strivings of slave communities and slave songs elude stark contrasts between the natural and supernatural. For many communities, divine powers and agents work within history, as coparticipants with human agents in efforts to alter the state of things.[57]

As Kahn points out, Du Bois's interpretation of the sorrow songs is an example of piety, of acknowledging and remembering struggles and losses

that make his life and writing possible. Du Bois refers to the sorrow songs as "siftings of centuries," as songs that travel across time, affecting and influencing successive generations. Referring to an old melody that was passed down by his ancestors, he writes, "The child sang it to his children and they sang it to their children's children, and so two hundred years it has traveled down to us and we sing it to our children."[58] Although this description elicits the notion of a tradition, we should not think of the sorrow songs as forming a seamless line or trajectory. According to Du Bois, there are gaps and fissures in these songs; there are meanings that are veiled and "half articulate," meanings that have to be decoded and reinterpreted. He mentions songs, for instance, in which there is no mention of a father, indicating the ways the institution of slavery shattered family bonds. By exhorting us to be attuned to the "eloquent omissions and silences," he suggests that what is unsaid is often just as important as what is said (in fact, the unsaid and said, absence and presence, condition each other). If, as Freud points out, mourning is always a response to a lost object, then the omissions and silences register this absence, an absence that remains partially present due to the work that remembrance and mourning accomplishes.[59]

Du Bois locates his intellectual and political project within this half-articulate musical tradition. He informs the reader that the sorrow songs motivate his efforts in *The Souls of Black Folk* to document the vicissitudes of black life. He writes, "And so before each thought that I have written in this book I have set a phrase, a haunting echo of these weird old songs in which the soul of black folk spoke to men."[60] Since the fragments of these songs are presented as a succession of notes without words, Du Bois suggests that there is something beyond ordinary language that both inspires and evades his thoughts and reflections, an excess that conditions his writing. In addition, Du Bois affirms an indirect relationship between music and social critique, between the rhythmic cry and his attempt in *Souls* to unveil deeply embedded modes of violence and exclusion within our social arrangements. By reminding us that a trace of the cry precedes each thought, that his reflections on racial injustice are both haunted and inspired by the sorrow songs, Du Bois reinforces the connection that Douglass makes between aesthetic expression, politics, and resistance. More strongly, we might imagine the cry or holler as an inchoate mode of resistance. As Theodor Adorno points out, the fact that pain "is spoken, that distance is won from the trapped immediacy of suffering, transforms suffering

just as screaming diminishes unbearable pain."[61] From the other side, hearing the cries and aspirations that are released in the sorrow songs potentially renders the listener more attuned and sensitive to the ways race-inflected formations of power have caused pain and suffering for black subjects. The strangeness of the songs makes us less at ease with the state of things; they compel us to confront the *Unheimlichkeit* that operates below the surface of the racial order. With Adorno, we might say that melancholy and sorrow are a response to disavowed tensions, contradictions, and injustices in the social world and that this melancholic response can turn into a refusal of this denial and the order of things more generally.[62]

One of the conditions refused by the sorrow-song tradition is the dehumanizing quality of white supremacy, chattel slavery, and antiblack racism. In his attempt to trace the musical strands that precede and implicitly inspire hip hop music, Anthony Pinn follows Du Bois by claiming that the spirituals enabled slaves to make sense of a senseless predicament, to "humanize a dehumanizing environment."[63] In other words, this incipient form of black musical expression countered a set of arrangements that reduced black people to useful objects, arrangements predicated on the exclusion of blacks from the category *human*. The spirituals provided a way of giving a voice to conditions and experiences that many have labeled absurd. They permitted black subjects to begin to locate these absurd episodes within a set of sense-conferring narratives while also unsettling simplistic ways of making sense of history and social life. Referring specifically to "Motherless Child," Pinn reminds us that the spirituals enabled slaves to record a history marked by loss, dislocation, struggle, and possibilities for transformation. The spirituals emerged as the cries of those who survived (the Middle Passage) and are indicative of a kind of witness to those bodies that perished. Through this music, dislocated black bodies become grievable, worthy of lament, compassion, and remembrance. Pinn surmises, "Perhaps the sounds and sights of this experience, this journey, remained alive in the new rhythms of their new world musical expression, first presented through the spirituals."[64] Crucial here is the notion of the remainder or that which survives a traumatic experience. To speak of "remains" is to register a tension between loss and survival, absence and presence. The hope that emanates from the spirituals derives from gathering the remains of the past and present in the endeavor to create a better future. Mourning and hope are therefore intertwined.

This relationship between ancestor piety, loss, and hope that Du Bois articulates through his reading of the sorrow songs resonates with Walter Benjamin's reflections in "On the Concept of History." As Alexander Weheliye suggests, authors like Du Bois and Ralph Ellison share with Benjamin a tendency to interrupt linear histories that either erase or domesticate legacies of oppression and struggle.[65] In the second thesis of Benjamin's influential essay, Benjamin insists that "the image of happiness we cherish is thoroughly colored by the time to which our own existence has assigned us. There is happiness . . . only in the air we have breathed, among people we could have talked to, women who could have given themselves to us. In other words, the idea of happiness is indissolubly bound up with the idea of redemption. The same applies to the idea of the past, which is the concern of history."[66] Notwithstanding Benjamin's misogyny in this passage, he suggests that our image of happiness is motivated by unfilled desires and missed opportunities; it is emboldened by the gaps and fissures in experience. Similarly, visions of a liberated future are constrained and enabled by memories of past events and interactions, events that could have been otherwise. When Benjamin claims in the second thesis that "the past has a claim" on the present and that this "claim cannot be settled cheaply," he is refusing notions of liberation and futurity that consider the past relatively insignificant or only useful when the past reinforces the present course of things. The possibility of a better future, for Benjamin, depends on our capacity to remember our ancestors' losses and disappointments as well as their aspirations, hopes, and struggles. What he refers to as the present's weak redemptive power is precisely our ability to keep these memories and hopes alive, especially when they work against oppressive frameworks of meaning and interpretations of history. For Benjamin, the past, or our relationship to the past, is unfinished, and because of this quality the past can be reimagined in ways that contest status quo–affirming constructions of time and history. More strongly, Benjamin claims elsewhere that resistance to the status quo is strengthened when struggles are "nourished by the image of enslaved ancestors rather than by the ideal of liberated grandchildren."[67] (In other words, these struggles have to be inspired by the dissonant, unsettling qualities of human experience rather than some idealized version of a harmonious human community.) What connects Benjamin and Du Bois is a shared sense that a better future depends in part on how we remember and keep alive the cries, struggles, and missed opportunities of enslaved ancestors.

Now to be sure, Du Bois also envisions and projects "an ideal of liberated grandchildren" throughout *Souls* and his corpus more broadly. A commitment to remembering the dead and disappointed, to those who have experienced the violence of white supremacy and Western imperialism, can certainly be compatible with a strong commitment to progress and the civilizing processes of modernity. In fact, the attachment to civilizing processes is often inspired by understandable desires to redeem and compensate for past struggles and losses. The logic here would suggest that the struggles and sufferings of enslaved ancestors would be rendered vain and irrelevant if they did not ultimately contribute to a liberated world or if future generations did not complete the struggles begun by those forebears. While this logic makes sense, I want to think about the dangers and limitations involved when the end or goal of black freedom struggles is assimilation into the nation-state, full citizenship, or inclusion into advanced civilization without an accompanying urge to transform, destabilize, contest, and even undermine the order of things. Part of this contestation, as Benjamin explicitly states, entails "rescuing" past images (and sounds) of suffering, trauma, and struggle from interpretations of history that would either explain away these experiences or convert these memories into an affirmation of the prevailing, normal course of things. Du Bois can be read as advocating a simple assimilation of the cries of his enslaved ancestors into American history, an assimilation that would merely confirm the Americanness and humanity of black folk and the essential greatness of America. I am arguing that we read "the cry" prior to each thought as a signifier of strivings, agonies, and experiences that cannot be integrated into a coherent and reassuring image of America, modernity, or humanity. Something about the legacy of these cries and hollers underscores themes of loss, disappointment, pain, ambivalence, and socially produced death in a manner that links hope and longing for a better future with melancholy and a compulsion to remember the violence that those reassuring images both justify and deny.

But if Du Bois celebrates and reenacts an aesthetic legacy of sorrow, lament in the final chapter of *Souls* does not only refer to black people's experiences with death, suffering, and disappointment. Du Bois also bemoans the misappropriation and false imitation of the sorrow songs. While tracing the stages of its development, he refers to a phase "where the songs of white America have been distinctively influenced by the slave songs or have incorporated whole phrases of Negro melody . . . Side by side, too, with

the growth has gone the *debasements* and *imitations*—the Negro minstrel songs, many of the 'gospel' hymns, and some of the contemporary coon songs,—a mass of music in which the novice may easily lose himself and never find the *real* Negro melodies."[68] Here Du Bois refers to the minstrel shows as imitations of "real" Negro songs, imitations that devalue the quality of the songs. He bemoans the fact that "caricature has sought again to spoil the quaint beauty of the music, and has filled the air with many debased melodies which vulgar ears scarce know from the real. But the true Negro folk song still lives in the hearts of those who have heard them truly sung and in the hearts of the Negro people."[69] Du Bois reinforces this distinction between "real Negro songs" that are "truly sung in the hearts of the Negro people" and the debased, adulterated form of these songs. For Du Bois, something vital is lost or devalued in black musical expression when songs no longer emanate from the heart and soul of black folk, when they are no longer connected to the genuine desires and emotions of black people.[70]

Du Bois is understandably concerned about the ways black culture has been caricaturized and at times appropriated without due recognition. Yet the language of "real songs" and "hearts of the Negro people" betrays Du Bois's romantic understanding of black culture and identity. As many commentators have pointed out, Du Bois operates with an expressive view of culture indebted to German romantics like Johann Herder.[71] An expressive notion of culture assumes that there are specific cultural sites where the shared purposes, commitments, desires, and aspirations of a people or nation become transparent. It holds that certain individuals, institutions, or practices express and reveal the common, shared spirit of a community. As Paul Anderson describes, the spiritual, for Du Bois, is one practice that expresses the intrinsic and unique characteristics of black folk.[72] These songs are authentic because they embody the heart and soul of black people, because they express their common strivings and aspirations. This romantic connection between black music and black folk runs into problems when it assumes that the hallmarks of black identity are pregiven, that they exist prior to history, discourse, and social practice. References to cultural authenticity presuppose that essential qualities can be attributed to black people, an assumption that downplays history, social construction, competing ways of performing blackness, and divisions along class and gender lines. In addition, a unified vision of black peoplehood, by downplaying division, tension, and conflict, renders black history and

experience more susceptible to being assimilated into neat, reassuring accounts of American history and progress. But it is also important to remember that while Du Bois adopts a holistic notion of the folk in his description of the sorrow songs, he also troubles this notion by highlighting the traumas, dislocations, and gaps that mark black history, qualities that don't easily coincide with coherent, unified notions of peoplehood and racial identity.[73]

My reading of the sorrow-song tradition departs from Du Bois's romantic notion of the folk, a notion that subtly continues to shape discussions about race, black politics, and the "state" of the black community. (At the same time, I acknowledge that any discussion about identity or peoplehood involves some imagination of unity and continuity that always bears the trace of essentialism.) I do not, for instance, claim that sadness and melancholic hope define some authentic black self. As sociologist Jon Cruz argues, one must keep in mind how the sorrow songs were imagined by the broader culture as expressive of an "idealized singing subject," an image that blocked more complicated ways of interpreting black culture and political acitivty.[74] I am similarly not claiming that black individuals who do not identify with or who are not moved by the "beauty and tragedy" of the spirituals are somehow inauthentic or unfaithful to the black community. In addition, I do not valorize these songs in order to "prove" black people's humanity or to underscore their Americanness. This chapter simply argues that Du Bois's reading of the sorrow songs implicitly offers a powerful way to rethink the relationship between racial loss, remembrance, and hope. His interpretation of this tradition, which highlights the pervasive references to death and suffering within the spirituals, implicitly challenges narratives and imaginaries that deny or easily reconcile the traumatic underside of the nation's history, especially in the context of black American strivings and struggles.[75] As Shamoon Zamir rightly argues, Du Bois's interpretation of the rhythmic cries invite slow contemplation, reflection, patience, and receptivity in a culture that tends to underappreciate these dispositions in favor of action, agency, and problem solving.[76] I further contend that while the final chapter in *Souls* links melancholy to the spirituals and shows Du Bois's piety to this musical legacy, melancholy also resonates throughout the entire text as a general mood, tone, disposition, and mode of attunement. *Souls* evokes and performs melancholy in a way that captivates, disturbs, and unsettles the reader. Persistent mentions of loss, death, and alienation curb desires for reconciliation and inclinations

toward complacency. In each chapter, Du Bois draws the reader's attention to those who have been marginalized and excluded by America's arrangements and practices—working-class blacks, rural Southern communities, tenant farmers, criminals used as involuntary labor, dislocated Native American communities, and international targets of America's emerging imperial interests and policies. In chapter 2, I look specifically at three of the chapters in *Souls*—"Of the Meaning of Progress," "Of the Coming of John," and "Of the Passing of the First Born"—showing how Du Bois's writing induces sorrow and registers pain in ways that complicate categories like freedom, liberation, agency, and progress. In addition, I consider how Du Bois's fissured text, a text that draws upon different genres and styles, prompts the reader to think about the fraught relationship between aesthetics and politics.

TWO

Unhopeful but Not Hopeless

MELANCHOLIC INTERPRETATIONS OF

PROGRESS AND FREEDOM

While Du Bois includes a musical line from a spiritual as a kind of epi-graph to each chapter in *The Souls of Black Folk* and also concludes the book with an ode to the sorrow songs, he also invokes sorrow as a trope, mood, and affective strategy throughout the text. In this chapter, I con-tinue to consider how sorrow, melancholy, and loss form a tension-filled relationship with ideals and values like freedom, progress, and agency in Du Bois's classic literary work. Beyond the concluding essay, I contend that sorrow works generally and consistently in the collection to trouble, and even sully, these cherished values, to show how they are entangled with death, loss, and suffering. By examining the historical, autobio-graphical, and fictional dimensions of *Souls*, I also contend that Du Bois demonstrates the complicated and precarious relationship between art, literature, and politics.

To think about and argue for a relationship between the literary and the political is to invoke Adolph Reed's powerful, against-the-grain study of Du Bois's thought and legacy. In his brilliant study *W. E. B. Du Bois and American Political Thought*, Reed provides a kind of corrective to post–civil

rights trends in African American studies, especially the tendency to interpret Du Bois through the framework of literary and cultural studies.[1] This post–civil rights trend, according to Reed, works to take *Souls* out of its immediate historical context by overemphasizing the formal and aesthetic dimensions of the text. Consequently, the political aspects of Du Bois's work, life, and activism (including his opposition to Booker T. Washington's accommodating agenda) get downplayed. This literary and cultural framework, according to Reed, "is troubling because of its fundamentally conservative and depoliticizing effects on black American intellectual life."[2] In the final section of this chapter, I challenge Reed's assumption that a literary reading of *Souls* is necessarily apolitical and conservative. More strongly, I argue that the aesthetic qualities of Du Bois's work, those qualities that affect, disturb, and prompt the reader, those qualities that invoke feelings of sorrow, loss, alienation, pleasure, joy, and ambivalence within the context of black people's strivings, have the potential to alter and show the limits of traditional conceptions of politics and political resistance.

HOPE IN THE FACE OF JOSIE

In his pensive essay "Of the Meaning of Progress," Du Bois recounts his experience as a teacher in the "hills of Tennessee" during his college days at Fisk. As a Northerner making his foray into this Southern space, Du Bois's journey exemplifies what Robert Stepto calls a narrative of immersion. The immersion narrative is a genre of black writing in which the protagonist sacrifices individual autonomy in order to connect with the broader black community, a connection that entails a descent from the North to the South.[3] But as many commentators point out, Du Bois's ability to identify with the larger group and overcome isolation is often blocked and frustrated, a condition that heightens the mournful tone in this chapter and the book as a whole.[4] In the beginning of the chapter, Du Bois hints at the excitement, energy, and happiness that accompanied the prospect of teaching rural black folk. He writes, "I was a Fisk student then, and all Fisk men thought that Tennessee—beyond the Veil—was theirs alone. . . . Young and happy, I too went, and I shall not soon forget the summer, seventeen years ago."[5] Du Bois's eagerness is curbed, though not destroyed, by several experiences and encounters during the process of securing a school, experiences that remind the reader of the vast racial Veil that

hinders progress and mutual recognition between blacks and whites in the late nineteenth century. He writes, for instance, "First, there was a Teachers' Institute at the county-seat; and there distinguished guests of the superintendent taught the teachers fractions and spelling and other mysteries—*white teachers in the morning, Negroes at night.*"[6] After securing a school, Du Bois remembers riding with a white companion to the commissioner's house in order show his teaching certificate. He laments, "But even then fell the awful shadow of the Veil, for they [white companion and the commissioner] ate first, then I—alone."[7] As these passages suggest, the prospects and hopes associated with the vocation of black teaching are shadowed by the realities of Jim Crow and consequent feelings of alienation and isolation.

In the same way that Du Bois refers to the racial lines and borders that separate him from his white peers, he also emphasizes the separation between the Tennessee community and the rest of the world. While describing his search for a school, he writes, "So I walked on and on . . . until I wandered beyond railways, beyond stage lines, to a land of 'varmints' and rattlesnakes, where the coming of the stranger was an event, and men lived and died in the shadow of one blue hill."[8] After settling into the Tennessee town, he refers to the community as its own, isolated "little world" where the inhabitants often look toward the horizon, the surrounding hills, and neighboring towns with "wistful longing." According to Du Bois, this alienated world is held together by "common hardship in poverty, poor land, and low wages; and above all, from the sight of the Veil that hung between us and Opportunity."[9] Here again Du Bois refers to the Veil as a barrier to equal opportunity, progress, and black flourishing (in addition to movement and the expansion of one's horizon). While the Veil is certainly a figurative concept, Du Bois also suggests that the Veil, like the color line, has a material, geographical component—the hills, for instance, prevent the residents from seeing and experiencing the world beyond. And even though he has been offered more opportunities than the inhabitants of this town, he downplays class and regional differences to emphasize the common experience—he collapses I and "us"—of living behind the racial Veil.[10]

Du Bois offers a poignant, and sometimes condescending, description of the conditions and limitations that prevent these inhabitants from flourishing. These constraints become visible in Du Bois's discussion of his attempt to educate and "uplift" the children of the town. Although he

expresses wonder and delight at the eagerness and energy of his students, especially the hard-working and determined "child-woman" Josie, he underscores the ways this energy and "longing to know" runs up against the realities of racial and class inequality. These inequalities become evident in his description of the physical space and contents of his school building: "Furniture was scarce. A pale blackboard crouched in the corner. My desk was made of three boards, reinforced at critical points, and my chair, borrowed from the landlady, had to be returned every night. Seats for the children—these puzzled me much. I was haunted by a New England vision of neat little desks and chairs, but alas the reality was rough plank benches without backs, and at times without legs. They had the one virtue of making naps dangerous, possibly fatal, for the floor was not to be trusted."[11] In this passage, Du Bois alludes to the favorable educational conditions that formed him as a child in New England and the deprivations that mark this rural Tennessee community. He describes the furniture in his schoolhouse in terms of what it lacks (rough and not neat, benches without backs and legs). He mentions that his chair is borrowed; the fact that he has to repeatedly return the chair to the landlady suggests that he is reminded daily of how resources, power, and possessions are distributed in an unequal manner. He is haunted by the "neat little desks and chairs" from his New England days precisely because this nostalgic image of the past is out of joint with his present reality, a situation in which attending school and embodying the space of the schoolhouse is "dangerous, possibly fatal." In addition to the features of the schoolhouse, Du Bois points to broader socioeconomic conditions that hinder education and learning when he attributes the absence of several pupils to various household responsibilities and duties like tending to crops, responsibilities that need to be fulfilled to ensure the survival of the community.

When Du Bois returns to the Tennessee hamlet ten years later, he quickly discovers that the town has experienced "a heap of trouble" instead of progress and good fortune. Josie has died (presumably from overwork and hunger) and her brother has been imprisoned. Other residents of the town have moved or passed on. Many of the town's denizens continue to labor and struggle under the crop-lien system. One woman, Thenie, dies after being brutally assaulted by her husband. Reflecting on the space where his schoolhouse used to stand, Du Bois writes, "My log schoolhouse was gone. In its place stood Progress; and Progress, I understand, is necessarily ugly."[12] Here Du Bois acknowledges, in a blunt, terse manner, the

horrifying underside of progress. It is not only that progress ignores those who are deprived of vital social resources and goods; progress actually relies on the isolation of certain communities, the unequal distribution of resources, the maintenance of harmful power relationships, and the often slow elimination of beings, objects, and ways of life that stand in the way of progress. As Robert Gooding-Williams reminds us, this reference to the underside of progress can be understood as a response to Booker T. Washington's flawed plan for racial uplift.[13] Gooding-Williams points out that this chapter on the Tennessee community follows Du Bois's essay on Washington in which Du Bois criticizes the founder of Tuskegee for assuming that economic advancement for blacks can occur without struggles to secure political rights. While Washington believes that racial uplift will come about through teaching blacks basic technical skills that will enable them to work diligently and accrue wealth, Du Bois argues that blacks cannot prosper economically (and more broadly) without voting rights, civic equality, and moral training. According to Gooding-Williams, Du Bois's description of the struggles and harsh realities that beset Josie and her community "testify to [his] deep sense that, while Washington reigns and the veil prevails, the prospects for uplifting black masses, must remain tenuous at best."[14]

While Gooding-Williams is right to attribute Du Bois's skepticism about progress to the apolitical nature of Washington's influential uplift program, we can also ferret out a more general critique of triumphant narratives of human advancement. Recall that Du Bois connects progress and ugliness after providing an image of loss, of a schoolhouse that is no longer there. Progress stands in the place of loss and vice versa. Progress and loss are intertwined even if the former often obscures and denies the latter. Immediately after this image, he draws the reader's attention to the visible remains of the schoolhouse in addition to a "jaunty board house" with broken glass windows, a part of an iron stove that "lies mournfully," and seats that are "still without backs." Throughout this passage, Du Bois describes images of ruins and broken parts, intimating that loss is inscribed in the topography and architecture of this Tennessee community. As Walter Benjamin suggests, the image of the ruin can expose the limitations and failures of harmonious narratives of history and sociality that mitigate the history's tragic quality. The ruin similarly demonstrates, for Benjamin, how the broken quality of history is refracted in everyday objects, settings, and spaces. In his well-known work *The Origin of German*

Tragic Drama, Benjamin writes, "In the ruin history has physically merged into the setting. And in this guise, history does not assume the form of the process of an eternal life so much as that of irresistible decay."[15] The physical ruins that capture the reader's attention in Du Bois's description remind us of those fractured dimensions of the social world that are not easily assimilated, that cannot be easily reconciled by narratives of progress, the promise of future happiness, and so forth.

Shannon Mariotti argues that "Of the Meaning of Progress" as a whole disrupts, even as the chapter mimics, universalizing inclinations, discourses, and concepts. Placing Du Bois in conversation with Adorno, Mariotti contends that Du Bois in this chapter and throughout *Souls* "stares directly at the disruptive particular."[16] The disruptive particular is what Adorno sometimes calls the nonidentical. The nonidenticial signifies those events, objects, and experiences that resist being subsumed into conciliatory categories like progress. The nonidentical troubles tendencies to look beyond or past particular instances of suffering toward some reassuring meaning or signifier. Staring at the disruptive particular similarly prompts Du Bois and the reader to contemplate the materiality of black strivings and acknowledge the limitations of abstract concepts and ideas in endeavors to make sense of and respond to suffering. As Adorno argues, "The smallest trace of senseless suffering in the empirical world belies all the identitarian philosophy that would talk us out of that suffering."[17] For Adorno, the "compulsion toward identity," the pressure to speak and think coherently, falters in the face of particular expressions of torment. Identity thinking cannot manage and resolve incoherence and ambivalence without "talking us out of suffering."

Du Bois's writing style in this chapter and throughout *The Souls of Black Folk* works against strategies to explain away particular instances of anguish and loss. By juxtaposing the "meaning of progress" with a particular story about an isolated Tennessee town (marked by struggles, joys, aspirations for a better life, unsatisfied longings), Du Bois demonstrates the failure of abstract, universalizing categories in the face of life's messiness and complexity, qualities experienced by enfleshed communities with specific narratives and struggles. To put this a bit differently, we might say that Du Bois entices the notion of progress to encounter its other. He suggests that the meaning of progress necessarily involves and generates conditions that are typically imagined as incompatible with progress—loss, suffering, disappointment, and death—even as these inescapable realities must

be downplayed for progress to be a desirable concept and ideal. In addition, by juxtaposing the meaning of progress with a particular experience and narrative, Du Bois creates a tension-filled constellation between the universal and the particular, rather than subordinating the particular to a general notion of advancement. Du Bois concludes the chapter by asking, "How shall man measure Progress there where the dark-faced Josie lives? How many heartfuls of sorrow shall balance a bushel of wheat? How hard a thing is life to the lowly, and yet how human and real! And all this life and love and strife and failure—is it the twilight of nightfall or the flush of some faint-dawning day? Thus sadly musing, I rode to Nashville in the Jim Crow car."[18] Notice how Du Bois uses the language of "measuring" and "balancing." His rhetorical questions introduce doubt and uncertainty regarding our ability to easily measure Josie's life and death using the rubric of progress. "There where" the "dark-faced" Josie resides, that particular space, complicates the way we imagine, quantify, and reassure ourselves about racial improvement. Du Bois ends this passage somewhere between the twilight of nightfall and the faint possibility of a new day. In other words, the hope and promise of a better, more just world is for Du Bois intertwined with and chastened by the shadow of suffering and tragedy. By ending the passage and chapter "sadly musing" and by emphasizing the space of a Jim Crow car, Du Bois refuses any kind of affirmative conclusion. He prevents the reader from absorbing his reflections on this Tennessee hamlet into a consoling framework that would assure the reader that happiness, freedom, and equality will eventually reach this community. The ending enables sorrow, doubt, and ambivalence to linger without being explained away.

Other commentators, most notably Hazel Carby, have read "Of the Meaning of Progress" and Du Bois's broader project with a much more critical eye. In her brilliant text *Race Men*, Carby argues that Du Bois's understanding of black strivings and his proposal for racial improvement rely on the exclusion of black women. Du Bois's vision of the black intellectual and leader is "gender specific; not only does it apply exclusively to men, but it encompasses only those men who enact narrowly and rigidly determined codes of masculinity."[19] Although Carby acknowledges that Du Bois was an advocate for women's rights throughout his life, she rightly draws attention to the ways the language of striving and uplift is often couched in masculine terms—the end of black strivings is true manhood. Booker T. Washington's plan of compromise, according to Du Bois,

threatens to stunt and deform black masculinity.[20] On Carby's reading, Du Bois is attached to standard notions of progress and this attachment is exemplified by his rigid, linear understanding of the path from immaturity to mature manhood. Du Bois's project of racial uplift is chiefly concerned about the training of black men. If black women like Josie are going to be rescued, they will be saved by the black community's exceptional men, those men who have absorbed the higher ideals of culture.

While Du Bois underscores the importance of black male development in *Souls*, Carby contends that Du Bois only introduces female bodies and strivings as symbols of contradiction and failure. She writes, "Josie's life and death become a metaphor for what progress has meant for the folk; her body is the ground upon which the contradictions between African American desires and ambition and the ambition and desires of white society are fought."[21] According to Carby, Josie is not a "symbol of hope for the future of the African American folk . . . [she does not have] a viable political, social, or intellectual future in Du Bois' text."[22] Carby is right, in my view, to underscore the ways the female body is used and symbolized by Du Bois in ways that are confining for women and that reinforce traditional gender hierarchies and exclusions. Yet Carby misses something important by suggesting that Josie is excluded from Du Bois's broader understanding of hope and futurity. On the contrary, Josie's life and death constitute a central place in Du Bois's vision and the reader's experience of the text—Josie contests glib notions of uplift and progress that the writer of *Souls* occasionally adopts. Du Bois's reflections on this Tennessee community show that black American strivings for a better future must be informed, shaped, and haunted by the memories of loss, neglect, alienation, exploitation, and suffering. Carby, in this instance, seems to downplay the political significance of loss and melancholy in Du Bois's text, motifs that are just as vital to his political imagination as freedom, hope, uplift, and progress.[23] If Josie does not have a "viable future," perhaps this means that her life, untimely death, and experiences cannot be easily rendered instrumental or useful; she cannot be easily placed within a political project, especially one that is animated by the rhetoric of uplifting the masses. As Adorno and Horkheimer argue in *Dialectic of Enlightenment*, instrumental reasoning converts nonidentity (difference, contradiction, suffering) into material that can be controlled and managed.[24] Instrumental logic converts the complexities of history into resources for progress and the preservation of extant configurations of power. In the same way that the

"place where Josie lives" exceeds the logic and measuring standards of progress, perhaps Josie connotes a kind of excess that cannot be rendered intelligible and useful for a project of racial uplift. Carby might respond by reminding us that women are reduced to excess (and lack) and contradiction in Du Bois's thought, thereby reinforcing patterns of power and social expectations that are damaging to women. While I share Carby's concerns, my point is that Josie's "lack of a viable future" within Du Bois's vision of uplift actually betrays the gender and class-related limitations and problems within Du Bois's occasional optimism with regard to the ends of black strivings. This forward-gazing vision founders in the face of Josie. Josie and her community might indicate the need for Du Bois and the reader to imagine a different kind of future, one that troubles, questions, and interrogates the logic of uplift, progress, and the salvation of the masses. In sum, if Josie is a metaphor for failure, she also shows the failure of uplift strategies in addition to political projects that do not cultivate a space for melancholy.

TROUBLING AGENCY AND FREEDOM

The significance of melancholy in Du Bois's thought is also evident in his fictional piece, "Of the Coming of John." This is a short story—the only piece of fiction in *Souls*—centered around a character named John and his white childhood friend with the same name (hereafter referred to as the other John or white John). The content of the story is fairly straightforward. John leaves his Georgia community to pursue a college education, an achievement that is supposed to put him in a position to uplift his people. While he attends Wells Institute, in Johnstown, the other John attends Princeton. Both of these characters embody the dreams and aspirations of their respective communities (in addition to the racial tensions and conflicts between whites and blacks in this Georgia town of Altamaha). The following passage is telling: "Thus in the far-away Southern village the world lay waiting, half consciously, the coming of two young men, and dreamed in an inarticulate way of new things that would be done and new thoughts that all would think. And yet it was singular that few thought of two Johns—for the black folk thought of one John, and he was black; and the white folk thought of another John, and he was white. And neither world thought the other world's thought, save with a vague unrest."[25] During his stint at the Johnstown college, John struggles to excel

and fit in. Although the North is typically imagined as a space of freedom and possibility for blacks, John realizes that the North is also split by the racial Veil, a realization that he makes when he is removed from an all-white section of a New York City theater where the other John and his date are seated. Disappointed with himself for thinking that he could escape his destiny, John returns home to Altamaha with the dream of "saving" his people. Yet this dream runs up against several constraints—an increasing feeling of alienation from the black community and suspicion from the white community that John's education might upset the status quo. The story concludes with John's killing of the other John as retribution for sexually assaulting Jennie, the former's sister (who happens to work as a domestic servant for the other John's father). While being pursued by a lynch mob, John surrenders to his fate.

Before examining the themes of alienation, loss, and death in this short story, it is important to underscore the significance of Du Bois's use of multiple literary genres in *Souls*. Although this fictional account of the two Johns is the most salient departure from the style of the other chapters, this short story also reminds the reader that the text as a whole employs different kinds of writing genres and styles. As commentators have pointed out, Du Bois incorporates, among other genres, the essay form, autobiography, history, ethnography, poetry, and prayer to make sense of the struggles and aspirations of black bodies living behind the Veil. According to Rampersad, for instance, "Du Bois recognized the problem of unity in compiling his anthology," a problem manifested by his use of a variety of writing styles.[26] While Du Bois was never really satisfied with the "lack of unity" in *Souls*, the reader might see this lack as generative, especially when thinking about the relationship between form and content. The form of the text, according to this interpretation, reflects the content. Since *Souls* is very much about breaks and fissures within the social world (divisions between blacks and whites, divisions within the black self, conflict between American ideals and the lived realities of people of color), it is appropriate that the form and style of this anthology would occasionally lack coherence and unity. At the same time, Du Bois's use of fiction and nonfiction suggests the need for a plurality of approaches, frameworks, and styles when responding to the effects of racial injustice. Perhaps the fictional mode can capture something significant about the racial order and America's racialized history that nonfictional forms of writing cannot get at or register. Or, to put it differently, perhaps fiction

enables us to relate differently to history and empirical reality, to reconsider what we assumed was familiar, evident, and readily knowable.

In "Of the Coming of John," Du Bois compels the reader to reimagine concepts like progress, reconciliation, and freedom after being confronted with John's existential crisis, his inability to overcome his double-consciousness, or twoness. As Rampersad points out, the "two John" motif itself "elaborates the duality of the black soul."[27] The doubling motif resonates throughout the narrative, a motif that suggests both similarity and difference between the two Johns, both connection and distance. For instance, while the two Johns are childhood playmates, one struggles while the other enjoys the benefits of power and prestige. Both Johns go away to college in the North with high expectations and both return home disappointed. Both visit a New York City theater to enjoy a performance of Wagner's *Lohengrin* yet black John is ushered away from his seat. The doubling theme seems to allow the narrator to identify moments of similarity and proximity between the two Johns while simultaneously showing how the racial Veil marks a rift that prevents mutual recognition and friendship. Like his white double, John is attracted to the higher ideals of Western culture but, unlike his counterpart, is denied access into the "kingdom of culture." This slippery relationship between recognition and alienation is exemplified in a poignant way when John passes the other John in the theater aisle: "For the first time the young man recognized his dark boyhood playmate, and John knew it was the Judge's son. The white John started, lifted his hand, and then froze in his chair; the black John smiled lightly, then grimly, and followed the usher down the aisle."[28] This brief encounter contains a fleeting moment of acknowledgment between the two Johns followed by reluctance, refusal, and separation. John's "grim smile" expresses the ambiguity here, the play between intimacy and alienation, pleasure and sadness. The other John's frozen response to his childhood friend connotes shock as well as coldness and indifference to his counterpart's current situation. The "frozenness" also signifies a body that teeters along the boundary between life and death.[29]

Wagner's music heightens the tensions in the theater scene. Like the sorrow songs, the music of *Lohengrin* invokes feelings of sadness and grief as well as hope and joy for John. In addition, the sound of Wagner's music expresses and incites John's longing to transcend the Veil, to connect with others across the racial divide. The narrator describes, "The infinite beauty of the wail lingered and swept through every muscle of his frame, and put

it all a-tune. He closed his eyes and grasped the elbows of the chair, touching unwittingly the lady's arm. And the lady drew away. A deep longing swelled in all his heart to rise with that clear music out of the dirt and dust of that low life that held him prisoned and befouled. If he could only live up in the free air where birds sang and setting suns had no touch of blood! Who had called him to be the slave and butt of all? And if he had called, what right had he to call when a world like this lay open before men?"[30] In this passage, the narrator juxtaposes the beauty and transcendence of Wagner's music with John's desire to escape the limitations of earthly existence. The music incites utopian longings for a world without violence and humiliation; this utopian longing for a world marked by unlimited openness, flight, and play propel John to question the legitimacy of a racial order that keeps him in a subordinate position. Yet John's utopian vision is fleeting; in this passage it constantly bumps up against the inescapability of the body and the earthbound conditions that shape and constrain bodies. Notice that he feels and experiences the "infinite beauty" of Wagner's music in "every muscle" of his body (as if his physical body is being possessed and carried away). In addition, even as the music leads him outside of himself, this momentary transcendence is frustrated by the white woman sitting next to him. Her "drawing away" reminds John and the reader of the anxieties and fears attached to black male bodies, the historical taboos placed on intimacy between white females and black males. Therefore, even though Wagner's music gestures toward a radically transfigured world, the utopian moment runs up against the realities of human finitude and alienation and the particular conditions of racial discord and mistrust.

While Wagner's music induces a longing for a world without racial discord, it also provokes John to think wistfully about his home and family. "When at last a soft sorrow crept across the violins, there came to him the vision of a far-off home—the great eyes of his sister, and the dark drawn face of his mother."[31] Here the sound of sorrow resonates with John's longing for home and intimacy; his separation from home and family connotes a kind of existential loss. This sense of separation and loss is actually heightened when John returns to Altamaha. Upon returning home, things, places, and people that were familiar have become strange and uncanny. John's home now appears gloomy and sordid, qualities that are emphasized by his nostalgia for a time when "the world seemed smooth and easy." When John articulates new ideas to his community, they cannot understand him; he "speaks an unknown tongue." There are several ways to read John's in-

creasing distance from his community. Stepto might suggest that John's predicament betokens the sacrifice involved in ascent narratives, stories in the black literary tradition in which the freedom and autonomy offered to a black protagonist by the symbolic North involve surrendering ties with the broader black community.[32] John's ascent (which itself was not fully successful) prevents his reimmersion into his Southern home community. To read John's journey using Stepto's concepts already suggests that freedom and loss are intertwined, that the black self's traditional path toward autonomy, literacy, and advancement entails a break from his or her home community. Another way to interpret John's alienation vis-à-vis the black community is through Du Bois's vision of black leadership. As Gooding-Williams argues, John's character should be read as a fictional example of failed black leadership, the failure resulting from John's double estrangement from whites and blacks.[33] On Gooding-Williams's reading, John exemplifies the problems that arise for Du Bois when black leaders privilege the importance of futurity and new ideas at the expense of remembrance and racial and communal identity.

Although there is truth to both of these possible interpretations, I propose a slightly different reading. I suggest that John's estrangement from his community tells us something more general about the relationship between cultivating a critical consciousness, the experience of brokenness, and the inescapability of loss. According to the narrator, when John begins to think critically about the world around him, "he grew slowly to feel for the first time the Veil that lay between him and the white world; he first noticed now the oppression that had not seemed oppression before, differences that erstwhile seemed natural, restraints and sights that in his boyhood days had gone unnoticed or been greeted with a laugh. . . . A tinge of sarcasm crept into his speech and a vague bitterness into his life; and he sat long hours wondering and planning a way around these crooked things."[34] Here the narrator suggests that becoming critically aware of the world can render that world strange and "crooked." Seeing oppression in spaces and arrangements for the first time engenders a different relationship to those sites, sites that have become unfamiliar, troubling, and painful. When differences and rifts that were once imagined as natural are reinterpreted as products of power and domination, this can be a moment of sadness—the world you thought you knew is not as you imagined—and hope insofar as we realize that the current order of things is contingent and malleable. The sarcasm and "vague bitterness" that slips

into John's speech suggest that his language reflects the tensions and ambiguities that can accompany the emergence of a critical consciousness. This relationship between critical awareness and a sense of unease becomes more evident when Jennie asks her brother if studying and learning lead to unhappiness. John's response affirms his sister's hunch that reflection and sadness are often intertwined. Reflecting and lingering over the familiar and unfamiliar dimensions of the social world can place an individual in a dissonant relationship with a culture that privileges immediately useful knowledge or ideas that solidify the status quo. Education can also alienate individuals from communities that have historically been denied access to institutions of higher learning. What is important here is that John's alienation shows us that while literacy and learning are worthy goods for black communities traditionally excluded from educational institutions, these goods are not simply sources of freedom and uplift; they also bear the trace of loss, alienation, and division.

In addition to altering the way we think about freedom, uplift, and recognition, the work of sorrow troubles notions of agency in this short story, especially in the final scene. Recall that John strikes and kills the other John after hearing Jennie's "frightening cry" and after witnessing Jennie's struggle to free herself from the other John's libidinous clutch. There is a tinge of irony in this final scene considering the fact that historically lynching was a punishment for black men's illicit sexual desire for white women. Similarly, lynching became a brutal way for the patriarchal order to protect white women from being sullied and tainted, a form of protection designed to regulate white female sexuality as much as the desires of black men. In this story, the white mob attempts to enact vigilante justice on a black male who murders his white counterpart, the latter act designed to protect black womanhood from the predatory desires of the white male. Again, we see a doubling mechanism at work here, a doubling that inverts the way we think about the logistics and anatomy of lynching. Yet in this inversion, certain factors remain the same. There is still a relationship between John's agency and the protection of (black) womanhood. As Carby points out, "In his struggle over the control of female sexuality and sexual reproduction, John gains self-respect in his own manhood."[35] According to Carby, John's murder of his white double shows that for Du Bois, black male subjectivity emerges through assertion and struggle, a struggle that occurs "among men over the bodies of women."[36]

While agency is usually associated with assertiveness, control, and possession, John's final moments also suggest that we might think of agency as a kind of letting go or surrender. After murdering the other John, black John visits his mother for the final time, informing her that he is headed North again. The reader, however, is skeptical about the North's being a place of freedom, possibility, and escape from injustice in light of John's previous experiences in Pennsylvania and New York. After bidding farewell to his mother, John wanders up the path and passes by the space where the other John's corpse used to lie. All that remains is the other John's blood, an allusion that haunts the reader, compelling us to think about the slippery relationship between life and death (since blood is often symbolic of both). The allusion to this blood remainder also suggests that even as we might identify with John's struggle and strivings, we cannot simply forget or reconcile the other John's death, the cost of the protagonist's self-assertive act. As John approaches the top of the wandering path, he remembers the concert hall and the sad and joyful melodies of Wagner's music. Yet his recollection of these sounds quickly slides into an acknowledgment of the wails and shouts of the lynch mob. "Hark! Was it music or the hurry and shouting of men?"[37] The conflation of Wagner's melodies and the sounds of shouting men and galloping horses works to aestheticize the impending tragedy, to confer a musical quality to the clamor of the pursuing white mob. John gazes at one of the white men "wondering if he had the coiling twisted rope," the rope serving as a vivid reminder of the hanging and twisting of black bodies involved in racialized vigilante justice.[38]

The final two lines invite multiple interpretations: "Then as the storm burst around him, he rose slowly to his feet and turned his closed eyes toward the Sea. And the world whistled in his ears."[39] One plausible reading is that John surrenders to the lynch mob; he passively accepts his fate. According to Gooding-Williams, for instance, John exemplifies the Schopenhauerian spirit of surrendering the will in the face of life's ineluctable misfortunes. By "closing his eyes to a world that has rebuffed him, black John epitomizes the attitude of resignation."[40] Jonathan Kahn argues that John acts as a mortal black Christ figure, one of many in Du Bois's corpus.[41] According to Kahn, John's death is comparable to the lynching, or crucifixion, of Jesus (recall that John hoped to save and uplift his community in a messiah-like manner). Yet because Du Bois endorses a natural, rather than supernatural, piety, John's lynching cannot be easily placed within a

divine, teleological schema or a promise of eternal reward.[42] If we can glean meaning and hope from John's lynching, it is not because a divine power will eventually make sense of and redeem this death. Perhaps there is a kind of possibility in the fact that his death contravenes these traditional kinds of redemptive schemas and frameworks. For Kahn, unlike Gooding-Williams, this black Christ figure is not merely a passive, surrendering subject. On the contrary, Khan suggests that John's "sacrifice" is active. His "agency . . . takes the form of activist actions in the name of racial justice."[43] If we take anything from this event recalling the crucifixion, it is the importance and inevitability of sacrifice for those involved in ongoing struggles against injustice, inequality, and cruelty.

If Kahn is right about the active quality of John's surrender, then perhaps Du Bois's John complicates standard notions of agency. Perhaps John embodies a kind of agency that is defined by self-loss, death, and vulnerability. (This explains why his silence at the end of the story stands out in contrast to the boisterous "world whistling in his ears.") Agency is a complicated concept with a tortuous history that is beyond the scope of this chapter.[44] Within our culture, agency typically means something like self-determination, the ability to act and make decisions without being determined by something outside of the self. Following the Kantian tradition, agency is usually associated with autonomy and either assumes or imagines a coherent self that can act rationally and individually. The coherence of this self, however, relies on avoiding or disavowing threats to that coherence—such as vulnerability, death, radical alterity, and trauma, all qualities and conditions that are inescapable for humans.[45] David Kim, in his book *Melancholic Freedom*, exposes the limitations and dangers of triumphant notions of agency. Drawing from Charles Taylor and Judith Butler, Kim puts forth a notion of agency and individual action that takes seriously various forms of loss within modernity—the erosion of certain traditions and practices and the loss and exclusion of bodies and communities that don't fit within prevailing norms and practices. For Kim, agency is an ideal that we should hold on to and revive while also acknowledging its complicity with loss, erasure, and violence. John's final act, his surrender, resonates with Kim's refusal to treat agency as a triumphant category, as a concept tethered to overconfident notions of selfhood and unaffected by death and its various intimations. Moreover, as Kahn insists, John's self-undermining agency cannot be easily placed in a redemptive scheme that would eventually overcome and compensate for death and loss.

Yet there may be another way to read this final scene or to supplement the interpretations provided by Kahn and Gooding-Williams. While these authors assume that the lynching takes place, I suggest that the line "turned his closed eyes toward the Sea" is ambiguous. It can refer to John's surrendering to the tempestuous lynching crowd or to his preparing to plunge into the water below. Even if the latter possibility is not what Du Bois has in mind, the image of John's standing between a lynch mob and a cliff that hangs over the sea conjures up the "flying home" motif in African American literary and folk traditions. In her analysis of the use of the flying-African motif in Toni Morrison's *Song of Solomon*, Gay Wilentz describes the trope: "Legends abound throughout the New World about Africans who either flew or jumped off slave ships as well as those who saw the horrors of slavery when they landed in the Americas and 'in their anguish sought to fly back to Africa.'"[46] Here Wilentz refers to a tradition that links escape, agency, and death. The sea in the flying-home stories is both a symbol of possibility and freedom and the site of a different kind of death, a self-willed perishing, in contrast to the brutal conditions and experiences of the Middle Passage or the social death brought about by slavery. Death, as Wilentz points out, was reimagined and even valorized by dispossessed Africans as a form of liberation from conditions that were dehumanizing, anguish-filled, and unbearable. This relationship between flight and death resonates with Du Bois's point about the sorrow-song tradition's tendency to locate liberation from injustice and suffering in the event of death (without the necessary consolation of otherworldly bliss and redemption). At the same time, the notion of returning home does hold open the possibility of some kind of repatriation or reconciliation. Even if returning to a space and time before the fall of the Middle Passage is an impossibility, the image of home, when informed and mediated by the realities of death and trauma, articulates a longing for a radically different world and predicament, a longing that is itself wistful and tinged with sadness.

The work of sorrow and the relationship between liberation and death are also prevalent themes in Du Bois's reflections on the death of his son. In 1899, his son, Burghardt Gomer, died in Atlanta after battling a ten-day sickness. While Burghardt's death was partly "natural," it was also the result of a Jim Crow system that prevented white doctors from treating black patients and a social world marked by a paucity of black doctors. In "Of the Passing of the First Born," Du Bois offers a poignant memoir of the brief life of his son, underscoring the ways his firstborn becomes a

site of melancholic hope. He writes, "Within the Veil was he born, said I; and there within shall he live—a Negro and a Negro's son. Holding in that little head . . . clinging with that tiny dimpled hand—ah wearily!—to a hope not hopeless but unhopeful, and seeing with those bright wondering eyes that peer into my soul a land whose freedom is to us a mockery and whose liberty a lie."[47] Here Du Bois departs from the tendency to treat the child as an unequivocal symbol of a brighter, more perfect future. Instead he sees in his child the "shadow of the Veil," a reminder that the world is harsh and cruel for black subjects, that freedom and liberty are ambiguous, broken, and unfulfilled ideals. Futurity is therefore shadowed and colored by the anticipation of pain and suffering. He recounts, "I held my face beside his little cheek, showed him the star children and the twinkling lights as they began to flash, and stilled with an evensong the unvoiced terror of my life."[48] This passage juxtaposes the "flashing of twinkling lights" with the terror of life, as if glimmers of hope are traversed by a deep sense of the pain and horror of (black) existence. Similar to John's utopian longing in response to Wagner's music, Du Bois flirts with moments of transcendence in this essay. He refers to his child as a "revelation of the divine life." He hears in his child's voice "the voice of the Prophet that was to rise within the Veil." But it is important to remember that these flickering moments of hope, possibility, and transcendence embodied by the child form a tension-filled relationship with the realities of racial injustice and the fragility of life, qualities that Du Bois experiences and ponders through the untimely death of his son.

Reflecting on the death of his son, Du Bois confesses that he derives some pleasure and happiness knowing that his son escaped a world of race-inflected anguish. He writes, "All that day and all that night there sat an awful gladness in my heart—nay, blame me not if I see the world thus darkly through the Veil—and my soul whispers ever to me, saying, 'Not dead, not dead, but escaped; not bond, but free.'"[49] Here Du Bois reiterates the notion that seeing through a Veil can render the world obscure and strange, opening up "queer" ways of thinking about life, death, and freedom. For Du Bois, his son's death signifies liberation from a "living death," from a condition in which he would be "choked and deformed within the Veil." Du Bois assumes that childhood is a brief moment of plenitude and bliss and that there is something hopeful about leaving life before this moment vanishes. Addressing his absent child, he writes, "Well

sped, my boy, before the world has dubbed your ambition insolence, had held your ideals unattainable, and taught you to cringe and bow. Better far this nameless void that stops my life than a sea of sorrow for you."[50] Should we be suspicious of Du Bois's celebration of death here? Isn't he making death redemptive insofar as it liberates us from a world marked by contingency, disappointment, and agony? In other words, is death a stand-in for all of those traditional categories (god, soul, afterlife) that, according to Nietzsche, enable humans to cope with contingency? Even if death becomes quasiredemptive for Du Bois, what is important is that his son's death cannot be easily reabsorbed into affirmative narratives in a manner that reassures us of life's possibilities, a necessarily better future, a world that is becoming more just and free. The pleasure and hope that accompany his son's death remind us of how horrific earthly existence can be for marginalized subjects, for his son if he had survived.

Du Bois does, however, follow this melancholic line of thought with a different understanding of hope and possibility. He writes wistfully that his son "might have borne his burden more bravely than we—and found it lighter too, some day; for surely this is not the end."[51] By claiming that "this is not the end" and that "some day" things might get better, Du Bois reminds us that while contingency is a source of pain and disappointment, it also signifies the possibility of change and transformation. Following William James, Du Bois might say that the world is never finished and always becoming something different (even if this becoming is ordered by stubborn, inveterate constraints). At the same time, Du Bois avoids simple optimism here; the language of "might have" in reference to the redemptive potential of his son connotes a missed opportunity, thereby linking possibility and loss. In addition, the final line in the essay gently urges his son to sleep until Du Bois sleeps with him, above the Veil. Although the motif of rising above the Veil occasionally signifies hope for a world no longer beset by racial injustice and cruelty, the author decides to end the essay underscoring the connection between transcendence, eternal rest, and death. If there is a future reconciliation, it will occur in the moment of death, in the moment when life is no longer and we return home. This is not to trivialize the other connotations related to "transcending the Veil" but to, again, show the lingering, haunting presence of death in the text and Du Bois's political and ethical imagination (in addition to the connections between death and loss and liberation and freedom).

Why should we still read and engage *The Souls of Black Folk*? What is Du Bois's relevance for thinking about the current relationship between race, gender, class, and politics? How does *Souls* invite the reader to reimagine the relationship between literature, aesthetics, and politics? Why should we pay as much attention to themes of loss, sorrow, death, and alienation in his thought as we do to motifs of progress, uplift, recognition, and the training of the black masses? While scholars disagree about how to interpret and understand Du Bois's legacy, there seems to be consensus that engaging his thought continues to be productive and useful (even if only to trace and examine the limitations and gaps that Du Bois passed down to future generations). Commentators like Robert Gooding-Williams, for instance, argue that *Souls* is a major contribution to modern political thought because it attempts to delineate the appropriate political response to white supremacy, particularly as it operates in the Jim Crow era. Yet for Gooding-Williams, there are severe blind spots in Du Bois's vision. For one, Du Bois adopts an expressive, romantic understanding of black peoplehood. He is seduced by a notion of the folk that assumes a coherent, pregiven racial identity, a seduction that I discussed and criticized in chapter 1. In addition to this limitation, Gooding-Williams argues that Du Bois's political imagination is defined by a simple notion of recognition. The goal of black people's strivings, according to the author of *Souls*, should be assimilation into, without a transformation of, the social-political order. As Gooding-Williams puts it, "Thus the raison d'etre of [black] leadership was to incorporate the excluded Negro masses into the group life of American society. To be exact, it was to assimilate them to the cultural standards, or norms, constituting American, and more generally Euro-American modernity."[52] In opposition to this simple model of assimilation, Gooding-Williams turns to Frederick Douglass, who offers a pragmatic, nonessentialized understanding of race and politics in which the elimination of white supremacy requires the transformation of the social order.[53]

This interpretation underscores the more optimistic side of Du Bois's thought, the part of *Souls* that argues for the resolution of black double-consciousness through assimilation into the nation-state and Euro-American modern life. This is a Du Bois who is relatively sanguine about the ideals, norms, and practices of American democracy and Western civilization more broadly. The basic arrangements are good; the problem

is that certain groups are excluded from these essentially good arrangements. Yet as I have argued in this chapter, Du Bois often undermines and troubles his own optimism. Throughout the text and his corpus, he acknowledges that these arrangements rely on ongoing exclusions and erasures, imperial violence, and cultural amnesia. In addition, while Du Bois might endorse assimilation, the incorporation of black bodies and black cultural forms (especially the sorrow songs) into the nation-state disrupts and unsettles prevalent ways of narrating and imagining American history, modern life, and human existence. By placing racial trauma at the heart of American history, this heart becomes a broken one; experiences of racial loss and disappointment, experiences that constitute America's brief history, challenge deeply entrenched fantasies of American exceptionalism and human triumph. Finally, Du Bois suggests that while the language of recognition, freedom, and rights are indispensable for political struggles, these struggles also need to be inspired by memories of loss, memories of disappointed longings and strivings, and a heightened sensitivity to those bodies, practices, communities, and desires that reside on the opaque sides of our multiple social Veils, those that elude current forms of recognition and protection. The sphere of recognition, in other words, never exists without shadows, losses, and specters. Progress always both involves and excludes a Josie, someone for whom progress is "necessarily ugly."

While Gooding-Williams points out the limitations in Du Bois's political vision, Adolph Reed examines the problems, constraints, and exclusions within fashionable, literary interpretations of Du Bois. Throughout his study of Du Bois's thought, Reed's language can sound scathing and dismissive of African American studies, especially the work of Henry Louis Gates and Houston Baker. Yet it is important to keep in mind that Reed is responding to what he sees as an overabundance of particular kinds of readings of Du Bois, readings that reify or essentialize the notion of double-consciousness and black identity more generally, that conflate the cultural politics of difference with real politics, and that downplay Du Bois's life-long activism within spaces and institutions outside of the academy. Throughout *W. E. B. Du Bois and American Political Thought*, Reed examines and historicizes the recent obsession with Du Bois's notion of double-consciousness, a concept that clearly informs my interest in themes of loss and alienation in Du Bois's work. There are several basic claims that Reed makes in opposition to the recent fad in cultural and literary studies to frame our understanding of black people within a general notion of "two-ness."

For one, Reed suggests that the idea is not as unique as some commentators assume, nor was it very significant for Du Bois. To show the ordinariness of Du Bois's concept of double-consciousness, Reed situates the idea within the tradition of liberal reform and the general disillusionment with American ideals at the beginning of the twentieth century. As he reminds the reader, many progressive activists and intellectuals, including Jane Addams, underscored experiences of fragmentation and alienation in response to the complexities of American life. Reed also reminds the reader that "Du Bois dropped the double-consciousness idea early in his career," a fact that should generate skepticism toward the recent obsession with this concept by African American studies scholars.[54] Reed further contends that the recent fascination with the first essay in Souls and the accompanying double-identity motif (instead of the essay arguing against Booker T. Washington's model of accommodation) is indicative of the tendency to depoliticize Du Bois and African American studies in general. Finally, Reed argues that scholars essentialize the black experience by assuming that double-consciousness applies to black people's struggles across time and space. This causes them to overlook the ways this concept has been contested and reimagined as it travels to different contexts. In its most recent expression, according to Reed, the notion of double-consciousness is a product of black middle-class angst and often functions to accentuate racial commonality and downplay class and gender differences within black communities and political discourses.[55]

According to Reed, when we take the double-consciousness motif out of its "proper" context, we attribute this quality to all black people, thereby reinforcing an ahistorical notion of blackness and black peoplehood. As he puts it, "As a proposition alleging a generic racial condition—that millions of individuals experience a peculiar form of bifurcated identity, simply by virtue of common racial status—the notion seems preposterous on its face."[56] I agree with Reed that double-consciousness is a limited heuristic concept; it clearly does not apply to all blacks in the same way and it can be used to ignore tensions and conflicts within black communities. At the same time, this concept continues to generate meanings and possibilities that Reed does not consider. Because every idea travels and takes on new contexts during its journey, it can form new constellations with ideas, concepts, and imaginaries that were either absent or neglected in the "original" context. In light of this and in light of the broader claims in this book about loss and melancholy, I suggest a revision of the double-

consciousness motif that escapes both racial essentialism and Reed's narrow, historical, and contextual interpretation. As Reed implies, the doubling trope in Souls can actually apply to human subjects more generally, even as it gets articulated differently across space and time and even though it has a particular set of historically shifting meanings and implications for black selves. Recall that the twoness that Du Bois articulates in the first chapter of Souls is defined in part as an internalization of the conflict between democratic ideals and the concrete realities for black people. It is also a way to register strivings that remain unreconciled, longings that remain unsatisfied. As many authors have argued, especially those associated with psychoanalytic thought, there is something about human desire, in a broad sense, that often leaves selves disappointed, that leaves human subjects with a sense of incoherence and brokenness. Our desires clash and collide with the aspirations of others; the satisfaction of one person's desire often requires that someone else's desire is thwarted or frustrated; people often long for an existence marked by happiness, plentitude, and the absence of discord, a longing that can create a greater sense of internal conflict when contrasted with the vicissitudes of everyday life. To suggest that this fractured existence is a general human condition does not foreclose an examination of the ways this condition is mediated and differentiated by history, race, gender, class, and other identity markers. It doesn't mean that all of us experience and perform this general human quality in the same manner; in fact, certain kinds of communities bear the onus of "owning" this fractured condition while others are imagined as being whole, coherent, and liberated from the tragic quality of human existence.[57] Du Bois's concept, on my reading, provides one powerful articulation of the broken quality of being human, a feature that modern black subjects experience (with varying degrees of intensity and relevance) in ways that are historically specific but also analogous to other groups and experiences. In addition, Du Bois shows us how this sense of twoness might enable a critical disposition toward the social world; critique and resistance, to put it differently, often rely on a sense of unease, discordance, or unhappiness with the state of things.[58]

Reed's major qualm with literary interpretations of Du Bois is that they depoliticize his thought and legacy. In his engagement with scholars like Baker and Gates, Reed detects a tendency in African American studies to focus on literary tropes and cultural vernacular within a text like Souls rather than concrete political goals, aims, and strategies. This specific

accusation exemplifies his long-standing feud with cultural studies; for Reed, these sets of discourses are characterized by posturing, esoteric rhetoric, trope-mongering, and an avoidance of concrete political activity, especially the kind of politics that takes shape in labor struggles.[59] Yet Reed seems to be tethered to a narrow conception of the political when he claims, for instance, that Du Bois's critical chapter on Washington's conservative plan for racial uplift is the chapter that *really* matters politically. As Gooding-Williams points out, Du Bois's political vision is very much shaped by a model of mutual recognition, a model that he endorses in the first chapter of *Souls* and troubles in many of the other sections, including the chapters on Josie, John, and the death of his son. These chapters are just as important politically insofar as they expand our imagination of political struggle, an expansion that entails taking loss and death just as seriously as freedom, recognition, and the protection of rights. In general, Reed's reductive understanding of politics neglects the important relationship between aesthetics and politics in *Souls*. The sorrow-song tradition, in addition to poetry, inspires and haunts Du Bois's thoughts and reflections throughout the text; sorrow reverberates throughout *Souls* as mode of remembrance and reflection, as sensitivity to loss and suffering, as a longing for a different kind of world, and a way to trouble triumphant, forward-marching ideals. Reed might rejoin by pointing out the dangers of conflating aesthetics and politics, of thinking that literature and music can function as a substitute for the slow, tedious labor of organizing bodies and developing strategies to alter laws, policies, and conditions. I would certainly agree with him here. At the same time, it would be dangerous to completely separate aesthetics and politics, especially if we define the former as the organization of desires, sensibilities, and affects.[60] It seems to me that any political struggle must take seriously the ways the order of things secures itself by producing complacent, indifferent selves, selves unaffected and unmoved by the pain and anguish that we inflict, directly and indirectly, on others. This indifference is facilitated and reinforced by narratives of progress, reassuring narratives that necessarily work to manage and tame dissonant memories, feelings, and affects. The writing in *Souls* exposes wounds in the social order; it invokes feelings of grief, sorrow, disappointment, ambivalence, longing, and hope but in a manner that does not allow the hope to mitigate or resolve the melancholic attachments and feelings. In a culture that generates amnesia and fantasies of racial reconciliation, in ways that have detrimental effects for communities that con-

front daily the ugly side of progress, how could the affective work of sorrow and remembrance in Du Bois's thought not have political implications?

Reed's critique of African American studies and cultural politics points to a broader discussion about the relationship between art and political resistance, a relationship that authors like Du Bois and Adorno help us think about. In his well-known essay "Criteria of Negro Art," Du Bois contends, against the purists, that "all art is propaganda."[61] In other words, for Du Bois, art (from the spirituals to fiction and poetry) should always be advancing a political agenda, particularly the struggles and strivings of black people. Art, for Du Bois, is one way for blacks to demonstrate their humanity in a world that either questions or denies this attribute. But because black people's artistic creations will resemble those of other groups, Du Bois suggests that art points beyond rigid notions of racial difference. Similarly, because black art will most likely express recurring themes and values, Du Bois resists a rigid understanding of politicized art (one in which authentic art refers exclusively to works that speak to the struggles and strivings of black people). For Du Bois, an artwork connects truth, beauty, and the imagination in a way that broadens human understanding and potentially increases "sympathy and human interest."[62] Of course the relationship between the imagination and social and political realities, like power and oppression, is complicated. The products of the artistic imagination are both real and more and less than real. Any piece of art is made, produced, consumed, and interpreted within social arrangements and realities that make that work possible. At the same time, the artistic imagination is always reconfiguring and reexpressing the empirical world. As Adorno puts it, "The non-existing in artworks is a constellation of the existing."[63] Artworks are therefore inspired by existing relationships and conditions but they also place these relationships into novel and unprecedented configurations, enabling selves to relate to the familiar in unordinary ways.

Adorno claims that while art points to better possibilities not yet realized, it also expresses social wounds and fissures that tend to be ignored or denied in everyday life. By placing empirical realities and details in a "new light," art exposes agony, loss, and social wounds in ways that threaten our sense of coherence and assurance. By representing suffering in a creative and nontraditional manner, art can disrupt our everyday ways of perceiving and responding to bodies in pain and struggle. Alluding to Picasso's famous painting *Guernica*, Adorno writes, "The socially critical zones of artworks are those where it hurts; where in their expression, his-

torically determined, the untruth of the social situation comes to light."[64] In other words, part of the hopeful, or unhopeful, dimension in art is its ability to expose the agony of social existence, the ways social life excludes, alienates, fractures, and erases. A better world, Adorno suggests, relies, in part, on our capacity to be affected, hurt, and figuratively wounded by this predicament. For Adorno, the style and form of the artwork is one way the broken quality of social existence is performed and articulated. Along this line of thought, certain kinds of genres such as atonal music or the essay resist expectations of unity and harmony, potentially rendering selves more open to ambiguities, tensions, and fissures in the social world (or at least expose strong desires for coherence and neatness). Adorno beautifully delineates the relationship between artistic style, resistance, and identity: "The moment in the work of art by which it transcends reality cannot, indeed, be severed from style; that moment, however, does not consist in achieved harmony, in the questionable unity of form and content, inner and outer, individual and society, but in those traits in which the discrepancy emerges, in the necessary failure of the passionate striving for identity."[65] This fraught relationship between style and content is, as described above, exemplified by the different genres and styles that Du Bois draws from in *The Souls of Black Folk* (prayer, poetry, fiction, music, essay, history). While Du Bois was always unsatisfied with the lack of coherence in the text, we might read this lack of stylistic coherence, this fragmented quality, as a dimension of his work that continues to unsettle our investments in rendering racial difference and history lucid and easily manageable. In light of the ways many of our popular narratives tend to disavow the complexities and tensions involved in modern racial formations and dramas, reflecting on the relationship between style, content, and resistance within literary works carries political implications.

In response to Reed's general concerns about the evasion of politics within black and cultural studies, I suggest that we avoid two false options. One option suggests that we should conflate politics and aesthetics or politics and the reading and interpretation of cultural productions. This position would permit subject matters like affect, remembrance, interpretation, and "vulnerability to the other" to supersede the tedious work of organizing, grassroots politics, supporting progressive candidates, and changing laws. The other option, sometimes put forth by Reed, assumes that the latter activities are what really matter politically, that these actions exhaust the political field. This position consigns the former matters

(literature and aesthetics) to a realm of cultural politics, a realm that is both ancillary to and derivative of material, class-inflected relationships. This standpoint similarly contends that the importance ascribed to interpretation, affect, vulnerability, and imagination in the sphere of cultural politics evades real, practical action and therefore capitulates to the neoliberal regime. My reading of the work that melancholy and sorrow perform in Du Bois's text avoids these false alternatives. While I acknowledge that political struggle always exceeds and involves more than what we can glean from a text, I also contend that the affects and sensibilities produced by reading, interpretation, and the production and consumption of art can complicate our conception of the political. Similarly, these affects, these ways of being unsettled by the suffering of others, reminds us that transformation of our social worlds requires what Hebert Marcuse calls a "new sensibility."[66] Cultivating this different sensibility might render us more attuned to the erasures and exclusions involved in the proverbial expansion and progression of freedom, democracy, and capital. Cultivating different modes of attunement and levels of sensitivity may also make selves more open to neglected possibilities and novel ways of being within the current order of things. Finally, by affirming what Reed disparagingly refers to as cultural politics, one acknowledges the limitations of "real" politics, the sobering fact that there will always be conditions that governments, states, and laws will not be able to fix.

Whereas Du Bois hints at the relationship between aesthetics, politics, and ethics, authors like Ellison and Morrison develop and rearticulate this relationship. In chapter 3, I examine how Ellison and Morrison emulate Du Bois's use of the sorrow songs by introducing jazz tropes and motifs in their novels and essays to contest triumphant narratives of racial progress. I examine how jazz provides Ellison and Morrison "with a slightly different sense of time" and history, much as sorrow songs did for Du Bois.

THREE

Hearing the Breaks and Cuts of History

ELLISON, MORRISON, AND

THE USES OF LITERARY JAZZ

Du Bois uses the spirituals and the trope of sorrow in *The Souls of Black Folk* to underscore black experiences of "death and disappointment" and to trouble ideals like freedom, progress, and agency. Not only does he devote the final chapter to "the rhythmic cries of the slave," but he also deploys sorrow and melancholy in the text (as a mood, tone, and attitude) to render the reader more sensitive to black American losses, struggles, and (unfulfilled) longings. In the same way that the sorrow-song tradition "breathes hope" by giving voice to and remembering American modernity's racial trauma, Du Bois articulates a melancholic hope, a future tied to remembrance and contemplation of loss, for black Americans and other marginalized groups. In this chapter, I examine how Ralph Ellison and Toni Morrison do something similar with jazz in their respective novels, *Invisible Man* and *Jazz*.[1] Ellison and Morrison, in corresponding yet distinct ways, use jazz as a literary trope. The qualities associated with jazz—such as improvisation, dissonance, and breaking—work, in their writings, to undercut progressive accounts of American history that deny, among other realities, the prevalence of racial violence within that history. At

the same time, these authors incorporate jazz-informed motifs to imagine new and more promising ways of relating to others and engaging the plurality of our social worlds.

It has become somewhat commonplace to think about how black literature uses, performs, and riffs on jazz motifs. In other words, commentators have demonstrated how novelists, poets, and essayists not only make allusions to legends like Louis Armstrong, Bessie Smith, or Charlie Parker but how these musicians influence the style and structure of black literary works. According to literary critic Jürgen Grandt, jazz and black American literature have always been intertwined insofar as both traditions constitute forms of storytelling.[2] Jazz musicians, like novelists, communicate experiences and offer stories that require interpretation.[3] More specifically, jazz influences the ways stories about black life have been articulated and expressed. As Grandt suggests, it is not only important to consider how writers like Langston Hughes, James Baldwin, and Ann Petry talk about jazz and its significance for black American culture. It is also important to pay attention to the manner in which jazz informs the style, structure, and form of these authors' writings, reflections, and storytelling endeavors. According to Grandt, "African-American narratives are jazz—in other words, they attempt to wrest beautiful art from the terrors of American history, to improvise a meaningful narrative of freedom over the dissonant clusters of American experience."[4] One of the ways these narratives mimic jazz is by incorporating ideas and practices associated with this musical tradition. For instance, the practice of call and response, a practice that compels the audience to participate in a musical performance, is often used by authors to prompt the reader and include her in the development of a story.[5] This device, among other effects, prevents the reader from becoming a detached observer. The reader, in other words, is affected by the text, moved by the story, involved with the themes and motifs being articulated. In addition to call and response, authors often use the notion of "swinging" or "swing time" to frame the development of a story.[6] Swing, as many commentators describe it, may refer to the body's visceral response to music and the coexistence of different temporalities and rhythms. Authors tend to appropriate these different temporalities to interrupt linear, teleological narratives. By introducing flashbacks and disruptive memories into a story, novelists work against the general desire to leave the past behind and reach a future state of fulfillment, a state devoid of loss, painful memories, and so forth. Swinging suggests a back and forth move-

ment; it suggests that as time moves forward, it also moves backward. In other words, historical events don't necessarily disappear with the passage of time. Because past episodes can influence, haunt, and disturb the present, a predicament facilitated by memory and melancholic attachments, going forward in life is usually accompanied by an act of reaching back. This reaching back concept is often associated with the Akan term *Sankofa* and the corresponding image of a bird with its head turned backward. According to the logic of swing time and reaching back, hope and possibility are always shaped and determined by the way we remember and imagine the past.

While jazz has been used as a literary device, it has similarly been used to reimagine various categories like racial identity, nationality, and democracy. Since improvisation is the quality most linked to jazz, it makes sense that jazz often engenders a complicated, unstable notion of identity. As Walton Muyumba points out, jazz improvisation serves as a model for black writers and intellectuals for understanding the relationship between self and other, self and community, as well as the connections between racial identity and other categories of identification, such as gender and sexuality. Jazz, according to these writers, teaches us that we will never "find an essential or absolute self because our identities are complex, elusive, jagged, multiple, and fragmented."[7] Recall that Du Boisian double-consciousness hints at complexities of identity, at the fragmented quality of black American experience and subjectivity even though Du Bois also flirts with a romantic notion of an essential black self and culture. For Muyumba, jazz-informed narratives suggest that individuals are not defined by some essence that precedes their actions and interactions in this precarious world. The self is always incomplete and in a state of becoming. Yet this does not mean that individuals can act, behave, or create in a willy-nilly manner. Selves are defined in relationship to others; individual expressions, movements, and creations are enabled, constrained, and mediated by the expressions of others. In a jazz ensemble, for instance, each performer is trained to anticipate the unexpected movements and actions of another performer. Because one can never perfectly prepare for the unexpected, an individual performance might clash and conflict with that of a coparticipant. This predicament leads to a series of negotiations and interactions among the participants, a form of cooperation that doesn't aim for complete harmony. Within a jazz ensemble, individuals express themselves over and against the group while also relying on the other members of that group. Therefore, any solo or break from the group is, to some ex-

tent, constrained and made possible by the established patterns and rules of the band and the broader jazz community. As Ellison puts it, "There is in this a cruel contradiction implicit in the art form [jazz] itself. For true jazz is an art of individual assertion *within* and *against* the group. Each true jazz moment springs from a contest in which each artist challenges all the rest; each solo flight, or improvisation, represents a definition of his identity: as individual, as member of a collectivity and as a link in the chain of tradition."[8] Jazz-influenced notions of identity resonate with Judith Butler's claim that individual agency and structure are not opposites; in fact, agency relies on social patterns, codes, and rules even as individual acts occasionally transgress social conventions.[9]

Walton Muyumba suggests that this play between social norms and individual improvisation within jazz reflects America's highest democratic ideals and aspirations. In his provocative book *The Shadow and the Act*, he shows how black intellectuals like James Baldwin, Amiri Baraka, and Ralph Ellison utilize jazz to critique rigid notions of identity, to expose the racial contradictions internal to democracy, and to imagine a world marked by greater democratic freedom. Muyumba's insightful book exemplifies an understandable tendency to imagine jazz as a model and analogue for American-style democracy. As Ken Burns's documentary *Jazz* suggests, jazz supposedly registers the pulse and rhythm of American life.[10] The openness to plurality, creativity, and individuality within this musical tradition dovetails nicely with the prevalent images of America as a pluralistic nation of immigrants, as an unfinished democratic experiment, as a nation that values and cherishes individual freedom, and as a place marked by infinite possibility. While this tendency to treat jazz as a symbol of America is valid and warranted, it potentially obscures the ways jazz tropes and qualities can interrupt and contest prevailing narratives and visions of America. In this chapter, I show how literary uses of jazz challenge triumphant notions of history, linear notions of time, and conceptions of hope that rely on the denial of racial violence and loss. The dissonance of jazz music, the breaks and cuts associated with this art form, compel us to imagine history as turbulent movements marked by both painful and pleasure-filled contradictions. Hope is not defined by evading the traumas of history but by swinging, or working, through the breaks and cuts of our social worlds. Ellison's *Invisible Man* and Morrison's *Jazz* offer powerful examples of how jazz performs this melancholic hope.

By juxtaposing *Invisible Man* and *Jazz*, I aim to highlight certain features of black American history and experience that are germane to my attempt to reimagine progress, hope, and loss. Both novels, for instance, refer to and riff on the black migration narratives, stories that record the massive relocation of black people from the South to the North, from rural areas to urban spaces in the early part of the twentieth century (Morrison perhaps does this in a more explicit manner than Ellison). As Farah Jasmine Griffith puts it, these novels signal the emergence of the "migration narrative as one of the twentieth century's dominant forms of cultural production. Through migration narratives, African American artists and intellectuals attempt to come to terms with the massive dislocation of black peoples following migration."[11] Cornel West underscores the historical importance of black American movement and dislocation when he claims, "The fundamental theme of New World African modernity is neither integration nor separation but rather migration and emigration."[12] Insofar as Ellison and Morrison reimagine the relocation of black bodies from the rural South to an urban space in the North, Harlem, they participate in a set of discourses attempting to make sense of successive flights and journeys that black people have endured—the Middle Passage, the mass exodus of black people to Kansas in 1879 after the federal troops were removed from the south, and the movement of blacks from the South to northern and western cities in the early part of the twentieth century.

For my purposes, it is important to consider how this spatial movement "upward" was often associated with a temporal movement forward; in other words, the North is and was imagined as a site of progress, advancement, and bountiful opportunities for black people. Yet as Du Bois's fictional character John realizes, the North often becomes a space where new, and old, problems and expressions of violence are reencountered. Both Ellison and Morrison therefore acknowledge that forward- and upward-marching narratives and aspirations—from Marxist-inspired projects to those projects and discourses associated with the Harlem Renaissance— are enticing. Marginalized subjects are understandably eager to identify with and be integrated into the movement of freedom and progress. But this identification comes with a cost. Certain kinds of dissonant memories and attachments have to be disavowed or violently deflected onto other people for this identification with progress to work. In response to this predicament, Ellison and Morrison offer the reader a jazz-informed

temporality and style that underscores the disjointed quality of time, the repetition of violence in the place where progress stands, and the breaks and cuts involved in dislocation, migration, collective and individual longings for a better life, and precarious social existence. Finally, by pairing these two novels and authors, my aim is to show the gendered limitations and omissions that diminish *Invisible Man*. As I demonstrate below, Morrison suggests that experiences of dislocation, movement, and loss are differentiated along gender lines. In addition, Morrison's novel, which is haunted by the absence and presence of a dead girl or young woman, reminds the reader that the jazz tradition has been male-centered and marked by various forms of exclusion and erasure regarding the contributions of women.

TOWARD A BLUES-IMBUED JAZZ AESTHETIC: ELLISON'S *INVISIBLE MAN*

Ralph Ellison's 1952 novel, *Invisible Man*, is a beautiful and at times harrowing story about a nameless protagonist (hereafter referred to as IM) who attempts to "find himself" while confronting the racial conflicts and absurdities of American life. Like Du Bois's fictional character, John, IM journeys from the South to the North, realizing that the violence and terror associated with the Deep South repeats itself in places like Harlem. As Kenneth Burke suggests, Ellison's novel—with its themes of journey, discovery, and maturity—can be compared to the German *Bildungsroman*, or coming-of-age novel.[13] Burke compares IM to Goethe's Wilhelm Meister, a character who undergoes "progressive education from 'apprenticeship' to 'journeymanship' toward the ideal of 'mastery.'"[14] According to this reading, IM goes through a succession of edifying ordeals and trials that constitute decisive points in the narrative. In the beginning, we are introduced to IM as a high school graduate who participates in a brutal battle royal with other black men to satisfy the perverse desires of a white male audience and in order to procure a scholarship from these white men. Later, the narrator is in college, chauffeuring a trustee, Mr. Norton, to the edges of campus. He takes the paternal, idealist trustee to meet Jim Trueblood, a black man infamous for having an incestuous relationship with his daughter. IM also takes Norton to the Golden Day, a chaotic brothel and saloon that due to the violence and commotion, ultimately causes Norton to get sick and pass out. Blamed for taking Norton to the "unpleasant" side of town, the other side of progress, IM is expelled from

the college by the president, Dr. Bledsoe. He is then sent by Bledsoe to New York City to find a job but soon realizes that the president betrayed him with bad letters of recommendation. While in New York, IM continues to face obstacles and trials. He joins and becomes a spokesperson for the Brotherhood, a quasi-Marxist interracial organization that aims to mobilize disenfranchised blacks in Harlem. Over time, he recognizes the manipulative, instrumental quality of the organization, especially when it comes to black people and issues of race. In addition to the Brotherhood, the narrator clashes with Ras the Extorter, a black nationalist who opposes interracial cooperation. He also encounters white women, such as Sybil, who use the protagonist to express and project prurient fantasies about the black male body (and who themselves are frequently reduced to passive objects in the novel). Although IM's journey is marked by a series of bad decisions and despite the fact that these decisions increasingly alienate him from others, he purportedly becomes wiser and more mature through these experiences, ultimately gaining a sense of control over his narrative and life.[15] This "coming of age" reading mirrors progressive notions of history because it suggests that the protagonist follows a rather transparent path toward maturity and fulfillment. This interpretation yearns for a resolution in the text, for the protagonist to eventually make sense of and overcome various social conflicts and tensions, including those related to America's racial formations. But as Kenneth Burke suggests, Ellison's text "does not solve the [race] problem."[16] In addition, even as the text seems to follow a progressive, coming-of-age model, it also works against linear, continuous conceptions of time, history, and identity formation. It does this primarily through the use of jazz motifs.

In the prologue of the novel, Ellison introduces a jazz-influenced notion of temporality. The protagonist, while reflecting on the pains and pleasures of being invisible and unrecognized, suggests that he is telling his story after the events he is about to share have occurred. He refers to episodes—such as his confrontation with Ras the Destroyer—that will only make sense to the reader later in the novel. IM admits, "But that's getting too far ahead of the story, almost to the end, although the end is in the beginning and lies far ahead."[17] Because the end is in the beginning and the beginning is in the end (the epilogue finds the narrator residing in the same basement or hole that he speaks from in the prologue), Ellison hints that the novel will juxtapose circular and linear conceptions of time. This maneuver exemplifies Grandt's claim that jazz or swing time is "a complex

interaction of . . . linear and circular elements."[18] Circular time is marked by repetition and returns. Within this imaginative framework, past events, decisions, and conditions play a constitutive role in one's understanding and embodiment of the present. In addition, circular time alludes to the fact that forgotten dimensions of the past have a way of unexpectedly reappearing and interrupting the current state of things. An example of this is how the advice of the narrator's grandfather repeatedly haunts him, especially in those moments when IM assumes that he has discovered a new identity and abandoned his old one. Another example is how the Harlem riot at the end of the novel reiterates the earlier battle royal, suggesting that the North can be just as dangerous for blacks as the Deep South. We must be careful, however, not to confuse this jazz-informed circularity with Mircea Eliade's famous understanding of the eternal return.[19] Recall that for Eliade, "primitive" cultures believe that meaningful events are always the reenactment of some original creation or divine act. Existence is significant for these cultures only because they can circle back to a primordial event. Whereas these cultures acquire a sense of meaning and coherence through ritual reenactment, modern, Western selves tend to adopt a linear, future-oriented notion of time, which leaves them in a perpetual state of anxiety. Ellison's combination of the circular and the linear evades Eliade's rigid distinction. Even though the narrator claims that the "end is in the beginning," he also hints that there is some distance between the beginning and end ("the end lies far ahead"). Therefore, the repetition associated with a circular temporality is accompanied by the anticipation of change, movement, and a future that is somewhat open and unpredictable. To borrow from philosopher Gilles Deleuze, we might say that repetition and difference are joined at the hip. And in line with James Snead's analysis of black culture, Ellison's prologue shows how repetition, and change, provide an alternative way of thinking about time and history in contrast to sweeping images of progress.[20]

Throughout the prologue, the protagonist repeatedly refers to his possessing an awkward sense of time. He connects this awkward sense to his invisibility within America's racial order. He also claims that one can hear and feel this strange temporality in black music, particularly the music of Louis Armstrong. He explains, "Invisibility . . . gives one a slightly different sense of time, you're never quite on the beat. Sometimes you're ahead and sometimes behind. Instead of the swift and imperceptible flowing of time, you are aware of its nodes, those points where time stands still or

from which it leaps ahead. And you slip into the breaks and look around. That's what you hear vaguely in Louis' music."[21] Even though invisibility is a painful mode of existence, and nonexistence, it can also occasion a resistant and creative way of being and moving in the world. Invisibility, according to the protagonist, enables one to live against the dominant beats and rhythms of the social world. It compels racialized individuals to participate in practices and bodily movements that are sometimes ahead of and sometimes behind the dominant pulse of everyday life. To be behind the prevalent beat might suggest that one is more attuned to dimensions and facets of the past inscribed in the present, dimensions of the past that are typically obscured by the present's dominant rhythms, narratives, and modes of being. In opposition to the swift and speedy tempo of capitalist practices, invisibility gives the protagonist time to reflect, step back, and even retreat or hibernate. Because he is offbeat, he is also able to "slip into the breaks" of his social world, making him more alert to new rhythms, unanticipated forms of novelty, and future possibilities. At the same time, these "breaks" signify the fractured quality of our social worlds. They are reminders of bodies and communities that endure various forms of violence and loss. These breaks occasionally urge us to "stand still" and patiently listen to life's discordant notes. Finally, to dwell in a temporal node (a node indicates both a crossing and a branching) is to reside in a space where the past and present intersect, occasionally in a dissonant manner. This intersection resists the "swift flowing of time" associated with linear notions of progress. History, as the protagonist warns the reader, moves "not like an arrow, but a boomerang."[22] To treat history as a boomerang suggests that we have to be prepared for the unexpected return of the past, for the ways time can fold back and compel us to respond to facets of the past that have been disavowed or forgotten. The image of the boomerang, which combines circular and linear time, indicates that what is in front of us is partly constituted by the return of ideas, images, events, and realities that we ostensibly left behind.

By lauding Louis Armstrong's ability to make "poetry out of being invisible," Ellison subtly works against prevailing depictions of Armstrong by bebop musicians like Charlie Parker and Dizzy Gillespie.[23] The bebop generation tended to dismiss earlier jazz musicians like Armstrong as Uncle Toms and minstrel entertainers.[24] As James Harding points out, the bebop musicians assumed that they could supersede and leave behind Armstrong and the minstrelsy tradition, an assumption that, according to Harding,

relies on a linear notion of history.[25] In other words, the beboppers cling to a future that will erase the tensions and contradictions of the past, a future completely liberated from social arrangements that have reduced black people to entertainers and comedians. Even though Ellison is sympathetic to the beboppers' concerns about minstrelsy and despite his reliance on bebop aesthetics, he refuses to relegate Armstrong to the "waste bins of history."[26] In his essay "On Bird, Bird-Watching, and Jazz," Ellison writes, "The thrust toward respectability exhibited by the Negro jazzmen of Parker's generation drew much of its immediate fire from their understandable rejection of the traditional entertainer's role—a heritage from the minstrel tradition—exemplified by such an outstanding creative musician as Louis Armstrong. . . . By rejecting Armstrong they thought to rid themselves of the entertainer's role. And by way of getting rid of the role, they demanded in the name of their racial identity, a purity of status which by definition is impossible for the performing artist."[27] According to Ellison, Armstrong understood the significance of mask-wearing, playing the trickster, and donning different personas. Although he played the clown for white and black audiences, he performed different roles in other contexts. His music and life remind us that racial identity is unstable and complex; he also shows us that the dispossessed often manipulate social rules and expectations to their own advantage. On the other hand, the beboppers, despite their insistence on improvisation, betray a yearning for purity in their rejection of Armstrong and his tendency to assume multiple identities and embody ambiguity. In addition, by associating older forms of jazz with minstrelsy and bebop with progress and respectability, bebop artists neglect the ways they repeat many of the clown-like roles and functions that they debunk.[28] What is important here is that by introducing Louis Armstrong in the prologue as the poet of invisibility, Ellison exemplifies a jazzlike sense of time and history. By reclaiming, without romanticizing, an artist that his contemporaries consider to be antiquated, Ellison works against forward-marching interpretations of history; he relates to his cultural past in a manner that is not quite in step with the dominant beat. This allows him to gather and use fragments from the past that proponents of linear progress discard.

Introducing Louis Armstrong's music in the prologue, particularly his well-known track "What Did I Do to Be So Black and Blue," also suggests that the novel will express a blues-inspired sensibility. This resonates with Ellison's general belief, as interpreted by Robert O'Meally, that "there can be no jazz without a blues foundation."[29] Throughout the novel, blues is

associated with experiences of pain, horror, and chaos, one example of this being the character Trueblood's confession that a blues song enabled him to confront his crime of incest and the consequent alienation from his community.[30] For Ellison, blues, like jazz, refers to a specific set of musical practices and rituals as well as a more general mode of existence. Blues, according to Ellison, marks a way of relating to and working through life's dissonant notes and chords. In his essay on Richard Wright, Ellison writes, "The blues is an impulse to keep the painful details and episodes of a brutal experience alive in one's aching consciousness, to finger its jagged grain, and to transcend it, not by the consolation of philosophy but by squeezing from it a near-tragic, near-comic lyricism."[31] A blues sensibility, as the passage indicates, encapsulates indelible memories of loss, disappointment, injury, and violation. It acknowledges that life is cruel, especially for racialized subjects who have been both shaped and mutilated within America's social arrangements. An aching consciousness is one that bears the wounds and "keeps alive the details" of "brutal experience." At the same time, blues signifies the possibility of transcending painful limitations and constraints that are imposed on us. But we must be careful here. Transcendence, as Ellison suggests, is not tantamount to the elimination or resolution of conflict. It does not console us with visions of a world devoid of agony and discord. As Ellison points out, blues offers no solution to life's contradictions.[32] Rather, transcendence marks a creative way of responding to, working through, and coping with the painful incongruities that mark our social worlds. There will always be conditions that humans cannot overcome, including death, vulnerability to injury, conflict, and pain. Yet this does not mean that there isn't room for play, creativity, and experimentation within these inescapable constraints. By acknowledging both the tragic and comic dimensions of life, Ellison's notion of transcendence retains the tension-filled quality of blues and jazz. Even as blues makes audible the sufferings and losses of black people and human beings more generally, it also registers our hopes, aspirations, pleasures, and achievements. If the blue note has a melancholic quality that invokes tears, then it also has a festive dimension that compels us to dance, stomp, and occasionally laugh.[33] But as we will see later in this chapter, even laughter is not easily separable from tears, pain, and incongruity.

The prologue to *Invisible Man* introduces jazz and blues motifs that repeat themselves throughout the novel, confirming Horace Porter's claim that "*Invisible Man* is a jazz text."[34] As Fred Moten points out, Ellison's

musical novel prompts the reader toward news ways of listening and seeing, new ways of reading and interpreting.[35] For the aims of this chapter, I focus on how jazz and blues give the narrator a strange sense of time and history. Jazz images and sounds also prompt the reader of the text to confront the discordant quality of our social worlds, this discord being both a source of agony and loss and a locus of hope and possibility. One specific way a jazz-informed temporality operates in the text is to expose and challenge the Brotherhood's rigid construction of history. Whereas the Brotherhood tends to minimize the importance of the past for the sake of a liberated future, the narrator embodies a discordant, playful sense of the past's relationship to the present. Similarly, while the Brotherhood's vision of history threatens to erase the memory of those who sacrificed their bodies for their liberation movement, the narrator identifies music (jazz and blues especially) as a site for mourning those who have "plunged outside of history."

PERFORMING SUSPICION TOWARD MASTER NARRATIVES

It would seem that the Brotherhood, as an organization that aims to mobilize and improve the conditions of disempowered blacks and oppressed people more generally, is a vehicle for good, a progressive force in opposition to the conventions, rituals, constraints, and power dynamics that define the protagonist's Southern experience (Jim Crow segregation, Battle royal, white paternalism, the conservative, perfidious Dr. Bledsoe). In other words, the Brotherhood exemplifies the new, better opportunities and possibilities that the North has to offer the protagonist and Southern blacks more generally. In his 1948 essay, "Harlem is Nowhere," Ellison seems to buy in to this kind of story about the North as a site of unequivocal progress. He writes, for instance, "Here [in Harlem] it is possible for talented youths to leap through the development of decades in a brief twenty years, while beside them white-haired adults crawl in the feudal darkness of their childhood. Here a former cotton picker develops the sensitive hands of a surgeon, and men whose grandparents still believe in magic prepare optimistically to become atomic scientists. Here the grandchildren of those who possessed no written literature examine their lives through the eyes of Freud and Marx, Kierkegaard and Kafka, Malraux and Sartre."[36] While Ellison suggests that black people have made certain leaps "simply by moving across the Mason-Dixon line," he also acknowledges

that living in Harlem is like living in a "labyrinthine existence" amidst "ruins, garbage, and decay."[37] To live in this space is to experience and be vulnerable to "casual violence," rape, muggings, theft, invisibility, poverty, and insanity. In addition, according to Ellison, living in this chaotic and surprise-filled space often requires black migrants from the South to abandon traditions and rituals that sustained them and made life somewhat livable in the face of racism. It is interesting that Ellison uses the language of "Nowhere" to describe Harlem, a term that invokes the image of utopia (which literally means no place) as well as the experience of being rendered invisible, of being deprived a place or location in the social world. Ellison underscores this tension when he refers to Harlem as a site of "the folk-Negro's death agony" as well as the "setting of his transcendence." This tension between death and utopia, loss and possibility, past and future, is operative in *Invisible Man*. While the Brotherhood organization acknowledges these tensions and frictions, it ultimately downplays these qualities for the sake of harmony and order. Ellison suggests that it is precisely in these tensions (and breaks) that a more promising world might emerge for black people, Americans, and human subjects more generally.

According to Danielle Allen, it is not clear to what or to whom the Brotherhood refers in Ellison's novel. Although many assume that the Brotherhood is "a parody of the American Communist party," Allen contends that the reader actually cannot pin down the identity of the group.[38] And as Beth Eddy reminds us, Ellison himself refuses to equate the Brotherhood with a particular Communist organization.[39] Ellison confesses, "I did not want to describe an existing Socialist or Communist or Marxist political group . . . primarily because it would have allowed the reader to escape confronting certain political patterns, patterns which still exist and of which our two major political parties are guilty in their relationships to Negro Americans."[40] Here Ellison suggests that equating the Brotherhood with a Marxist group would turn Marxism into a scapegoat, enabling many of his readers to deny their investment in rituals and practices that are harmful to black people, practices that are just as internal to American democracy as they are to competing political and social forms. In my view, many of the Brotherhood's qualities, traits, and aims resonate with certain strands of Marxism, thereby inviting a comparison. Yet I also take it that the novel's implicit critique of Marxism, as Ellison suggests, can and should be extended to other metanarratives. One quality typically associated with Marxism that Ellison exposes in the novel is the desire to

control the course of time and history, the wish to "determine the direction of events."[41] To be sure, this is a tendency that has been critiqued internally by authors, like Walter Benjamin, who identify more strongly than Ellison with the Marxist tradition. The wish to control the course of history, a wish often intertwined with the attempt to eliminate outdated practices and forms of life, is motivated by an eagerness to bring about and construct a more just world. It betrays a vision of a future that is no longer tainted by various forms of discord, alienation, and inequality. This can certainly be a valuable and inspiring vision. Eliminating certain forms of conflict is necessary to bringing about a world in which more people flourish and live well. Yet this thrust toward unity can also lead to the denial and suppression of recalcitrant forms of difference and plurality, including practices that signify temporal gaps and lags. In *Invisible Man*, this is exemplified by the Brotherhood's tendency to downplay racial difference and reject black American experiences and histories that don't fit into the Brotherhood's unifying telos.

The reader is introduced to the Brotherhood's sense of history during the initial conversation between IM and one of the leaders, Brother Jack. After IM incites a crowd to intervene in and prevent the eviction of an "old black couple," Jack attempts to recruit IM into his organization, a group that purports to be "friends of the people."[42] While congratulating IM for his moving speech at the eviction scene, Jack refers to the evicted couple as "the living dead," as subjects who no longer matter. He claims,

> I only mean metaphorically speaking. They're living, but dead. Dead in living . . . a unity of opposites. . . . The old one, they're agrarian types, you know. Being ground up by industrial conditions. Thrown on the dump heaps and cast aside. . . . Those old ones . . . It's sad, yes. But they're already dead, defunct. History has passed them by. Unfortunate, but there's nothing to do about them. They're the dead limbs that must be pruned away so that the tree may bear young fruit or the storms of history will blow them down anyway.[43]

There are several features of this passage that require attention and elaboration. For one, the notion that the black couple inhabits a space between life and death resonates with the narrator's description of being a "phantom" or specter in the prologue.[44] Because self-identity, as discussed in chapter 1 of this book, is determined by recognition, being rendered invis-

ible (not being seen or recognized) is a kind of death within life. According to authors like Hegel and Butler, our persistence and survival in this world depends on a broader social existence; to be a recognizable subject, an individual has to accept the terms and conditions that govern social life. But as Butler also suggests, practices of recognition always generate a remainder. The coherence and legibility of the social world relies on excluding bodies and desires that appear to be a threat to the social order.[45] Social life, in other words, produces a kind of social death or loss, a death that haunts the world of recognizable subjects and practices.

Brother Jack too eagerly accepts the notion that the evicted couple has socially and historically perished (or he doesn't consider that these so-called phantoms might disturb or reconfigure his understanding of life in the present and future). For him, the evicted black couple is already dead and defunct. The couple has been ejected by the movement of history. Whereas life and death, recognition and invisibility, will take on a dissonant relationship for the narrator, Jack proclaims a "unity in opposites" or a resolution of the tensions that the couple embodies. History has both absorbed and discarded these individuals; they are no longer valuable. In other words, linear progress and forward movement require the narrator to concede that certain bodies have to be cast aside from the realm of meaning, recognition, and value. The language of "unity in opposites" is an allusion to Hegel's and Marx's dialectical understanding of history. Kim Benston has argued that "the most prominent critique of the Western historical mystique embodied in *Invisible Man* is that directed against the Hegelian dialectic and its determinist theory of history."[46] Although Benston's depiction of Hegel's dialectic is debatable, his critical description of historicism is helpful. Historicism, which Ellison supposedly dismantles in the novel, is characterized by coherent, teleological interpretations of history that leave little to no room for dissonance, creativity, individual agency, or remembrance of suffering and loss. Because history is depicted as a forward march—of ideas, principles, and forces—the past or that which is behind us is only useful if it reinforces this forward movement. Aspects of the past that threaten to frustrate, challenge, or slow down this movement must be discarded. In addition, because historicism assumes that we can grasp life, history, and humanity in terms of coherent patterns and transparent meanings, historicism mitigates the disruptive, fragmenting impact of trauma and traumatic events (including the traumas and "storms" that

progress creates). The above passage suggests that Jack and the Brotherhood embody these historicist principles, one of the main reasons that they urge the narrator to "put his past aside."[47]

Jack suggests that liberation requires people to cast aside those bodies, ideas, and practices that are no longer immediately useful or that have plunged outside of history. As he puts it, "There is little that the dead can do; otherwise they wouldn't be the dead."[48] At the same time, he does acknowledge that "it would be a great mistake to assume that the dead are absolutely powerless."[49] Jack informs IM that certain heroes, including Booker T. Washington and Abraham Lincoln, can be "called back to life," resurrected in order to embolden projects of liberation. Yet this concession that "great men of history" occasionally impact current projects and agendas simplifies the relationship between aspirations for a better future and remembrance of past events and episodes. As Du Bois suggests in his essay on the sorrow songs, hope for a different kind of future depends on remembering, hearing, and being receptive to the cries, pleasures, longings, and strivings of enslaved ancestors. Imagining a better tomorrow, in other words, is emboldened not simply by honoring the prominent, well-known "movers" of history but by showing piety to those who have been erased and obscured by the movements of history. By highlighting the gaps and omissions in the sorrow songs, Du Bois directs the reader's attention to those who have been silenced and rendered invisible or inaudible by dominant practices and narratives. Benjamin echoes Du Bois's sentiment when he links liberation with remembrance and mourning, suggesting that struggles against the status quo are diminished when they are no longer motivated by past suffering or when the legacies of the oppressed are integrated into reassuring, trauma-denying stories and myths.

Du Bois's and Benjamin's assertion that the "past has a claim on the present" resonates to some extent with Ellison's notion of piety. Borrowing from literary critic Kenneth Burke, Ellison's notion of piety underscores human contingency, the fact that each individual is dependent on others for his or her persistence through life. Piety is a particular way of acknowledging debts to the sources of our being—family, community, ancestors, anonymous others.[50] But as Beth Eddy points out, piety does not entail blind obedience to these sources. According to Eddy, Ellison's "pious posture is not one of loyalty but of antagonistic cooperation."[51] Like a jazz band that is made up of individuals competing against and working with each other, selves both affirm and disavow tradition, according to Ellison.

Ellison, on this reading, adopts a Freudian ambivalence with regard to tradition and the past, a posture of reverence and rejection because even as the past shapes and constitutes us, it also constrains and eclipses certain desires, aspirations, and possibilities. In addition, prevalent ways of interpreting the past impose severe constraints on the ability to imagine and construct alternative histories. Therefore piety, for Ellison, entails a high degree of impiety. Although the language and demands of piety can carry conservative implications, what is important for our purposes is how a critical form of piety opposes the tendency (demonstrated by the Brotherhood) to erase, forget, or neglect aspects of the past that don't appear immediately useful. Eddy rightly argues that Ellison's piety encourages him to discover possibilities in the trash, to find treasures in what has been marked as waste.[52] While waste can connote garbage and that which is no longer useful, it also signifies excess, leftovers, and that which escapes current expectations and structures of meaning. This acknowledgment that waste carries a double meaning partly explains Ellison's refusal to follow the beboppers and debunk Louis Armstrong and the minstrel tradition. Ellison's jazzlike sense of time, which imagines a dissonant relationship between past and present, suggests that the past should not be romanticized or rejected (as if we could ever completely disentangle ourselves from the struggles, achievements, follies, and disappointments of those who preceded us). It also suggests that ideas, desires, and images from the past that appear outdated might actually be appropriated to form what Benjamin refers to as a dissonant constellation with the present, opening up novel ways of understanding and relating to our social worlds.

Throughout Ellison's novel, the narrator's discordant relationship to the past constantly undercuts the Brotherhood's coherent, unifying telos. Think, for instance, of how the narrator's grandfather, a former slave described as "odd" and a source of "trouble" for IM, haunts the text. On his deathbed, IM's grandfather advises: "'Son, after I'm gone, I want you to keep up the good fight. I never told you, but our life is a war. . . . Live with your head in the lion's mouth. I want you to overcome 'em with yeses, undermine 'em with grins, agree 'em to death and destruction, let 'em swoller you till they vomit or bust wide open.'"[53] It is significant that this advice, originally given to the narrator's father, is associated with the image of the deathbed, with the precarious line between life and death. It is also important that this message seems to be out of joint with the grandfather's life and character. Although he "had been the meekest of

men," the above passage suggests that this humility was a mask, a deceptive way to undermine white people's power and authority. Similar to Judith Butler, IM's grandfather suggests that power can only be unsettled from within. By performing one's role in deceptive, unexpected ways, black subjects secretly undermine the norms that govern racial arrangements and hierarchies. While IM's grandfather dies after this final utterance, the narrator confesses, "It was as though he has not died at all, his words caused so much anxiety. . . . And whenever things went well for me, I remembered my grandfather and felt guilty and uncomfortable."[54] Notice that the memory of his grandfather is a source of discord, discomfort, and ambivalence, especially in moments of ostensible triumph. These qualities constantly thwart his effort to take on a new identity. They similarly prevent him from fitting into an organization that urges its members to sever ties with the past. Before he gives his first speech before the members of the Brotherhood, he reflects, "This was a new phase, I realized, a new beginning. . . . Perhaps the past of me that observed listlessly but saw all, missing nothing, was still the malicious, arguing part; the dissenting voice, my grandfather part; the cynical, disbelieving part—the traitor self that always threatened internal discord. Whatever it was, I knew that I knew that I'd have to keep it pressed down. . . . No more flying apart at the seams, no more remembering forgotten pains."[55] The narrator's success and acceptance not only rely on becoming a new self; they also hinge upon contriving a coherent, harmonious self that denies "internal discord" as well as the dissonant quality of the past—a past that includes enslavement, racial violence, painful losses, and ambiguous forms of treachery and resistance. Progress, in other words, requires him to "keep pressed down" those dimensions of life, experience, and identity that are incompatible with transparency and a sense of wholeness.

This helps to explain why Brother Tarp's shackle becomes a source of discomfort for members of the Brotherhood, especially Brother Westrum. At one point in the novel, Brother Tarp gives IM a piece of his leg chain, a reminder of the former's nineteen-year prison sentence as well as his escape from a black chain gang. This passing down of the chain link, a link that "bore the marks of . . . violence," signifies many things: the fractured quality of traditions (the link signifies connection as well as a break), irrecoverable loss (Brother Tarp lost his family, land, and nineteen years of his life because he challenged white authority), and the effects of the past on the present (although Brother Tarp escaped the chain gang, this link

and his limp are physical reminders and permanent traces of confinement and enslavement).[56] Therefore, Brother Tarp's chain link might symbolize liberation from enslavement, but it also points to a permanent wound that Brother Tarp exhibits anytime he walks or moves. His movement, like progress, is a crippled and constrained movement. When Brother Westrum notices this chain link, he admonishes, "I don't think we ought to have such things around. . . . Because I don't think we ought to dramatize our differences. . . . That's the worse kind of thing for Brotherhood—because we want to make folks think of the things we have in common."[57] Here Brother Westrum suggests that the success of the Brotherhood relies on downplaying racial difference. Brotherhood, or unity, is threatened by IM's attachment to events and experiences that signify a history of racial conflict and disparity. Fidelity to the common trumps an embrace of difference; identity supersedes nonidentity. Here we might think of the Marxist tendency to underscore the unity of the working class and reduce racial conflict to a relatively insignificant moment in the class struggle. Frantz Fanon famously exposes this inclination in Sartre's treatment of anticolonial struggles. The formation of black identity, in Sartre's formulation, is simply a contingent, temporary moment in the dialectic of class conflict. Black subjects only really participate in history insofar as they contribute to the subversion of capital. Their racial identity is ultimately sublated and assimilated into a class position.[58] My aim here is not to suggest that Ellison or Fanon imagine racial identity as a permanent obstacle to something like the affirmation of common humanity. In fact, according to Ellison, "the role of the writer . . . is to structure fiction which will allow universal identification, while at the same time not violating the specificity of the particular experience and the particular character."[59] Here Ellison advocates a notion of identity that exists at the edges of the particular and the universal, whereas Westrum and the Brotherhood seek a universal that will ultimately assimilate and absorb recalcitrant differences. But while Brother Westrum's warning about dramatizing differences invokes the limitations of Marxist thought and practice, it should also prompt us to think critically about contemporary neoliberal rhetoric that treats discussions about race as divisive and a threat to national cohesion.

In addition to conflict, difference, and the intransigent past, the Brotherhood's triumphant sense of history minimizes the disruptive impact of traumatic loss in the present. Think, for instance, of Brother Hambro's response to Clifton's execution by a police officer and the impending violence

in Harlem. Hambro glibly says, "It's a risk we all must take. All of us must sacrifice for the good of the whole. . . . We have to protect our gains. It's inevitable that some must make greater sacrifices than others."[60] As Danielle Allen points out, Hambro easily accepts that certain bodies and communities must bear the brunt of this sacrificial process.[61] In addition, by claiming that sacrifice will continue "until a new society is formed," Hambro "hopes [that] sacrifice will produce a new and internally consistent society."[62] Notice the instrumental logic that is operative here, a logic that Brother Jack adopted in response to the evicted couple. Whereas Jack considers the evicted couple useless to the current course of history, the death of other black bodies is rendered useful and significant through the rhetoric of sacrifice. In both cases, instrumentality determines the value of these individuals. Brother Clifton, according to what Hambro calls "the laws of reality," is a part of the greater whole. He constitutes a part that is sacrificed for the well-being of the whole and for a future society marked by the absence of injustice and cruelty. Hambro suggests that a liberated society will somehow redeem violent events like the killing of Brother Clifton. In the name of progress and a coherent future, his death is made sense of and given a future compensation.[63]

IM, on the other hand, refuses to accept the kind of historical narrative that would underscore humanity's potential triumphs and achievements while downplaying its losses. Similarly, he realizes that racial loss and invisibility call into question the assumptions and aims of historical knowledge. After Clifton's murder, he reflects:

> For history records the patterns of men's lives, they say. . . . All things, it is said, are duly recorded—all things of importance that is. But not quite, for actually it is only the known, the seen, the heard and only those events that the recorder regards as important that are put down, those lies his keepers keep their power by . . . What did they ever think of us transitory ones? Ones such as I had been before I found Brotherhood—birds of passage who were too obscure for learned classification, too silent for the most sensitive recorders of sound; of natures too ambiguous for the most ambiguous words, and too distant from the centers of historical decision to sign or even applaud the signers of historical documents?[64]

Here IM attaches terms like *transitory, obscure, silent,* and *ambiguous* to those black bodies, like Brother Clifton, who have plunged outside of his-

tory (a plunging that refers to different kinds of erasure, including death and invisibility). IM suggests that the official recording of history cannot capture these qualities; official histories necessarily produce and exclude "men outside of time . . . living outside the realm of history."[65] Those who desire to determine the course of history or those who want to grasp history and render its patterns and meanings transparent necessarily eschew events, episodes, desires, and losses that resist structures of meaning and sense. In order for Brother Clifton's murder to be significant, it has to be incorporated into a teleological schema—since liberation is the end and meaning of history for the Brotherhood, the loss and sacrifice of black bodies can be placed within this schema and ultimately redeemed. But of course this circumvents the fact that certain qualities and dimensions of life (silence, loss, obscurity) work against our all-too-human desire to know, act, see, and hear in a coherent, assured manner. Here we might recall Benjamin's concern about linear notions of history murdering the dead a second time. When Benjamin claims that "even the dead will not be safe from the enemy if he is victorious," he is not simply saying that progressive notions of history silence the dead again by not including the dead in official, recognized narratives.[66] He is also indicting the way death, loss, and trauma are integrated and included into our frameworks of meaning, the way the dissonant, unsettling quality of these conditions is reduced in order to fit into current schemas and structures of meaning. This transforms trauma from a kind of disconcertion into a form of reassurance.

It should not surprise us that IM turns to music, particularly jazz and blues, to make sense of Brother Clifton's execution and the chaotic conditions in Harlem. While passing by a record shop playing "a languid blues," IM stops and asks himself, "Was this all that could be recorded? Was this the only true history of the times, a mood blared by trumpets, trombones, saxophones, and drums, a song with turgid, inadequate words?"[67] It is important that the music makes him stop and reflect amid the frenzied movement of the urban crowd. This resonates with the aforementioned description of jazz as a movement replete with breaks, gaps, and pauses. It is also significant that the narrator poses the connection between music and the mood of the current moment as a question; it is not necessarily the case that music is any better than historicism at capturing the significance of mundane struggles, aspirations, and erasures. In addition, the narrator emphasizes the loud, blaring sound of the music, which potentially signifies the attempt to compensate for the silencing of black selves. The

thundering sound and the "turgid" words connotes an excess, an extravagance that is engendered to some extent by a lack, by the silencing and inaudibility of black voices in many public spaces. Yet the words, according to the narrator, are still not adequate to the complexities of history, black life in Harlem, and so forth; in fact, the words potentially betray their inadequacy through the excessive moaning associated with blues, through the always abortive attempt to put suffering and loss into words, even if these words bear the trace of the cry. Here I want to underscore how Ellison implicitly identifies art as a different way of ascribing meaning to history than rubrics of progress; this difference marked by art includes a recognition that some events thwart our eagerness to classify and grasp things, to find and secure meaning. The dissonant, cacophonous sound of blues and jazz provides an alternative model for thinking about and approaching history vis-à-vis the Brotherhood's sense of time and historical movement. This blues-inspired model suggests that history is not so much of "a reasonable citizen," but a "gambler" and a "madman."[68] Or for history to be imagined as a reasonable citizen, the unmanageable facets of history have to be disavowed.

Ellison would concur with Adorno's claim that art satisfies "the urge to rescue the past as something living, instead of using it as the material of progress."[69] Although art does not completely escape instrumental logic for Adorno, it can resist the tendency to treat images from the distant and recent past as fodder for progress. Art rescues past images and ideas as living material that potentially disturbs, unsettles, and agitates our confidence in the status quo. In addition, art can render selves more attuned to the ambiguities and opaque qualities of history and experience. Art, music, and literature prompt us to be attuned to what Adorno calls "the waste products and blind spots that have escaped the dialectic . . . the cross-grained, opaque, and unassimilated material" that does not "fit properly into the laws of historical movement."[70] In Ellison's language, these are selves, bodies, desires, and possibilities that have ostensibly plunged outside of history, or at least the kind of transparent history imagined by the Brotherhood. But a skeptical reader might wonder if Ellison is susceptible to the critique that is implicitly wielded against the Brotherhood in *Invisible Man*. She might wonder if Ellison rejects a Marxist-inspired vision of historical movement only to accept a triumphant American project and narrative. In other words, he attempts to redeem the sufferings and losses of black communities through his commitment to America's "infinite pos-

sibilities." Even if Ellison suggests that the Brotherhood does not represent communism (but refers to all political and social orders that sacrifice black bodies), his critique of American democracy does not seem as trenchant as his critique of Marxism, or black nationalism, for that matter.[71] To begin to respond to these concerns, I examine how jazz serves as a model or metaphor for democracy in Ellison's writings. While jazz and blues operate in Ellison's texts as signifiers of dissonance, pain, and possibility, the possibility component might cling too much to the myth of the American frontier. Ellison's fidelity to the idea of America, in other words, potentially diminishes the work of mourning in his texts. While Beth Eddy claims that Ellison offers a tragic-comic vision of American democracy, we might wonder if this formulation marks a tension or a resolution of the tragic quality of history.

AMERICA, JAZZ IDENTITY, AND THE TRAGIC QUALITY OF DEMOCRACY

There are moments in Ellison's corpus where he betrays a commitment to the American frontier myth—America is defined in terms of experimentation, novelty, the transgression of limits, and the expansion of borders. As a native of Oklahoma, he inherits the idea that America is characterized by a kind of openness; it is necessarily an unfinished project and this quality is the source of hope and possibility.[72] Yet Ellison's jazz-influenced imagination of democracy also registers the relationship between (democratic) possibility and loss. While American democracy, according to Ellison, is marked by plurality and openness to difference, it is also the site of painful contradictions. To think about how literary jazz articulates this "doubleness" within American democracy, I turn briefly to Ellison's insightful essay "The Little Man at Chehaw Station."

In "The Little Man at Chehaw Station," Ellison articulates a jazz-informed conception of American identity that accents a play between the familiar and unfamiliar. At the beginning of the essay, Ellison recounts a conversation with his music teacher, Miss Harrison, who admonishes him to always be prepared for the little man behind the stove. She tells him that, when performing for an audience, "you must always play your best, even if it's only in the waiting room at Chehaw Station, because in this country there'll always be a little man hidden behind the stove. There'll always be a little man whom you don't expect, and he'll know the music, and the tradition, and the standards of musicianship required for whatever you

set out to perform."[73] Ellison is shocked because "Chehaw Station was a lonely whistle-stop," a "claustrophobic little waiting room." It is the "last place where one would expect to encounter a connoisseur lying in wait to pounce upon some rash, unsuspecting musician."[74]

What we need to draw out from Miss Harrison's riddle is the relationship between the artist and the little man and the significance of the "lonely whistle-stop." The little man is at once the artist's highest ideal and the artist's radical other. It is important to include both aspects of the little man's function so that the notion of an ideal isn't reduced to a projection of the familiar. Thus Ellison suggests that if the little man "were not already manifest in flesh, he would still exist and function as an idea and ideal because he is a linguistic product of the American scene and language, and a manifestation of the idealistic action of the American Word as it goads its users toward a perfection of our revolutionary ideals."[75] But as an ideal that goads the artist toward perfection, the little man also interrupts and alters the artist on her odyssey toward perfection. As the artist projects ideals and generates certain expectations, the little man interrupts these expectations. The little man, as Ellison points out, is "a day-coach, cabin-class traveler—but the timing of his arrivals and departures is uncertain. Sometimes he's there, sometimes he's here."[76] Therefore the little man is indicative of people, events, and ideas that cannot be anticipated by our familiar patterns of meaning and structures of anticipation. The little man disrupts our everyday temporal rhythms, flows, and expectations. He often "materializes when you least expect him." As a figure who shatters the artist's sense of stability and harmony, he is emblematic of the incongruous dimensions of American life that many tend to ignore and deny. In fact, "if the little man's neighbors were fully aware of his incongruous existence, the little man's neighbors would reject him as a source of confusion, a threat to the social order, and a reminder of the unfinished details of this powerful nation."[77] These "unfinished details" connote that life is constantly in flux and not yet complete; life is therefore always offering us more to respond to, engage with, and discover.

Analogous to the little man, Chehaw Station is a metaphor for those unexpected places that potentially transform our imaginations and conceptual frameworks. But as Miss Harrison urges Ellison, the artist must be attentive to these nearly invisible places, these lonely whistle-stops. A station is a place where different bodies, styles, traditions, and rhythms meet and cross, even if only for a moment. Like a concert hall, railroad stations

are "gathering places, juncture points for random assemblies, reminding us that in this particular country even the most homogenous gatherings of people are mixed and pluralistic."[78] Much as Adorno claimed that the secret telos of identity is nonidentity, Ellison suggests that plurality and fecundity (of styles, desires, ideas, traditions) are immanent in everyday practices and mundane spaces.[79] The artist must be attuned to the modes of nonidentity within the semblance of identity; her onus is to express and unveil the unfamiliar that marks the familiar. As Ellison puts it, the artist's role is to "define and correlate diverse American experiences by bringing previously unknown patterns, details, and emotions into view along with those that are generally recognized."[80] The play between the familiar and the unfamiliar elements of American life, expressed by the artist, is not directed toward a facile harmony. Rather, Ellison understands American culture, like a jazz ensemble, as a "whole that is always in cacophonic motion. Constantly changing its mode, it appears as a vortex of discordant ways of living and tastes, values and traditions."[81] Being faithful to this cacophonic motion requires an openness to the strange and unfamiliar, a receptivity to that which is different and unexpected, and an acknowledgement that the different and unfamiliar is often intertwined with the banal and familiar features of everyday life. But of course this receptivity is not an easy task. Insofar as America is marked by a "vortex of discordant ways of living," this discord is often the site and source of unease and discomfort. Or as Ellison puts it, "In our intergroup familiarity there is a *brooding* strangeness, and in our underlying sense of alienation a poignant—although distrusted—sense of fraternity. Deep down, the American condition is a state of *unease*."[82]

There is a buoyant quality to Ellison's vision of American plurality, a hopeful attitude toward the unexpected possibilities that emerge within neglected spaces—behind the stoves and at lonely railway junctures. As Houston Baker informs us, the railway juncture itself signals a transient intersection of different paths and trajectories; it is a place that exists betwixt and between arrivals and departures. The little man often resides in places (and temporal schemes) that are betwixt and between. This liminal space is a potential site of transformative encounters with others, a site where we cross paths with strangers who occasionally surprise us and disrupt our prefabricated concepts and expectations. Ellison suggests that little men and women appear on the scene intermittently. After being surprised by four black workers in the basement of a New York tenement who

are debating over the Metropolitan Opera, Ellison confesses, "Not behind the stove, it is true, but even more wondrously, they had materialized at an even more unexpected location: at the depth of the American social hierarchy and, of all possible hiding places, behind a coal pile."[83] But if the space behind the stove and the coal pile (what Ellison calls a hiding place) is a site of possibility and hope, it is also often a site of pain, alienation, and disappointment.

Therefore, the resiliency of little men and women who inhabit these neglected crevices is intertwined with the ponderous quality of conditions that tend to render them invisible. Jazz is a proper metaphor for this resiliency expressed by subjects who have been relegated to the "waste bins of history." Insofar as black subjects have contributed to the formation and development of this aesthetic form, jazz music indicates the possibility of, to borrow from Beth Eddy, discovering treasures amid the trash. Jazz, on an upbeat reading, signifies creativity, mobility, and improvisation against an inveterate backdrop of hardship, poverty, and systemic injustice. It also connotes the possibility of solidarity among a plurality of styles, desires, skills, and gifts. But if jazz suggests the possibility of transforming trash into treasure, jazz is also connected to a blues tradition that registers the pain and suffering embodied by those who have been hurled into the trash. In other words, the significance of generating meaning and hope out of a chaotic situation cannot be divorced from expressing the pain that accumulates within this situation. The backdrop of the hardship and loss just mentioned must irrupt into the foreground.[84]

Ellison claims that Americanness is marked by a deep sense of unease, a sense of the uncanniness that marks familiar, everyday practices and relationships. Part of this unease, Ellison suggests, is generated by a denial of the painful details of America's past and present. A denial of something unpleasant is often intertwined with an implicit acknowledgment, and it is precisely this tension between denial and awareness that can be unsettling. Ellison writes, for instance, "We possess two basic versions of American history; one which is written and as neatly stylized as ancient myth, and the other unwritten and as chaotic and full of contradictions, changes of pace, and surprises as life itself. Perhaps this is to overstate a bit, but there's no denying the fact that Americans can be notoriously selective in the exercise of historical memory."[85] Here Ellison shows his Freudian side by adverting to a chaotic underside that looms underneath and behind the neat, tidy versions of American history. He suggests that within America,

beneath the myths that sustain a spurious order, there is an unrecorded history of both chaos and contradiction but also surprise and possibility. Ellison also contends that although this underside is repressed, it actively shapes events in American life. Ellison writes, "For in spite of what is left out of our recorded history, our unwritten history looms as its obscure alter ego, and although repressed from our general knowledge of ourselves, it is always active in the shaping of events."[86] According to Ellison, the obvious, taken-for-granted patterns in everyday life are shaped by an opaque, active underside, an underside that consists of painful contradictions that haunt the nation's collective images of itself.

Jazz, as we witness in essays like "The Little Man at Chehaw Station" registers plurality, creativity, and the potential for transformation (within inescapable, yet unstable social constraints and structures). At the same time, the dissonant, antagonistic quality of jazz also renders audible the violent, painful, and even broken dimensions of American life. While jazz might be used in *Invisible Man* to dislodge teleological narratives associated with Marxism, jazz is also employed throughout Ellison's corpus to expose the ways more traditional American myths work to erase the tragic kernel of American history. Ellison writes, "Perhaps more than any other people, Americans have been locked in a deadly struggle with time, with history. We've fled the past and trained ourselves to repress, if not forget troublesome details of the national memory, and a great part of our optimism, like our progress, has been bought at the cost of ignoring the processes through which we've arrived at any given moment in our national existence."[87] Progress, optimism, and amnesia, as this passage indicates, form a treacherous constellation.

This relationship between American progress and the repression of violent, uncomfortable details is symbolized in the famous battle royal scene in *Invisible Man*. As Allen and Eddy point out, this scene can be interpreted as an initiation rite, a symbol of the violent process of becoming a recognizable subject or a national citizen. It is important to note that IM's participation in this brutal fight with other black men occurs after he delivers a graduation speech about progress, a speech that "was a great success" and a "triumph for the whole community."[88] Before the narrator can deliver this speech again to the "town's white leading citizens," he and nine other black bodies must satisfy the "twisted" desire to see black males destroy each other. The scene, as commentators have noted, is highly sexualized—a "magnificent, stark naked blonde" woman is violently thrust into the gathering, forced to

dodge and elude the invasive, possessive gropes of the town's respectable white males. After beholding the white woman's naked body, IM reflects, "I wanted at one and the same time to run from the room, to sink through the floor, or to go to her and cover her from my eyes and the eyes of others with my body; to feel the soft thighs, to caress her and destroy her, to love her and murder her."[89] Notice that the narrator harbors highly ambivalent feelings and desires toward the female subject, or object—he admits feelings of shame, lust, and tenderness as well as a violent desire to destroy her. He and the other black participants are both tempted to look at her body and compelled to avert their gaze. It is almost as if IM's ambivalent desire for the white female subject becomes a stand-in for the violent, sexualized fantasies that the white males project onto the black male bodies. Although IM expresses rancor toward the woman, he briefly identifies with "the terror and disgust in her eyes." There is a moment of recognition, at least by the narrator, that they are both subjugated objects in a violent economy of desire and pleasure. As Walton Muyumba points out, this scene invokes the spectacle and ritual of lynching. He claims that "as in the lynching spectacles, the battle royal is underwritten by myths of black male sexual potency, and myths of sanctified white womanhood."[90] Like the ritual of lynching, a practice that secured white male identity by policing black male and white female desire, the battle royal is a site in which sex, violence, and trauma intersect. The visibility of the white woman's flesh "incites fainting, moaning, crying, hatred, and fear amongst the Negro teens."[91] The moan and the cry indicate sexualized responses to the white woman but these sounds also signify a bodily reaction to the violence that the black teens (and the white woman) undergo.

The moaning and crying allude to the blues tradition, and throughout this scene, IM uses musical metaphors to describe the multiple interactions that take place. At one point, while describing his struggle with another participant in this brutal spectacle, he recalls, "Pushed this way and that by legs milling around me, I finally pulled erect and discovered that I could see the black, sweat washed forms weaving in the smoky-blue atmosphere like drunken dancers weaving to the rapid drum-like thuds of blows."[92] Here the "weaving of dancers" and the "drum-like thuds of blows" are musical images that amplify the violent character of this American ritual. While dance is often associated with play, intimacy, and festivity, the novel suggests that dance can also signify turbulent movements, antagonistic interactions, and painful negotiations between bodies, a set of connotations

that Morrison also highlights in her novel *Jazz*. Ellison, as the battle royal scene indicates, sees jazz and American democracy as analogous forms of antagonistic cooperation. If this is the case, then the qualifier "antagonistic" does not simply refer to the liberal dream of tolerating difference and diversity. It is not reducible to the facile vision of multiculturalism in which all cultures get along and respect difference without discomfort and unease. This qualifier also indicates the painful quality of social life and interaction. Ellison contends that "the diversity of American life is often painful, frequently burdensome, and always a source of conflict, but in it lies our fate and our hope."[93] Like the instruments in a jazz ensemble, cultures, bodies, and individuals clash and conflict; even though this might be an opportunity for negotiation and improvisation, it is also the occasion for suppression, assimilation, erasure, and loss. This is exemplified at the end of the battle royal when the narrator gives his speech while swallowing his blood, the residue of the preceding violence. He is "accepted" by the white male elites only on the condition that he, in Butler's words, enters a domain of intelligibility—he attempts to make a case for social "equality" between blacks and whites but the white elites promptly interrupt his speech, compelling him to adopt the more palatable language of social "responsibility." Progress, as this battle royal scene shows, is a violent, assimilative movement and process; it also requires participants within this movement to deny or swallow the blood that progress demands.

Jazz, for Ellison, registers possibility and limitation, hope for a more inclusive world and memory of the cuts, ruptures, and breaks that mark our social worlds. While America might be a national space historically defined by improvisation and experimentation, this hopeful collective vision cannot be divorced from antagonisms, conflicts, and losses that optimistic notions of American possibility often deny and produce. So when the narrator claims at the end of the novel that his world has "become one of infinite possibilities," I suggest that we read in this a tinge of irony and sarcasm.[94] For one, the narrator says this while inhabiting a "hole" in the ground (a basement in an abandoned building), a hole that he plunged into while escaping police officers, and a hole that symbolizes an inescapable wound that punctures visions of a coherent, self-assured individual. In addition, IM carries his briefcase into this hole, a briefcase that contains, among other things from his recent past, Brother Clifton's doll, or puppet. Although he tries to burn the doll, an act that again invokes the scene of lynching, the doll "burns stubbornly." Even if the future is somewhat open

and unpredictable, this inability to eliminate painful, dissonant memories, including Clifton's death, indicates that futurity is always constrained and informed by a complicated past. Even if the past does not completely determine the present, the two are intertwined in ways that undercut linear, trauma-denying conceptions of time.

Despite the fact that Ellison uses the phrase *infinite possibility* with a tinge of irony and sarcasm, there are several critiques that one could introduce in response to Ellison's jazz-informed ideas. For one, Ellison's affirmation of a discordant identity is often attached to American soil and the image of the American frontier. By tethering his provocative vision of antagonistic cooperation to American territory, he domesticates difference and discord, reducing these qualities to national identity. America, or American-style jazz, becomes the privileged territory of possibility and creativity. Fred Moten suggests something like this when he claims that Ellison's musical imagination gets subordinated to a confining image of America. Moten writes, "This domestication is a kind of nationalist reconfiguration wherein the music is presented as the trope of a certain understanding of totality as America, of representation as America, of democracy as America, of the future—which is to say the end—as America."[95] In a world where American interests and practices leave their imprint across the globe in ways that many non-Americans cannot control, this part of Ellison's thought is particularly troubling. In addition, even though Ellison uses jazz motifs to counter progressive notions of time, history, and development, he remains trapped within the frameworks and paradigms that he criticizes (as we all are to some extent). It is difficult to deny the fact that his novel can be read as a typical coming-of-age story in which the protagonist makes the comforting transition from blindness to insight, from a state of chaos to one of meaning and coherence. Although I argued against this reading, the form and structure of the novel don't necessarily render this alternative reading untenable. Since the novel centers around the journey and trials of an isolated male protagonist, we might also think about the kinds of gender-inflected exclusions and omissions that render his narrative intelligible. As Claudia Tate points out, the narrator's story is made possible because the female characters in the novel are relatively invisible and superficial.[96] In order for IM to become somewhat visible and audible, at least to the reader, women have to be hailed into the shadowy background. These limitations, I argue, are indirectly addressed, but not resolved, in Toni Morrison's novel *Jazz*.

JAZZ, TURBULENT MOVEMENTS,
AND THE COLLECTIVE PROMISE OF THE NORTH

Toni Morrison's novel *Jazz* also enacts a jazz-inspired notion of time, marked by a discordant play between past and present. Like *Invisible Man*, Morrison's novel refers to the black American migration trope and narrative but does this in a more explicit manner than Ellison's text. *Jazz*, more than its counterpart, underscores the collective hopes, aspirations, struggles, and losses that black Americans endured and carried from Southern spaces to the North. Similar to Ellison's novel, *Jazz* treats New York City, particularly the space of Harlem, as a kind of synecdoche for the North and its broken promise of progress and freedom. More than Ellison's *Invisible Man*, however, Morrison's novel shows how brokenness and loss and the endeavor to fix and resolve these conditions are often mediated and informed by gender violence. In addition, her text highlights the intersubjective quality of melancholy, the ways experiences of loss can be shared (and denied) by members of the black community. Morrison's *Jazz* is a novel about many things—love, desire, infidelity, murder, loss, and the possibility of forgiveness—to name a few. It revolves around a vicious love triangle involving Joe and Violet Trace and a young teenage girl named Dorcas, all characters who have migrated to Harlem from the South and Midwest. After a brief affair between Joe and Dorcas, the latter begins to deny the former's advances and seeks another lover. Angered over this unrequited desire, Joe murders Dorcas at a house party. The novel begins with Violet, presumably jealous of Dorcas even in Dorcas's death, attempting to "cut the dead girl's face" at her funeral. The novel therefore begins with what the narrator calls a "crooked kind of mourning."[97] By opening the story with an interrupted funeral and by starting in front of many of the events narrated later on in the novel, the reader is prepared for an unconventional narrative sequence with cuts, gaps, and unexpected transitions.

As literary critic J. Bouson points out, Morrison's novel, especially the murderous relationship between Dorcas and Joe, was inspired by a photograph and corresponding story collected in James Van Der Zee's *Harlem Book of the Dead*, "a collection of photographs of 'beloved, departed people' in their coffins or in the arms of their parents."[98] Like Morrison's earlier novel *Beloved*, which was inspired by Margaret Garner's infamous killing of her daughter to save her child from slavery, *Jazz* is haunted and animated by a particular instance of death, or murder. The novel therefore

exists somewhere between life and death, past and present, fiction and history, as well as sound and image (of loss). Since jazz is typically associated with movement, or a state of being that is always in-between locations and positions, then the eponymous title is appropriate.

Jazz operates in multifarious ways throughout the novel. For one, jazz images and motifs record and trace the migration of black people from the South, the past, to the North, the future, while also signifying how these newly arrived black bodies navigate their urban environments. Jazz, as Ellison suggests, is a proper trope for these migration narratives. Jazz typically signifies movement, instability, and improvisation, all qualities associated with migrating and adjusting to new spaces and settings. Yet relocation for the characters in these novels and black Americans historically is often motivated by dislocation. Migration patterns are often attempts to escape constant disturbances to one's well-being and sense of home. As Griffin points out, migration narratives typically attribute the urgent need to flee the South to an oppressive power arrangement that leaves its marks on black bodies in the form of beating, rape, and lynching.[99] Although dislocation and dismemberment, within these narratives, is typically the product of white supremacist practices, violence against black women is often perpetrated by black men. Therefore, while Morrison's novel draws tropes, images, and concepts from the practice of jazz to trace the movements of black people to the North and to track their attempts to adjust to new territories, the novel also employs jazz as a way of recording and remembering the losses and wounds that have accrued along the way.[100]

As Ellison does, Morrison highlights the relationship between jazz and dance, the ways jazz is intertwined with corporeal practices, habits, and movements. This is evident in the description of the arrival of Joe and Violet to Harlem. By treating their journey and arrival as a kind of performance, Morrison's narrator invites the reader to think of the migration as a dance. The narrator informs us,

> Joe and Violet wouldn't think of it—paying money for a meal they had not missed and that required them to sit still at, or worse, separated by, a table. Not now. Not entering the lip of the City dancing all the way. Her hip bones rubbed his thigh as they stood in the aisle unable to stop smiling. They weren't even there yet and already the City was speaking to them. They were dancing. And like a million others, chests pounding,

tracks controlling their feet, they stared out the windows for the first sight of the City that danced with them, proving already how much it loved them. Like a million more they could hardly wait to get there and love it back. . . . However they came, when or why, the minute the leather of their soles hit the pavement—there was no turning around. Even if the room they rented was smaller than the heifer's stall and darker than a morning privy, they stayed to look at their number, hear themselves in an audience, feel themselves moving down the street among hundreds of others who moved the way they did, and who, when they spoke, regardless of the accent, treated language like the same intricate, malleable toy designed for their play. Part of why they loved it was the specter they left behind.[101]

Here Morrison's narrator uses the image of dancing to capture a festive quality of the migration narrative. Joe and Violet arrive in New York with an optimistic attitude, with the anticipation that the city will embrace them. They embody a faith that they will be in sync with the rhythms of the city, that the city will dance with them. The use of dance imagery (chests pounding, which can refer to a heartbeat or to two people embracing, and soles hitting the pavement) highlights the energy and excitement that accompanied the northbound journey. In addition, this imagery foregrounds the somatic dimensions of jazz, the ways the sounds of jazz music are interwoven with the rhythms and movements of the body.[102] This passage reminds the reader of the bodily investments and risks involved in moving, relocating, and traveling. As Violet and Joe dance into the city, they form an ensemble with other blacks who have danced to the city in order to find jobs, security, and a better quality of life. They have joined a moving audience, an audience that will have to modify their bodily dispositions and habits to the terrain of the city.

Two phrases in the above passage are significant for thinking through the relationship between jazz, remembrance, and loss. According to the narrator, "there was no turning around" and "part of why they loved it was the specter they left behind." Here the narrator suggests that once these former inhabitants of the South arrive, they can leave the violent Southern past behind them. Yet, claiming that their love for the city is attributable to the "specter they left behind" is ambiguous. A specter resists being left behind; it marks the reappearance or lingering presence of something that was abandoned. (In fact, as we shall see below, the specter is actually waiting

for Joe and Violet in the city; it is ahead of them.) Even as the narrator speaks of leaving the painful episodes of the Southern past behind, the *South* being a figurative term that includes Midwestern territories, she still must identify these episodes in order to make sense of the possibilities and opportunities that the city supposedly offers. In other words, the hope of a better life in the North becomes intelligible alongside the memory of trauma and pain in the South. What these black subjects are moving toward is informed by what they are trying to escape. After mentioning the specter left behind, the narrator delineates features of the past that are being abandoned, thereby inscribing these aspects into the migration narrative. She mentions, for instance, "The broken shoes of two thousand Galveston longshoreman that Mr. Mallory would never pay fifty cents an hour like the white ones. The praying palms, the raspy breathing, the quiet children of the ones who had escaped from Springfield Ohio, Greensburg Indiana, New Orleans Louisiana, after raving whites had foamed all over the lanes and yards of home. The wave of black people running *from* want and violence crested in the 1870s; the 80s; the 90s but was a steady stream in 1906 when Joe and Violet joined in."[103] Notice here how the movement associated with music and dance is reimagined through water imagery— the crest being analogous to a crescendo and the steady stream analogous to a regular pattern or rhythm.

This dialectic between escape and arrival, between from and toward, between roots and routes, invokes Alain Locke's famous essay announcing the advent of the new Negro and the Harlem Renaissance. In "The New Negro," Locke sets out to reenvision black life in a way that is unfettered by previous definitions and "formulae." He suggests that a new way of being for black people, based on group expression and self-determination, has a geographical referent—the Northern city. What is interesting for our purposes is how Locke narrates the motivations behind black migration to places like Harlem. He writes,

> The tide of the Negro migration, northward and city-ward, is not to be fully explained by the demands of war industry coupled with the shutting off of foreign migration, or by the pressure of poor crops coupled with increased social terrorism in certain sections of the South and Southwest. Neither labor demand, the boll weevil nor the Ku Klux Klan is a basic factor, however contributory any or all of them may have been. The wash and rush of this human tide on the beach line of the northern

city centers is to be explained primarily in terms of a new vision of opportunity, of social and economic freedom, of a spirit to seize, even in the face of an extortionate toll, a chance for the improvement of conditions. With each successive wave of it, the movement of the Negro becomes more and more a mass movement toward the larger and more democratic chance—in the Negro's case a deliberate flight not only from countryside to city, but from medieval America to modern.[104]

Here Locke underscores and reiterates the idea that the spatial movement from the countryside to city accompanies a temporal movement from the past to the present, or future, or from the old to the new. At the same time, he suggests that the motivating factors behind the migration have more to do with the possibilities that beckon black migrants than the losses that lie behind them. He foregrounds the fecundity and excess that marks the Northern city, the abundant opportunities for freedom and improvement, the "larger" and "more" democratic chance that promises a better life for black people. He mentions the "extortionate toll," but relegates the pain, suffering, and loss (Ku Klux Klan, natural upheavals like the boll weevil, leaving one's community) to the background. These factors are not as "contributory" to the displacement of black bodies as the "new vision" of opportunity. Insofar as he hopes that "in the very process of being transplanted, the Negro is being transformed," this transformation has everything to do with how the migration is narrated and remembered, how we understand the relationship between the possibilities ahead of these black migrants and the pain and loss that sparked the movement.[105] For Locke, the emergence of a "New Negro" depends in part on privileging the novelty and possibility associated with the North over past forms of suffering and pain.

While Morrison's use of jazz and dance imagery captures the vibrancy, energy, and anticipation inscribed within Locke's formulation of the transformed black subject, her appropriation of jazz also registers a stubborn, intruding past that refuses to completely remain behind. Following Ellison's claim that "music gives resonance to memory," Morrison shows throughout the novel how sounds and chords can mediate and shape a certain relationship to the past.[106] In addition, music often expresses something about that relationship that cannot be fully captured in words. Think, for instance, of the scene in which Alice Manfred, Dorcas's aunt, observes the marching band during the silent protest on Fifth Avenue in response to the East St. Louis riot of 1917. The narrator reveals,

Like that day in July, almost nine years back, when the beautiful men were cold. In typical summer weather, sticky and bright, Alice Manfred stood for three hours on Fifth Avenue marveling at the cold black faces and listening to drums saying what the graceful women and the marching band could not. What was possible to say was already in print on a banner that repeated a couple of promises from the Declaration of Independence and waved over the head of its bearer. But what was meant came from the drums. It was July in 1917 and the beautiful faces were cold and quiet; moving slowly into the space the drums were building for them. . . . Now, down Fifth Avenue from curb to curb, came a tide of cold black faces, speechless and unblinking because what they meant to say but did not trust themselves to say the drums said for them, and what they had seen with their own eyes and through the eyes of others the drums described to a T.[107]

In this scene, the narrator suggests that the drums elicit desires, meanings, and memories that the "print on a banner that repeated a couple of promises from the Declaration of Independence" cannot capture. The juxtaposition of "cold, black faces" with "typical summer weather, sticky and bright," suggests a dissonance between the apparent "climate" of the city and the somber lived experiences of black subjects, a dissonance that Alice Manfred presumably hears in the beating of the drums. The drums express "what they had seen with their own eyes and through the eyes of others." They express the violence and turbulence that coerced many blacks, including Dorcas, who lost her parents in the riots, to search for a new home. Similarly, the sound of the drum might connote resistance, struggle, and a desire to survive amid painful conditions. What is interesting in this passage is the intersection between remembrance and different modes of perception—hearing the drums conjures up and expresses the memory of what has been seen or witnessed by these black subjects. Insofar as Morrison mentions the Declaration of Independence, I suggest that she is using music to generate a form of countermemory (since parades in July are often associated with Independence Day and the festivities around this national holiday). As the narrator puts it, with reference to the pervasiveness of black music in the city, "The lowdown music had something to do with the silent black women and men marching down Fifth Avenue to advertise their anger over two hundred dead in East St. Louis, two of whom were her sister and brother-in-law, killed in the riots."[108] Lowdown

music like jazz and blues, music that operates on the lower, visceral levels and that offers a different type of "lowdown" or story, has something to do with remembering and mourning those who passed away in these riots. Music signifies something that is not reducible to words on a banner, particularly platitudes from the Declaration of Independence. To borrow from the Nag Hammadi epigram that begins the novel, music is the "name of the sound and the sound of the name," a sound that is often dissonant and indicative of painful memories.

BREAKS, RUPTURES, AND REPETITION

If sounds from an instrument can give resonance to memory, then the practices and activities that constitute jazz, as Morrison shows, register this memory in particular ways. Think, for instance, of the language of "breaks" and "cuts," two important components of a jazz performance that Ellison alludes to in his description of disjointed time. According to Barbara William Lewis's helpful description, a break "is a brief flurry of notes played by the soloist during a pause in the ensemble playing."[109] Cutting, as Ted Gioia describes it, refers to the practice of competing with and outplaying other participants in a jam session.[110] As Lewis points out, Morrison's novel incorporates these concepts to underscore the breaks, cuts, and ruptures within black American history and experience. The notion of a break or cut in *Jazz* refers not only to "dislocation and severed ties, but also the overall image of violence in the city."[111] The image of cutting elicits the dismemberment involved in lynching and the severed ties that resulted from leaving the South. Yet it also indicates the violent conditions in Northern cities that compelled men and women to stay armed, including Violet, who "wields a *blade* as she approaches Dorcas's coffin."[112]

The notion of the break or cut therefore registers the discontinuity and the continuity between the past, the South, and the present, the North. The reader experiences this play between continuity and discontinuity as each chapter in the novel resumes a thought or sentiment from the end of the preceding chapter. For instance, chapter 2 ends with the narrator's describing how music is tied to the rhythms and moods of the city—"the circles and grooves of a record can change the weather. From freezing to hot to cool."[113] Chapter 3 begins with the line "like that day in July, almost nine years back, when the beautiful men were cold."[114] While chapter 3 continues the thought from the preceding section, it also connotes a kind

of temporal rupture, a reaching back to an event from the past. In addition, the space, or page, in between the chapters signifies a gap, a pause, and prepares the reader for a change in direction even if that change carries traces of what the reader just experienced. So to some extent the reader participates in the back and forth, discontinuous movement of the novel. As *Jazz* unfolds, the reader's sense of time and temporal sequence is unsettled; aspects and images from the past constantly interrupt desires to keep moving forward. At the same time, this interruption reminds the reader that the past is always present, always part of a playful, tension-filled interaction with the present and approaching future.

Like the reader, the characters undergo various breaks and cuts to their identities and narratives, compelling them to deal with this play between continuity and discontinuity. On the one hand, the move to the North is a sort of rupture from familiar patterns and settled ways of life in the South. At the same time, the attempt to leave the past behind can lead to specters from this past reemerging in ways that are not only unanticipated but that are dangerous and debilitating. This past can return and institute a break or cut in the present. The cut or break therefore alludes to recurring conditions and experiences of loss and struggle that puncture, wound, but potentially transform selves and communities. Think, for instance, of Violet Trace's relationship to her environment and community. In the beginning of the novel, the narrator suggests that Violet cannot withstand the dynamics of the city. At one point, she is so tired that she can no longer move or dance. Therefore she sits down and rests in the middle of the street. Another episode that the narrator recounts is Violet's attempt to walk off with another woman's child, which can be read as an attempt to fill a void in her life, insofar as she and Joe are unable to produce a child (the narrator mentions briefly that Violet has undergone three miscarriages). The narrator refers to these episodes as cracks in Violet's life. She explains,

> I call them cracks because that is what they were. Not openings or breaks, but dark fissures in the globe light of the day. . . . The globe light holds and bathes each scene, and it can be assumed that at the curve where the light stops is a solid foundation. In truth, there is no foundation at all, but alleyways, crevices one steps across all the time. But the globe light is imperfect too. Closely examined it shows seams, ill glued cracks and weak places beyond which is anything. Anything at all. Sometimes when Violet isn't paying attention she stumbles into these

cracks, like the time when, instead of putting her left heel forward, she stepped back and folded her legs in order to sit in the street.[115]

If "putting her left heel forward" refers to the dancing metaphor mentioned above, then the cracks that cause Violet to stumble refer to the gaps that punctuate and interrupt our movement forward. They are traces of loss, tracks of the painful conditions, features, and episodes that beset our travels and wanderings. These fissures betoken the broken quality of our lifeworlds. They indicate conditions and arrangements that, for instance, prevent Violet's body from enduring the full term of her pregnancy. When the narrator says that her husband, Joe, "didn't want babies either so all those miscarriages—two in the field and only one in her bed—were more inconvenience than loss," she is making a passing reference to the physical labor that took a toll on Violet's body while she was a sharecropper in the fields of the South (and also playing with the meaning of *labor*).[116] In addition, the narrator suggests that Joe refuses to mourn with his wife; he neglects the loss and pain that Violet experiences through these miscarriages. Since he can treat a miscarriage as an inconvenience while Violet embodies it as a loss, a loss that she attempts to fill or substitute for by the pilfered child, the novel suggests that mourning is mediated by gender norms, expectations, and conventions. Joe's body presumably doesn't have the same ties and attachments to the phantom child as Violet's body does, a contrast that has something to do with biological difference but that is also a result of a social imaginary that places the onus of having children on women. It is important to note that these broken conditions and arrangements that make a mark on Violet's body compel her to "step back" and sit down from time to time. This stepping back, "instead of putting her left heel forward," doesn't have to be interpreted as resignation, but perhaps indicates the need for moments of rest, moments to reflect, time to stand back from the usual course and flow of things.

Violet's tendency to stumble into cracks connotes a kind of repetition with regard to her mother, Rose Dear. Rose Dear, beleaguered by the absence of her wandering husband and the violence against blacks that permeates the South, decides "to drop herself down a well and miss all the fun."[117] The well that Violet's mother drops into is described as a kind of crevice. "Violet never forgot Rose Dear or *the place* she had thrown herself into—a place so narrow, so dark it was pure, breathing relief to see her stretched in a wooden box."[118] To never forget this place is to remember

the gaps that often swallow people, to remember the torn quality of our social tapestries that can lead someone to commit suicide and "miss all the fun" (or because she missed all the fun). But to never forget that place, that void that indicates loss, absence, tornness, and pain, is also a warning against attempting to fill that void too easily, to use an object as a stand-in for that which is desired but absent.

The desire for substitution or the tendency to treat others as vicarious objects motivates and structures many of the relationships in the novel. For instance, Joe Trace implicitly treats Dorcas as a quasiredemptive object that might make him whole and compensate for the losses and erasures that constitute and haunt his identity. His last name, "Trace," already indicates a Derridean play between presence and absence. His parents, Joe is told, "disappeared without a trace," and as Joe understands it, "the 'trace' they disappeared without was [Joe]."[119] Joe is haunted by a glaring absence in his life, the looming absence of his parents, a sense of history, identity, and so forth. Therefore, when the narrator juxtaposes Joe's search for his mother, Wild, in the woods of rural Virginia with his search for Dorcas, a search that culminates in the Dorcas's death, the narrator is again highlighting a repetition that marks the passage from the past to the present, from the South to the North. Joe reveals, "I tracked my mother in Virginia and it led me right to her, and I tracked Dorcas from borough to borough."[120] The search that pulls Joe forward, toward Dorcas, also pushes him back, toward past encounters and disappointments (since his mother, like Dorcas, rejects him). As Phillip Page points out, by treating Dorcas as a vicarious object, as an object that might fill the void or lack that marks his identity, Joe ends up committing figurative and real violence on her.[121] The novel's use of terms like *tracking* (in the sense of tracking down) and *hunting* suggests that Joe's search, animated by an irresolvable lack, anticipates treating the desired female object as prey. Desire, as Freud famously points out, is ambivalent; it aims to create and unite as well as destroy and consume.

Joe's relationship to Dorcas indicates the dangers involved in the Freudian conception of mourning, especially when mourning is defined in strict opposition to melancholy. Recall that Freud defines mourning as a successful response to loss, as an agonizing process that eventually results in the replacement of the lost object with a new one. This definition, as many commentators point out, assumes that objects are interchangeable.

In addition, this emphasis on replacement and substitution in Freud's "Mourning and Melancholia" essay downplays his own insistence on painful disappointments and losses that cannot be recovered and in some cases cannot even be recognized.[122] Here I am not implying that we should simply privilege melancholy over mourning and that this shift will somehow prevent us from using objects and subjects in this world to substitute for former attachments or foreclosed attachments. Yet without thinking carefully and critically about the different, yet patterned, ways that we respond to loss, we are condemned to repeat the kind of violence that Joe enacted on Dorcas, a murder that ultimately stems from her inability, or anyone's capacity, to make Joe whole. Joe's search for Dorcas, juxtaposed in the novel with the hunt for his mother, represents an insatiable yearning for wholeness and coherence, a desire to "find oneself" by reconciling the past and the present. Although these are all too human desires and fantasies, we must be vigilant toward the violence involved, especially when certain objects of desire prove to be recalcitrant toward this desire for wholeness. Luce Irigaray might add that we should become more aware of the ways patriarchal orders encourage men to treat the female body as a place that they can occupy, a home that men can dwell in, without providing women with a proper place of their own.[123] Because the female serves as the placeholder or home for male desire, the social order tames and represses her in order to provide men with the semblance of stability. Keeping in mind Irigaray's analysis of the relationship between the desire for male stability and female repression, it is significant that Joe's mother bears the name Wild and that his pursuit of her is described in hunting terms. It is also important that Joe punishes Dorcas for her "infidelity," for her unstable desires, even though his relationship with Dorcas results from his own promiscuity. The juxtaposition of Freud and Irigaray heightens our attention to the dangers involved in wishing that mourning can ever be complete, that objects are exchangeable, or that objects of desire can make us whole, that they might cover constitutive wounds and fissures within our experiences and narratives. This wish often repeats the violence and trauma that it is designed to overcome.

While addressing gender subordination and violence in black communities, Morrison's novel alludes to the underside of the jazz tradition. As Eric Porter points out in his intellectual history of black musicians, jazz began as a male-dominated practice predicated on the exclusion of women (or

the limited inclusion of women, typically as singers or piano players). According to Porter, jazz culture has often been defined by an "ethos predicated on the marginalization of women in musicians' circles and the cultivation of the idea that one's artistry was linked to one's manhood."[124] The qualities associated with jazz, such as creativity and experimentation, are not simply linked to the assertion of heteronormative manhood; they are also enabled by imagining the female body as the available site and object of experimentation, desire, and manipulation. According to this logic, men are the geniuses and creators and women are the "playgrounds" in which male genius can be expressed and performed; in other cases women represent bodily constraints to male genius and creativity. Recall that Morrison's novel is haunted by Dorcas's erasure and the lingering memory of her murder by Joe Trace; like the eponymous tradition that the novel mimics, the narrative is made possible by the erasure, or more accurately the presence and absence, of a female body. Morrison therefore does not simply use jazz motifs and tropes, like cutting and breaking, to trouble linear migration narratives; she also uses literary jazz to direct the reader's attention to the violent, exclusive dimension of this musical practice and legacy, a quality often downplayed by celebrants and proponents like Ellison. Morrison also implicitly contributes to discussions and discourses about black music that highlight how men and women participate in, experience, and appropriate these musical traditions differently. Hazel Carby, for instance, famously argues that early female blues singers like Bessie Smith and Ma Rainey often talked about migration and the flux of black life differently than their male counterparts.[125] Whereas male singers often moaned about leaving and travelling, women tended to sing about being left or abandoned (like Violet's mother Rose Dear's being abandoned by her husband, or like Violet's being routinely left by her husband, a "travelling salesman" who can express himself and experiment with his desires outside of the home). In addition, as Carby points out, blues provided a space for these female singers to talk about abuse, violence against women, and homoerotic desire, topics that violated the reigning politics of respectability. Crucial here is how blues and jazz, when performed by women, voice and perform tensions, struggles, disappointments, and desires that work against simplistic notions of progress, unity, uplift, and respectability. Authors like Morrison and Carby draw attention to how gender difference, subordination, and resistance within musical practices and black communities more generally create a cut or break in any imagination of a homogeneous, harmoni-

ous black collective. They remind us that many of the unifying terms and metaphors that we use to make sense of black people's experiences—community, peoplehood, progress, collective struggle—often cover or downplay what the political theorist Cathy Cohen calls the "cross-cutting" dimensions of black life.[126] Race is always cut (and intersected by) gender, sexuality, class, and other identity positions, rendering selves and communities complex sites of tension, discord, and possibility.

The related ideas of the cut and break, repetition, and tracking form an assemblage in Morrison's text, an assemblage that is best understood if we think about the qualities of a record. At the end of the novel, as the narrator reflects on the lives of the characters, she likens the past to a record. She claims "that the past was an abused record with no choice to repeat itself at the crack and no power on earth could lift the arm that held the needle. I was so sure, and they danced and walked all over me."[127] Here Morrison invites us to think about the duplicity in the meaning of various terms. A music record is also a record of the past; similarly *track* refers to a song on a record but also to the trace or footprint of the past, to hunting and searching (not to mention the train tracks that black migrants travel on). The word *crack* refers to the groove in the record but also to the fissures and breaks that constitute a fractured world. Insofar as the past is repeated at the crack or groove, the jazz or blues record often records a history of ongoing suffering, a history of "abuse." The arm that holds the needle might refer to God or to the contingent forces of life that "no power on earth" can fully control. For Morrison, the record becomes a metaphor for the repetition and production of life, a life replete with grooves. As Adorno puts it, in one of his several essays on the phonograph, "As music is removed by the phonograph record from the realm of live production and from the imperative of artistic activity and becomes petrified, it absorbs into itself, in this process of petrification, the very life that would otherwise vanish."[128] For Morrison, the record absorbs the fragments of black life that would vanish not simply because of the evanescence and passing of life's moments, but also because much of black life has been omitted from dominant narratives and official records.

It is important that the narrator follows the claim about the past's being an abused record with the concession, "I was so sure, and they danced all over me." As several commentators have pointed out, the narrator is a character who changes and develops throughout the novel. At times, she seems to be adopting the third-person-omniscient perspective and at other times she

speaks in the first person. Yet there are moments in the novel when each of the main characters is permitted to tell his or her individual story; each performs a solo or break within the text's arrangement.[129] What is important for our purposes is what the narrator's development suggests about the relationship between repetition and novelty. She opens up the novel, for instance, by informing the reader, "I know that woman," referring to Violet and her attempt to deface Dorcas's corpse. There is a sense of epistemic authority and confidence in this opening passage; at the beginning of the novel, Violet's actions and desires are already known and figured out. Toward the end of the novel, however, the narrator adopts a different attitude toward the characters. She admits, "I was so sure and they danced and walked all over me. Busy they were, busy being original, complicated, changeable—human. . . . It never occurred to me that they were thinking other thoughts, feeling other feelings, putting their lives together in ways I never dreamed of."[130] Here the narrator discovers that there is an excessive quality to the lives, relationships, and desires of these characters that she thought she "knew." They dance and walk all over her. They move, change, improvise, and remake themselves. They relate to the world in myriad, complex ways. The record's "repetition at the break" therefore suggests a repetition of novelty and difference, a repetition that alters and destabilizes the narrator's perspective and telling of the story. Of course, this destabilizing effect is experienced by the reader as well. As described above, the reader is affected, moved, and figuratively punctured by the unpredictable movement of the novel. Because the reader is often unsure where he or she is, whether he or she is in the past or present, the North or South, the novel disrupts coherent notions of time, history, progression, and identity. Similarly, since the novel riffs on the meanings of different terms, like *cutting* and *breaking*, the reader's sense of continuity is agitated.

Throughout the novel, the language of breaks and cuts alludes to other, similar signifiers and images. While these motifs register pain and injury, they also indicate the possibility of transformation and novelty. Likewise, a fissure creates a void or chasm but it also indicates an opening, a possibility. It is important to keep in mind both sets of connotations and hold them in tension so that we don't divorce possibility and hope from the losses and wounds involved in change, dislocation, and movement. At the risk of being redundant, I draw the reader's attention to how the meaning and import of "the crevice" shifts and changes in Morrison's novel, signifying loss and death as well as laughter and possibility. The

crevice initially refers to the crack that Violet stumbles into; it also refers to the well that Rose Dear jumps into. Yet at the end of the novel, the narrator offers a different meaning of the crevice—"pushed away into certain streets, restricted from others, making it possible for the inhabitants to sigh and sleep in relief, the shade stretches—just there—at the edge of the dream, or slips into the *crevices* of a chuckle."[131] Here the crevice is a site of laughter, even if this is a quiet, suppressed laughter. But we must keep in mind that laughter, for both Morrison and Ellison, is intimately related to pain, incongruity, and suffering. According to the narrator, "laughter is serious. More complicated, more serious than tears."[132] Laughter is serious because it is often a confrontation with pain (think here of the comedy of Richard Pryor or George Carlin). Laughter is serious because it is often a response to and indication of the painful incongruities and absurdities of our lifeworlds, incongruities that we wish we could alter, but in the meantime can only chuckle and laugh at. It is more complicated than tears because it often defies expectations and confuses our sense of what is appropriate. When Ellison, for instance, writes about Southern laws that prevented blacks from laughing in public, he attributes these laws to a need to "make it unnecessary for white folks to suffer the indignity of having to observe the confounding and degrading spectacle of a bunch of uncultivated Negroes knocking themselves out with a form of laughter that had no apparent motivation or target."[133] Black laughter, according to Ellison, can be unsettling to the oppressor because it doesn't seem to make sense. It doesn't seem to accord with the painful situation that black people often find themselves thrown into. Insofar as laughter "has no apparent motivation or target," Ellison suggests that it has no immediately identifiable function, especially if the term *function* refers to fitting properly and predictably within current frameworks of meaning. Laughter, as Ellison points out, can "turn the world upside down and inside out."[134] Laughter, as Ellison puts it, is extravagant or excessive; in some contexts, it can be subversive.

It is important that laughter is one of the responses that mark the conversations between Alice Manfred and Violet after Dorcas's murder and funeral. Although Alice claims that she cannot give Violet forgiveness for the Violet's attempt to deface her murdered niece, she does seem to offer openness and receptivity to Violet. In their encounters, they develop a dialogical relationship that resembles the improvisatory "back and forth" associated with jazz. They talk to each other about the past. Alice expresses

her anger over Violet's "crooked" form of mourning at Dorcas's funeral. Violet articulates how her attachment to her husband is motivated in part by a fear of being alone. They discuss the importance of loving "anything you got left to you" and making something out of that. Their conversations are often interrupted by breaks of silence because "the women had become so easy with each other talk wasn't always necessary."[135] What develops through their conversations is a shared practice of mourning, a shared vulnerability to the other, particularly the other's experiences of pain and loss. Like jazz musicians who must cultivate a readiness for unanticipated breaks and changes in the movement of an ensemble, Alice and Violet develop a readiness for unexpected "silences and murmurs," indicative of moments when usual forms of communication break down, requiring selves to develop alternative ways of understanding and responding to the unpredictable expressions or silences of others. Although undeveloped, this scene suggests that jazz enables one to think with and against conventional notions of communication, dialogue, and social interaction. This scene gestures toward a jazz-inflected notion of communication that registers moments of opaqueness, broken speech, silence, laughter, or unanticipatable expressions that defy the telos of consensus. These interactions between Alice and Violet highlight Ellison's point that cooperation between selves involves antagonism, dissonance, intimacy, patience, and unpredictability. Although the novel only offers hints, we might infer that in the same way that jazz temporality introduces conflict, loss, melancholy, and wounded intimacy into narratives of progress and forward movement, literary uses of jazz introduce these qualities into our everyday understanding of dialogue and communication. Instead of hoping for something like transparent interaction between selves, jazz gestures toward the possibility of communicating through cuts, breaks, and wounds.

BACK TO ADORNO AND JAZZ

In a book that draws insights from Adorno's corpus, it would be remiss not to discuss Adorno's infamous, yet widely misunderstood, critique of jazz music. At the same time, since so much ink has been spilled over Adorno's encounter with the jazz tradition, one might wonder if there is anything new to contribute. As I conclude this chapter, my aim is not to offer a complete analysis of the debates and concerns that have been prompted by his treatment of jazz. My aim, rather, is to show how Ellison and Mor-

rison challenge Adorno's assumptions about this musical tradition and everyday cultural practices more generally. Yet, I also argue that aspects of Adorno's critique of the production of culture and his understanding of the possibilities within art are useful for making sense of contemporary predicaments.

Why does Adorno hate jazz so much? What is the substance of his critique of jazz music? For Adorno, jazz is not what is seems. Whereas many supporters of jazz celebrate its subversive qualities—its movement away from rigid structure, the space it provides for improvisation, creativity, and spontaneity—Adorno can only hear uniformity in this musical genre. The dynamic movement that jazz admirers celebrate is superficial. Beneath this dynamic surface is a rigid harmonic structure that does not tolerate real change or movement. Each individual musician must conform to this basic structure. For Adorno, the so-called dissonant aspects of jazz merely cover a static consonance, which preempts the emergence of anything new.[136] His critique of jazz resonates with his broader reading of the culture industry. The production of culture operates, according to Adorno, by erasing alterity and absorbing difference (rendering each product or object within its field more exchangeable). For Adorno, the internal structure of jazz reflects the conforming pressures of the culture industry. This musical form, in other words, reflects a world that is becoming increasingly intolerant of difference, nonidentity, and that which goes against the grain. Adorno therefore contends that the proponents of jazz who celebrate its improvisational, rebellious qualities are mistaken. On the contrary, "everything unruly in jazz was from the beginning integrated into a strict scheme, its rebellious gestures are accompanied by the tendency to blind obeisance."[137] According to Adorno, the improvisational features in jazz music are "mere frills." What seems like spontaneity in jazz ensembles and performances is really "carefully planned out in advance with machinelike precision."[138] Adorno contends that jazz music is marked by a rigid structure or scheme that prevents the creativity and improvisation that jazz supporters mistakenly celebrate. At times, he attributes this rigidity to the "basic beat." At other times he attributes it to the basic rhythmic structure within jazz, and occasionally he suggests that most of the material of jazz is constituted by renditions of popular, hit songs.[139] Jazz is therefore monotonous, repetitive, and predictable. This cultural form reflects and fortifies the planned production of capitalist arrangements, a planned production which "seems to purge the life-process

of all that is uncontrollable, unpredictable, and incalculable in advance and thus to deprive it of what is genuinely new, without which history is hardly conceivable."[140]

As Adorno dismisses the resistant, subversive potential in jazz, he also seems to dismiss the contribution of black people to this musical tradition. He claims, for instance, that "the extent to which jazz has anything at all to do with genuine black music is highly questionable; the fact that it is frequently performed by blacks and that the public clamors for 'black jazz' as a sort of brand-name doesn't say much about it, even if folkloric research should confirm the African origin of many of its practices."[141] Adorno resists the tendency to imagine jazz as the expression of authentic blackness, an authenticity that usually is verified by tracing elements within jazz to its African origins. Adorno recognizes that there are African elements in jazz, yet he rejects the idea that somehow these African elements (the drum, various levels of syncopation, polyrhythmic arrangements) constitute jazz's "unruly" quality.[142] Similarly, he rejects the idea that jazz music, because of these African traces, is the expression of unmediated desire. Adorno therefore challenges the romantic idea that was in vogue in Europe during the early part of the twentieth century that jazz is "a breakthrough of original, untrammeled nature."[143] This idea is connected to the assumption that Africa is the repository of primitive instincts, practices, and ways of life. This romanticized vision of Africa animates the "belief in jazz as an elementary force with which an ostensibly decadent European music could be regenerated."[144] Jazz, in Adorno's view, is not the articulation of pure, elementary desires and feelings that are unhindered by the arrangements of power within the modern world.[145] Following Hegel, the immediate for Adorno is always mediated to some extent; for Adorno, our desires are mediated and shaped by the social world that we inhabit, a social world that is becoming increasingly driven by profit and the exchange principle.

Adorno is therefore not denying that blacks have contributed to jazz. He is simply contending that we shouldn't assume the following inferential chain—authentic jazz refers back to Africa, which signifies unhindered spontaneity. In addition, he wants to remind us that even if jazz is performed mostly by black musicians, jazz music is a hybrid of many different cultures and traditions.[146] He claims that "it is difficult to isolate the authentic Negro elements in jazz. The white lumpenproletariat also participated in its prehistory."[147] More important, Adorno's concern is directed toward the ways the entertainment industry promotes and advertises the

supposed vitality and spontaneity of jazz and black people, while obscuring the conditions that reproduce racial inequality. He writes, "In no way does a triumphant vitality make its entrance in these bright musical commodities; the European-American entertainment business has subsequently hired the [supposed] triumphant victors to appear as their flunkies and as figures in advertisements, and their triumph is merely a confusing parody of colonial imperialism."[148] Here Adorno makes a peculiar link between the entertainment industry, comedy, and the ongoing effects of colonization on black people. As James Harding suggests, Adorno "desires to point out where blacks are being exploited as 'eccentric clowns' and where jazz subtly makes entertainment out of what has been done to African-Americans."[149] The problem, in other words, is that the entertainment industry tends to downplay the suffering and pain that have historically been intertwined with the jovial aspects of black entertainment. The industry enables consumers to laugh without feeling a sense of melancholy. As discussed above, Ellison is very aware of the entertainment industry's attempt to "reduce blacks to grotesque comedy" even if Ellison thinks that the minstrel tradition is more complicated than most critics, including the bebop generation, assume.[150]

There is much in Adorno's treatment of jazz that is Eurocentric, elitist, and racist. Commentators like Tom Levin and Frederic Jameson attempt to exonerate Adorno by claiming that the term *jazz* refers specifically to popular, mainstream musicians like Paul Whiteman rather than "the richness of black culture we have long since then discovered."[151] Yet these authors overlook moments where Adorno is clearly alluding to artists like Louis Armstrong and Duke Ellington in a dismissive manner. In fact, Adorno suggests that Armstrong sounds as if he is castrated (without offering a thorough critique of the historical assumptions and fantasies that link the phallus with white male power and control) and he applauds Ellington only because he has mastered European musical techniques. Although we cannot forget or erase the Eurocentric legacy that Adorno exemplifies in his writings, we also shouldn't dismiss the powerful resources that Adorno offers for thinking about everyday forms of violence and erasure, qualities that are indispensable for critically responding to this ongoing legacy. More than most thinkers, Adorno reminds us of quotidian forms of violence and repression that accompany desire, thought, and human agency. He underscores how our concepts and linguistic patterns are riddled with blind and deaf spots. In order to make sense of the world, we tend to exclude or disavow those

opaque aspects of the world that threaten to reduce the world's intelligibility. To use the dominant trope in Ellison's novel, Adorno would say that invisibility is a necessary condition of visibility. But concepts don't just exclude; they also integrate and absorb things according to the logic of similarity. When we think, interpret, or speak, we necessarily impose unified meanings onto the world's plurality, enacting a kind of violence on the world. This explains why Adorno constantly encourages the practice of "thought thinking against itself," an activity that examines the limits and blind spots as well as the possibilities within our everyday concepts, perceptions, and frameworks of meaning.

One way to motivate Adorno to think against himself is to put his ideas about jazz into a different constellation, a constellation that includes literary uses of jazz. If my analysis in this chapter has been accurate, then jazz for Ellison and Morrison, when used as a set of literary tropes, metaphors, and styles, compels us to think about time, history, and identity in a manner that highlights dissonance, loss, temporal cuts, incoherence, and broken movements. Both Ellison and Morrison use these qualities to expose the limitations of triumphant, forward-marching aspirations, projects, and narratives—those associated with Marxist liberation as well as those that imagine the North and Harlem, or any singular place, as relatively stable sites of freedom and progress, as spaces that promise coherence and wholeness and escape from violence, loss, and ruin. While jazz is certainly associated with progress, freedom, and moving forward (through time and space), these authors employ blues-informed jazz idioms to render perceptible and readable the cuts, breaks, plunges, and wounds that progress both produces and leaves behind. Perhaps there is something about jazz, like the sorrow songs, that records the sounds, experiences, and tracks of black bodies. But more than Du Bois's use of sorrow, which is accompanied by a romantic conception of blackness, Morrison highlights the cross-cuts and divisions within black identity and black communities. But as Ellison would insist, the connection between jazz, blues, and black people's movements should not obscure the ways jazz and blues articulate the tragic, comic quality of being human, the general condition of being thrown into a world marked by painful realities as well as limited possibilities for change and transformation. It is important, however, that the notion of possibility is not divorced from remembrance of loss; in fact, this blueslike memory of life's painful details, this "aching consciousness," potentially opens up space for an alternative future, one in which selves are

more attuned to the violence we inflict on each other and more receptive to the pain and anguish of others.

But because Adorno reduces jazz to its commercial significance, to the way it reinforces the terms and dictates of the culture industry, he omits the possibility that jazz might assume new meanings and connotations as it travels to new contexts, including literary domains and discourses. Here I think of how Butler, in *Excitable Speech*, criticizes Pierre Bourdieu for reducing the force of an action or speech act to previously established conditions. What Bourdieu downplays, according to Butler, is the way an act or utterance can break from its "original" context, thereby generating new contexts and unexpected expressions and interpretations.[152] While Adorno is right to highlight how the entertainment industry imposes stringent constraints on the production of different music, which breeds conformity and redundancy, he does not underscore the ways musicians, artists, novelists, and literary figures have appropriated and employed jazz practices and idioms in novel, unpredictable ways. Even if there is no way to completely escape the logic of capital, we should not assume that aesthetic production, whether low or high, is reducible to this logic. Although Adorno is rightly described as a dialectical thinker, his dialectic comes to a standstill in the case of jazz. Yet aspects of Adorno's critique of jazz and the culture industry continue to haunt, disturb, and illumine. In light of Adorno's insights into how music, film, and television work to shape and structure perceptions and sensibilities (how we see, hear, feel, and remember), I contend in the next chapter that his critique of the culture industry, while flawed, remains generative. In addition, even though Adorno might dismiss jazz as legitimate art, his broader understanding of art is rich and illuminating, and can certainly find affinities with jazz-inspired artists and writers dealt with in this book. Art, for critical theory and black literature, is a site where melancholy and hope intersect, a site where the cuts and wounds of the social world can be articulated in addition to desires for a better, more satisfying existence. The more generous and generative ideas in Adorno's reflections on art and culture are relevant to discussions about film and cinema, particularly discussions directed at the film industry's representation of black bodies, racialized conflict, and the painful contradictions that mark the nation's history.

FOUR

Reel Progress

RACE, FILM, AND

CINEMATIC MELANCHOLY

In the first two chapters, I indicated that Du Bois's idea of double-consciousness has been used and reinterpreted to delineate and make sense of two aspects of black American existence. One feature is the "sense of twoness," or division, that black Americans have traditionally experienced because they define and measure themselves through the "eyes of the Other," a white supremacist Other that devalues black existence. Another dimension of black life that this idea alludes to is the desire to be recognized, the desire to see oneself and be seen as an equal among those who have historically stigmatized black life, a yearning to finally be a copartici-pant in the life of the nation-state. This dimension, which calls for both an expansion and transformation of current practices and arrangements, has historically been articulated in struggles for citizenship rights, endeavors to attain greater access to public spaces and institutions, and efforts to acquire capital, wealth, and property. At the same time, this desire for recognition, to be included within the unstable categories of the "human" and the "citizen," is also expressed through struggles to see black cultures, practices, bodies, and histories represented by visual media. Because of

this, recognition by the film industry has been one benchmark for measuring the progress and advancement of blacks and other historically marginalized groups. The representation of blacks on film supposedly tells us something about the broader world's recognition or misrecognition of black people.[1]

In the past decade, several events have sparked discussions and debates around this relationship between film, representation or misrepresentation, and black people's progress. In 2002, for instance, Denzel Washington won the academy's best actor award for his portrayal of a rogue police detective in *Training Day*, becoming only the second black actor to receive this prestigious award. In the same year, Halle Berry became the first black American woman to win the best actress award for her role in *Monster's Ball*. Many people involved with the film industry saw this as a sign of progress and hope for black actors and actresses, especially considering Hollywood's history of relegating blacks to inferior roles and its legacy of not recognizing black talent. Others were not so optimistic. Black viewers and critics were concerned that both of these films merely reinforced stereotypes that have historically been attributed to black people. Critics, for instance, bewailed the fact that Washington's character in *Training Day*, Alonzo Harris, exemplifies the fears and anxieties associated with the "deviant" black male body. By comparing himself to King Kong in a pivotal scene toward the end of the film, Washington invokes a filmic figure that historically serves as a metaphor for displaced fantasies and concerns about black male aggression and sexuality.[2] In addition to Washington's performance, viewers renounced Berry's relationship with Billy Bob Thornton's character in *Monster's Ball*. Disturbed especially by the infamous sex scene between the two actors, many people identified the film as an updated example of the tendency to mark the black female body as hypersexual, dependent on men, and powerless.[3] More recently, Quentin Tarantino's *Django Unchained* sparked controversy, in part, because of the film's supposed misrepresentation of American slavery (in addition to the excessive use of the n-word in the film). Even though Jamie Foxx's character, Django, ultimately triumphs over white slave owners in the film, his success relies on a heroic narrative that emphasizes the actions of the protagonist and downplays the structural factors of chattel slavery.[4] So while recent films seem to demonstrate that the film industry, and America more generally, is moving forward on the matter of race (offering more opportunities for black actors and filmmakers and recognizing the talents

and achievements of these artists), these changes may simply be repeating and concealing old formulas and devices.

If the success of a few actors and actresses or filmmakers indicates racial progress, then the format and content of films work to enact and visualize this notion of progress. In other words, most standard films, in an attempt to address racial conflict and violence, portray these matters with narrative formulas that strive for resolution. Filmic narratives tend to introduce a racial "problem" and eventually allay, fix, or displace this dilemma. Among other effects, this excludes the structural dimensions of race and safeguards the viewer from being unsettled by the tensions and contradictions attached to race and racial difference. The linear, conciliatory quality of most Hollywood films reinforces the notion that race and racial inequality are realities that can be easily surpassed and placed behind us as society moves forward. These films buffer the spectator from the less manageable, and more intractable, dimensions of race, history, and human existence.

In this chapter, I look at film as a site where progressive trajectories are both reinforced and undermined. I revisit Stanley Kramer's classic film *Guess Who's Coming to Dinner* (1967), arguing that this "message" film about interracial intimacy anticipates the postracial commitments and investments that are evident today. Similarly, I show how the film encourages a certain way of interpreting the achievements of the civil rights struggles, an interpretation that minimizes entrenched class and gender hierarchies. At the same time, this chapter draws attention to how the conciliatory thrust in Kramer's film fails, how the film accidentally invites the viewer to read this cinematic work against itself. As Adorno might put it, some kind of conflict or antagonism has to be concealed or displaced in order for the film to reach a resolution, to strive for identity. The rest of this chapter offers readings of films that visualize and perform melancholic hope. I look, for instance, at Charles Burnett's *Killer of Sheep*, showing how the form and content of this film, which depicts a Watts community a decade after the Watts rebellions, challenge standard civil rights narratives and representations of race and class. In the process, I highlight Burnett's use of blues and sorrow, which supplement and intensify images of struggle, alienation, intimacy, and pleasure in working-class black spaces. I then turn to F. Gary Gray's *Set It Off*, a film that uses the heist genre to illumine entrenched structures and practices of dispossession and theft. By focusing on the lives, contexts, and struggles of four working-class black women, Gray's film visualizes the inherent failures of the American-dream trope as well

as entrenched racial "uplift" paradigms. Before delving into these films, I trace and examine some of the general concerns in discourses about race, film, and cultural theory that are germane to my investigation.

RACE, REPRESENTATION, AND CRITICAL THEORY

As I suggested above, most discussions about race and film privilege the theme of proper representation. Black spectators justifiably desire to see some semblance of their lives and cultures on the screen. More specifically they want to see positive, affirming images of black life. To some extent, this fixation on positive, respectable images is the result of the film industry's well-documented history of screening stereotypical images, of depicting black people as unintelligent, inane, subordinate, and almost, but not quite, human. This concern, in other words, is motivated by cinematic legacies that have relegated black bodies to confining, demeaning personas and caricatures. Donald Bogle's notable work *Toms, Coons, Mulattoes, Mammies, and Bucks* exemplifies this tendency to foreground the distinction between positive and negative images in discussions about blacks on film. According to Bogle, the traditional character types for black actors, including the lazy coon, the submissive tom, the nurturing and loyal mammy, the confused and sad mulatto, and the violent and lustful Buck, all have a similar effect: "To entertain by stressing Negro inferiority."[5] While Bogle acknowledges that there has been some change and development within the film industry since the release of *Birth of a Nation*, he also contends that the racialized personas and roles introduced in *Birth* have not gone away; rather, they repeat themselves throughout the twentieth century in subtle, undetected manners. As he puts it, "Because the guises were always changing, audiences were sometimes tricked into believing the depictions of the American Negro were altered too. But at heart beneath the various guises, there lurked the familiar types."[6] For a critic like Bogle, Denzel's performance in *Training Day* is just another version of the black buck persona. Halle Berry's role in *Monster's Ball* is a recent example of the tragic mulatta type. Current configurations and patterns within the film industry, according to this reading, remain tethered to a recalcitrant legacy of racism.

While Bogle's personas represent the negative side of black representation, many viewers respond to this predicament by demanding and endorsing images of intelligent, complex, respectable, and successful black people

(*The Cosby Show* or a film like *The Best Man*). While this demand is understandable, it often imagines a rigid positive-negative binary that forecloses more productive ways of reading and interpreting films. Drawing from the pioneering work of James Snead, Valerie Smith claims that this binary wrongly assumes consensus around what a positive image looks like, an assumption that is tied to troubling notions of authentic blackness often inspired by narrow, middle-class sensibilities.[7] This notion of authenticity, as discussed in previous chapters, ignores divisions and fractures within black identity, divisions informed by class, gender, and sexual difference. A film or television show that might be affirming for a middle-class, heteronormative black family might have different effects and implications for black subjects that don't fit within this "ordinary" framework. In addition, as Smith points out, this fixation on positive-negative depictions "focuses viewer attention on the existence of certain types and not on the more significant questions around what kind of narrative or ideological work that type is meant to perform."[8] As I take it, Smith invites (and challenges) film viewers and critics to think more expansively and creatively about how traditional roles and personas, like the buck or mammy, enact, reinforce, and potentially destabilize certain kinds of cultural narratives and fantasies. One of these cultural narratives that this chapter and book examines is that of racial progress and its accompanying tropes and images.

Ed Guerrero's insightful text *Framing Blackness* combines Bogle's commitments with Smith's challenge. Before offering an interpretive history of the black image in popular, Hollywood-produced films, he lays out his overall assessment of the commercial film industry in a provocative and frank manner. According to Guerrero, "In almost every instance, the representation of black people on the commercial screen has amounted to one grand, multifaceted illusion. For blacks have been subordinated, marginalized, positioned, and devalued in every possible manner to glorify and relentlessly hold in place the white-dominated symbolic order and racial hierarchy of American society."[9] Here Guerrero concurs with Bogle's claim that cinema, for the most part, represents black people in demeaning, dehumanizing—and therefore negative—ways. Moreover, he initially adopts a vulgar Marxist notion of ideology, suggesting that the historical representation of blacks is an illusion that hides and obscures the objective reality of black life and experience. Yet Guerrero also employs a more nuanced notion of ideology, one that he adopts from Louis Althusser, when he underscores what film does, how it operates to secure certain kinds of

power relationships.[10] For Guerrero, film is a central site where ideology is both reproduced and contested. And ideology, "instead of being a 'false consciousness' rigidly imposed from above on dominated people, permeates all strata of society and is a people's imaginary relation to their real conditions."[11] Ideology might conceal certain realities, but its main function is generative; it engenders reliable ways of relating to and imagining the world, reality, self, and other. Ideology secures the order of things, in part, by displacing conflict and explaining away the dissonant features of the world; it trains us to desire and expect coherence and harmony in our interactions with others. Ideology produces subjects, spectators, and viewers who act, interact, see, and hear in ways that generally accord with the status quo. But for Guerrero, ideology, especially those narratives and representations that naturalize the hierarchy between whites and blacks, is never completely successful. Following the notion that power is constituted by a set of relationships, Guerrero maintains that power always involves and generates resistance and contestation. More specifically, the film industry's tactics and strategies, including the reproduction of racial hierarchies and the displacement of racial conflict, have always encountered opposition by black American actors and filmmakers (even as the industry can adjust to and incorporate these oppositional endeavors).[12] Here one might cite a legacy of filmmaking that extends from Oscar Micheaux to Julie Dash and Spike Lee, a tradition that experiments with cinematic forms and narratives to proffer multidimensional and uncommon representations of black lives and experiences. As Adorno points out, even in his darkest moments, "There is no system without its residue."[13]

While Guerrero is right to locate moments of resistance within film production, identifying these moments in practices of consuming and watching film is just as important. In her well-known essay "The Oppositional Gaze," bell hooks elaborates on the connections between vision, power, critique, and agency. Acknowledging that sight is often the privileged sense and medium of knowledge (seeing is believing), hooks reminds the reader in this essay that the capacity to look is not always distributed and conferred equally across the social body. Think for instance of black slaves that were punished for looking back at their masters while these slave bodies were subject to the gaze and surveillance of the "overseer."[14] Or recall that black men could be tortured and lynched for looking the wrong way at a white woman. In addition, one might invoke Laura Mulvey's oft-cited contention that most films are designed to cater to the viewing fantasies

of men, thereby consigning women in these films to objects of visual plea-sure.[15] For hooks, these legacies of regulating and policing how subjects look and see enable certain subjects to observe and scrutinize others while being protected from the gaze of these scrutinized objects. This predica-ment, she suggests, has especially troubling implications for black women, whose bodies are looked at, framed, and represented in ways that reinforce pernicious gender and racial arrangements. But hooks also contends that marginalized groups, especially black women, develop strategies and habits of "looking back," of watching films with a critical, suspicious eye. Accord-ing to hooks, "As critical spectators, black women participate in a broad range of looking relations; [we] contest, resist, revision, interrogate, and invent on multiple levels."[16] Watching films that marginalize black women might be painful and difficult, but these films also prompt a viewer like hooks to read films against the grain, to interrogate narrative strategies and devices, and to invent new ways of telling stories through film.

Spectators, in other words, are never simply passive subjects. Viewers are always actively involved with the movement and unfolding of the film. We bring intentions, aims, desires, commitments, and modes of looking to the viewing experience that don't completely cohere with those of the filmmaker (or other spectators). Therefore, when a person watches a film, he or she might not always identify with the "appropriate" characters, the intended protagonists, or the content and argument of the film. In fact, our attachments and sympathies become split and scattered during the cinematic experience. At times, I might find myself drawn to a character that in "real life" would repel, disgust, and terrify me. Similarly, a film might prompt me to identify and connect with conflicting characters and subject positions as the narrative develops. For instance, even though the social order tells me not to identify with the violent criminal, there is something alluring about Denzel Washington's character in *Training Day*, at least in those moments when he navigates his environment in a cool, savvy manner. While watching *Guess Who's Coming to Dinner*, I might find myself drawn to Sidney Poitier's wit, cleverness, and amiability. Yet there may be moments when I distance myself from his character because he appears too virtuous, too pure and bereft of complexity. In addition to this ambivalent identification, I might notice and see things in a film that I am not "supposed" to focus on; by re-watching a film, I might register aspects, dimensions, and omissions that I overlooked in previous encounters. In general, the relationship between the moving image and the viewer's

response is not as reliable and consistent as it might seem. And if hooks is right, this discontinuity between production and consumption and spectatorship is a potential site of resistance, revision, and reinterpretation for marginalized subjects, particularly for black women.

But a caveat must be introduced here. Claiming that black women or other historically marginalized groups develop alternative ways of seeing and interpreting does not suggest that these groups are somehow outside of and exempt from the broader forces, mechanisms, and ideologies that shape, constrain, and delimit filmmakers, spectators, and critics. In other words, while it is important to be mindful of the ruptures and breaks within cinematic experiences and interpretations, it is also vital to remember that these ruptures are immanent openings; they open up possibilities within the arrangements that persecuted bodies and communities desire to contest and escape. And even if a rupture creates new spaces and possibilities, it will also repeat and introduce new constraints, limitations, omissions, and erasures. Adopting Mikhail Bakhtin's language, one should be attentive to both centripetal and centrifugal forces, especially as they operate within the film industry.[17] The centripetal refers to, among other things, those narratives, practices, and images that work to produce conformity and agreement. The centrifugal refers to the divergent desires, ideas, and forms of expression that prevent the status quo from being totally seamless and unchallenged. My argument, which is in line with that of authors like Guerrero and hooks, is that human beings always exist at the intersection of these two kinds of forces even as the centripetal type seems to prevail most of the time. Therefore if images of narrative progress and resolution work to maintain certain modes of power, the viewer should look for moments in standard films or in nonstandard narratives that contest and diverge from cinematic strategies of containment, order, and linearity.

This discussion about film, power, and resistance invites an engagement with Benjamin and Adorno, particularly their reflections on the ambiguous qualities and possibilities of art and film within the modern world. Even though the "black image on film" is not an explicit concern of these authors, their work is germane to thinking about how the film industry employs narrative strategies to smooth over the dissonant features of America's racial formations.[18] In Benjamin's famous essay "The Work of Art in the Age of Mechanical Reproduction," the German author contends that modern technological forces both diminish previous kinds of experiences and enable new ones.[19] While traditional artworks were defined by

their unique existence and their participation in specific rituals and traditions, modern artworks are increasingly defined by the standard of reproducibility, a quality that undermines a work's uniqueness or aura. It might seem as if Benjamin is being romantic here and committed to something like a more authentic past that existed before the emergence of capitalism. While there is some truth to this accusation, it is important to remember that the term *aura*, for Benjamin, does not simply signify authenticity; it also registers the distance between an object, or work, and an individual. As he puts it, the erosion of the aura is associated with "the desire of contemporary masses to bring things closer spatially and humanly. . . . Every day the urge grows stronger to get hold of an object at very close range, by ways of its likeness, its reproduction."[20] While this desire for intimacy, closeness, and familiarity is all too human and certainly valuable, it can lead to an aversion to that which is unfamiliar or to objects, images, and ideas that are close but yet difficult to grasp and render intelligible. More specifically, this desire to make things close and familiar can become an evasion of topics and subject matter, like race, death, loss, and violence, that render our sense of the familiar and mundane strange and unsettled.

For Benjamin, the medium of film contributes to revealing hidden and unknown features of everyday experience. He writes, "For the entire spectrum of optical, and now also acoustical, perception the film has brought about a deepening of apperception. . . . By close-ups of the things around us, by focusing on hidden details of familiar objects, by exploring commonplace milieus under the ingenious guidance of the camera, the film, on the one hand, extends our comprehension of the necessities which rule our lives; on the other, it manages to assure us of an immense and unexpected field of action. . . . Slow motion not only presents familiar qualities of movement but reveals in them entirely unknown ones."[21] What is interesting here is how film responds to the destruction of aura and distance by rendering the familiar and mundane strange, by inviting the spectator to confront the hidden and unknown dimensions of the social world, life, and human interaction. (Recall Ellison's claim that one of the functions of the artist is to discover and reveal the unfamiliar dimensions of everyday life.) But this process of making the familiar strange is also an occasion for illumining and making intelligible those parts of human experience that, without film, would remain hidden and unconscious. Film, furthermore, can expand what and how we see, the way we hear voices, expressions, and cries; it can open up new ways of being attuned to and affected by the

world. Through slow motion, close-ups, interruptions, cross-cutting, and other techniques, cinema can transform the way subjects relate to, respond to, and interpret everyday, "taken for granted" features and details of their worlds. As Benjamin points out, in his utopian moment, film might actually shock and disturb collectives toward more radical practices and ways of being. Because film, according to Benjamin, is the site of critique, receptivity, intersubjectivity, and pleasure, he suggests that certain films can galvanize the masses toward more progressive political practices. Whether or not Benjamin is naïve here, what is important is the relationship between political resistance and human structures of perception. He writes, for instance, "The manner in which human sense perception is organized, the medium in which it is accomplished, is determined not only by nature but by historical circumstances as well."[22] Here Benjamin insists that our capacity to see, hear, or feel is mediated and shaped by historical conditions. Human interactions with the external world are never direct or immediate, but rather structured by, among other facets, technology, education, historical changes in the function of art, cultural practices, and the arrangements of social space. Any endeavor to alter the status quo will involve examining how current conditions both constrain and enable more promising ways of experiencing the world, perceiving suffering and loss, and discovering glimmers of hope and pleasure among what Benjamin calls the ruins of history.

Adorno picks up on some of Benjamin's insights even if he diverges from the Benjamin's occasional optimism about the possibilities within cinema. As discussed in the previous chapter, Adorno underscores how the culture industry, including film, increasingly "infects everything with sameness."[23] This infection of sameness extends to thinking patterns, behavior, and how selves experience the world around them. Like Benjamin, Adorno is concerned about how new forms of technology and entertainment structure our perceptions, sensibilities, and capacity to be affected. By operating as a schema, the culture industry increasingly predetermines how subjects hear, see, and respond to their environments and lifeworlds. This industry obstructs ways of thinking, seeing, hearing, and feeling that are not in agreement with prevailing norms and expectations. For Adorno, the structure and format of most films diminish viewers' capacities to experience and contemplate the complexities and richness of social life. As he puts it, "In a film, the outcome can invariably be predicted at the start—who will be rewarded, punished, forgotten."[24] By producing rigid

structures of expectation, the film industry shapes how individuals relate to and contemplate conflict, antagonism, and suffering. According to Adorno, the entertainment industry's ability to flourish relies on the denial of the agony that the world produces. Whereas Marx viewed religion as an opiate, Adorno suggests that film, television, and radio serve a similar function insofar as they enable viewers to imaginatively escape the dissonant, painful features of the world. Adorno claims, "To be entertained means to be in agreement. . . . Amusement always means putting things out of mind, forgetting suffering, even when it is on display."[25] Here Adorno claims that amusement involves a longing for harmony and an aversion to anything that might frustrate this sense of harmony. More specifically, he suggests that even representations of suffering and agony can be rendered agreeable, pleasurable, and painless for the viewing and listening subject.

But if most products of the culture industry reinforce desires for coherence and harmony, Adorno knows that certain works remind viewers of the antagonisms and conflicts that must be denied in order to produce the semblance of harmony. And echoing hooks, he also acknowledges that, no matter how successful the culture industry seems to be in creating conforming, obedient subjects, viewers never simply accept what they are given. He writes, for instance, "If . . . film accommodates various layers of behavioral response patterns, this would imply that the ideology provided by the industry, its officially intended models, may by no means automatically correspond to those that affect the spectators."[26] For Adorno, the medium of film is defined by a gap between intention and effect, between the intended meaning of a film and the effects on the viewer's interpretive capacities. In addition, Adorno suggests that films often invite us to question and reflect on taken-for-granted viewing habits, desires, and expectations. Through editing, various forms of montage, and unexpected juxtapositions of images, scenes, and sounds, films can trouble and expose yearnings for an uninterrupted narrative or experience.[27] By introducing flashbacks and by prompting the viewer to tarry with disturbing scenes and images, a film can resist inclinations to keep moving forward, to keep progressing toward a reassuring resolution. In the rest of this chapter, I think about films that promote and enact racial progress as well as cinematic works that refuse to do the work of progress. I first examine *Guess Who's Coming to Dinner*. Through its content and narrative form, I argue, Kramer's film attempts to create a sense and feeling of harmony and resolution in response to racial difference, suffering, and loss. The end of the film implicitly tethers civil

rights struggles to a linear, forward-marching trajectory of progress. At the same time, I show how this strategy occasionally fails and undermines itself, allowing the viewer to contemplate lingering conflicts and tensions that *Guess* cannot fully resolve or explain away. I then make a transition to Burnett's *Killer of Sheep* and Gray's *Set It Off*, showing how narrative form, image, and sound work in these films to contest "reel progress" and to leave the viewer with ambivalent feelings of melancholy, loss, hope, and painful pleasure in the face of America's racial order and predicament.

PROGRESS AND TRANSCENDENCE
IN *GUESS WHO'S COMING TO DINNER*

Revisiting Stanley Kramer's film *Guess Who's Coming to Dinner* (1967) enables us to interrogate how cinema "brings to life" yearnings for progress and forward movement. Kramer's classic message-film about the fears and taboos around interracial romance and marriage can be seen as an implicit rejoinder to and break from previous works that denounced interracial intimacy, most notably *The Birth of a Nation*. Recall that D. W. Griffith's film, released in 1915, introduces the insidious mulatta character, Lydia, and the brutal buck, Gus, to condemn the mixing of races (even though chattel slavery depended on different kinds of cross-racial desire, intimacy, and sexual coercion that the film ignores). In Griffith's film, Lydia is presented as tormented and sinister, qualities that we are supposed to attribute to her ambiguous identity, a product of an interracial sexual act. And Gus is infamously screened as a threatening black body who unsuccessfully attempts to satisfy his violent lust for white women by chasing Flora Cameron through the woods, leading her to "sacrifice her life" by jumping off a cliff. This incident in the film justifies the formation of the Ku Klux Klan and the practice of lynching. As Linda Williams points out, this lynching ritual, historically and in the film, was a way to discipline black male desire and to contain the desires of virtuous white women, keeping both subjects in their place.[28] In opposition to Griffith's renunciation of black-white romance, *Guess Who's Coming to Dinner* concludes with an acceptance of the future marriage between a black man and a white woman. And while Griffith's earlier film depicts black men as either docile, obsequious servants or violent monsters, Sidney Poitier's character, Dr. John Prentice, seems to escape this reductive binary. Unlike his cinematic predecessors, he is portrayed as intelligent, handsome, well-mannered, independent, considerate,

and successful. He therefore represents a substantially more "positive" portrayal of black men than Gus and the black buck persona more generally.

While the content of *Guess Who's Coming to Dinner* and Poitier's role in this film indicate progress within the film industry and America more broadly, this change came about through successive struggles within and outside of the industry. For instance, as Bogle points out, even though Griffith's controversial film was praised by some American audiences, it was also heavily criticized and protested by organizations like the NAACP. Because of the controversy, dissent, and protests sparked by screenings of *The Birth of a Nation*, the film "was banned in five states and nineteen cities."[29] More generally, as the film historian and critic Thomas Cripps emphasizes, the first half of the twentieth century saw persistent protests against "Hollywood racism," forms of creative resistance that included the formation of an independent black cinema.[30] For some critics, *Guess Who's Coming to Dinner* is the result of persistent demands for more complex roles for black people and indicates the more immediate gains made by the civil rights movement (including the famous *Loving v. Virginia* case in 1967, which rendered antimiscegenation laws unconstitutional). For other critics, this film, especially Poitier's performance, introduces new problems and concerns. Poitier's character, presumably embodying and typifying the success of black freedom movements, generated suspicion because of his flawless, unbelievable personality. Prentice, according to this reading, is too perfect and caters too much to the concerns and desires of mainstream audiences. For some, this scenario is troubling, especially at a tension-filled juncture when laws and policies were being implemented to expand the circle of freedom and equality but, at the same time, many of America's cities were experiencing escalated violence, police repression, and destruction. What are we to make of the fact that Kramer's film and Poitier's performance emerge amid rebellions, protests, and uprisings by black communities that had not reaped the material benefits of the new civil rights laws?[31] And what are we to make of James Baldwin's concern that some of the characters and scenarios in *Guess* resemble and repeat tropes prevalent in *The Birth of a Nation*?[32]

Stanley Kramer's classic film centers around an interracial couple, Dr. John Prentice and Joanna Drayton, who have recently met and fallen in love in Hawaii. In the opening scenes, we find them arriving in San Francisco with the intentions of informing Joanna's parents (Spencer Tracy and Katharine Hepburn) of their plans to marry in Switzerland.

According to Glen Harris, the spaces of interaction and intimacy between the couple are important; Hawaii and San Francisco are, Harris notes, traditionally more open, tolerant, and diverse than most American states and cities. By making Europe the wedding destination, the film evades some of the tensions, anxieties, and dangers in America around interracial romance and marriage, especially at a time when nearly twenty states still consider miscegenation illegal.[33] Harris therefore claims that the film's narrative would have been more difficult and unwieldy if the setting and wedding took place in a region such as the American South. But as James Baldwin suggests, the very notion of San Francisco's openness and tolerance would have been questioned if the film alluded to the urban renewal programs that had recently removed and dislocated black bodies from certain parts of San Francisco.[34] Since the opening sequence takes place in San Francisco, supposedly one of the most "liberal metropolitan areas in America," we are introduced to John and Joanna frolicking, hugging, laughing, and walking through the airport in a carefree, yet eager, manner—as if romance between a black male and a white female is widely tolerated and accepted. There is little to no anxiety in their facial expressions and bodily interactions even as they seem to be in a rush to inform the world of their newfound love. As they walk, we hear the lyrics to "Glory of Love" telling us that love involves giving and taking, laughing and crying, and a willingness to be vulnerable. Love entails an openness to "having the blues a little." The song suggests that love is not easy but that two people bonded by love can successfully overcome, or at least survive, life's obstacles. In many ways, the lyrics to this classic track foreshadow the film's narrative. While this classic tune sounds cheery in this opening sequence, it is important to point out that it is performed later in the film (in the midst of tensions, uncertainties, and resistance to their relationship) by a female lounge singer with a tinge of melancholy, a blue note, so to speak. This relationship between the upbeat and the blue, a tension that exists in the song's content, is reinforced by different versions and performances of the song throughout the film.

John and Joanna's initial upbeat attitude runs into several obstacles throughout the day. We are reminded that intimacy is partly constrained and enabled by the social world, its expectations, conventions, taboos, and collective fears. For instance, when John and Joanna kiss in the backseat of the cab, the cab driver is understandably stunned. We see the kiss from

the cab driver's perspective, through a mirror, but the faces of the couple are obscured. We can see that they are kissing but we cannot really see the kiss; the touching of their lips is not quite representable. While Glen Harris might see this as an indication of the film's "cowardly approach to controversy," I suggest that this obscured, shadowy moment of intimacy reminds the viewer of how controversial interracial intimacy is during this time.[35] The sense of opaqueness in this scene, the need to conceal something about the kiss, actually reveals that something dangerous (for most audiences at the time) is going on. After the cab driver's mirror gaze, we witness a succession of startled faces and uncomfortable encounters, awkward moments that involve Joanna's parents and John's parents (played by Roy Glenn and Beah Richards). While their families, especially the fathers, are initially resistant and uncomfortable with the situation, they eventually "come around" and accept John and Joanna's relationship. In fact, those in the film who express lingering concerns and discomfort over the "problem" of racial difference are silenced, castigated, or in the case of Hilary, Mrs. Drayton's appalled assistant, fired.

One character who expresses resentment and indignation toward John's presence is Tillie, the Drayton's domestic servant. From her initial encounter with John, it is clear that she has a problem with another black person stepping outside of his or her boundaries. As she puts it, "I don't care to see another member of my own race getting above his self."[36] Playing the role of an updated mammy, Tillie is a guardian of the order of things. John's presence is a problem because he is out of place; he enters the Drayton home in a subject position—guest, romantic interest, potential husband—that is out of joint with the roles and positions of the other blacks that occupy space in the Drayton's home. Similar to the mammy character in films like *The Birth of a Nation*, Tillie's devotion is first and foremost to a white family that both depends on and subordinates her. Her rancor toward Prentice appears to derive from an imagined need to protect the Drayton family from this outside nuisance. This becomes evident in the scene where Tillie barges into a room while John is dressing. Pointing an authoritative finger in his face, calling him "boy," Tillie accuses John of being a "smooth-talking, jive nigga" and an intruding troublemaker. She even associates his troublemaking with black power but also warns him that she is the real bearer of black power. In addition, Tillie takes a kind of maternal ownership over Joanna's body and safety. She warns John that she raised Joanna and that

because of this familial intimacy and obligation, she will protect Joanna from any danger or trouble. Like the mammy character fighting off black soldiers in *The Birth of a Nation* to save the plantation owners, Tillie assumes the role of protector and rescuer with respect to Joanna and the Drayton family. Notice that John's body and presence are signified as dangerous in ways that are similar to the black buck. Tillie of course attempts to neutralize the danger and trouble that Prentice represents by scolding him like a child, repeatedly calling him "boy."[37]

The analogy between John and someone like Gus seems strange. While the black buck is seen as a sexual threat to white women, one of the concerns about Prentice (and Poitier's early roles more generally) is that he appears to lack sexual desire. According to Harris, "[Prentice] is virtually sexless. Dr. Prentice is well behaved at all times in the presence of the woman he adores. There are a few brief moments when the film offers a fleeting suggestion that passion might play some role in Prentice's interest in Johanna, but for the most part his relationship appears Platonic."[38] In this critique, Harris suggests that Prentice's "sexless" interactions with Joanna are part of the film's attempt to make Poitier's character seem flawless, well-behaved, and nonthreatening. (In fact, Joanna "reassures" her mother at one point in the film that she and John have yet to have sex.) Perhaps Kramer is afraid of sexualizing the black male body in light of the fears and controversies attached to the black buck persona that casts a shadow over Poitier's character. Even though John departs from the black-buck tradition, his lack of visible and tangible sexual desire betrays a worry about digging up this controversial and painful legacy. In other words, Poitier's character, through a kind of absence or denial of erotic expression, signifies the lingering presence of that legacy.

But Harris misses something important when he calls John "sexless." While Prentice's sexuality or sexual desire is rendered safe and nonthreatening throughout the film, this does not mean that he does not exhibit sexual desire. In addition, while John's relationship to Joanna might seem asexual, he is more ambivalent in his interactions with black women. Think, for instance, of the moment when Dorothy, the young, attractive black servant, catches John's eye when he first arrives to the Drayton home. He appears to be captivated; he playfully asks Joanna about Dorothy's work schedule. He exhibits sexual attraction toward Dorothy in a way that we don't see expressed toward his future wife. But, of course, by turning his attraction to Dorothy into a joke, his fascination and ex-

citement over Dorothy is rendered innocuous, innocent, and harmless. Although Dorothy does not speak (Joanna speaks for her), the camera lingers on her body and her gaze after Joanna and John leave the room. The viewer senses that Dorothy is mainly an object of visual pleasure and a rare occasion for Poitier's character to express sexual desire. Dorothy, to put this differently, is a vicarious object of sexual desire. Any physical, erotic desire that might be directed toward Joanna is displaced and redirected toward Dorothy. This process of displacement is emblematic of the historical discomfort over interracial sexual intimacy as well as the "usefulness" of black women as silent targets of desire and pleasure.[39] Harris also misses something important in the scene with Tillie and John. At the beginning of this scene, we see Dr. Prentice getting undressed and with his shirt off; although he quickly and clumsily covers his front from Tillie as she intrudes into his space, the viewer can still see parts of his back and shoulders while Tillie scolds him. My point here is not to conflate nudity with sexuality, sex, and sexual desire. In other words, I am not suggesting that sexual desire is only or always operative when clothes are taken off. My point is that parts of the black male body are exposed only when John is interacting with Tillie. White bodies, the characters at least, are absent from this scene, protected from John's partially revealed body. In addition, even though Tillie is extremely close to John's body, her role as the traditional, asexual mammy potentially renders John's nakedness nonthreatening to audiences. What is noteworthy about this scene is that the camera tilts while Tillie is admonishing Poitier's character. This slanted angle heightens the tension between Tillie and John; it also amplifies the viewer's feeling of unease and something being off-kilter. It reflects one of the many obstacles to Joanna's and John's new relationship and serves as an occasion to frustrate the linear movement of the film.

In addition to Tillie, John's father expresses frustration over his son's "unwise" decision to get romantically involved with a white woman. Among other concerns, Mr. Prentice mentions the fact that interracial marriage is still illegal in many states. He also makes a prescient claim that even if the laws change, people's attitudes and feelings about racial matters and interracial intimacy might not alter. In a father-son confrontation toward the end of the film, Mr. Prentice is portrayed as the voice of tradition, law, and the past while John articulates the voice of change, novelty, and futurity. After John disrespects his father (he tells him to shut up after being scolded), Mr. Prentice reminds John of the sacrifices that

enabled John's success. Mr. Prentice contends that John owes him respect and gratitude because of these sacrifices. John disagrees. He claims to owe his father nothing and rejects any authority that his father assumes he might have over his decision to marry Joanna, his future, and his sense of identity. John suggests that his father represents an older generation that cannot see or think beyond an antiquated horizon.[40] This generation thinks that "their way" is the "way it's supposed to be." They conflate history and essence, thereby foreclosing the possibility of change. John vehemently refers to his father's "lousy" generation as "dead weight," as a burden to progress, tolerance, interracial harmony, and so forth. He further claims that once that "dead weight" has perished, once his father, the past, "gets off his back," a better future might be possible. John's relationship to the past departs from the kind of piety that we see in Du Bois and Ellison. While both of these authors are concerned about a better future, as discussed in the previous chapters, this better future does not come about by letting the past go, by eagerly waiting for the recent past or older generations to perish. Rather, hope for these authors is connected to and enabled by relating to and remembering the past in a certain way, by acknowledging how the past is always already shaping, informing, and constraining the present. Hope is made possible by piety, which is not necessarily an uncritical veneration of ancestors or past generations. Piety, according to Du Bois's reading of the sorrow songs or Benjamin's weak redemption, is one way that we are motivated and emboldened by the often unrecognized struggles, cries, and losses of those who came before us. We don't necessarily "pay our debts" or show gratitude to the past by unreflectively accepting the norms, commitments, and decisions of previous generations. Yet we might show gratitude by resisting culture amnesia around certain struggles and losses or by refusing the tendency to assimilate the past into convenient public narratives and rituals of remembrance that neglect the dissonant, painful dimensions of these struggles (in addition to radical possibilities within these struggles that were foreclosed and unrealized). However, by referring to his father's generation as "lousy" and by claiming that he owes that generation nothing, John is not simply being impious; he also denies that we might cultivate complicated, ambiguous relationships to the past in a manner that evades uncritical veneration and complete rejection.

Here my aim is not to dismiss John's desire to break from certain aspects of the past, to depart from a generation that looks down upon or

fears interracial intimacy. In general, people like to be relieved from burdens, from the weight of past events and modes of being, especially when they hinder our ability to flourish and live better. Resistance to authority, father and mother figures, and inherited traditions contributes to bringing new things into the world. And according to an author like Nietzsche, moments of forgetfulness and amnesia are necessary as well.[41] At the same time, I don't want to dismiss Mr. Prentice's suggestion that changing laws does not necessarily alter desires, attitudes, fears, and feelings around race and racial difference. Getting rid of certain burdens introduces new burdens or reintroduces old ones in new forms and guises. The tension in this father-son confrontation, the tensions and interactions between structure and novelty, tradition and invention, constraint and agency, remembering and leaving behind are fruitful and worth investigating. Yet the film attempts, perhaps unsuccessfully, to resolve these tensions in the remaining part of this scene and in the final monologue by Mr. Drayton. After a brief silence and gap in John's passionate response to his father, he reassures his father that he loves him but also identifies a potentially irreconcilable difference—"You think of yourself as a colored man; I think of myself as a man." John's independence from his father's authority occurs through a denial or abandonment of his "colored" status, his black identity. His affirmation of manhood requires him to relinquish his racial identity, to associate racial particularity with the dead weight of the past. As Adorno might suggest, John's statement is an example of the false identity between the particular and the universal, false because in order for John to embody the more general category, manhood, he has to deny or detach himself from racial particularity. The ostensibly more general and open space of mere manhood is less confining and more desirable than a form of manhood accompanied by and attached to a racial qualifier. John's success, achievement, and movement into a space of recognition and acceptance require him to get rid of any dead weight, any burden, any tension that might disturb his entrance into that space. Being black and male, black and American, black and human, human as black (and embodying the historical tensions, contradictions, and possibilities that exist in between) is not an option for John. This refusal is anticipated in an earlier scene when Joanna describes John to her mother as someone who is calm, assured, and without any tensions. Interestingly, Joanna follows this laudatory description by informing her mother of an accident that killed John's former wife and son.

Since John does not mention this event, Joanna becomes the bearer of this memory as we see her crying while she divulges this tragic episode. Joanna becomes a displaced subject of mourning as if to protect Poitier's character from this past, or at least from expressing his relationship to and memory of this past. John's coherence and tensionless appearance, qualities that are certainly troubled in the passionate discussion with his father, might be the result of various forms of displacement and denial throughout the film. If John is the embodiment of racial progress, then this forward movement entails eliminating dead weight, releasing oneself from the burdens of the past—including racial difference and racial logic—and deflecting painful tensions and leftover memories.

While the confrontation between John and his father is left unresolved, the final monologue by Mr. Drayton is designed to both make sense of and reconcile the antagonisms, anxieties, and conflicts that have developed throughout the film. In most of the film, Mr. Drayton is depicted as the consummate liberal, exemplified by the photograph of President Franklin Roosevelt on his desk. He has always been a tolerant "friend to blacks" but understandably expresses concerns and qualms when he meets John. As Robert Toplin points out in his sympathetic reading of the film, "Acceptance of marriage requires one of the broadest forms of tolerance. It takes the issue beyond questions about social intercourse at the workplace, bar, the schoolhouse, or the playground. A sanction for inter-group marriage involves acceptance of the 'other' both in day to day life within the home and acceptance of the children produced from such unions."[42] John's proposal to Joanna, to put it slightly differently, exposes the limitations of Drayton's tolerance, the ways liberal notions of acceptance and openness (as important and valuable as these ideas have been) run up against disgust, fear, resentment, and unconscious desires and attachments. In addition, acceptance and tolerance are convenient ideals for Mr. Drayton as his interaction with the other, Tillie, for instance, typically occurs in a safe, comfortable space and within a relatively stable hierarchy. Throughout the course of the film, characters like Monsignor Ryan compel Mr. Drayton to confront his tenuous liberal principles. In the final monologue, Mr. Drayton appears to have extended his liberal openness to include John and his family.

The content and arrangement of this scene and speech are significant. After gathering all the guests and members of the Drayton

household, Mr. Drayton renarrates the events of the day. He then offers a passionate, tear-inducing monologue about the importance of feeling and perseverance in the face of racial prejudice, fear, and stupidity. He refers to racial difference as a "pigmentation problem," but a problem that should not deter John and Joanna. And he refers to his love for Mrs. Drayton, his memories of a time when a spark was first kindled, as a way to identify with John and Joanna's newfound passion. But just as important as the love-can-conquer-all content of the speech is the way Mr. Drayton secures his authoritative voice in this scene. After Joanna interrupts him, he tells her to "shut up." He also claims this might be the last time he can claim this kind of authority over her, thereby suggesting that he is relinquishing her and his power to John. According to Andrea Levine, this moment exemplifies Joanna's paradoxical position in the film. Even as her character is central to the development of the narrative, she also becomes increasingly marginal as the tensions and potential resolution of these tensions begin to revolve more and more around the men, namely Mr. Drayton, John, and Mr. Prentice.[43] As Mr. Drayton's speech unfolds, the camera shifts from Mr. Drayton to the characters gathered around him, from his authoritative voice and body to the captivated, teary-eyed faces of his addressees. When he is finished, the group proceeds into the dining room, reconciled and prepared to break bread. Mr. Drayton gently places his hand on the reluctant Mr. Prentice's back, ushering him into the dining room (this follows a moment in the speech when he reassures everyone that Mr. Prentice will eventually see the light). As we hear the lyrics of "Glory of Love" repeated at the end of this scene and as the credits emerge, the audience gets a sense that Mr. Drayton's beautiful speech has allayed the film's tensions, anticipating a brighter future for blacks, whites, America, and the possibility of racial reconciliation.

According to Ed Guerrero, the ending to Kramer's film follows a typical Hollywood format. This format, he writes, involves "presenting the audience with a communal problem completely stripped of its social and political context, reduced to a conflict between individuals, sentimentalized and happily resolved at the picture's end."[44] While a commentator like Robert Toplin applauds the film for confronting the controversial issue of interracial romance, Guerrero chides the film for placing this controversial topic within a standard, predictable Hollywood narrative. For Guerrero, *Guess Who's Coming to Dinner* "introduces topical issues into stable,

easily recognized and consumed genres, narratives, and plot structures,"
thereby repeating the conservative ideologies of a film like *The Birth of a
Nation*.[45] As I take it, Guerrero is not necessarily saying that Kramer's film
is not an improvement with respect to Griffith's earlier attempt to renar-
rate America's racial history. He is claiming that what connects these two
films is a tendency to contain and domesticate the complexities, contra-
dictions, and excesses of racial matters. In other words, he worries that
the structure, style, and arrangement of a film like *Guess Who's Coming to
Dinner*—its linearity, harmony, sentimentality, and conciliatory quality—
prevents the viewer from being unsettled and challenged by the film's con-
tent. The viewer can easily identify with a sentimental love story, with the
love-transcends-all-conflict motif, without being affected or discomfited
by the social conditions and arrangements that sustain racial division, in-
equality, and hostility. Yet what Guerrero does not explicitly point out is
that the harmonious ending undermines itself; it is not entirely success-
ful. As Andrea Levine astutely argues, Mr. Drayton's conciliatory speech
necessarily includes narrative gaps, including his convenient omission of
his racist reaction to a heated encounter with a black man at a drive-in
restaurant.[46] He therefore omits the conversation with his wife when he
bewails the fact that he cannot get ice cream without running into a black
person. Levine rightly claims that this scene indicates the "racial uncon-
scious" of the film, a moment that cannot be easily incorporated into the
film's happy ending or Mr. Drayton's renarration of the day's events. It has
to be disavowed or forgotten in order for the happy, harmonious ending to
work. Similarly, Drayton's outburst signifies those unconscious, repressed
forms of resentment that operate underneath or outside of liberal notions
of tolerance and acceptance, betraying the limitations of these ideals. In
addition to this omitted event, Drayton's final words should give us pause:
"Tillie, when the hell are we gonna get some dinner?!" While John has been
accepted into the family as a potential equal, Tillie's position as a subordi-
nate, as someone who takes orders, is secure. Tillie's character indicates the
interplay between race and class difference (in addition to intraracial con-
flict along class and gender lines). These differences, tensions, and sites of
power disparity do not go away. In fact the final scene and speech intensify
some of these lingering concerns.

It is tempting to look back at films from earlier periods of history
with a self-righteous attitude, excoriating the limitations and blind spots

of these films, acting as if we are exempt and liberated from these constraints. What is important for me is how relevant and pervasive some of the ideas and strategies within *Guess Who's Coming to Dinner* continue to be, especially as they relate to race, remembrance, the imagination of history, and the longing for a (racially) reconciled future. Similarly, it is important to follow authors like Baldwin and Guerrero, who encourage us to think about the affinities and continuities between Kramer's film and earlier representations of racial difference and history such as *The Birth of a Nation*. In Griffith's film, a better future involves not only acknowledging and retrieving a tragic episode from the past, the Civil War, but it also involves placing that episode in a triumphant narrative, visualized in the film by the sweeping, forceful actions and rescue missions of the Klan. A better future, a state where Americans, especially whites and devoted blacks, are rescued from conflict and oppression—from Northern interlopers and dangerous blacks—involves restoring a past epoch and way of being through violence and elimination. Griffith's film assumes that there was some historical period, before the introduction of foreign ideas and personas to the South, and America in general, of plentitude and happiness, qualities depicted in opening scenes on the Cameron family plantation with dancing, obedient, and content slaves. This nostalgic fantasy involves various denials and disavowals. It denies the trauma of order, the violence of ordinary life, the erasures that make nation-building possible. In *The Birth of a Nation*, the traumatic quality of slavery, the kidnapping of Africans, and the systematic dislocation of Native American communities does not enter the screen; the sources of violence and disorder are relocated and discovered away from white supremacy and patriarchy, in Africa, the uncivilized black body, and lustful women. While the overt racism in Griffith's film might seem irrelevant a century later, the relationship established in the film between progress and nostalgia continues to operate in everyday discourses and imaginations. Just think, for instance, of how conservatives often suggest that a better America involves going back to the good old days before Obama, a time of plentitude that includes Reagan's presidency and accompanying economic policies. This idealized version of the time before the Obama-inspired fall completely ignores the pernicious effects that Reagan's policies had on blacks, working-class people, and gay communities responding to the emerging AIDS crisis. Or think about how wars and invasions are justified through the language of defense,

protection, eliminating a threat, and making the world safe for something more desirable. This kind of rhetoric almost always assumes and legitimates a distinction between violence that is despicable and reprehensible and violence that is necessary, laudable, and redemptive. In Griffith's film, this distinction occurs along the axis of racial difference, between the vilified actions of blacks and the redemptive, rescuing actions of the Klan. Today our predicament is similar, as widely acceptable violence against Latinos, Arabs, and Muslims compel us to reconfigure, rethink, and expand traditional conceptions of race, that is, the white-black binary.

Kramer's *Guess Who's Coming to Dinner* does not call for a restoration of an idyllic past, as its filmic predecessor does. On the contrary, the film suggests that a better, more integrated future will entail gazing forward, resolving tensions and divisions through love and interpersonal relationships, and overcoming fears, anxieties, and resentments through perseverance and courage. Progress involves a release from the past. Progress will occur through assimilation; the site of this assimilation is a space comfortably removed from black residential communities. As described above, John is depicted as the embodiment of racial progress. His success and ability to assimilate into the upper echelons of our social world occur through a break from his father's generation, a transition from black man to universal manhood, from the burden of particularity to the freedom of the universal. Instead of returning to an idealized past, John represents the desire to be liberated from this past. His familiar and understandable desire to be free from the tensions and conflicts that have historically weighed upon black people reflects the film's conciliatory thrust, a quality that it shares with *The Birth of a Nation*. Progress, in other words, is often the flipside of nostalgia. The forward-looking and backward-looking gazes share a desire for wholeness and reconciliation that minimize our capacity to relate to and contemplate the antagonisms of race and racial difference.[47] But of course several lingering questions and knots remain. While John desires to leave behind racial particularity, he does this by affirming gender particularity, by affirming his identity as a man. His disavowal of race requires a valorization and accentuation of manhood, a quality that, like whiteness, has traditionally served as a stand-in for the universal. This is important, considering Levine's point about the film's narrative revolving primarily around male relationships, a predicament that results in the marginalization of female characters, especially Joanna. In addition, while the film underscores racial acceptance, particularly John's inclusion into the

Drayton family, John's acceptability depends on contrasts with other black bodies that are not easily assimilated into the film's happy conclusion: Tillie, a visible reminder, and remainder, of race, gender, and class subordination; Dorothy, the displaced object of sexual desire, exemplifying the historical availability and "usefulness" of black female bodies; the anonymous black male who prompted Mr. Drayton's racist rant, an episode that expresses what Levine calls the racial unconscious of the film. Even though Kramer's film seems to enact and anticipate racial progress, both through its content and familiar narrative format, the film actually betrays lingering tensions, omissions, and gaps around race, class, and gender that constrain and impede the film's linear, forward movement.

CUTTING AGAINST REEL PROGRESS:
KILLER OF SHEEP

It is tempting to think of *Guess Who's Coming to Dinner* as an allegory for the achievements of the civil rights struggles for black Americans. To some extent, the film encourages viewers to think of assimilation and the transcendence of racial difference as the main goals of these struggles. It incorporates the achievements of "Dr. Prentice's generation" into a forward-looking framework, identifying manhood or raceless humanity as the telos of antiracist freedom movements. By making Dr. Prentice the embodiment of a postracial possibility, Kramer's work minimizes the ways racial difference is mediated by other subject positions and identities, a condition that, when taken seriously, troubles dominant interpretations of the civil rights movements that continue to influence and shape our memories of the recent past. In response to a film like *Guess Who's Coming to Dinner*, as well as broader endeavors to attach black freedom struggles to linear, optimistic narratives, a succession of films in the 1970s attempted to represent what Kramer's film excluded. Some of these films are classified under the so-called blaxploitation genre. Inspired by the black power movements and radical developments within the civil rights movement, the blaxploitation films of the early 1970s combined typical action-hero narratives with political awareness of the inequalities and obstacles that beset working-class blacks.[48] Because new laws permitted images and content that used to be prohibited from the screen, these films were able to include lurid, graphic subject matter previously unavailable to most audiences. Blaxploitation films like *Sweet Sweetback's Baadasssss Song* (1971), *Shaft* (1971), *Super Fly*

(1972), and *Foxy Brown* (1974) address subject matter such as drug addiction, underground economies, poverty, rape, sexual slavery, and police brutality. These films prompt the viewer to enter spaces, buildings, streets, corners, and situations that are far removed from a space like the Drayton household. The viewer cannot evade working-class black bodies, vernacular, desires, struggles, and interactions. The viewer encounters and must linger with images and sounds that are not always pleasant and easy to digest. While some of the earlier films located in this genre used unconventional techniques and narrative strategies, many of the popular and mainstream blaxploitation works tended to adopt standard narratives and tropes, including the heroic action genre, to respond to a history of racial injustice and subordination. This strategy, as many critics contend, flattened the complexities of black life; it also enabled the victorious actions of the hero to allay concerns about structural patterns of violence and exclusion.[49] In other words, blaxploitation films suggest that these patterns can be overcome by the actions of a black hero or leader and a few of his or her companions.

Charles Burnett's *Killer of Sheep* (1977) is a landmark film that responds to what Guerrero calls the traditional containment of the black image on film as well as the blaxploitation genre's exaggerated representations of black heroism, masculinity, and violence. Burnett was a member of the so-called L.A. school of filmmakers—a group that also included Haile Gerima and Julie Dash—that emerged in the late 1960s. As Paula Massood points out, "members of the L.A. School expressed an explicit political agenda that extended beyond profit-making and the superficial interrogation of representation; they were concerned with what they saw as the internal colonization of African Americans and film's role in the construction of subjectivity and self-respect."[50] Combining new and unorthodox cinematic techniques, especially those associated with neorealism and third-world cinema, with strands of postcolonial thought (Frantz Fanon), these filmmakers demonstrate Guerrero's insistence that power and resistance are intertwined within the film industry or any ideological field. In what follows, I show how Burnett's film specifically resists and contests reassuring, linear narratives about race and the nation's racial history. I argue that the film consequently frustrates tendencies to absorb race, black bodies, and working-class black experiences into a forward-marching imaginary. By juxtaposing *Killer of Sheep* and *Guess Who's Coming to Dinner*, I similarly

suggest that Burnett's cinematic achievement reminds the viewer of the ambivalences, tensions, and failures of the civil rights movement and its legacy.

Killer of Sheep gives the viewer a glimpse into a postindustrial and post-civil rights Watts family and community. From the opening scene, which features a young boy's being scolded by his father, it is difficult for the viewer to get a handle on the narrative, to figure out what the story and plot are all about or what relationships the various characters have to each other. According to the film critic Dana Stevens, "*Killer of Sheep* is a collection of brief vignettes which are so loosely connected that it feels at times like you're watching a non-narrative film."[51] It is helpful to think about the assemblage and succession of scenes and shots according to Benjamin and Adorno's previously mentioned notion of the constellation. For these authors, a constellation refers to a configuration or construction of images and concepts without a central principle or unifying source. This does not mean that the pieces are not "loosely connected"; it does mean that the viewer must do some work to figure out how the pieces fit together. In the process, standard practices of watching, viewing, and constructing meaning are troubled and placed on trial. Throughout the film, we see connected and unconnected images of children playing in the streets, sheep being prepared for the slaughter, two men committing a robbery, the main character, Stan, and his wife dancing awkwardly to "This Bitter Earth," children leaping across rooftops, and a house party with a group of men rolling dice. The images and scenes are accompanied by the voices and sounds of Dinah Washington, Paul Robeson, and Louis Armstrong; the blues and spirituals provide a soundtrack to the film, articulating the pleasures and pains, the joys and sorrows of this Watts community.[52] But while the interplay between image and sound tells a kind of story, this is a story in which nothing significant appears to happen. There seems to be no progress in the film. As critic David James points out, there is little to no movement in the film, a lack that is heightened by the absence of freeways and commerce as well as the characters' limited access to car transportation. This lack of movement is exemplified when a planned day trip to the "country" fails because the car breaks down.[53] It is also visualized in the repetition of certain scenes and scenarios—including Stan's laborious job at the slaughterhouse and the children repeatedly throwing rocks and dust at each other. The occasional feeling of monotony and lack of movement in the film signify conditions

and feelings of confinement, isolation, and inertia. In addition, the work of the camera (the play between close-ups and long shots, the focus on deteriorated spaces and buildings, the moments of documentary-style filming) compels the viewer to remain ensconced in and attuned to the topography of this urban space, even as the film's fragmented style makes this a difficult experience. Finally, the fact that *Killer of Sheep* uses black-and-white film stock at a historical moment when color film had become the norm suggests to the viewer that one's sense of time, advancement, and temporal movement is going to be impeded during the viewing process.

While *Killer of Sheep* focuses on a slaughterhouse worker named Stan and his alienation from his family and community, the film begins with several vignettes highlighting the predicament of children. As Nathan Grant points out, the film opens with the theme of innocence as we hear a woman and child singing the lullaby "My Curly-Headed Baby."[54] This theme of innocence is quickly undermined as we encounter the dour face of a child and hear the voice of his father chastising him for not defending his brother. The young boy is castigated for not intervening to protect his sibling even though his brother might have been responsible for the fight. He is told that he needs to be a "man," thereby suggesting that manhood is defined by being a defender and protector. After being scolded by his father, the camera cuts to the young boy's mother, who, with a semi-smirk on her face, approaches her son and slaps him. Grant astutely argues that "the slap . . . is itself a crisp depiction of loss of innocence, of a sense that violence in any form is the most powerful and enduring factor of human development in this setting."[55] The world is cruel; the young boy's parents are initiating him into this cruelty, preparing him for the violence that he tried to avoid by not defending his brother. After this slap, the voice of Paul Robeson sings and repeats the lyrics to "My Curly-Headed Baby." It sounds different this time; Robeson's voice sounds more somber than the version just heard from the woman and child, a transition that obviously resonates with the theme of the loss of innocence.[56] At the same time, Robeson's voice allows the viewer to listen to the earlier version differently, to potentially hear and notice some kind of interplay between levity and gravitas in both versions. This different hearing suggests that the child, the home, and the family are no longer transparent sites of happiness and innocence. Unlike *The Birth of a Nation*, the film does not provide the viewer with an idyllic space of innocence and harmony that exists outside of or prior to

violence, cruelty, and loss. Innocence, in the opening scene, is an immediate site of loss, especially for children.

Throughout the film, we repeatedly encounter unnamed and unidentified children. In the second scene, for instance, the viewer is introduced to Stan's son and a group of children playing aggressively with rocks and stones. Even though one of the boys only feigns being hurt, his simulated injury underscores the connections between play, intimacy, and danger. This relationship resonates throughout the film as the line between child's play and cruelty is obscured—exemplified in a later scene when a group of young girls push an invasive boy off of his bike, causing him to run away, covering his eye while the girls mock him. During the second scene, a freight train passes the group of frolicking boys. We see them—from the perspective of the train—running toward it, throwing rocks, unintentionally simulating the actions of robbers and bandits.[57] Following the connection made by Paula Massood between Burnett's film and the Watts riots, this shot invokes the kinds of actions, behaviors, and images associated with a riot or rebellion, with an event from the community's recent past. In addition, the perspective from the train visualizes the ruins and debris (stones, dirt, pieces of wood) produced by the uprisings; it depicts the presence of the past, the ways past struggles and losses are inscribed in the geography of this Watts community. The children's simulation of throwing objects, resembling scenes from the riots, suggests that the present and future are occasions for repetition. Yet this theme of the present's reiterating the past is troubled throughout the film. In one later scene, as Stan and his friend descend apartment stairs, several children run and jump across the rooftops as if to suggest the future possibility of transcending historical constraints and limitations. (These shots of leaping children are immediately followed by another rock-throwing image, visions of children crying, and a woman with a gun protecting her children from a man presumably her husband.) If the child is an ambiguous figure in the film, a site of hope, pleasure, possibility, violence, and cruelty, then perhaps Stan's daughter represents this ambiguity with her uncanny animal mask. This mask, which she wears in her debut scene, invokes themes of concealment, disguise, and obscured vision, similar to Du Bois's notion of the Veil and reminiscent of Paul Dunbar's famous poem "We Wear the Mask." At the same time, the animal mask signifies play, imitation, the process of becoming other, and the instability of identity. Since the film juxtaposes the sheep in the slaughterhouse and

the residents of this Watts community, the mask also expresses the continuities and affinities between humans and animals, obviously a fraught comparison considering legacies of associating black bodies with the nonhuman.

While the figure of the child is prominent throughout the film, most of the film's vignettes involve the main character, Stan, and his interactions with his lifeworld. We are introduced to Stan while he is working on his kitchen floor and conversing with his friend Oscar. He is bent over and his head is under the sink. The viewer can only see his back. This prostrate position almost resembles a praying body, a significant point considering Oscar's suggestion that church might be a solution to Stan's problems. In this scene, it is clear that Stan is exhausted, worn out, and devoid of energy. He admits that he is "working himself into his own hell," that he cannot sleep, and that he cannot attain peace of mind. Oscar responds in a casual manner, "Why don't you kill yourself?" exemplifying what Grant refers to as Stan's "lack of connection with all that is around him."[58] Stan's expression of suffering cannot be received; his confession is deflected by dry humor and then given a quick fix when Oscar mentions attending church. This sense of alienation is intensified in his later conversation with Bracy. After Stan compares the warmth of coffee to the forehead of a woman while making love, Bracy laughs at and mocks his friend's analogy. In the discussion with Oscar, he could not communicate his wounds. In this case, he cannot enjoy and share the interrelated pleasures of coffee and sex without being rebuffed. Stan's slightest pleasures and enjoyments become occasions for further alienation. But of course laughter is not always so transparent and easy to pin down. Perhaps Bracy's loud, raucous laughter is the only way he can respond; perhaps his extravagant laugher is not simply an expression of mockery but a response to the painful quality of the predicament that he and Stan have been thrown into. As Massood describes, the interactions between Bracy and Stan are marked by awkward dialogue, long pauses, and repeated moments of silence, characteristics that further indicate distance, separation, and immobility.[59]

The scenes showing Stan's interacting with his wife intensify these themes of alienation and lack of intimacy. In a poignant scene toward the end of the film, we see the couple slow-dancing to Dinah Washington's "This Bitter Earth." This song is relevant to Stan's existential predicament and feelings of alienation, considering the line in Washington's song that questions the possibility of sharing love or the later line expressing a

hope that one's cry will be heard. Although the couple begins with their hands around each other, their bodies are separated and disconnected. Stan looks numb and indifferent while his wife's face betrays a range of feelings and emotions—concern, sorrow, compassion, and desperation. She recognizes that he is unhappy, that he does not smile anymore. She is also unhappy, presumably from a lack of intimacy, being confined to domestic spaces, and worrying about Stan's getting involved in criminal activities. As she draws closer to him, desperately grasping for some kind of connection, Stan appears more distant. Her kisses are not returned and Stan eventually releases himself from her hold. In a later scene, we see that the intimacy that Stan cannot give to or receive from his wife are redirected toward his daughter. After another failed attempt to connect with her husband, Stan's wife sits by herself in a dark room while Stan and his daughter hug and caress in the kitchen. We see shots of the wife's sullen, disappointed countenance juxtaposed with images of the young daughter's attempting to give her father a back rub. In the final shot, the camera foregrounds a side of the wife's face as she watches Stan and his daughter, who are framed and captured in the light.[60] In this shot, themes of loneliness and longing are supplemented by images of displacement and substitution. The daughter, who we see looking back at her mother, has replaced her mother in this scene. She has, for a moment, successfully usurped her mother's place as the object of affection, as if Burnett is visualizing and resignifying Freud's oedipal economy of desire. Here I don't mean to suggest that Stan's wife is merely a passive object in the film or that her character lacks agency and power. This reading would ignore the complexity of her character. In an earlier scene, for instance, we see her chastising two men after they solicit Stan's assistance to commit a crime. As she confronts them directly (getting in their face, so to speak), Stan remains on the stoop, quiet and listless. When Stan's manhood is challenged by his friends, she defends him, while also redefining masculinity, suggesting that being a man is more than asserting oneself in a cruel, hurtful, and violent manner. While this scene might be interpreted as an instance of emasculation, further contributing to Stan's alienated and vulnerable state, I read this scene as a woman's attempt to usurp and speak within a male-dominated space in ways that trouble and challenge conventional gender norms and expectations.

Stan's alienation and loss of feeling are attributed to the repetitive labor that he undergoes at the slaughterhouse factory. In the course of the film,

we see different phases of the slaughtering process, interspersed with images of children playing and meandering through the Watts streets. In the first work scene, we see Stan cleaning the workspace, "hosing down the blood and carting the guts away in wheelbarrows."[61] In the second work vignette, several workers are preparing the hooks that the sheep will be hung on. After a shot of the supervisor leaving the floor, the camera cuts over to the goats that lead the sheep into the killing floor. As the film critic Inez Hedges points out, this scene seems to humanize the sheep as we hear Paul Robeson's powerful voice singing the lyrics to "Going Home," a song that articulates the relationship between death and home discussed in the Du Bois chapters of this book. While I agree with Hedges here, it is important, if the sheep become more human in this scene, that we also acknowledge the ways we draw unstable lines between the human and the nonhuman in order to reproduce human life. In other words, even though we might recognize the shared mortality among animals in this sheep-ushering scene, accompanied by Robeson's voice, this scene also reminds the viewer that human lives depend on the mundane, taken-for-granted deaths of animals. The continuous juxtaposition of the sheep with black children also invokes a history of marking black people as not quite human. As Adorno and Horkheimer might put it, human life relies on the manipulation and domination of nature—a realm that we both participate in and sacrifice in order to perpetuate survival—and those bodies and communities associated with the wild, uncontrollable qualities of nature. In the third and penultimate work scene, dead sheep are being skinned on hooks. Although there are several workers in this scene, we don't see many faces; we often see backs, feet, and fragments of the body. The viewer's vision is figuratively punctured and fragmented like the sheep that were recently slaughtered. By placing Stan next to white workers, some of the very few white characters and bodies in the film, Burnett suggests that the tedium and dread that Stan experiences is potentially shared across racial lines. Perhaps his particular situation is just as much a result of class formations, unequal access to capital and wealth, and the exploitation of the working class as it is a product of the color line. In general, the third workplace scene underscores the repetitive nature of Stan's job, a quality that is reenacted in the film by returning to the factory space, showing different facets of the labor process. The relationship between the tedium of labor and the dulling of the senses has been addressed by the Marxist tradition. As Adorno points out in *Dialectic of Enlightenment*, repetitive labor (both physical and

mental) contributes to the impoverishment of experience.[62] According to Adorno, the narrow logic and demands of capital, work, and production increasingly regulate bodily movements, actions, and desires. Bodies tend to become numb to the external world and find it difficult to experience pleasure, novelty, or the unfamiliar dimensions within mundane, everyday life. But while Stan's relationship to his family, friends, and environment is defined by numbness and lack of feeling, the viewer ironically connects with this feeling of disconnection. In other words, Burnett's film works to heighten the viewer's attunement, potentially opening the viewer to the conditions and sources of alienation and fragmentation.

By identifying the broader processes and arrangements that constrain and shape Stan's interactions with his social world, I am not suggesting that he lacks agency. As discussed in previous chapters, agency might be a capacity to act and perform something, but this capacity is always constrained and enabled by norms, conventions, the social world, environmental limitations, and so forth. Stan's agency, in accordance with this view, is marked by a kind of brokenness, intertwined with the aforementioned themes of alienation, vulnerability, and loss. This predicament is vividly symbolized when Stan and his friend attempt to buy an engine and place it on a pick-up truck. The truck is parked on an incline and the viewer's perspective is placed behind the truck. As the truck attempts to proceed up the hill, the engine falls out and breaks. As Stan and his friend drive away, the viewer takes the perspective of the truck and the camera lingers on the distant and fading engine, this evanescent object of hope and possibility. While Stan's world and sense of self-coherence seem to be beset by Sisyphean constraints, there are moments when he demonstrates pride, an expression that occurs by defining himself over and against others. For instance, after Bracy teases him for trying to be "middle class," Stan rejects the idea that he is poor (even though he acknowledges that his family might not have anything sometimes). His understandable rejection of the subject position "poor" occurs by redirecting that stigmatized identity to another member of his community. He is not poor, because this other person down the street really looks and behaves like a poor person. His self-affirmation at this moment relies on distancing himself from undesirable members of community even as they all endure similar circumstances. In addition to this contrast with poor people, Stan defines himself against those who live in the "country." He chides his son for addressing his mother as "Ma Dea," indicating that

this is a backward term, a term appropriate for the South or those who live in rural areas. Like Joe and Violet Trace, Stan desires to break free of his Southern roots, yet a complete break cannot occur since he holds on to the South, the country, as an object of contrast and an occasion for self-affirmation. This becomes even more complicated when Stan takes a trip to the "country" with his family and friends in order to get away from city life. The car breaks down, suggesting that some nostalgic return to the country is not available but that perhaps some interaction between past and present is necessary in order for Stan to endure, cope, make sense of life, and maintain a livable sense of self.

While *Killer of Sheep* takes the reader through a series of fragmented scenes and situations, the ending of the film seems to redeem and resolve the fraught, tension-filled features presented to the viewer. According to Nathan Grant, for instance, "resolution is clear in *Killer of Sheep* . . . men and women do come together at the end of these films, and they do so because the issue of male existential estrangement is solved."[63] Here Grant is alluding to the concluding scenes, when Stan and his wife lounge on the couch while Stan caresses her knee. They are smiling; this is a promising moment of happiness and intimacy. In the next sequence, we are introduced to a crippled girl who announces that she is pregnant, suggesting that injured bodies might produce something new and promising. When one of the women in this scene confesses that she thought the pregnant girl's boyfriend was impotent ("shooting blanks"), we get a sense that manhood has been revitalized in the traditional, and problematic, sense. In the final scene, Stan is energetically gathering and ushering in the sheep and this image is accompanied by a second playing of Dinah Washington's "This Bitter Earth." Stan appears to be revitalized and the story ostensibly ends on a comforting note. While I don't want to rob the characters or viewers of moments of pleasure and enjoyment, it is important to think about the open-ended quality of the final scenes. The film, for instance, has already suggested that the figure of the child is the site of ambiguity—play, imagination, possibility, cruelty, and the repetition of the past.[64] In addition, while Stan looks revitalized, he expresses this renewed energy in the slaughterhouse; conditions have not changed, this is still a space marked by death, tedium, and alienation. Even Grant qualifies his earlier, more optimistic reading when he claims, "Stan himself is finally buoyant and smiling as he is . . . seen driving a flock of sheep into the pen—but they crowd and shove toward an uncertain fate, a fate not unlike that of

the men and women who people Stan's neighborhood, nor is it unlike the fate of the smiling Stan himself."[65] This uncertainty is heightened when we remember that the film is a series of loosely connected scenes. In other words, it is not clear why this final piece of the film's constellation should overshadow and supersede the other pieces. In light of the film's format and narrative structure, one does not have to accept that the final scene provides the telos and resolution to the film.

It is important that in this concluding scene, we hear Washington's "Bitter Earth" for a second time. When the viewer hears this song for the first time, Stan looks frozen and gloomy; the second time, his demeanor and body language are different. He is more resilient. The lyrics to the song anticipate this interplay between sorrow and joy. While the song acknowledges that life is harsh and painful, it ends with the hope that "someone" might answer or respond to the singer's cry. The earth is cruel but "might not be *so bitter* after all"; the not-so-bitter quality depends on the listener's capacity to receive, respond to, and be opened by the cries, struggles, and longings of others. The song and the film's ending resonate with Ellison's idea of the tragic-comic or Du Bois's sorrow-filled hope. Recall that the comic part of Ellison's dyad does not downplay or provide consolations for mortality, violence, alienation, and loss. While there are some things that humans can remedy, there are certain constraints that are inescapable, even as humans try to evade and shield themselves from these markers of finitude. The comic dimension of Washington's song and Burnett's film suggests that we might relate to the bitter world in a way that does not deny suffering and pain but that discovers creative forms of expressing and responding to the tragic qualities of life and human existence. In addition, the repetition of Washington's song in the film indicates that while sorrow and loss are informed by social difference and exclusion, loss is also clearly a condition that all human subjects share. At one point in the song, Washington croons, "Today you're young, too soon you're old," reminding the listener that transience and mortality are constitutive human qualities that we all face. At the same time, by placing Washington's voice alongside other songs within the blues and spirituals legacy (Robeson's "Going Home" and Louis Armstrong's "West End Blues," for instance), the film maintains a tension between the general and the specific, showing how human evanescence and suffering are inflected by racial difference. In other words, the film attaches themes of untimely death, loss, and alienation to black American aesthetic strivings and expressions.

But the film also constantly reminds the viewer that these songs, images, and experiences are part of a complicated, dense American story or set of stories. Not unlike Du Bois's insistence that the sorrow songs tell the listener something about American history and experience, *Killer of Sheep* links the struggles, pleasures, and constraints of this Watts community to the broader nation that it participates in, albeit in an ambivalent, tension-filled manner. At times, the play between sound and image mimics, parodies, and troubles optimistic, patriotic attachments to the nation and the nation's ideals. This troubling of American history is beautifully portrayed in an early scene when children are frolicking in the streets to the non-diegetic sounds of Paul Robeson's "The House I Live In." To some extent, the lyrics, which honor the founding fathers, immigrants, and everyday neighbors, sound conventionally patriotic. At the same time, Robeson's deep, low voice and the fraught, unsettling images of the Watts topography both accompany and contrast with the song's upbeat lyrics, complicating traditional forms of patriotism and national piety. The interplay between image and sound in this scene does not indicate a rejection of America but calls us to reimagine this house that we reside in. It prompts us to think about and tarry with the underside of lofty ideals and images; Robeson's voice, juxtaposed with visions of the urban landscape, compels the viewer to contemplate the intersections and tensions between achievement and loss, freedom and violence, democracy and exclusion, belonging and alienation, pleasure and anguish. In many ways Robeson's own relationship to America (which included singing the national anthem with shipyard workers as well as being denied a passport because of his communist sympathies) reflects this ambivalence.

By reading *Killer of Sheep* alongside *Guess Who's Coming to Dinner*, I do not intend to argue that Burnett's depiction of racial matters is more authentic than Kramer's representation. I am not suggesting that Stan is more authentic, real, and representative of black people than Dr. Prentice. Finally, I am not implying that only films about blacks living in urban, working-class spaces can be subversive with respect to cultural fantasies and narratives that minimize the significance of race. I recognize the plurality of black life (the John Prentices, Tillies, and Stans) and refuse to reduce blackness to its working-class, urban expressions. Burnett's film is powerful not only because of the content and context—an impoverished community in Watts—but because of how these matters are depicted and presented to the viewer. There have been many films about black life in

urban spaces that repeat linear formats and conservative ideologies (think of John Singleton's *Boyz n the Hood*, a film that I discuss below).[66] And there are representations of middle-class existence that successfully challenge overconfident conceptions of racial progress and uplift (Burnett's *My Brother's Wedding* is one example). Furthermore, one should applaud *Guess Who's Coming to Dinner* for challenging the taboo of interracial intimacy and reimagining what intimacy, romance, and love might look like. My concern is that films like this become enticing sites of harmony and resolution, moments that heighten desires and fantasies to move beyond race without confronting the persistence of recalcitrant antagonisms and inequalities. At the same time, as I demonstrated above, the conciliatory thrust in Kramer's film does not really work; in many ways it betrays and draws attention to lingering tensions and fissures along class and gender lines. *Killer of Sheep*, in a more explicit manner, refuses to allow the experiences and struggles of a working-class black community to do the work of progress, to be placed in a palatable, reassuring framework and scheme. As Adorno might say, the film beckons us to "linger" with the negative, to tarry with objects, ruins, images, pleasures, and moments of intimacy without conciliatory reassurances. If there is hope in this film, it is a possibility that requires the viewer to enter, experience, and be affected by the tension-filled relationships, sounds, images, and landscapes that move across the screen.

More specifically, *Killer of Sheep* troubles prevailing accounts of the civil rights movement, accounts suggesting that the peaceful demonstrations and protests in the 1960s introduced the conditions for a colorblind, postracial society or at least a future in which race is not so significant. Kramer's film, Poitier's character, and the widening acceptance of interracial intimacy certainly indicate the achievements of black freedom struggles. But Kramer's work also dovetails with visions of the movement, and American history more generally, that downplay the fissures, cuts, and failures of these 60s struggles. As suggested above, the Watts rebellion and its aftermath, mimicked and reenacted by the children in the film, remind us of those dimensions of black life, experience, and history that cannot be easily integrated into conventional civil rights stories, especially those that ignore the violent alternatives to King's pacifist resistance or those that downplay the subsequent impact that these destructive uprisings (in addition to the structural, economic inequalities and state repression that spurred these uprisings) had on urban environments and communities.

As S. Craig Watkins points out in his interpretation of the flashback technique in films like *Menace II Society*, these allusions to the recent past implicitly "introduce a seminal period of events in post–World War II race relations: the swelling of urban uprisings in the 1960s that reflected the withering of the civil rights movement, its inability to ameliorate inner-city blight, and the ensuing backlash against black protest."[67] While Burnett does not use conventional flashbacks in his film, the actions and behaviors of the children and the depiction of topographical ruins and shards in the film refract the historical developments and events that Watkins delineates. This refracted depiction challenges conventional wisdom, which suggests that the civil rights movement was an unequivocal success and all that Americans must do now is finish the project initiated by our forebears. It therefore compels viewers to confront the failures, contradictions, and remainders that cut against any notion of a unified and linear civil rights project.

UPSETTING AMERICAN FANTASIES: *SET IT OFF*

In a more conventional and perhaps less detectable manner than in *Killer of Sheep*, F. Gary Gray's urban heist film *Set It Off* (1996) exposes the failures and erasures attached to conventional ideals and images of progress, particularly the American dream.[68] (In what follows, I define the American dream as that resilient, stubborn ideal expressed in John McCain's 2008 concession speech: America offers abundant and equal opportunities to all of its citizens who possess the will and effort to seize them.) Gray's film, about four working-class black women living in South Central Los Angeles who decide to rob banks after all other economic options seem exhausted, compels the viewer to critically interrogate the ways this dream trope operates and founders in a post–civil rights, postindustrial, neoliberal America. While *Killer of Sheep*'s representation of a specific Watts community compels us to rethink the purported triumphs and achievements of black freedom struggles a decade after the passing of the civil rights acts, *Set It Off* encourages us to rethink these achievements in the aftermath of Reagan-affiliated neoliberal policies and practices that in many ways "off-set" these victories. In addition, the film exposes the problems that arise when we imagine racial difference and its possible overcoming without highlighting what Patricia Hill Collins refers to as interlocking modes of power and regulation, especially patriarchy, class inequality, and heteronormativity.[69]

Set It Off both mimics and departs from what S. Craig Watkins calls the "ghetto action film," a genre that includes films released in the early 1990s like *Boyz n the Hood* (1991), *Juice* (1992), *South Central* (1992), and *Menace II Society* (1993). These films, inspired by the popularity of Spike Lee's early work as well as the emergence of so-called gangsta rap, attempt to screen and highlight conditions, realities, and struggles experienced by young or teenage denizens of urban spaces.[70] While these films use more conventional editing techniques and narrative formats than *Killer of Sheep*, the ghetto-action genre follows its predecessor—as well as blaxploitation cinema—by drawing attention to harsh realities that Hollywood and society more generally minimize or explain away: poverty, gang life, gentrification, underground drug economies, military-style police surveillance in communities of color, and existential feelings of confinement and isolation.[71] And since several of the early 90s ghetto action flicks take place in Los Angeles, it is important to keep in mind the immediate political context, which includes the 1992 L.A. rebellion, a racially charged event sparked by the acquittal of police officers who were caught on camera beating Rodney King.[72] In addition to unveiling these social conditions, what these ghetto-action dramas share is a tendency to focus on the experiences, actions, and struggles of young black men. In this well-intentioned endeavor, the overlapping but different struggles of black women are subordinated and devalued, a process that becomes transparent in a film like John Singleton's *Boyz n the Hood*.

True to the name of the film, Singleton's work chronicles and underscores the obstacles to and travails of black males in a Los Angeles community. This coming-of-age tale famously treats women as useful appendages to the maturing process of three childhood friends, Tre, Ricky, and Doughboy. As Gwendolyn Pough points out, "In *Boyz n the Hood*, for example, women are both crucial and peripheral. The film is completely male-identified, and women come into play only as they relate to men in the films."[73] On the one hand, women are typically relegated to the background until they are useful, until they contribute to the development, complexity, and sexual vitality of the male characters. On the other hand, women are pivotal to the film's main argument—the source of the problems that beset young black men is the lack of a strong father figure. In order to emphasize the good, responsible, and disciplinary qualities of Tre's father, Furious Styles, Furious is contrasted against the ostensibly irresponsible and shiftless mother of Ricky and Doughboy. In an early scene, Furious

prophetically foreshadows the untimely deaths of Ricky and Doughboy. He tells a young Tre that his friends across the street have no one to look up to and that "we will see what happens to them." Without a strong fatherly figure in their lives, the film tells us, black men's futures are fated to failure and death. The possibility of rescue and escape from the constraints and confinements of ghetto environments (at the end of the film, Tre goes to college) is tethered to the voice, wisdom, and disciplinary tactics of the father. In other words, racial uplift and progress rely, first and foremost, on the actions, behaviors, and strivings of men and the preservation and fortification of patrimony (the passing down of wisdom and life from father to son), a model that resembles Du Bois's early uplift paradigm. In addition to the conservative gender politics involved in Singleton's use of patrimony, as a vehicle and source of redemption, this strategy diverts attention from the broader social and economic conditions that make possible and acceptable the unequal distribution of wealth, value, opportunity, and vulnerability.[74] So while *Boyz n the Hood* vividly interrupts fantasies of racial progress and equality (by visualizing police repression and rendering audible military-style helicopter surveillance, for instance), we might say that it also employs a patriarchal uplift model to safeguard the American dream and the ideal of progress.

Gray's *Set It Off* works against the grain of *Boyz n the Hood*'s recuperation of conservative national tropes and its affirmation of male authority as the primary source and guarantor of racial progress. Even though Gray's attempt to fuse the heist genre with the urban action film occasionally relies on stereotypes, incredible scenes and plot twists, exaggerated violence, and a lack of nuance and subtlety, the film successfully draws our attention to relationships, conditions, and scenarios that refuse resolution and containment within forward-marching paradigms. From the opening scene, the viewer sees how individual strategies of hard work, sacrifice, and responsibility run up against constraints and contingencies that the characters cannot control. Frankie, played by Vivica Fox, is "let go" from her bank job after an assailant from her neighborhood, Darnell, leads an abortive robbery, a failed heist that results in the death of several people, including Darnell. Immediately after the robbery scene, we see Frankie being questioned by Detective Strode; our vision is "cut" insofar as the camera captures their dialogue on the other side of shattered glass. While Detective Strode and Frankie's managers raise suspicions about her being in collusion with Darnell, we notice the spatters of blood on her suit. She has

just undergone a terrifying event (her coworker shot in the head in front of her) yet the detective ignores this and proceeds to frame her as a suspect and collaborator. Because she knew Darnell, she must be complicit. The failure to see Frankie as a vulnerable subject of trauma (she reminds the black female detective that she couldn't even offer her water) and the assumption that she is guilty by association invokes a legacy of dehumanizing black people and historical tendencies to treat black collectives as a unified horde, devoid of individuality and complexity. In addition, the accusations of complicity with Darnell remind the viewer that women are often not seen as individual actors apart from their dependence on and affiliation with male agents. Finally, it is important to underscore Frankie's desperate reminder to her supervisors, after she is fired, that she was recently promoted and that she shows up on time every day; in other words, this first scene indicates the instability and reversibility of progress and mobility, especially for certain kinds of suspicious subjects and communities. When we later find out that she cannot even get a recommendation from the bank for another job, the viewer remembers that our dependence on the order of things (the system) is both a source of potential advancement and risk and vulnerability.

After the first scene with Frankie, the viewer encounters other characters whose actions and strivings collide with forces and limitations that signify what Adorno calls the "preponderance of the objective world." Stoney, played by Jada Pinkett, is introduced as a responsible, selfless woman who has taken on a maternal relationship to her brother, Stevie, after their parents died in a car crash. After she reluctantly surrenders her body to the manipulative devices and sexual desires of Nate Andrews in order to procure money for her brother's college tuition (she is under the impression that he was accepted), Stevie tells her that his application was denied and that college might not be for him. He deviates from the "plan of getting up out of here." After an argument and a slap from his sister, Stevie leaves the house and is later gunned down by police who mistake him for one of the bank robbery assailants. Again, we experience another break in a linear, uplift paradigm. Not only do Stoney's sacrifices not produce the desired outcome but we are left wondering if the desired goal—getting her brother out of their current situation—would somehow compensate for what Stoney was compelled to put her body through. In addition, the audience sees how the college dreams and aspirations attached to Stevie cannot overcome the dangers of police surveillance and

the vulnerabilities of inhabiting a black male body in a world that often sees and treats black men according to a pernicious logic of sameness. In addition to Stoney, T. T., played by Kimberly Elise, faces obstacles and structural constraints that cannot be overcome by some Herculean effort. A single mother who gets paid under the table as a night custodian, T. T. cannot afford childcare and therefore must take her son to work. After her son drinks cleaning fluid and is taken to the hospital, child protective services takes her child away. T. T. is clearly in an existential bind, a bind produced, in part, by certain social expectations and ideals about the good, responsible mother. As Pough rightly describes, "We see that in many ways she is in a no-win situation. She really cannot navigate a space for herself where she can come out ahead and free of blame. If she does not work, she is considered a lazy welfare mom living off the state . . . If she leaves the child at home alone, she is a bad mother. If she takes the child to work with her, she is a bad [negligent] mother."[75] Here the point is not that T. T. is without any options (that her actions are somehow completely determined by material realities), but that her options and possibilities are severely constrained by these realities. And in this specific case, each of the options available to her and her son carry some kind of punishment and stigma.

Visualizing the limited options available to Frankie, Stoney, T. T., and Cleo (played by Queen Latifah) for wealth accumulation, mobility, and escape generates a kind of sympathy in the viewer toward their decision to rob banks. In response to initial reluctance by T. T. and Stoney, Frankie provides her own justification for this momentous decision: "We just *taking away* from the system that's fucking us anyway." Here I am not concerned about offering a moral defense for robbing banks. I am more interested in how Gray's film uses the heist paradigm to draw attention to everyday forms of theft, taking away, and dispossession, especially those forms that are generally treated as more acceptable and legitimate than a bank heist. It is helpful to revisit Marx's understanding of the relationship between capital accumulation and theft. In opposition to those who would explain the origins of inequality and power relationships within the regime of capital by pointing to different character traits (some people are hard-working and frugal and other people are lazy and wasteful), Marx underscores the violent conditions and events that make property, wealth, and inequality possible. As Marx puts it, "In actual history it is notorious that conquest, enslavement, robbery, murder, briefly force, play the great part."[76]

Here Marx suggests that capitalism engenders a kind of forgetfulness to its own conditions of possibility; capital erases its own ambiguous history, in which flourishing, life, and productivity are intertwined with theft, coercion, and erasure. Adorno famously develops these insights by reinterpreting the relationship between freedom and domination in the modern world. Even though modern ideals of freedom and self-identity have been defined in opposition to domination, Adorno contends that modern practices and arrangements produce notions of the self that rely on the mastery, repression, and the control of nature or those groups identified with the threatening, unruly qualities of nature—people of color, women, working-class subjects. This is not necessarily a completely new predicament but the rhetoric of progress and advancement within modern life often reduces our ability to name and diagnose the painful complexities that mark relationships between the self and the other. While one does not have to accept Adorno's totalizing understanding of the modern self, it is important to acknowledge the ways power, agency, and taking away from others often work together.

Marx and Adorno provide helpful resources to think about the relationship between power, disparity, and theft, and *Set It Off* often visualizes this constellation. Think, for instance, of the scene in which we are introduced to Cleo, Stoney, and T. T. working as janitors and being chastised by their boss, Luther. The scene begins with a low-angle shot of a corporate building, a shot that signifies the ways power is associated with a sense of distance and height. This shot similarly reminds us that the height and quantity of high-rise buildings are usually signifiers of progress and wealth for American cities. But before the viewer is overwhelmed with the height and size of the building, the camera transitions to the parking garage area, where Luther berates his subordinates for not recycling (we see constant shifts in the vertical distance between him and the three women as he steps on and off a platform during his tirade). He speaks for "the good white folks" who presumably are unsatisfied with Cleo's, Stoney's, and T. T.'s performance; Luther acts as a stand-in for the authority of the absent white corporate subject. He refers to the three women as bitches and he calls Cleo a gentleman—an allusion to her lesbian, butch identity—showing how white supremacy is deployed through sexism, heterosexism, and intraracial tensions across class and occupational differences. When T. T. questions him about the inordinate reductions in her paycheck, Luther tells her to go back to work or "take her broke ass home," reminding T. T. that she is

replaceable, a fungible body of labor. What is important in this scene is the contrast, and connection, between the opening shot of the building, the visualization of a conventional signifier of power, wealth, and progress, and the mistreatment and exploitation of the three black female workers inside the corporate space. In fact, this contrast is repeated throughout the film as we see different shots and angles of the building before making a transition to images of the women performing custodial duties. The condition of possibility of corporate wealth is a kind of taking away, appropriating or contracting the labor of useful, fungible bodies without providing fair compensation. In addition, Luther's assertion of black male authority, which includes the ability to speak for good white folks, relies on reinforcing patterns of domination and subjugation that Luther presumably experiences as a black male body inhabiting various social worlds. He acquires and secures a sense of authority by silencing his workers, depriving them of a space to voice grievances and concerns. Cleo, depicted in the film as tough and assertive, certainly speaks back to Luther's power but her capacity to stand up to him is constrained—she has to "take his shit" due to her precarious economic circumstances.

This particular relationship between the assertion of black male subjectivity and the subordination of black women is shown, in a different manner, in the sex scene between Nate and Stoney. Recall that she reluctantly sleeps with him in order to procure money for her brother's college tuition. As the camera descends onto the two bodies during this scene, we hear Nate's grunts and the shaking sound of the bed. Stoney is silent. Initially we see Nate's back and Stoney's elbows through a mirror, as if we are supposed to experience some kind of alienation, separation, or division during this scene. The camera then transitions to a close-up of the back of Nate's head and Stoney's face. The rest of her body, which appears passive and frozen, is completely underneath Nate's thrusting body. The close up on Stoney's face suggests a kind of alienation from the rest of her body, perhaps an attempt to imaginatively escape this undesired act. At the same time, the close-up enables the viewer to detect traces of tears, sorrow, and pain in Stoney's countenance; her silent tears are glaring in contrast to the grunts and penetrating thrusts of Nate. This sequence immediately shifts to a long shot of Stoney walking away from Nate's house with her arms folded. Her back is facing the viewer and her face is hidden from us, as if to imply a sense of shame or guilt. As she walks toward what looks like an abandoned factory, we notice glimmers of light on a shaded ground.

The contrast between Stoney and her surroundings in this shot both reveals a sense of being tethered to her environment while also indicating a sense of solitude and aloneness within this environment. The viewer leaves this scene with a feeling of melancholy, reflecting on the relationship between sexual desire, objectification, and loss. The assertion of male power often relies on what Morrison alludes to as treating women as prey, objects that can be consumed, "taken," and possessed. By focusing on Stoney's bodily experience of being the object and subject of sexual appropriation, the viewer potentially identifies with and is affected by this painful predicament.

Another important segment that visualizes the relationship between power and dispossession, but in a less graphic manner, is the rooftop scene. After a long, tedious night of custodial work (Frankie's first night on the job), the four friends are shown lounging on a rooftop. They smoke, drink, laugh, engage in banter, and debate the viability of robbing banks while listening to the music of the hip hop group Bone Thugs-n-Harmony. At one point, Cleo talks nostalgically about the abandoned factory on the other side of the fence. We are informed that the factory jobs used to pay employees relatively well before laying workers off. As Cleo begins to reminisce about these decent-paying jobs, the camera shows the four women, their backs facing the viewer, looking from the rooftop across the fence at industrial machines and infrastructure. The fence seems to represent a divide between past and present; it indicates a set of possibilities that are no longer available, so spatially close but so far away. The film at this moment reminds the viewer of the structural transformations in the capitalist order that have reduced or relocated manufacturing jobs and opportunities. The instability of capital, that is, the transition from an industrial to a service-oriented economy, creates new relationships, occupations, and modes of life but only by taking away and withholding possibilities from certain groups and communities that cannot keep up with progress. But this scene does not simply infuse the viewer with a sense of loss and nostalgia. As suggested above, the rooftop segment also demonstrates the importance of laughter, intimacy, pleasure, momentary escape, and music for those who find themselves on the underside of social arrangements. While the particular strivings and representations of black women are often interpreted exclusively in terms of pain and suffering, this is one of many scenes that encourages the viewer to see and hear the pleasures and joys that accompany the struggles and experiences of working-class black

women.[77] The sound of Bone Thugs-n-Harmony's "Days of Our Lives,"
playing silently in the background, underscores the function and value
of hip hop in a postindustrial world, the ways rap music has replaced, but
also sampled, the kinds of musical expressions heard in *Killer of Sheep*. As
Tricia Rose points out, hip hop was born at the intersection of lack, sur-
vival, and pleasure, making rap music a powerful soundtrack for the com-
plexities and ambiguities that characterize contemporary urban spaces
and circumstances.[78]

Cleo's allusion to layoffs and the disappearance of jobs is one salient
example of how Gray's film refuses a tendency to depict the strivings of
black people within a narrow racial frame without highlighting class dif-
ference or the vicissitudes of capitalism. Throughout the film, Gray shows
how class, like gender, cuts against unified notions of blackness typically
associated with uplift strategies (in which middle-class values and visions
define the status and future of black people as a whole). The tension-filled
relationship between race and class is exhibited in the romance between
Keith, a Harvard-educated banker, and Stoney. On their first date, for in-
stance, Keith (wearing a vest and dress shirt in contrast to Stoney's jean
jacket) talks about the multiple cities that he has lived in while Stoney
confesses that she has never travelled outside of Los Angeles. Freedom
of movement and travel is often enabled and constrained by material re-
sources, access to wealth, and habituated levels of comfort with regard
to "leaving home." In their discussion about business school, in which
Keith has to explain what "b-school" means, Keith arrogantly laughs when
Stoney reveals that she desired to go to business school for typing and book-
keeping. Keith then defuses the burgeoning tension between the two when
he commends Stoney for being so beautiful even though she seems so
"hard and tough." Stoney's complexity defies Keith's gender expectations;
her surface, facial appearance, which accords with conventional standards
of beauty, does not seem to match her "stone-like" demeanor and attitude.
In the next scene, we see Stoney in Keith's apartment, staring intently at a
painting by Kadir Nelson, entitled "The Beckoning." The painting, which
shows a man struggling to free himself from earthly binds while being
summoned by some divine light, prompts Stoney to ask Keith if he feels
free. While he replies "hell yeah," she admits that she feels caged (similar
to the writhing body in Nelson's painting). Keith then asks her about her
plans for the future. When it becomes clear that Stoney does not have a
"five year plan," he makes a reference to how "we don't plan for the future

as a people." Here the language of "we" and "people" ignores the kinds of class and gender tensions and divisions within black communities that Keith's initial interactions with Stoney expose. Keith's appeal to a unified "we" exemplifies Evelyn Higginbotham's point about race being traditionally used as a kind of metalanguage, a term that refers to how "the totalizing tendency of race precludes recognition and acknowledgement of intragroup social relations as relations of power."[79] Keith's reference to futurity, planning, and dreaming enables the viewer to reflect on how our capacity to dream or imagine a different future is mediated and informed by experience, privilege, and current predicaments. When Stoney tells Keith about her previous plans to send her brother to college, Keith gets excited and assumes that college will be a source of mobility and liberation. But when she tells him about Stevie's death, the viewer is reminded of those events, realities, and traumas that interrupt progress and aspirations for racial uplift.

The budding romance between Keith and Stoney appears to resemble a prince-charming narrative. The film seems to prepare the viewer for a future moment when Keith will rescue Stoney from her troubles. He introduces her to new food, buys her new clothes, takes her to a professional, business gathering, and assures her that she can stay with him after she expresses a desire to move forward and break free from her current situation. But the film also troubles this male rescue fantasy when Stoney repeatedly makes distinctions between her life and his, remarking at one point that she is unsatisfied borrowing pieces of his life. Similarly, the film refuses the tendency, exhibited in *Boyz n the Hood*, to privilege the male voice as the purveyor of hope and freedom. This refusal is seen when Stoney reiterates Keith's five-year-plan motif to Cleo in an attempt to inspire her to desire more out of life, beyond merely living day to day. Cleo responds by saying that while Stoney might fit in suburbia or Hollywood, she belongs where she is; where Cleo lives, with all of its complexity and ambivalence, is home. Here the point is not that Cleo completely lacks dreams and aspirations or that we should question Stoney's desire to escape her current situation. The point is that Keith's voice and vision cannot do the uplifting, redemptive work that Furious Styles's paternal wisdom presumably does in *Boyz n the Hood*. Keith's notion of futurity does not resonate with the kinds of struggles and experiences that Cleo has undergone. Similarly, his unifying temporal imaginary fails to absorb Cleo's lived experience of time and her disposition toward the future. She implicitly refuses and shows the

limitations of the, at times, totalizing visions and dreams associated with middle-class (male) subjectivity.

To some extent, Cleo's character works to complicate our imagination of gender norms and expectations more generally. Throughout the narrative, she plays the role of the butch persona—she is tough, aggressive, intimidating, and adept at handling guns. In addition, we constantly see her taking control in her relationship with Ursula, who is reticent and usually silent in her interactions with Cleo. As Judith Halberstam argues in her book *Female Masculinity*, Cleo's performance of traditional masculine roles and norms both reinforces and challenges narrow, pernicious assumptions about black female identity. Halberstam writes, "Cleo's depiction of black female masculinity plays into stereotypical conceptions of black women as less feminine than some mythic norm of white femininity, but it also completely rearranges the terms of the stereotype."[80] In fleshing out the ambiguities of Cleo's character, Halberstam contends that the film does not suggest that Cleo's masculine traits are somehow inherent to her black female identity. Rather, the film shows how Cleo's black female masculinity is a contingent product of various social dynamics and circumstances; it reflects the multiple social positions that Cleo inhabits. As Halberstam puts it, "Cleo's masculinity is as much a product of her life in the hood as it is about her lesbianism; it is a masculinity learned in poverty as well as a masculinity cultivated in a female body."[81] While commentators typically focus on Cleo's gender complexity, it is interesting to think about how all the female protagonists refuse simple gender expectations and binaries— Stoney is called tough and hard; the nicknames (Frankie, Stoney) seem to be androgynous or gender indeterminate; Detective Strode warns bank executives not to be misled by the fact that the "bandits" are female. It is crucial to keep in mind two troubling legacies that *Set It Off* is responding to and resignifying. On the one hand, the film responds to stereotypical depictions of black women as not feminine enough, showing how conventional masculine behaviors and expressions, which can be separated from male bodies and performed by women, are informed by class, social location, and survival strategies. On the other hand, the film implicitly pushes back against traditional black uplift paradigms that promote and privilege heterosexual relationships and clear, stable distinctions between men and women (especially within the model family) as sources and vehicles of progress.

Set It Off frustrates linear notions of progress by depicting the inherent contradictions and problems with the American-dream trope, by showing the relationship between progress and theft, and by visualizing the intragroup divisions that trouble the black uplift fantasies of a unified black people. The concluding sequences in the film leave the viewer with lingering tensions. In the final bank robbery, T. T. is gunned down and killed by a police officer in the bank. Cleo is also killed by multiple shots as she tries to flee police cars and helicopters. We see Ursula weeping alone as she watches Cleo's death on television. Stoney escapes by boarding a bus headed to Mexico. Before fleeing, she witnesses Frankie get shot as she runs from police officers. Detective Strode sees Stony but remains silent as the bus pulls out of the station. This seems like a redemptive moment for Strode, who was involved in Stevie's accidental killing. In the final segment, we see Stoney in Mexico; she calls Keith to assure him that she is safe, cuts her hair, signifying a new identity, and rides off into the mountains as the viewer sees a panoramic shot of the mountains and ocean. But the final segment in Mexico also shows Stoney in a hotel room, kneeling at the edge of the bed—almost as if she is praying—with the cash from the recent bank robbery spread across the bed. Shots, and sounds, of her weeping in front of the pilfered money are intercut with flashbacks from previous scenes and images of her deceased friends and brother. Stoney's tears turn into a brief moment of laughter as she recalls the joys, pleasures, and intimacy of relationships that no longer exist, or that endure indirectly through mourning and remembrance. As I take it, this flashback sequence underscores the relationship between Stoney's escape, the act of moving forward, and loss—something or someone has to be left behind in order for forward movement to take place. (Here we might not only think about the deaths of her friends that made Stoney's freedom possible but the death of unnamed police officers.) To put this differently, the film's ending does not allow us to forget or resolve the fraught relationships among freedom, wealth, various forms of taking and theft, and death. As the film proceeds toward a denouement, the flashbacks compel the viewer to reach back, creating different affects and emotions—sadness, loss, nostalgia, pleasure, and laughter. While we see Stoney's riding into a new life and uncertain future, the viewer's hopes and desires are constrained by the fact that Stoney's individual freedom seems to leave her alienated and disconnected from the kinds of relationships invoked by the flashbacks. Survival

and escape are made possible by something vital being lost, taken away, and left behind.

By examining and interpreting the moving image, we can examine how film, alongside the written text, becomes a prominent site of progress. Not only has visual representation, especially the demand for positive images, become a benchmark for black progress, but the structure, format, and subject matter of a film can reinforce and undercut desires for resolution and linear, forward movements. In this chapter, I juxtaposed three films that are pertinent to discussions about racial progress, remembrance, and loss. Kramer's *Guess Who's Coming to Dinner*, while addressing anxieties about interracial intimacy, indirectly attaches civil rights struggles to triumphant notions of progress and reconciliation. Burnett's *Killer of Sheep* and Gray's *Set It Off* prompt the viewer to contemplate how this general yearning for reconciliation minimizes tensions, losses, and struggles attached to race, class, and gender. More specifically, films like *Set It Off* show how certain kinds of ideals, like the American dream, make us less attuned to the erasures and thefts that accompany freedom, advancement, and the seizing of possibilities. These two films, through different formats, suggest that a different kind of future or set of possibilities needs to be informed and punctured by remembrance of loss, the expression of ambivalent affects or painful pleasures, and the articulation of strivings that cannot be easily incorporated into prevailing images of progress. But the thrust of Kramer's film and the yearnings expressed by Dr. Prentice continue to haunt us. Prentice's desire to be treated as a man, rather than a colored man, to make a transition from racial difference to a more universal subject position, anticipates the rhetoric of a postracial America. This is a theme that I consider in the final chapter.

FIVE

Figures of the Postracial

RACE, NATION, AND VIOLENCE

IN THE AGE OF OBAMA AND MORRISON

There are at least two ways to think about the term *postracial*. On the one hand, this controversial term can allude to a society that (especially after the election of the first black president) is no longer hampered by the racism of the past. According to this view, we have moved beyond, or are in the process of transcending, racial reasoning; any attempt to introduce or broach the topic of race in public spaces is therefore identified as divisive, regressive, and disingenuous. This position might lead someone to either deny racial disparities in education, housing, health care, and prison or attribute these inequalities to certain cultural or individual deficiencies (a lack of a work ethic in certain communities, a lack of a strong family structure, an inability to accept personal responsibility). It might also lead someone to downplay the connections between antiblack racism and recent forms of racial cruelty and fear directed toward Muslims, Arabs, and Latinos. But there is another conception of the postracial that diverges from this stronger version. This sense of the term acknowledges that race is an unstable category, that black culture has never been monolithic, and that race points beyond itself—to other categories of identification. As the

philosopher and race theorist Paul Taylor points out, the notion of post-blackness, associated with artists like Thelma Golden, is not necessarily a denial of the ongoing, persisting significance of race. This term simply, or not so simply, registers the post–civil rights shifts, changes, and transformations in how black people imagine, relate to, and embody their racial identity. In opposition to narrow, confining meanings of blackness associated with the civil rights and black power movements, postblackness signifies that "new meanings have emerged: new forms of black identity that are multiple, fluid, and profoundly contingent."[1] This particular version of the postblack stance similarly opens up more fruitful ways of thinking about the entangled relationships between race and other markers of identity like class, gender, sexuality, nationality, and citizenship. These categories and identities are coconstitutive.[2] They inform and shape each other in ways that elude facile analyses of our social worlds. In other words, as the films in the previous chapter demonstrate, one cannot analyze events, conditions, and patterns of inequality that beset people of color with only a racial lens.

The stronger sense of the postracial often dovetails with attachments to progress, optimism, and what Nikhil Singh calls American universalism.[3] The postracial idea reflects and reinforces the wish for America to be a beacon to the rest of the world, the fantasy that America is more equal, free, and tolerant than other nations, a collective fantasy that justifies American rule and dominion over other nation-states and national communities. Attachments to the stronger sense of the postracial have become intensified and more explicit in the age of Obama, in a post–civil rights context that makes possible the first black president. Think, for instance, of the anchor and MSNBC commentator Chris Matthews's response to President Obama's State of the Union address in January 2010. Although Matthews acknowledged the lingering effects and consequences of racial difference, he suggested that Obama's speech signified a utopian, postracial moment. He proclaimed:

> I was trying to think about who he was tonight. It's interesting: he is postracial by all appearances. I forgot he was black tonight, by all appearances. I forgot he was black tonight for an hour. You know, he's gone a long way to become a leader of this country, and passed so much history, in just a year or two. . . . I said, wait a minute, he's an African American guy in front of a bunch of other white people. And he is presi-

dent of the United States and we've completely forgotten that tonight—completely forgotten it. I think it was in the scope of his discussion. It was so broad-ranging, so in tune with so many problems, of aspects, and aspects of American life that you don't think in terms of the old tribalism, the old ethnicity.[4]

There are several significant aspects about this enthusiastic forgetfulness, this investment in Obama as a leader that embodies and gestures toward a postracial future and possibility. For one, while Matthews underscores Obama's postracial status, he constantly refers to his racial identity, his blackness. In other words, to claim that he and the broader nation have forgotten about Obama's blackness requires Matthews to mention repeatedly the president's racial identity as well as that of the majority of Obama's immediate audience—a "bunch of other white people." He has to highlight the contrast, acknowledge the difference, in order to deemphasize it. Second, Matthews suggests that what allows him to forget about Obama's racial subjectivity "for an hour" is the "scope of the discussion," the president's ability to address "broad-ranging" problems that presumably eclipse traditional racial differences. For the MSNBC commentator, Obama's rhetorical and leadership abilities enable him to transcend racial particularity and assume a more universal subject position.[5] But, of course, this transition and elevation from the particular to the universal is not new for black people; there is a legacy of black public figures, a legacy that includes Sidney Poitier's character in *Guess Who's Coming to Dinner*, whom the broader public imagines as being above blackness. These are black people who, due to success, class mobility, and acceptance by white middle-class segments of society, are imagined and celebrated as individuals who are no longer determined and constrained by traditional racial parameters and strictures.[6] Finally, Matthews claims that Obama's public performance and unifying discourse enable us to think beyond old "tribalisms and ethnicities," and in terms of a greater national cohesion. What this final thought downplays or "forgets" is how the enthusiastic and victorious postracial rhetoric, this idea of overcoming and transcending past conflicts and antagonisms, supports and reinforces collective self-images of America as an exclusive benchmark of freedom, progress, and unity for the rest of the world. This collective commitment to American exceptionalism—in both its implicit and explicit expressions—often produces and renders acceptable various forms of erasure and theft within and outside national borders (because

this erasure and theft goes unnamed when done for the sake of the preservation of freedom and democratic ways of life). Even if we agreed with Matthews that Obama's speech illustrates how old tribalisms and divisions have been transcended, this transcendence might rely on the creation of new, and less legible, racial conflicts and antagonisms. As Jasbir Puar argues in her provocative text *Terrorist Assemblages*, national exceptionalism and triumphant notions of progress can become unacknowledged sites of racism, coercion, cruelty, and acceptable violence.[7] In a post-9/11 world, this relationship between exceptionalism and acceptable death has been especially deleterious for Muslims, Arabs, Latinos, and other groups that purportedly pose a threat to American ways of life. According to Puar's argument, the second sense of the postracial is appropriate insofar as it underscores the interconnections and tension-filled relationships between race, nation, and citizenship (a connection made explicit by the birther movement and repeated attempts to delegitimize Obama's presidency by questioning his citizenship).

In this chapter, I examine Obama's writings and speeches as ambivalent expressions of the postracial idea. On the one hand, Obama is very aware that his political ascendancy and success do not signify an end to racism and racial inequality. He acknowledges that progress is slow and unsteady, that racism is deeply embedded in the fabric of our social world, and that assimilation is an ambiguous process. In his book *The Audacity of Hope* (2006) he writes, for instance, "In general, members of the every minority group continue to be measured largely by the degree of our assimilation—how closely speech patterns, dress, or demeanor conform to the dominant white culture—and the more that a minority strays from these external markers, the more he or she is subject to negative assumptions."[8] In addition, Obama incorporates mourning, remembrance, and a sense of the tragic in his reflections about race, America, and the possibility of a more hopeful future. At the same time, I contend that his reflections tend to rely on a familiar logic of progress and a semantics of national exceptionalism that diminish attunement to race-inflected loss, suffering, and struggle. This tendency obscures how triumphant national narratives produce, justify, and make acceptable various forms of death, how they render certain forms of violence legitimate and necessary in the name of progress, democracy, freedom, and protection. (Even if one acknowledges the ongoing significance of race, these kinds of narratives diminish how strong attachments to the national community and its myths can produce and sanc-

tion hierarchies and erasures within, at, and beyond national borders.) Because he adopts this grammar of exceptionalism, Obama's rhetoric, in accordance with conventional political sensibilities, conflates hope and promise with the future of the nation-state, a conflation that minimizes the violence internal to nation-building. Because this troubling tendency to link hope with a conventional image of America resembles arguments made by the late Richard Rorty, I offer a comparison of Obama and Rorty in the middle section of this chapter. To offer a different way of thinking about the relationship between race, nation, identity, and war, one that links racism to the violence of nation-building, I turn to the work of Toni Morrison, particularly her novel *Paradise*. By offering a fictional account of the problems and dangers that arise when communities are solidified by proud, ascendant narratives, she suggests that a better future might involve a heightened sensitivity to the violence and trauma that undergird racial and national formations (in opposition to eager endeavors to convert memories of trauma into instances of optimism, pride, and collective strength). Following the second sense of the postracial, Morrison's novel shows the limitations and dangers involved in projects that underscore the significance of race while downplaying the struggles, erasures, and losses attached to other identities and subject positions.

It might seem inappropriate to juxtapose Obama and Morrison. Obama, as a politician and political leader, is constrained and limited by a different set of rules, norms, discourses, and expectations than a writer like Morrison. A presidential speech, for instance, has different aims and goals than a novel or essay; the speech is guided by strategies to make the nation more cohesive or to manage the body politic, while a novel has more room to play with and unsettle identities and expectations. In my view, these differences and tensions actually encourage, rather than deter, comparison and dialogue. A fictional account that troubles triumphant narratives and collective investments in stable, coherent identities can draw attention to the limitations, dangers, and tensions involved in "real" political discourses and practices. Literary works can generate alternative ways of relating to, hearing, interpreting, and being affected by a political speech or address. Similarly, a novel like Morrison's *Paradise* reminds the reader of pervasive, entrenched longings, attachments, and expectations that political speeches and writings draw upon, rely on, and reinforce. As Richard Leeman argues in his study of the conciliatory, teleological qualities of the president's rhetoric, Obama's speeches and writings expediently

privilege unity and harmony over difference and conflict. Obama's commitment to unifying notions of progress, according to Leeman, resonates with broader American and modern investments in a world that is perpetually advancing and approaching a better state.[9] Finally, by juxtaposing political speeches and novels, I intend to blur the line between fiction and nonfiction or at least make this line tractable. For instance, a novel like *Paradise* or *Jazz* incorporates and resignifies historical events and realities even as these works allude to necessary omissions and gaps in official historical records and documents; in addition, novels encourage readers to look back at widely accepted historical texts as sites of imagination and narrative construction. Similarly, political speeches, writings, and addresses rely on what Étienne Balibar calls the fictive quality of national identity, suggesting that imagination, myth, and narrative are involved in the construction and reproduction of collective belonging in ways that overlap with the creation and consumption of literary works.[10] It is important to keep these affinities and tensions between fiction and nonfiction in mind as we examine different expressions and articulations of loss, remembrance, and identity.

OBAMA, NATIONAL MOURNING, AND THE BEACON OF HOPE

In *The Audacity of Hope: Thoughts on Reclaiming the American Dream*, Obama attempts to offer an inspiring vision of American politics, a vision that transcends petty differences (between, for instance, conservatives and liberals, Republicans and Democrats) and that exhorts Americans to revamp and build on shared principles and values. He devotes an entire chapter to the topic of race, acknowledging that racial difference continues to shape the social fabric of American life and hinder the fulfillment of the nation's democratic promise. He begins the chapter with personal reflections on Rosa Parks's funeral, which he attended along with other notable public figures like Jesse Jackson and Bill Clinton. His reflections therefore begin in a state of mourning, recollection, and celebration. The death and celebration of the venerable civil rights activist become an occasion for Obama to reimagine the thorny relationship between race, nation, and politics. For Obama, it is important that we acknowledge our debt to activists like Rosa Parks, people "whose courage and grace helped liberate a people."[11] As he puts it, "Indeed, the magnificent church, the multitude

of black elected officials, the evident prosperity of so many of those in attendance, and my own presence onstage as a United States senator—all of it could be traced back to that December day in 1955 when, with quiet determination and unruffled dignity, Mrs. Parks refused to surrender her seat on the bus."[12] By honoring Rosa Parks, Obama suggests that we also pay tribute to the forgotten, silenced contributors to civil rights struggles; in the tradition of Emerson and Ellison, we express our piety toward the past, the sources of our current existence. Notice how Obama draws a linear trajectory from the event that sparked the Montgomery bus boycott to the prosperity, wealth, and political power of the black middle class. He suggests that this recently acquired power, success, and recognition demonstrates the successes and achievements of the civil rights movement. To deny the progress that black people have made, he claims, "dishonors those who struggled on our behalf but also robs us of the agency to complete the work they began."[13] Here we should be cautious of the teleological language used to frame black freedom struggles, the notion that historically there has been a unified end or goal for black people that the present generation needs to bring to fruition. In fact, black freedom struggles have been animated by a multitude of ends and concerns that don't always cohere or fit easily into the nation's popular narratives and projects—such as the call for structural economic change or the critique of American empire and militarism. We should also question the relationship between remembrance, progress, and agency that Obama imagines. While underscoring and acknowledging the progress that has occurred through black freedom struggles might inspire important forms of action, empowerment, and hope, we also need to remember the missed opportunities, failures, and the limitations and blind spots of these struggles (not to mention the more radical possibilities that had to be abandoned for the sake of recognition and practical, achievable change). These aspects of the civil rights movement might gesture toward alternative understandings of what we should hope for, alternative conceptions of what and how we should remember, and less predictable ways of acting, striving, and intervening in the current state of things.

While Rosa Parks's life and death prompt Obama to think about the favorable transformations in the racial order, he also acknowledges that America continues to be marked by racial inequities, conflicts, and losses. The nation and world witnessed these lingering tensions, according to Obama, during the aftermath of Hurricane Katrina. Obama offers poignant, unsettling images and stories of black, working-class suffering during

this tragedy to chasten and curb any kind of optimism around racial progress: "Images of teenage mothers weeping or cursing in front of the New Orleans Superdome, their listless infants hoisted to their hips, old women in wheelchairs, heads lolled back from the heat. . . . cars . . . on rooftops, bodies . . . still being discovered [two months after the storm], stories that the big contractors were landing hundreds of millions of dollars' worth of contracts, circumventing prevailing wage and affirmative action laws, hiring illegal immigrants to keep their costs down."[14] Obama acknowledges that natural violence is always mediated and exacerbated by social violence; natural disasters expose entrenched forms of power, inequality, and neglect. While natural disasters are colorblind, the conditions, effects, and consequences of these disasters are not. Certain factors that these tragedies render visible are mediated by race and class difference, such as the state's response or lack of response to the victims of nature's violence, the mobility and immobility of members of certain communities, and the existence of geographical and infrastructural constraints—the strength of levees, the durability of buildings, the arrangement of cities, and so forth. Obama also hints at the ways capitalist interests and projects can convert tragedies into opportunities for profit and material gain, a point that resonates with Naomi Klein's arguments in *The Shock Doctrine*.[15] Similarly, Obama draws the reader's attention to the exploitation of immigrant workers and the emergence of new constellations of race and class domination.

But Obama doesn't allow his language to become too harsh or critical in this chapter on race. He maintains a balanced tone, juxtaposing reasons for hope and optimism (the expansion of the black middle class, increasing opportunities for minorities to flourish and live well, moments of solidarity across racial lines) with a recognition that racial disparity is still prevalent in housing, employment, education, and other domains. He contends, "To think clearly, then, requires us to see the world through a split screen—to maintain in our sights the kind of America that we want while looking squarely at America as it is, to acknowledge the sins of our past and the challenges of the present without becoming trapped in cynicism or despair."[16] The split-screen image is enticing. It suggests that hope and mourning are not incompatible, that attunement to tragedy and loss shouldn't prevent us from envisioning a better world, a more perfect America. Similar to Du Bois, Obama advocates something like a double vision, a way of seeing that registers the conflict and gap between

possibility and reality, ideals and conditions that thwart the actualization of these ideals. As Robert Terrill suggests, Obama adopts and riffs on Du Bois's double-consciousness trope to reimagine American life, to look at the nation's past and present through a stereoscopic vision, a vision that accents tension and ambivalence without abandoning the possibility of greater unity.[17] This doubled vision becomes evident as he rejects the notion that we live in a postracial, colorblind society but also suggests that we should strive for a world in which racial identity is less significant than national identity and cohesion.[18]

While this notion of a split screen or double vision is intriguing, it potentially obscures the complicated relationship between what we long for and project as an ideal and how we understand and relate to the present. Contra Obama's exhortation, we never simply look at the world "squarely as it is." Our relationship to the empirical world is always mediated and shaped by narratives, desires, and fantasies that produce distortions and forms of misrecognition. More specifically, visions of a unified nation, world, or future influence the way people relate and respond to everyday expressions of difference, division, and conflict. A reading of Adorno's negative dialectics reminds us that understandable human desires for coherence and harmony (shaped in part by cultural practices, national agendas, and the logic of capitalism) weaken people's ability to engage facets of life, history, and human experience that are disturbing and uncomfortable. Following this insight, we should be attentive to the kinds of stories, ideals, and frameworks of meaning that shape the way selves experience, see, and interact with the empirical world and all of its complexities.

If certain kinds of narratives heavily shape the way we see current realities, remember the past, and imagine the future, then one of these narratives that Obama adopts in *The Audacity of Hope* is the American dream. He writes, for instance, "I believe that part of America's genius has always been its ability to absorb newcomers, to forge a national identity out of the disparate lot that arrived on our shores. . . . In this we've been aided by a Constitution that—despite being marred by the original sin of slavery—has at its very core the idea of equal citizenship under the law; and an economic system that, more than any other, has offered opportunity to all comers, regardless of status or title or rank."[19] Here Obama connects America's exceptional, unique status in the world to its ability to "absorb" newcomers, to convert foreigners and strangers into citizens and participants in the American dream. Yet he knows that there is an underside to

this story. As he puts it, "Of course, racism and nativist sentiments have repeatedly undermined these ideals; the powerful and the privileged have often exploited or stirred prejudice to further their own ends."[20] But perhaps the picture is more difficult and disturbing than Obama suggests here. As Ali Behdad points out in his book *A Forgetful Nation*, racist and nativist sentiments are not simply external constraints to America's collective understanding of itself. An ambivalence toward foreigners, immigrants, and racialized others (what Behdad refers to as the fluctuation between hospitality and hostility) has been fundamental to the construction and imagination of American culture.[21] More important, Behdad contends that the celebratory narratives that characterize America as uniquely tolerant and open result in a collective amnesia with respect to violence directed against internal and external others. Or the violent treatment of immigrants might be remembered as long as these memories are subordinated to an ideal picture of American tolerance. The point here is not that America is exceptionally bad, malevolent, or intolerant to strangers and others. The point is that triumphant narratives such as the American dream or American exceptionalism downplay, and at times erase, the violence and trauma involved in the construction of American identity and national identity more generally. They shield us from the dissonant, unsettling dimensions of American history and the making of nationhood. These triumphant images prevent the underside of these images from unraveling and undoing our attachments to them, thereby foreclosing a different and more melancholic kind of hope.

In his provocative and expedient speech "A More Perfect Union," delivered in 2008, Obama continued to articulate these themes of race, nation, memory, and hope. At a moment during his campaign when his association with Jeremiah Wright threatened to undercut his presidential aspirations, Obama reiterated the appeals and exhortations introduced in *The Audacity of Hope*. In short, he urged the nation to remember America's history of racial trauma without enabling this remembrance to prevent us from working to enhance and transform our social worlds. As Noelle McAfee puts it, Obama's speech called us to mourn and work through "the trauma of racism and slavery, but at the same time he could call on his listeners to take part in a collective project of changing these circumstances."[22] McAfee suggests that Obama maintained the doubled, stereoscopic vision mentioned above. Yet, as I will show, it is not clear in this speech if this doubled perspective retained the tensions and contradictions of the nation's racial

history or if, as Adolph Reed argues, this vision offered a rather simplistic promise of racial harmony, something like the final scene of Kramer's *Guess Who's Coming to Dinner*.[23]

It is important that Obama's "A More Perfect Union" speech took place in Philadelphia, across the street from the hall where the constitution was signed in 1787. By reminding us that this "place" is marked by memories of those who escaped "tyranny and persecution" and those who embarked on a unique democratic journey, Obama calls us to think about democracy as a treacherous experiment, born against the backdrop of dislocation, suffering, and European imperialism. After lauding the founding fathers for inaugurating this "improbable" democratic experiment, he contends that "the document they produced was ultimately unfinished. It was stained by the nation's original sin of slavery."[24] Despite this original sin, Obama claims that the extension of citizenship to black people was already implied or promised in the constitution's fundamental tenets. While the notion of a "promise" connotes a guarantee, Obama is quick to invoke the historical labor involved in actualizing this promise. He suggests that the ideals of equality, liberty, and justice do not simply unfold with the course of history as if progress is written into the nature of things or the essence of America. Rather these ideals have only been actualized by "successive generations who were willing to do their part—through protests and struggle, on the streets and in the courts, through a civil war and civil disobedience and always at great risk—to narrow the gap between the promise of our ideals and the reality of their time."[25] Obama locates his campaign and his biography within this ongoing struggle to achieve these ideals. In fact, his story, which he claims is only possible in America, corroborates the progress that the nation has made and can continue to make. As a viable candidate for the highest office in a nation that had, prior to 1965, systemically excluded blacks from the political realm, Obama embodies the American Dream. And his aim, as candidate and eventual commander in chief, is to contribute to shaping a "better future for our children and grandchildren."[26]

Obama acknowledges that this better future, which consists of a more unified, generous, and just America, is haunted by a past of racial inequality. His investment in the American promise is therefore tempered by an awareness that past decisions, policies, and conditions continue to shape and influence the (fraught) relationships between whites and people of color, the struggles of black Americans, unequal access to wealth,

capital, health care, and so forth. Invoking Faulkner's well-known epigram that "the past is never the past," Obama traces the effects of slavery and Jim Crow on current forms of racial disparity. The history of legalized discrimination, he suggests, "helps explain the wealth and income gap between black and white, and the concentrated pockets of poverty that persists in so many of today's urban and rural communities."[27] At the same time, Obama reminds black people that poor and working-class whites have a neglected history of being deprived of vital social goods. Alluding to the complicated interplay between race and class throughout the nation's history and to the ways race discourse often obscures class hierarchies, he expresses sympathy toward working-class whites who are "resentful" of blacks' benefitting from affirmative action and welfare. According to Robert Terrill, by taking seriously the anger, disappointment, and losses in both black and white communities, Obama "has invited his audience on each side of the color-line to view themselves with others' eyes. . . . The point is not to bring the two perspectives into harmonic equilibrium but to recognize that both sides are genuine."[28]

Even though Obama does not promise a perfect resolution to racial tension and ambivalence, he does urge the nation to move beyond the current "racial stalemate." In order to bring this about, Obama tells us that we have to collectively bear the burdens and traumas of the past without becoming victims of this past. Americans have to embrace their messy history, with its achievements and failures, without allowing this reclamation to foreclose new relationships, more productive visions of racial unity, and attempts to forge a more livable future. As he puts it, "For the African American community, the path [to greater unity] means . . . binding our particular grievances—for better health care, schools, and jobs—to the larger aspirations of all Americans—the white woman struggling to break the glass ceiling, the white man who's been laid off, the immigrant trying to feed his family."[29] Similarly, he suggests that the path toward a more perfect nation for white Americans includes a recognition that black people's grievances are not imagined; they are, rather, a justifiable response to everyday forms of neglect, discrimination, loss, and so forth. This forward trajectory also encourages white communities to support blacks and Latinos, because the flourishing of minorities increases the prosperity of the country as a whole. Ultimately, Obama assures the audience that blacks, whites, and other racial and ethnic communities can work through debilitating conflicts toward a mutual understanding and a collective, shared

project. A better, more prosperous future requires unity, cooperation, and a commitment to common American goals. Any obstacle to this hopeful vision would prove to be unproductive.

In this speech, Obama seems to perform Hegel's famous *aufheben*, a term that I discussed in chapter 1. Like Hegel, Obama identifies a difference or conflict that appears to be insurmountable and static, places this difference against the backdrop of a common third term (America's promise, America's future, American ideals), and enables the difference to approach a state of identity or unity without the differences being erased. Obama is therefore alluding to and endorsing the process of mutual recognition among America's racialized groups. Yet two concerns emerge here. First, as critical interpreters of Hegel point out, this conciliatory framework is necessarily enabled by excluding desires, grievances, claims, and ideas that might disrupt or unsettle this framework. In other words, while the logic and performance of mutual recognition might accept and reconcile certain kinds of difference, it does this by taming or dismissing the more recalcitrant forms of difference, resistance, and dissent.[30] Second, we should examine this third term or common set of practices and ideals that mediate difference in Obama's vision. While our collective attachment to America and American ideals is supposed to facilitate racial reconciliation, this often happens by redirecting many of the traditional racial fears, anxieties, and resentments to the nation's "threatening others"—immigrants, Muslims, Arabs, threats to America's imperial interests.[31] Racism is not reconciled or ameliorated in this process; rather, it is displaced, rearticulated, and mediated by subtle and explicit forms nationalism and national exceptionalism. So even though there is much to applaud in Obama's attempt to advance the process of mutual recognition between blacks and whites in this speech, we should be attuned to the residual conflicts and the less manageable forms of difference and alterity that cannot be easily incorporated into this conciliatory endeavor.

One instance of a moment that cannot be easily absorbed or assimilated into a productive vision of American futurity is Jeremiah Wright's critique of America. Even though there are aspects of Wright's sermons and public speech acts that I disagree with, I focus here on Obama's concerns with Wright's diatribe against America. To be sure, Obama lauds Wright, his former pastor, for the work he has done to strengthen and improve impoverished communities in Chicago. Obama also refuses to disown Wright or the black church, acknowledging that this institution, with all of its

flaws, strengths, and possibilities, has shaped and formed him and that the black church tradition constitutes a central part of American history and culture. Yet Obama distances himself from the incendiary rhetoric in Wright's sermons. He suggests that Wright's unfair and "distorted" critique of American empire undermines the project of creating a more perfect nation. He claims:

> But the remarks that have caused this recent firestorm weren't simply controversial. They weren't simply a religious leader's effort to speak out against perceived injustice. Instead, they expressed a profoundly distorted view of this country—a view that sees white racism as endemic, and that elevates what is wrong with America above all that we know is right with America; a view that sees the conflicts in the Middle East as rooted primarily in the actions of stalwart allies like Israel, instead of emanating from the perverse and hateful ideologies of radical Islam. As such, Reverend Wright's comments were not only wrong but divisive, divisive at a time when we need unity . . . The profound mistake of Reverend Wright's sermons is not that he spoke about racism in our society. It's that he spoke as if our society was static; as if no progress has been made; as if this country—a country that has made it possible for one of his own members to run for the highest office in the land and build a coalition of white and black; Latino and Asian, rich and poor, young and old—is still irrevocably bound to a tragic past. But what we know—what we have seen—is that America can change. That is [the] true genius of this nation. What we have already achieved gives us hope—the audacity to hope—for what we can and must achieve tomorrow.[32]

Notice that Obama does not object to Wright's willingness to speak out against injustice. The problem, however, is how Wright speaks about these injustices, how he frames them, and the effects of Wright's rhetoric on the nation's racially fragmented condition. Obama highlights three related problems with Wright's publicized sermons—they are divisive and a threat to unity, he assumes that America is static and cannot change, and he elevates the bad over the good, thereby vitiating hope. In what follows, I respond to the first charge separately and the second two accusations together.

As Richard Leeman stresses and as we have seen throughout this chapter, Obama's speeches and writings are structured by a teleological

framework, meaning that he interprets and understands present conditions and problems according to a unified end or goal (that America gradually advances toward and fulfills). Unity is a necessary good; while diversity is valued, division and conflict are qualities to be overcome and resolved. Referring to the "A More Perfect Union" speech, Leeman writes, "[Obama's] analysis is grounded in the teleological nature of America as a society that pursues unity through its diversity. Although in this vision Obama embraces diversity—for America's unity is achieved and strengthened through diversity—division is rejected because it prevents unity."[33] According to Leeman, when Wright's rhetoric works within this American telos, his dissent can be tolerated; when Wright's dissent troubles and unsettles this commitment to unity and harmony, he must be rejected. Wright, to put this differently, doesn't concede to this progressive teleology and therefore cannot be easily assimilated into Obama's vision of a better future and nation. One can partially agree with Obama's insistence that the possibility of change and transformation relies on moments of unity, moments in which different communities and constituencies gather and organize around common goods, desires, and concerns. At the same time, the possibility of change also relies on introducing and heightening tensions, conflicts, and dissidence that are concealed by the tendency to privilege or assume unity. As Bonnie Honig points out, liberal notions of "unity through diversity," despite good intentions, work to displace politics and political change. According to her analysis, the premium placed on consent and unity render us hostile to disruptive expressions of difference and dissent, expressions that open up possibilities for unanticipatable transformations in the way selves think, imagine, act, and relate to each other.[34] Think, for instance, of Obama's accusation that Wright attributes conflicts in the Middle East to "stalwart allies like Israel" rather than "perverse" ideologies of radical Islam. Here Obama relies on and assumes a consensus around how Americans should imagine and interpret the violence and suffering in this region. He rejects and depoliticizes the possibility that Wright is introducing an alternative way of framing and reading this violence, one that implicates both state and nonstate forms of terror and cruelty.

In addition to the divisive quality of Wright's speech, Obama criticizes Wright for being too pessimistic, for focusing too much on America's flaws, and for denying the possibility that America can change. This criticism assumes that underscoring the density and pervasiveness of conditions,

practices, and arrangements that produce everyday suffering for racialized others and communities outside of America is somehow unhopeful. It similarly omits the fact that Wright's excessive and incendiary rhetoric is a response to the entrenched indifference to suffering, to the ways violence and trauma become disguised under the rubric of expanding democracy, spreading freedom and opportunity, America's greatness, and so forth. Perhaps Wright gestures toward a different kind of hope, a hope that is tethered to the difficult practice of mourning those who typically remain unrecognized, to our capacity to become more sensitive to and aware of the violence that we directly and indirectly inflict on others. This is a hope that is certainly inspired by achievements in the past and present. But it is also motivated (and agitated) by losses and failures that are forever intertwined with these achievements, especially those losses that are entangled with celebratory images and motifs like the "genius of America." According to this interpretation, Wright's provocative sermons don't have to be interpreted as denying the possibility of change. Rather, his position implicitly acknowledges that with the introduction of novelty and change into the world stubborn, uncomfortable realities return and rearticulate themselves in new ways. As America, history, and human experience change, certain conditions and constraints remain in place—hostility toward those identified as deviant, deficient, and threatening to the general order, the desire to control and manage these threatening forms of difference, and the tendency to place a premium on certain lives over others. These conditions are expressed and organized through race, gender, class, and national difference; these intractable realities, when taken as constitutive aspects of social and political existence rather than as deviations, trouble the teleological vision of America that Obama adopts. They cut against this progressive telos, confirming Adorno's claim that the secret telos of harmony is dissonance.[35]

Authors like Robert Terrill and Noelle McAfee, who offer insightful and laudatory interpretations of the "A More Perfect Union" speech, downplay the limitations and dangers in Obama's progressive teleology. For instance, McAfee, as mentioned above, argues that this speech prompts the nation to collectively perform the work of mourning, a process that has vital political and ethical implications. She writes, "Over time, the socio-political work of mourning nurtures a democratic superego, norms and practices that honor trauma and reckoning, as well as a democratic soul, a psychology for citizenship where we become willing to be unsettled and culti-

vate a habit of being surprised."[36] She suggests that while Wright "blindly" focuses on America's contradictions, Obama offers us an integrative, conciliatory narrative that both calls the nation to mourn and to hope for significant change and a different future. Obama's speech, which she situates against the backdrop of John Dewey's philosophy and the broader tradition of American pragmatism, reminds us that the cultivation of good habits like mourning, self-questioning, respect for the other, and democratic dialogue might enable us to transform our conditions. While I agree with McAfee's point about the political work of mourning, my concern is that she does not address the relationship between this labor and other dimensions of Obama's vision that severely tame and constrain the work that mourning can perform—progressive teleology, American exceptionalism, and insistence on unity. If contemplating tragedy and loss is supposed to unsettle, disturb, and render selves more vulnerable, then this is accomplished by undoing our attachments to triumphant images and motifs that justify certain kinds of violence (in the name of a better, more prosperous future), that foster indifference to suffering and loss, and that turn dissonant memories and attachments into comforting ones. Confronting loss, in other words, figuratively wounds us; it exposes and potentially reduces our investment in being coherent selves, communities, and identities. Similarly, contemplating the tragic quality of America's racial history should unravel teleologies that privilege unity over difference, fragmentation, and brokenness, as if those qualities can be overcome by fulfilling the national telos or pursuing the path toward perfection. Becoming more open and vulnerable to the agony and torment of others requires us to loosen, rather than tighten, our attachment to reassuring narratives about the genius, uniqueness, and supremacy of our practices and ways of life, celebratory narratives that shield us from the unsettling work that mourning can accomplish. While McAfee is right to point out the mournful dimension of Obama's speech, she ignores the fact that this dimension is conveniently mitigated and diminished by his commitment to the familiar fortifying notion that America is the exceptional site of progress and freedom.

Obama's "A More Perfect Union" speech therefore offers a provocative way to think about the relationship between mourning and hope. This hope is motivated by the possibility of reimagining the past and working together to "finish and complete" the American democratic experiment. This hope is implicitly tethered to a teleological and imperial image of America, thereby lessening the unsettling effects that remembrance of loss

and suffering might engender. And even though the exceptional rhetoric is toned down and only implicit in this speech, it becomes more explicit in later public expressions, including his dedication to the Martin Luther King Memorial.[37]

In his dedication speech, delivered in 2011, Obama uses the occasion to honor the civil rights leader's accomplishments. According to Obama, King expanded our moral imagination and our conception of freedom. He spearheaded a struggle for economic justice, his political vision maintained a balance between division, or agitation, and reconciliation, and he showed us that peace and justice are intertwined in the struggle for a more free and democratic society.[38] For Obama, King's image becomes a signifier of difficult but hopeful realities. The civil rights movement that he helped galvanize shows us that progress is "slow but certain." While progress has certainly taken place, this "progress was hard. Progress was purchased through enduring the smack of billy clubs and the blast of fire hoses. It was bought with days in jail cells and nights of bomb threats."[39] Here Obama reiterates the point, articulated in the Philadelphia speech, that progress is the result of struggles, sacrifices, and losses. Or as he puts it, "For every victory during the height of the civil rights movement, there were setbacks and there were defeats."[40] Progress, at least in this instance, is a site of ambiguity. Similarly, the nation's current state is fraught with tensions and ambiguities, according to the president. While "America is more fair and more free and more just [than in King's day]," Obama acknowledges that "nearly 50 years after the March on Washington. . . . we have been tested by war and by tragedy; by an economic crisis and its aftermath that has left millions out of work, and poverty on the rise, and millions more just struggling to get by."[41] Obama also recognizes that for many communities in this country, conditions have remained the same during the last four or five decades. This is a moment when Obama is not only suggesting that progress is slow and difficult; he is also implying that progress is a broken, fraught, and tangled movement rather than a sweeping, unifying process.

The end of the speech, however, works to assuage the tensions and ambiguities that Obama locates in King's legacy, the civil rights movement, and the nation's racial landscape. He concludes on an optimistic note: "And that is why we honor this man—because he had faith in us. And that is why he belongs on the Mall—because he saw what we might become. That is why Dr. King is so quintessentially American—because

for all the hardships endured, for all our sometimes tragic history, ours is a story of optimism and achievement and constant striving that is unique on this earth. And this is why the rest of the world still looks to us to lead."[42] According to Obama, King's memorial "belongs" on the Mall; it fits properly alongside America's familiar and accepted images and icons. While it is important and valuable to publicly recognize the commitments, practices, achievements, and losses symbolized in King's image, aligning this image with America's celebratory symbols and rituals potentially dampens the dissonant aspects of the struggles that Obama associates with King. As Walter Benjamin points out, images from the past are always in danger of becoming a resource for those in power, a resource to solidify the status quo and reassure people of the order of things. This incorporation domesticates memories of past struggles, ruptures, and losses and prevents these memories from destabilizing our understanding of the present and opening up radical alternatives for the future.[43] Obama seems to confirm Benjamin's fears when he deploys the tragedies of American history to reinforce the idea of American exceptionalism. Where the complexities of this history might disconcert and unsettle us, it becomes a means, at the conclusion of this speech, to reassure the nation of its familiar collective self-image. The nation's endurance and optimism in the face of tragedy is, for Obama, an indication of the nation's uniqueness and a subtle justification of American empire. Among other things, this obscures King's insistence that racial injustice in America is historically connected to the violence directed toward black, brown, and yellow bodies abroad, violence that, for him, derives from the pernicious relationship between imperialism, nationalism, and militarism.[44]

I can imagine a skeptical reader's introducing some critical questions. Is Obama's understanding of America all that different from that of King (or Ellison and the early Du Bois)? Haven't many members of the black aesthetic and literary tradition flirted with American exceptionalism? Doesn't the very space or office of the presidency require Obama to adopt this hoary image and idea of America and American history? Doesn't this situation represent what James Baldwin calls "the price of the ticket"?[45] Isn't the aim of any presidential speech to inspire and galvanize the people with the use of available, unifying images and symbols? In response to the first set of questions, it is true that black writers, authors, and activists have always been seduced and shaped by what Sacvan Bercovitch calls the "symbol of America."[46] At the same time, as I have suggested throughout

this book, authors like Du Bois, Ellison, and Morrison have also challenged and resignified this trope by inscribing experiences of racial trauma, struggle, and loss into the nation's history. Obama certainly participates in this resignifying tradition. He inherits the ambivalent relationship to progress and the symbol of America from the authors discussed in this book. (In addition, he has witnessed and benefitted from changes and shifts within the racial order that someone like Du Bois did not experience.) But this should not dissuade us from examining how certain aspects of his thought and rhetoric, both before and during his presidency, function to diminish the ambivalences and tensions around race, nation, politics, and history. The conventional idea of America and the logic of progress work to manage and tame these tensions; they provide a conciliatory framework, telos, and horizon for dissonant memories, attachments, desires, and longings. At the same time, one should not expect much more from someone occupying the office of the presidency. As suggested above, I understand that Obama's public utterances, speech acts, and exhortations are constrained by certain rules, expectations, and interests that do not apply to the writings and interventions of someone like Morrison or Ellison (or that do not apply in the same way). Like anyone, he works with and within the norms, discourses, and subject positions that he has inherited. Yet this does not mean that one should not be suspicious and critical of Obama's speeches and writings. In fact, because he adopts and rearticulates ideas and assumptions about America that are pervasive, taken for granted, and readily available, it is important to examine and interrogate these ideas and rhetorical strategies. Because these all-too-familiar notions of America as an exceptional nation, as a unique site of progress and freedom, are invoked to reassure and comfort citizens, to deflect attention away from the violence and suffering involved in racial formations and nation-building, the president's speech-acts contribute to the overall shaping of political memory, forgetfulness, and desire. Therefore, as the political theorist Sheldon Wolin suggests, we should always be mindful of how presidential addresses, national rituals, and civic celebrations (like the Martin Luther King memorial speech) function to organize collective memory, tame dissent, and produce "reliable" subjects.[47] While celebratory images of the nation shape collective memories in ways that mitigate "the pain and costliness of past choices" and manage the dissonant, unsettling dimensions of history, these images also place constraints on our ability to imagine a different, more promising kind of future.[48] Yet, presidential discourses and

civic rituals do not completely flatten and reduce possibilities for thinking, remembering, and acting differently; as much as they constrain, they also open up space for critique, contestation, and revision.

RORTY AND THE COSTS OF ACHIEVING OUR NATION

Despite the fact that overconfident notions of national identity and achievement vitiate the capacity to remember and be affected by the painful details of the past and present, some would insist that a strong identification with the nation is still necessary to bring about change and improvement. The late Richard Rorty takes up this position in his provocative text *Achieving Our Country*. Broaching Rorty's reflections on the relationship among national pride, shame, and agency is instructive for several reasons. First, as intimated above, many authors have recently included Obama within the tradition of American pragmatism, a tradition that Rorty helped to revive.[49] Juxtaposing Obama and Rorty therefore illumines possibilities, limitations, and dangers in this influential tradition of thought and practice. Second, Rorty argues in this text that there has been too much melancholy in the intellectual Left since the 1960s, a trend that prevents these intellectuals from expressing pride in the nation's achievements, from hoping and struggling for a better America and world. Like Obama, he suggests that the possibility of change depends on balancing hope and melancholy, or in his terms, pride and shame. Finally, Rorty contends that leftists can embrace an inspiring image of America without adopting a metaphysical, redemptive narrative of the nation, a narrative that he himself cannot fully resist.

A charitable reading of Richard Rorty's aims and qualms in *Achieving Our Country* is certainly warranted. Motivating Rorty's provocative reflections is a concern that the contemporary academic Left has embraced a cultural politics (of reading and interpreting texts) and jettisoned its commitment to concrete political struggles, a commitment that he identifies and lauds in the work of progressives before the Vietnam War. His concerns therefore resonate to some extent with those of Adolph Reed, discussed in chapter 2. Instead of aligning itself with labor unions or promoting policy reform, the academic Left, he bemoans, has given up on the possibility of piecemeal change. Those who are seduced by the somber writings of Foucault and Heidegger assume that power is so pervasive, so deeply entrenched in the habits and dispositions of subjects, that only a

radical break from the present can bring about substantial change. With an abundance of melancholic theory that highlights domination, violence, and past injustices, the academic Left offers very little to inspire and motivate everyday people to get involved in efforts to ameliorate their communities. Contemporary theory, especially those ideas imported from Europe, produce a cadre of spectators who merely interpret power relationships, instead of agents who intervene in these relationships.

According to Rorty, inspiring everyday Americans entails offering a hopeful account of America's history that strikes a balance between national pride and shame. Hope, he suggests, requires a strong identification with one's country, its ideals, achievements, and losses. He writes:

> National pride is to countries what self-respect is to individuals: a necessary condition for self-improvement. Too much national pride can produce bellicosity and imperialism, just as excessive self-respect can produce arrogance. But just as too little self-respect makes it difficult for a person to display moral courage, so insufficient national pride makes energetic and effective debate about national policy unlikely. Emotional involvement with one's country—feelings of intense shame or glowing pride aroused by various parts of its history, and by various present-day national policies—is necessary if political deliberation is to be imaginative and productive. Such deliberation will probably not occur unless pride outweighs shame.[50]

Rorty acknowledges that the possibility of national improvement is necessarily enabled by remembering the past in an appropriate way. The nation's denizens must be instructed to remember achievements like the civil rights movement as well as the unjust treatment of black people, which sparked this movement. Rorty assumes that emotional involvement with the nation is necessary for effective deliberation and debate. He seems to leave out the possibility that questioning the discourses that render the nation an "immediate," taken-for-granted object of desire might be essential to cultivating a more insurgent political ethos. Even as Rorty acknowledges the play between pride and shame, he ultimately suggests that the former emotion must outweigh the latter. If this is the case, one might wonder what "productive" work memory and shame do besides chasten national pride and prevent pride from becoming imperialistic. His insistence on pride's outweighing shame suggests that hope for a better future and nation must outweigh and ultimately resolve the dissonant effects of

melancholy, of cultivating a heightened sensitivity to historical loss, suffering, and cruelty.

Though Rorty leaves space for painful memories in his initial formulation of the relationship between pride and shame, this space is usurped by a sanguine narrative of American progress that relies on enthusiastic interpretations of Whitman, Dewey, and Hegel. The following passage is telling:

> Hegel's philosophy of history legitimized and underwrote Whitman's hope to substitute his own nation-state for the Kingdom of God. For Hegel told a story about history as the growth of freedom, the gradual dawning of the idea that human beings are on their own, because there is nothing more to God than the march through the world—nothing more to the divine than the history of the human adventure. In a famous passage, Hegel pointed across the Atlantic to a place where as yet unimagined wonders might be worked: "America is the country of the future . . . the land of desire for all those who are weary of the historical arsenal of old Europe."[51]

According to Rorty, Hegel's theoretical success in rendering God immanent (or collapsing the qualitative distinction between God and man), renders us free from the constraints of an exterior, otherworldly power. The German philosopher's effort to show how the absolute, God, develops within time and through social interactions is a crucial step in the progressive movement away from authoritarianism. Rorty therefore lauds Hegel, and Whitman's implicit piety toward Hegel, for ascribing to ordinary people various responsibilities traditionally attributed to God or divinely sanctioned rulers. This Hegelian-inspired freedom from an outside, arbitrary authority leads to the contingent, human freedom to experiment, create, and cultivate solidarity—a freedom that Hegel suggested would be best exemplified in America. The development of spirit, history, and freedom, from now on, depends on the actions, creations, and projections of the demos. This insistence on the development of freedom being mediated by people's actions resonates with Obama's repeated claim that progress, rather than being an inevitable movement, depends on the struggles and sacrifices of everyday men and women.

But there is another side to the Hegelian story that Rorty tells in this chapter. Rorty does not sound too concerned about the dangers associated with "killing God" especially when humanity, or America, takes God's

sanctified place after the coup. (This substitution is even more troubling when God is reimagined as a human "march" through history.) Rorty, in accordance with this Hegelian reading, extols Whitman for "thinking that we Americans have the most poetical nature because we are the first thoroughgoing experiment in national self-creation: the first nation-state with nobody else to please—not even God. We are the greatest poem because we put ourselves in the place of God: our essence is our existence, and our existence is in the future . . . we define God as our future selves."[52] Here Rorty is suggesting that God, for Whitman, becomes something like John Dewey's notion of actualized ideals, ideals that are finite, contingent, and temporal. Along this line of thinking, divinity is no longer the property of a transcendent power; it is now identical to American futurity and possibility. Yet there are dangers, overlooked by Rorty, that arise from sublating the Kingdom of God into the nation-state or, to put it differently, substituting (American) futurity and self-creation for the absence or death of God. One danger that emerges is a potential deafness and blindness toward temporal and spatial others (the past and non-Americans). The autonomous and creative national will that Rorty celebrates is not animated by receptivity to those residing beyond our temporal and spatial borders.[53] The past can never "obstruct the future." We have "nobody else to please" but our "future selves." Here I think all too ruefully of the link between the unrestrained freedom to create and experiment and the violent expansion of liberal regimes. I am thinking of how the myth of America as an unoccupied land of the future anticipates and underwrites the erasure of the bodies, narratives, practices, and memories of Native Americans. I am thinking broadly of the many undersides of Rorty's Hegelian story of the march of freedom, undersides that Hegel acknowledged.

In addition to the dangers associated with replacing God with America or the nation's future, Rorty evades the theological remnants in Whitman's commitment to America's greatness and uniqueness. According to Bercovitch, the well-entrenched idea that America is the privileged site of democratic freedom cannot be divorced from the jeremiad tradition, a tradition that identifies America as a divinely chosen nation with a special errand to rescue the world. Whereas Rorty claims that authors like Whitman evade the redemptive, quasitheological framework of Marxism, Bercovitch contends that Whitman's picture of America exemplifies a tendency to fuse the religious and the secular, to combine the sacred and the profane.[54] As Bercovitch puts it, "America has united . . . secular and

redemptive history . . . in a single synthetic ideal."[55] For Bercovitch, the idea of America, even in its so-called secular guises, acts as a redemptive force, which justifies the expansion of national borders in the name of a civilizing mission and resolves the tensions and contradictions involved in fulfilling this mission. By broaching Bercovitch's reading of the American jeremiad tradition, I am not suggesting that Rorty's picture of America and American history is necessarily a redemptive one or that he is confined to the jeremiad tradition. My contention is that by not seriously addressing what Charles Taylor might call the theological "sources" of his optimistic image of America, he ignores the ways this optimistic image can easily slide into a redemptive narrative (one that enables the infinite possibilities of America's future to dampen the unsettling effects of historical trauma, suffering, and loss or that similarly justifies a violent, civilizing mission).

To be clear, I am not suggesting that Rorty is unaware of America's tortuous history, in which expansion and experimentation are intertwined with violence, erasure, and loss. Nor am I suggesting that he condones the violence that has been done in the name of the nation-state. What I am arguing is that by reconstructing a story of America's emergence and development that privileges pride, achievement, and futurity, he mitigates the more dissonant elements and affects of that story, those painful dimensions that are intertwined with and inseparable from America's temporal and spatial march forward. This is exemplified in Rorty's brief engagement with America's racial history as he contrasts the civil rights writer and activist James Baldwin with the founder of the Nation of Islam, Elijah Muhammad. Disclosing to the reader that the title of his book *Achieving Our Country* is taken from a line at the end of Baldwin's book *The Fire Next Time* (1963), Rorty applauds Baldwin for not succumbing to hatred and disgust, for not giving up on the possibility of crossracial solidarity. Whereas Elijah Muhammad and the Nation of Islam demonstrate rancor toward white America, Baldwin, according to Rorty, "combines a continued unwillingness to forgive with a continuing identification with the country that brought over his ancestors in chains."[56] But as the philosopher Bart Schultz points out, "Rorty's Baldwin is not the angry Baldwin who, like Richard Wright, moved to France to escape American racism."[57] In other words, in order for Baldwin to fit into Rorty's story of hope and achievement, certain dimensions and qualities of Baldwin's text (visceral anger, feelings of anguish, the relationship that Baldwin articulates between racism and terror) have to be minimized. Baldwin's more unsettling

qualities have to be managed in order to fit into Rorty's picture of America, a scenario that resembles Obama's treatment of Wright in the Philadelphia speech.[58] Rorty downplays Baldwin's claim that racism persists in America in large part because the nation's dominant self-images, rituals, and narratives tend to deny what he calls the irreducible "fact of death."[59] For Baldwin, the myth of American innocence and the general human desire to guard and hold onto individual and communal fantasies of purity, seduce us into thinking we can disentangle ourselves from the messy, dirtying features of modern life and American history. The persistence of racism for Baldwin is intertwined with narratives that diminish the importance of shame and melancholy, connections that Rorty downplays. In Baldwin's writings, the black body historically provides a powerful reminder and signifier of death and suffering, a "past of rope, fire, torture, castration, infanticide, rape; death and humiliation."[60] Baldwin suggests that hope for a better America must be tethered to the capacity to remember and work through various forms of death and loss, a capacity that has been vitiated by America's triumphant narratives and rituals. Even though Rorty purports to eschew these kinds of stories and images, his reading of Hegel and Whitman actually reintroduces them.

Similar to Obama, Rorty rightly insists that enhancing our social worlds requires a level of resiliency. Like Ralph Ellison's jazz artist in "The Little Man at Chehaw Station," Rorty urges us to creatively respond to the painful details of life and history in a way that does not leave us hopeless or stagnant. In order to imagine and construct a better nation and world, we have to tell inspiring stories about the nation's achievements, about successful struggles against injustice that expanded our conception of freedom, democracy, and possibility. Pride and hope, according to Rorty, must outweigh shame and melancholy if we are to continue and advance these struggles. While resistance and change certainly depend on stories and images that inspire and galvanize, resistance also depends on stories that disrupt, unsettle, and disturb (of course these affects and responses are not mutually exclusive). A world in which selves are more receptive and vulnerable to the torment and pain of others requires us not only to create new, inspiring accounts of history but to become more vigilant of the tendency to tell stories that reassure us of our power, coherence, and self and communal identity. This would be a world in which hope is not divorced from shame and melancholy but enabled by these affects and dispositions; in fact, hope would involve the capacity to be figuratively wounded, un-

done, and transformed by the violence and suffering that selves are always implicated in, particularly the violence that sustains racial and national formations. In opposition to notions of hope that rely on fortifying and reinforcing established identities, an alternative hope might link the possibility of a better world to cultivating practices and interactions marked by receptivity, vulnerability, and heightened attunement to loss and damage. This would be a risky, precarious hope prompted by desires to build new relationships and communities, modes of coexistence that are suspicious of narratives that transform trauma into an instance of progress or national pride. This would be a striving for a better future that is more willing to linger and tarry with the "negative" affects, desires, and sensibilities that accompany human experience, an engagement with possibility that takes seriously the violence that often accompanies our best efforts and projects. In the final section of this chapter, I turn to the work of Toni Morrison to trace these possibilities.

MORRISON AND THE UNDERSIDE OF PARADISE

In the age of Obama, it is tempting to interpret black people's achievements as a confirmation of America's exceptional status. As the strong notion of a postracial America reinforces commitments to American supremacy, we forget about traditional forms of racial cruelty that linger in the present and neglect new expressions of racism that are mediated by nationalism, exceptionalism, and imperial dispositions. This scenario also betrays a tendency to conflate hope and optimism, suggesting that communities cannot engender hope without clinging to compensatory teleologies, progress, or sanitized accounts of history and nationhood. Toni Morrison's work gestures toward an alternative way of thinking about the relationship between race, nation, remembrance, and violence. By turning to her work, I am not suggesting that she resolves the problems and tensions associated with these relationships. Similarly, I am not implying that Morrison completely escapes the logic of national exceptionalism or the notion that America's unique qualities and possibilities can redeem the traumas of history. As George S. Shulman points out in his fascinating study of American prophecy, Morrison's public utterances occasionally reveal patriotic and conventional nationalist sentiments that seem incompatible with her novels and essays.[61] Acknowledging these limitations, I turn to her fascinating novel *Paradise*, in order to trace a more promising

way of thinking about, interpreting, and relating to national and racial formations, one that challenges the tendency to minimize or deflect the trauma and loss involved in these formations. In addition, I suggest that Morrison offers a more promising and productive conception of the post-racial, one that diverges from a unifying telos of national progress and that draws attention to struggles, tensions, and losses that are not reducible to racial differences and logics.

Morrison's *Paradise* is a novel published in 1997 about an all-black town in Oklahoma named Ruby, whose identity and sense of unity is largely determined by memories of historical loss and dislocation as well as ancestral triumph. Established in 1950 by the descendents of slaves, exiles, and refugees (especially those who fled the South after the period of Reconstruction), Ruby is a patriarchal community defined by rigid norms, a proud attachment to the struggles and achievements of the "Old Fathers" against racism and white supremacy, and a refusal to confront the tensions and conflicts that haunt its inhabitants. The novel begins with the men of Ruby tracking down and murdering five women who reside in a convent located seventeen miles outside of Ruby. Referred to as "strange neighbors," these women are also exiles, subjects who have been forced to flee hostile and physically harmful situations. The wild, "lawless" women of the convent pose a threat to the residents of Ruby not only because they disrupt the rigid gender norms and codes of the all-black community (they live in a space without men), but also because these women remind the community's members of internal tensions and conflicts that have been neglected and suppressed. The hunt for and murder of these women, the treatment of these women as prey, is apparently justified insofar as "the target, after all, is detritus: throwaway people that sometimes blow back into the room after being swept out the door."[62] One question that Morrison seems to be interested in in this novel is why the construction of "paradise" or the perfect community is predicated on violent exclusions and the treatment of recalcitrant outsiders as detritus, as garbage that, despite the community's purging efforts, "blows back" and cannot be completely swept away.[63]

The settings and timeline of the novel are important to consider. Like most of Morrison's novels, the narrative is not linear and refuses to be confined to one historical moment or context. Like *Jazz*, *Paradise* is marked by an agonistic relationship between present and past, an interaction in which the past haunts, unsettles, and interpenetrates the present. While the opening scene, in which the five convent women are murdered, occurs

in 1976, the novel encapsulates a history that begins in 1755. As Peter Widdowson points out, by tracing the genealogy of the town of Ruby to ancestors dwelling in French territory in 1755, the novel acts as "a fictional intervention in American historiography."[64] It contests accounts of the nation's birth, such as the one that Obama offers in the Philadelphia speech, that begin with or privilege the actions of the founding fathers, the signing of the Declaration of Independence in 1776, or the ratification of the constitution in 1787. Morrison's literary intervention does not deny the importance of these moments but enables the reader to reimagine the nation's timeline and to remember events, communities, bodies, and possibilities that antedate and challenge the nation's official beginnings (and that tend to get buried under the founding-father motif). In addition, Morrison's fictional retelling of American history reminds the reader that history and myth are intertwined; the stories that we tell and the stories that shape our understanding of history, nationhood, and identity are never completely objective.[65] On the contrary, these historical accounts always include fantasy, nostalgia, selective interpretations, and convenient omissions. Finally, it is significant that the opening scene and the novel's current actions take place during the bicentennial of the Declaration of Independence. This coincidence compels the reader to think about the connections, affinities, and tensions between black freedom struggles (the novel begins almost a decade after the historic civil rights victories that secured black people's rights as citizens) and other, related national struggles for freedom, independence, and equality. More specifically, the sacrifice of the convent women, among other effects, intimates and reenacts the violent erasures and exclusions that mark the emergence and establishment of national identity. Morrison therefore inscribes violence and loss into the bicentennial, one of the nation's celebratory rituals and ways of remembering.

Even though the structure and timeline of *Paradise* challenge standard foundation stories, the characters in the novel inherit and pass down myths that mimic the more familiar narratives about the origins of America. The town of Ruby, especially the elder men of this all-black town, imagine themselves carrying out and fulfilling the master narrative bequeathed to them by Zechariah Morgan. Referred to as Big Papa (which clearly reiterates and resignifies the founding-father motif), Zechariah is remembered as a Moses-like figure who leads Ruby's ancestors from the terror-filled conditions of the South to the promised land of Haven, Oklahoma in 1890. While this heroic story of migration, survival, courage, perseverance, and

building a community is supposed to be a source of pride and a sense of collective achievement, this story is also marked by moments of shame, humiliation, and loss. "On the journey from Mississippi and two Louisiana parishes to Oklahoma, the one hundred and fifty-eight freedmen were unwelcome on each grain of soil from Yazoo to Fort Smith. Turned away by rich Choctaw and poor whites, chased by yard dogs, jeered at by camp prostitutes and their children, they were nevertheless unprepared for the aggressive discouragement they received from Negro towns already being built."[66] The humiliation that Zechariah and his followers experience on their journey culminates in the "Disallowing," a name ascribed to the rejection of these dark-skinned migrants by the light-skinned residents of Fairly, Oklahoma. Because Zechariah and his followers are "too poor, too bedraggled looking," they are denied access into the all-black towns that have recently been established.[67] They don't belong. After this denial, these migrants "become a tight band of wayfarers bound by the enormity of what happened to them."[68] In response to the rejection of their dark skin by the residents of Fairly, Zechariah and the other patriarchs of this migrant community rename themselves the "8-Rock men," signifying that their coal-colored skin has been converted from a marker of ridicule and exclusion into a signifier of pride, honor, power, and respect. The underside of this sense of pride is the community's rejection of light-skinned blacks and whites, a kind of repetition of the disallowing.

As Katrine Dalsgard argues, this story of wandering through a hostile wilderness toward a new home, toward a "promised land," resembles the standard historical account of the Puritan pilgrims (escaping persecution in Europe and making an exodus to the American promised land), an account that, according to Bercovitch, underpins and anticipates American exceptionalism.[69] Like the Puritans, the residents of Haven and Ruby locate their struggles and achievements within a framework of divine selection. God, through a mysterious, nomadic mediator, guided Zechariah Morgan and aided the migrants in their turbulent journey to a new haven and home. But as Dalsgard rightly points out, Morrison is also alluding to traditions of black nationalism, especially those strands that proclaim a special relationship between God and black people.[70] As Eddie Glaude argues in his provocative text *Exodus!*, the biblical story of God's liberating the Israelites from Egypt has been appropriated and reinterpreted by black Americans to imagine and forge a communal identity over time.[71] According to Glaude, black communities before and after the Civil War

have embraced the themes and motifs in this story to make sense of racial suffering, dislocation, and injustice and to imagine a liberated future, a better predicament for black people. In his insightful investigation of the relationship between race, religion, and nation in antebellum America, Glaude focuses on the more auspicious and promising dimensions of black nationalism, especially as it opens up space for black people to oppose white supremacist practices and create bonds, relationships, and counterpublics in the face of these unjust, exclusionary practices.[72] He similarly underscores the democratic, community-creating effects of the exodus story for persecuted groups while downplaying the underside of this story—the destruction of the Canaanites or those communities and peoples that already inhabit and lay claim to the promised land. The exodus story, as we have seen throughout history, repeats the violence and suffering that it purportedly redeems.[73]

In *Paradise*, Morrison directs the reader's attention to the dangers, limitations, and exclusions that mark the tradition of black nationalism, especially those expressions of nationalism that are solidified by the exodus narrative. The novel, for instance, addresses the ways this legacy implicitly repeats and mimics some of the pernicious practices, narratives, and attitudes associated with the broader nation-state. This tendency is exemplified by Ruby's exclusion of those considered impure (light-skinned blacks) and the town's fear of women who threaten the stability of the nuclear, heteronormative family structure and the patriarchal order. Morrison's story therefore resonates with Wahneema Lubiano's claim that black nationalism, because of its traditionally rigid gender and family norms, can operate as a stand-in for the nation-state, a vicarious way to discipline and manage black bodies (desire, sexuality, relationships).[74] Similarly, I take it that Morrison is also drawing connections between the triumphant images and stories that shape, solidify, and fortify the nation-state and those that shape black communities. These celebratory narratives don't just identify foundational moments, events, symbols, and heroes. They articulate and juxtapose these elements in ways that convert shame into pride, trauma and loss into victory and success. Consider, for instance, the account of Zechariah Morgan's name change.[75] The reader discovers late in the novel that, before his migration to Oklahoma, he is known to others as Coffee and he has a twin named Tea. When a group of intoxicated white men order the twins to dance at gunpoint, Tea obeys while Coffee refuses to comply. Because of his defiance, a white man shoots Coffee in the

foot. After this incident, Coffee changes his name to Zechariah, a biblical prophet, and because of his brother's capitulation, severs all ties with his twin. As J. Bouson suggests, the transformation from Coffee to Zechariah does not just involve an active, assertive response to shame, humiliation, and loss. It also involves disavowing this shameful incident, or projecting and redirecting that shame onto someone else. As Bouson puts it, "Consolidating his identity as the proud and masterful patriarch . . . Zechariah projected his socially induced feelings of shame and self-contempt onto his twin brother, Tea, who became the humiliated and excluded Other."[76] In fact, Tea's name is even excluded from the official histories and genealogies of Haven and Ruby. Similar to Rorty's analysis in *Achieving Our Country*, this scene in the novel suggests that the relationship between (and negotiation of) pride and shame is pivotal to the survival of communities. Morrison would agree with Rorty's claim that a community's well-being depends in part on how it relates to, remembers, and bequeaths (to future generations) the successes and losses of that group's history. But Morrison also underscores the tendency to strengthen our individual and communal identities by separating ourselves from the messiness of life and history, from that which is shameful, disgusting, ugly, and self-undermining. In these instances, pride in self, community, or country is enabled by denying our complicity and involvement in the unpleasant facets of life and by relocating and ascribing shame, dirt, and death to other people and communities.

The point here is not that all forms of pride are pernicious or that we should not derive some pleasure and enjoyment from achievements and successes. Nor am I suggesting that there are not more healthy ways of imagining and performing the pride-shame dyad. The example of Zechariah, or Coffee, and the rejection of his twin, on my reading, is Morrison's way of exposing a tendency within national and racial communities that have been organized around experiences and memories of persecution, dislocation, and loss. These communities rely on foundational narratives that either minimize these experiences or convert them into sources of pride, power, and a sense of victory. This is understandable and perhaps necessary for the survival of these communities. At the same time, the denial, minimization, or deflection of shame, loss, and trauma can engender communities and selves that imagine that they can eventually be shielded or protected from these inescapable conditions. In these cases, my unique, exceptional community is imaginatively characterized by life, fullness, self-sufficiency, and plentitude while other communities that threaten my

sense of completeness and coherence are marked as dangerous, evil, broken, death-producing, and so forth. This imaginary distinction has been used to justify invasions, expansion projects, and erasures as well as closures, disallowings, and the creation of rigid borders. It is almost as if the desire to protect a community from violence and loss, a protection that is necessary for the well-being, success, and survival of that group of people, tends to reproduce this violence.

Along this line, *Paradise* describes how the members of Haven and Ruby engender stories, practices, and borders that are designed to protect themselves from undesirable elements—outsiders, impure blacks, white people, "deviant" women, the contradictions of the past, internal conflicts and tensions. These threats are so troubling precisely because they expose the contingency and precariousness of these all-black communities, contingencies that characterize any self, group, or formation. The residents of Ruby, for instance, are proud of the fact that "from the beginning its people were free and protected" and that death appeared to be "blocked from entering Ruby."[77] In fact, since 1953, "nobody in Ruby has ever died. They are real proud about believing that they are blessed and all because after 1953 anybody who died did it in Europe or Korea or someplace outside this town."[78] Death, in other words, occurs "Out There," in a space that is "unmonitored and seething," in "a void where random and organized evil erupted."[79] But Morrison's work constantly plays with and destabilizes the boundaries between the interior and the exterior, home and out there, life and death. Her work displays the impossibility, as well as the seduction of, screening death and its effects from our lives. Deek and Soane Morgan, for instance, are intermittently affected by the death that is out there, particularly by the death of their two sons in the Vietnam War. In addition, the town of Ruby is named after Deek's and Steward Morgan's sister (Zechariah's granddaughter) who, as we are told, dies in a hospital outside of Ruby that refuses to care for black patients. Therefore, inscribed in the very naming of the town is a kind of mournful remembrance, an implicit acknowledgement of the residents' vulnerability to death, not to mention their dependence on others outside of the community. But because the name Ruby is also an anagram for "bury," the novel indicates that this recognition is coupled with collective endeavors to conceal, hide, and hide from the death, loss, and trauma that haunt the town.

The reader experiences this burying, concealing mechanism in moments when the men of Ruby attempt to reconcile internal tensions and

conflicts, especially tensions that exhibit unequal power relations between the men and women. Think, for instance, of the meeting between the Morgans and the Fleetwoods, a meeting convened to redress K. D. Smith's public act of violence toward his fiancée, Arnette Fleetwood. Although Reverend Misner acknowledges that striking Arnette represents "a serious injury," the men gathering to execute justice refuse to confront the broader problems and tensions within the community that lead to violent outbursts against women. After Reverend Misner asks K. D. why he hit Arnette, the reverend "expected this forthright question to open up a space for honesty, where the men could stop playing bear and come to terms. The sudden quiet that followed surprised him. . . . In that awkward silence they could hear above their heads the light click of heals: the women pacing, servicing, fetching, feeding."[80] After the awkward silence, Arnette's brother, Jeff Fleetwood, rejoins, "'We don't care about why. What I want to know is what you going to do about it?'" Notice how the why question is hastily dismissed by a commitment to immediate action, by a desire to quickly resolve the conflict without engaging deeper questions and concerns that surround K. D.'s opprobrious act. Yet the awkward silence that the reverend's question generates does some work for the reader. The silence reminds the reader of the presence and absence of the boisterous women "above their heads." It reminds the reader that the resolution of K. D.'s infraction, the healing of his injury to the social body, is enabled by the absence of women's bodies during the deliberation process. Reconciliation between the men of Ruby, in other words, occurs through the absence and silencing of the very female body that was injured. The men don't have to face or listen to the injured female subject, Arnette, who might compel the defenders of patriarchy to deal with the why question posed by Misner. Women are "nowhere in sight" because "what they said was easily ignored by brave men on their way to Paradise."[81] At the same time, through this notion of an awkward silence, Morrison might be suggesting that noticing and hearing others who are usually neglected and not heard requires moments of silence and habits of patience that militate against a disproportionate eagerness to display loud assertiveness.[82]

Reconciliation in this case occurs through the exclusion of women. The conciliatory process is protected from the injured body that the meeting is supposed to address. As Adorno might suggest, the spurious reconciliation reached by the meeting is predicated on ignoring and suppressing painful tensions and conflicts within the social body (tensions and conflicts that

leave their mark in this case on a female body). There is a relationship between this suppression of internal violence and conflict and the deflection of these painful, discomfiting qualities to the outside, to the women in the convent. The convent becomes a convenient space for the residents of Ruby to displace and "leave behind" anything that threatens to undermine the stability of Ruby. Because of this, Ruby is highly dependent on and intimately involved with this all-female space that also invokes fear and a sense of danger. The reader is told, for instance, that both Soane Morgan and Arnette go to the convent to deal with undesirable and painful aspects of their respective pregnancies. Soane's girl, we are told, "would be nineteen years old now if Soane had not gone to the Convent for the help sin needed."[83] And Arnette, at one point in the narrative, "was pregnant, but after a short stay at the Convent, if she had it, she sure didn't have it."[84] The novel suggests that Soane suffers a miscarriage at the convent, while Arnette delivers and abandons her "out of wedlock" child at the convent (yet the child dies soon after birth). In other words, the unpleasant, even unspeakable, experiences of Ruby, in addition to the various failures to reproduce the community, are deposited on the convent women. As Bouson points out, by blaming the women for killing her baby, Arnette "transfers onto them her own shame and guilt."[85] The convent, in other words, "becomes a repository of Ruby's scandalous secrets," a distorted mirror exposing Ruby's perverse and undesirable sides.[86] It is the place where K. D. goes to have an illicit affair with one of the convent women, Gigi (the narrative suggests that K. D. treats Gigi as a punching bag, a target for his violent desires and impulses). It is also a place Menus, a Vietnam veteran, stumbles toward during a drunken outburst. The narrative indicates that the convent allows Menus to hide his tears, to conceal his vulnerability from the other "brave and strong" men who, in the tradition of the founding patriarchs, are supposed to provide a solid anchor for the town of Ruby.

René Girard's analysis of the scapegoat effect provides a useful framework to understand Ruby's relationship to and treatment of the women in the convent. According to Girard, the scapegoat mechanism is the process by which a community "deflects upon a sacrificial victim, the violence that would otherwise be vented on its own members, the people it most desires to protect."[87] One of the main effects and uses of the scapegoat is the resolution of tension and violence within a group. He claims that a scapegoat effect is "that strange process through which two or more people are reconciled at the expense of a third party who appears guilty or responsible for

whatever ails, disturbs, or frightens the scapegoaters."[88] Girard's formulation explains why, after the convent women "disturb" K. D.'s and Arnette's wedding ceremony, Anna Flood thinks that "the Convent women saved the day. Nothing like other folks' sins for distraction."[89] It also illumines why, despite "irreconcilable differences among the congregations in town, members from all of them merged solidly on the necessity of the action," the necessity of sacrificing and erasing the women.[90] The convent women, in other words, become the vicarious embodiment of the painful dimensions within Ruby that the inhabitants both acknowledge and displace. Thus, Jeff and Arnold Fleetwood join the hunt for and slaughter of these women because "they'd been wanting to blame somebody for Sweetie's [damaged and sick] children for a long time."[91] And although Menus spends time in the convent "drying out," he joins the sortie because "those women must have witnessed some things, seen some things he didn't want ranging around in anybody's mind in case they fell out of their mouths."[92] For the residents of Ruby, the scapegoating and violent treatment of the convent women, of these strange neighbors, derives in part from an inability to confront and work through the painful contradictions, memories, and relationships that shape and beleaguer the town of Ruby.

How might the actions, behaviors, desires, and fears expressed by the residents of Ruby prompt us to think critically about the relationship between nation, race, and gender? On the first glance, the analogy between this quaint, exclusive community and the broader nation-state does not seem to work. While Ruby is a racially exclusive town that prohibits access to light-skinned blacks and whites, America is supposedly defined by its openness to a plurality of cultures, races, and traditions. America, unlike Ruby, is an inclusive nation of dislocated, migrant communities and peoples. Similarly, while Ruby protects itself through isolation, America, especially since the turn of the twentieth century, has endeavored to expand and extend its power and influence across the globe. Even though there is some truth to these differences, the comparisons are a bit more complicated. As Behdad suggests, America's relationship to the foreigner, like any nation-state, has been ambivalent; it has oscillated between hospitality and hostility. While the model, successful immigrant is often celebrated as "proof of America's exceptionalism" and used to bolster the idea that we are a nation of immigrants, Americans have also imagined the immigrant or foreigner as a threat to the nation's identity, health, and well-being.[93] In other words, while America might be a nation of immigrants, its national

identity has often been consolidated by rejecting and denigrating the foreigner, by defining itself over and against the threatening other. And in order for the foreigner to become assimilated, he or she typically defines himself or herself against America's internal pariahs. Therefore, interrogating Ruby's fear of and aversion to strangers (and their unacknowledged fascination with and dependence on these others) and its desire to protect itself from those who reside outside of and at the limits of its borders is relevant to ongoing discussions and debates over immigration, border-making, and border surveillance. In addition, while Americans would seem to have expansive, universalizing aspirations, in opposition to Ruby's insularity, this dichotomy obscures the tensions and contradictions involved in nation-state sovereignty. As Wendy Brown points out, we live in a world in which the nation-state's power and influence seem to be waning—due to globalization, transnational forces, capitalism, and so forth. Imperial projects, animated by the need or desire to expand markets and accumulate capital, rely on transgressing and erasing borders, boundaries, and limits. At the same time, according to Brown, we also live in a moment in which the construction of walls and borders between nations is becoming more prevalent (between America and Mexico; Israel and Palestine; India and Pakistan), an emerging phenomenon precipitated by anxieties over terrorism and crime, the movement and relocation of refugees, the stability and instability of economies, and the increasing vulnerability and permeability of nation-states.[94] Even though Ruby does not initially seem to provide a good comparison for the broader nation-state, many of this fictional town's traits (a fear of and dependence on the outside, converting histories of struggle and loss into ascendant myths, justifying the erasure of those that threaten the community's sense of coherence) illumine contemporary national formations and projects. Ruby, in crucial ways, serves as a microcosm of the larger nation.

Alongside these general features and relationships, the novel explores the specific intersection of race and nation, an intersection that invites further examination in order to identify the dangers and drawbacks of current postracial rhetoric and optimism. By juxtaposing black people's struggles against founding-father motifs, the image of the American frontier, and the trauma involved in settling the American frontier (for both the settlers fleeing violence and the settled Native American communities), Morrison places black people's history against the broader backdrop of America's history of expansion. By adverting to the exodus narrative and its motifs

of persecution, liberation, promise, and exception, Morrison implicitly situates black people's struggles and aspirations among other groups and communities that have adopted this story or one of its secular analogues to make sense of dislocation, suffering, migration, and strivings to overcome misfortune. While black people's histories might be unique to some extent, the novel compels readers to think about the affinities and intersections between black American strivings and the histories and experiences of other groups and peoples. It also invites us to underscore the fact that black subjects are just as shaped and constrained by the nation-state's prevailing images, stories, and symbols as other groups. The hamlet of Ruby might contest, challenge, and revise national and racial narratives that identify black bodies as deviant, unintelligent, overly dependent on others, and uncivilized, markers that have historically vindicated the erasure of blacks. At the same time, the residents of Ruby adopt and repeat subjugating attitudes and dispositions with respect to the convent women, a repetition that is animated by a constellation of factors—excessive pride, anxieties about shame and vulnerability, tendencies to deflect shame and trauma, concerns over the town's permeability, the endeavor to protect patriarchal norms and expectations. What connects Ruby to the broader nation-state is a set of narratives, desires, and fantasies that convert historical trauma into triumph, that attempt to protect its ideal members from death and loss by locating death and loss elsewhere. The dissonant, but often disavowed, relationship between triumph and loss, exceptionalism and violence, power and subjugation, form a common backdrop to this all-black town and the larger nation-state.

WAR AND THE AMBIGUOUS POSTRACIAL IDEA

As Anna Mulrine points out, Morrison initially selected the title "War" for the novel but her editor rejected this title, fearing that it might offend Morrison's audience.[95] To some extent this scenario, the suppression of the disturbing title, War, reflects an implicit theme in the novel—how the fantasy and construction of "paradise," or the ideal community, depends on the propagation and justification of war (and therefore a denial of this fractured relationship). Morrison introduces war motifs and images in the first scene as the men of Ruby march into and invade the convent, and hunt the convent women. In addition, there are repeated allusions throughout the narrative to historical wars—World War II and Vietnam, for

instance. By beginning the novel with a warlike raid, by hurling the reader into this opening invasion, depriving the reader of some overarching explanation, the novel makes us confront head-on the violence that undergirds the formation and preservation of communities, collective identities, and nations. Because certain kinds of violence are usually rejected or prohibited by these communities, we are prompted to think about the distinction between acceptable and unacceptable forms of violence, between justified killing and unjustified killing. By invoking these distinctions, Morrison's novel gestures toward Michel Foucault's oft-cited analysis of the relationship between race, death, and state power. Although his understanding of biopower is complex and beyond the scope of this chapter, I am interested in Foucault's claim that "race or racism is the precondition that makes killing acceptable."[96] In other words, race, for Foucault, is one way of inserting a distinction within populations between those who are worthy of death and those worthy of life. Morrison's novel suggests that this distinction between acceptable and unacceptable death and loss always shifts, moves, and is redrawn. While the ancestors of Ruby resided on the "acceptable" side of this distinction within the orbit of white supremacy, the women in the convent reside in the space of acceptable death within the framework of Ruby's patriarchal exceptionalism.

Morrison's text therefore points to and symbolizes how national communities justify invasions, imperial projects, the killing of noncitizens in ways that are analogous to racism. American exceptionalism, for instance, implies that the life of an American is more full, complete, coherent, and valuable than the life of a non-American; in its supposedly more salutary expression it assumes that non-American lives and conditions can become more full and complete by adopting American values and ways of living. This triumphant national sentiment often enables Americans to tolerate or accept the systematic killing of non-Americans or the mistreatment and exploitation of individuals within the nation's borders who deviate from the picture of the ideal citizen. I am not suggesting that America is necessarily unique in its exceptionalism, nor am I denying that this commitment to America's uniqueness has been used to critique injustices committed by American citizens, the nation-state, and so forth. I am simply attempting to highlight a troubling connection between national exceptionalism and racism, between the taken-for-granted and seemingly innocuous notion that America is unique and the greatest nation on earth and the production and justification of death, suffering, and loss. Morrison's novel, by

drawing a connection between the yearning for paradise and the deployment of war, between fantasies of collective supremacy and the justification of violence, demonstrates how national exceptionalism can become a site in which the line between acceptable and unacceptable deaths is established and legitimated. Since the language of a postracial America tends to reinforce commitments to America's uniqueness and greatness, it can and does lead to new expressions and articulations of racism; this aggrandizing rhetoric both produces and obscures mechanisms, discourses, and practices that continue to make certain kinds of atrocities acceptable and tolerable.

While Morrison's novel offers resources to challenge haughty notions of a postracial America, there are moments in *Paradise* that accord with Paul Taylor's more nuanced understanding of being postracial or postblack. Recall that Taylor suggests that we might understand this condition as a creative response to rigid, narrow definitions of blackness and racial identity. This narrowness, which often breeds notions of racial authenticity, is exemplified by the 8-Rock men's rejection of impure, light-skinned blacks, a rejection that itself is a response to being refused or disallowed by other black communities (communities that were repulsed by the wretched, broken appearance of Ruby's dark-skinned ancestors.) A more subtle notion of the postracial idea would acknowledge and affirm different expressions and articulations of blackness even as this variety is constrained and limited by certain kinds of social and historical constraints and expectations. In addition, this more promising conception of the postracial acknowledges that selves are always more than their racial identities; each individual inhabits different, overlapping subject positions such as class, citizenship, gender, and sexuality, subject positions that mutually inform each other but that don't always cohere or express some harmonious whole. Certain traditions of black nationalism, proclaiming a kind of racial expressivism or harmonious black self and community, accentuate the primacy of race at the expense of these other subject positions and expressions of identity.[97] Among other consequences, this ignores the fact that struggle and resistance occur along multiple axes and at different sites of identity formation. By endorsing what Patricia Hill Collins refers to as "the matrix of domination," one acknowledges that selves exist within a web of power relationships, simultaneously occupying positions of domination and positions of subordination.[98]

I take it that the controversial first line of *Paradise* alludes to the particular intersection between race and gender and subtly undermines the idea

that race trumps other, "less important" categories. "They shoot the white girl first" is a haunting first line; it entices the reader to focus on and ascertain which one of the convent women is not black, which one of these women is the inverted racial other in this all-black context. By cajoling the reader to fixate on race, Morrison is playing with us; similar to the work she does in the short story "Recitatif" and her recent novel, *A Mercy*, Morrison exposes the way that some of us obsess over race. While denial and forgetfulness have characterized the nation's treatment of race, so have obsession and preoccupation, preventing the kinds of crossracial bonds and relationships that Obama affirmed in his Philadelphia speech. The first line in the novel, especially for the reader who takes the bait and focuses on racial identity, but later realizes that the white girl is never definitely revealed in the novel, makes the reader wonder why racial identity stands out more than the act of gender-inflected murder. In other words, the novel asks those who read exclusively with a racial lens, why the victim's whiteness matters more in the opening passage than the fact that she is a woman being hunted by men. Of course Morrison is not suggesting that race does not or should not matter even as her novels constantly destabilize, undo, and rewrite this category. At the same time, by loosening our fixations on race, Morrison compels the reader to think about traumas, losses, relationships, struggles, and aspirations that cannot be reduced to racial logics and frameworks (even as connections and affinities exist among different struggles and identities). In *Paradise*, the convent women occupy a similar space as the ancestors of Ruby; the rejection and exclusion of the convent women with respect to gender norms and hierarchies resembles the treatment of Ruby's ancestors with respect to the racial order. While this comparison obviously does not allow for a conflation of race and gender, it might suggest that race and gender formations share overlapping histories, logics, and patterns of subordination.

By pairing Obama's speeches and writings with Morrison's novel, I underscore and develop the aforementioned distinction between a strong version of the postracial idea and weak version. The strong version, I have argued, uses the successes and advancements made by blacks (culminating in the election of Barack Obama) to reinforce national exceptionalism. The idea that America is the unique, special site of freedom and progress both vindicates and conceals new expressions of racism and racial cruelty toward, among others, Arabs, Muslims, and Latinos. Similarly, this strong version of the postracial idea makes people think that assimilation is an

unequivocal good rather than a process marked by ambiguities and tensions, especially for those bodies and communities that continue to bear the stigmas and negative markers associated with alterity, deviance, and brokenness. In order to read and interrogate the dangers and limitations of the overconfident notion of the postracial, I have suggested that we think more about the tortuous relationship between race and nation and race and gender, intersections that Morrison examines in *Paradise*. An examination of these nodal points reveals that the adoption of exceptional, triumphant narratives (which convert experiences of shame and loss into a collective sense of victory and pride) told by racialized and national communities works to justify the subjugation and elimination of groups and communities marked as threatening and less valuable. These narratives, at their worst, enable communities to collectively project internal tensions, conflicts, and ambivalences onto others, thereby solidifying rigid, invidious distinctions between self and other, inside and outside, safety and danger, and dominance and weakness. While overconfident images of self and communal identity imaginatively shield subjects from the traumatic dimensions of life, history, and communal formations, other groups become the imagined site of death, loss, and trauma, an imaginary that renders certain kinds of violence and death more acceptable. Obama's writings and speeches demonstrate a greater awareness than many of his presidential predecessors of these tragic qualities of American history, especially as it pertains to race. One should applaud moments when he acknowledges the other side of progress, the ways the idea of progress and the rhetoric of the postracial miss the complexities and ambiguities of the current moment. At the same time, his commitment to the "genius" of America reinforces troubling tendencies, particularly the ways national exceptionalism becomes a neglected site of cruelty, suffering, and acceptable death.

A weaker notion of the postracial concept affirms the ongoing significance and weightiness of racial subject matters while introducing a sense of play and irony into traditional conceptions of race. This version follows authors like Morrison and Taylor by departing from essentialized notions of blackness, Du Bois's romantic notion of the folk, or frameworks that accentuate the significance of race while ignoring other, co-determining identity positions that shape, mediate, and inform how one embodies and performs race. This articulation of the "post-" or the "more than black," does not necessarily place race in some teleological framework or imagine national cohesion as the end and resolution of racial difference. Rather,

this notion of the post- marks an opening, a way of opening up to multiple sites of suffering, loss, resistance, hope, pleasure, and struggle within and outside of national borders. It suggests that a heightened sensitivity to the suffering of others requires recognition of various expressions of difference (different histories, identity formations, and experiences of struggle) and acknowledgement of shared, human qualities and conditions that selves often deny or try to escape: vulnerability, cruelty, contingency, and death. In my view, a better, more promising hope entails a combination of contemplation, remembrance, and critical encounter with respect to these all-too-human conditions rather than endeavors to resolve or deflect them through reassuring images of progress and national supremacy.

CODA: THE FLICKERING POSSIBILITY OF A DIFFERENT PRACTICE OF COMMUNITY AND BELONGING

To develop this possibility, I conclude with a brief analysis of the counter-community that the convent women create in *Paradise*. My aim is not to treat this community as a redemptive site (even as this cannot completely be avoided) but as a set of relationships and interactions that gesture toward alternative ways of thinking about community, identity, and being with others, especially as these relationships emerge and form against the backdrop of trauma, dislocation, and painful memories. In the novel, the convent is juxtaposed to Ruby as the all-black town's shadow, both resembling and departing from the practices that form the patriarchal hamlet. Like the residents of Ruby and their ancestors, the convent is made up of refugees, of women escaping physically threatening situations and searching for a safer space. The need to escape is a product of social arrangements that are debilitating to these female subjects. Mavis, for instance, flees her home because of a sexually abusive husband who, after Mavis accidentally kills two of her children, orders the other children to inflict pain on their mother. Gigi, who accidentally arrives in Ruby after being deceived by her boyfriend, is haunted by the memory of a young boy's being shot and spitting up blood during a Black Panther demonstration that precipitated a clash with the police. Seneca is abandoned by her mother at a young age; she grows up in foster homes where she becomes a perpetual victim of sexual abuse. Pallas is betrayed by her mother, who has an affair with Pallas's lover. On her way to the convent, Pallas is attacked and raped by a group of young men. And Connie, the elder of the

convent, is brought to Oklahoma from Brazil by a Catholic nun when she is nine years old. Prior to her journey, she is the victim of molestation. Each of these women endure experiences that remind the reader that social arrangements, such as the family, and communal spaces are ambiguous sites; while they shape and nurture selves, they also mutilate and injure individuals.

The convent is an intersection of different trajectories, a gathering of scarred bodies, narratives, and experiences. In Deleuzean parlance, we can call the convent an assemblage of nomads, a gathering of exilic subjects who have each experienced and embodied what Ellison calls a cacophonous movement, a painful journey. It seems to represent an alternative space, a "heterotopic" space, where female subjects who have been injured, denigrated, and marked as deviant can gather, work through their pain, and cultivate a different kind of community. It is a wounded space or a space where its members relate to each other through wounds. To call this a wounded space also registers the fact that the convent bears a history of Christian imperialism and expansion, a history alluded to in the novel through images of nuns teaching Native American children. According to the chicana theorist Gloria Anzaldúa, a wound is both a mark of being torn or injured and an indication of an opening toward others, a signal of a heightened sensitivity to the world.[99] Anzaldúa calls this opening toward the world a bridge, and this bridge, with all of its damage, instability, and promise, is what she refers to as home. In line with Anzaldúa's powerful formulation, the women in the convent have been wounded; their bodies have been torn and ruptured. Perhaps this woundedness renders the women in this alternative space more vulnerable and receptive to the pain and suffering of others, including the residents of Ruby. Recall how they care for Menus, the Vietnam veteran, when he is drunk (they specifically clean up his vomit and defecation). Similarly, Connie's garden provides Soane with a medicinal herb that helps Soane with her sickness and depression. In addition, Sweetie Fleetwood treats the convent as a refuge from the rigid constraints that the town of Ruby imposes on female bodies. The alternative space that the convent provides is, at times, a hospitable space, a place where those who have been traumatized and hurt are welcomed, listened to, and cared for.[100] But, as I mentioned above, this is also a space where pain is displaced, left behind, and reproduced.

But we must tread lightly here. It would be wrong to imagine a rigid binary between the convent and the town of Ruby, to think of the convent as a fluid, open space in complete contrast to the rigid, closed, and

hierarchical community of Ruby. As Erica Edwards astutely points out in her reading of *Paradise*, "The novel writes against a simple binary equation of male space with fixity, order, and sameness and female space with fluidity, nurturing, and openness."[101] Morrison's attempt to challenge this neat contrast is exemplified by the constant bickering and fighting between Mavis and Gigi, and Connie's increasing frustration with the other women, due to their annoying presence. Edwards aptly describes how Connie becomes less tolerant of her fellow housemates, perturbed by their brokenness and unwillingness to heal themselves.[102] In fact, there are moments when Connie desires to kill and get rid of these disturbing interlopers. By challenging and evading a neat separation between Ruby and the convent, Morrison enables the reader to examine both the affinities and differences between the two communities. It is important that both communities bear a legacy of dislocation, migration, and resettlement. And it is important that the resettling of these communities invokes images and memories of theft, dispossession of Native American land, and the imperial dimensions of nation-building and expansion. By juxtaposing the convent and Ruby, the novel compels the reader to think about the difficult, and often disavowed, relationships between settlement and erasure, between defending borders and expanding borders. Similarly, the novel prompts the reader to contemplate the figurative and psychological aspects of settlement, the ways group and self-identity rely on a desire and need to be settled in the world, to discover in the world a stable home. While this longing for home might seem innocuous, Morrison's work suggests that attempts to establish a settled identity can be harmful for those bodies, subjects, and desires that threaten to undermine or expose the contingencies of that "stable" identity.

In addition to the complexities of settlement, violence, and identity, the convent also demonstrates the significance and ambiguity of healing and reconciliation. Morrison's novels frequently suggest that the process of healing is necessary, yet difficult and painful work. Like Obama's speeches, her work shows that communities have to work through their wounds and scars if they want to construct a more fulfilling existence. A glimpse of this process occurs in the healing scene toward the end of the novel. Overseen by Connie, the women draw templates of their bodies on the floor and lie in them while sharing their traumatic stories and experiences. Referred to as "loud dreaming," the women share "half-tales and the never dreamed," which indicates that this healing ritual includes

both memory of accumulated suffering and memory of the not-yet, of possibilities that have yet to be actualized. As Channette Romero remarks, the women go through the process of healing by "first articulating their traumas (both verbally by narrating their experiences and nonverbally by painting them onto their templates) and then learning to recognize and love the connections between them . . . Loud dreaming does not demand that these women deny their past traumas or differences. Instead, it encourages them to confront them, acknowledge them, and to recognize similarities between their own and others' experiences."[103] Romero's reading of this collective healing ritual affirms the importance of the practice of story-sharing, practices of shared vulnerability, and the externalization of pain through aesthetic, ecstatic, and religious experiences—all bodily rituals that potentially minimize the tendency to deflect pain and violence onto other people in the attempt to shield oneself from these undesirable features of life.

The healing ritual seems, at least initially, to engender a kind of reconciliation for the female subjects in the convent. We are told, for instance, that after this event, the women are "no longer haunted." The narrator, at one point, refers to the "rapture of holy dancing in hot sweet rain."[104] And we are told that Seneca, described in the novel as a cutter, stops inflicting wounds on her body. "When she had the hunger to slice her inner thigh, she chose instead to mark the open body (the template) lying on the cellar floor."[105] Her self-flagellation, in other words, is reexpressed through painting, rearticulated as art. Yet there is something terribly ironic about this new, conciliatory state, especially since the women are dancing blissfully in the rain on the day in which they are slaughtered, or treated as prey. It is not clear what the reader is to make of this transition from ecstatic bliss to murder. This relationship is complicated further by the fact that the murdered bodies disappear, then reappear as specters to respective family members (Mavis visits her daughter and Gigi visits her imprisoned father, for instance). Does Morrison's text offer the possibility of a different, alternative future? Does this depend on treating the women as redemptive figures, thereby absolving their murder and erasure?

Here I think it is helpful to invoke Adorno's playful, ironic understanding of reconciliation that he articulates in *Aesthetic Theory*. For Adorno, various works of art intimate a state or time that is not-yet. Art betokens the promise of a radically different world, expanding our conception of what is possible. The promise of happiness and reconciliation is always,

however, a broken promise, always bumping up against a fragile world that is contingent and messy. In fact, the pleasure that artworks promise is entangled with the wounds of the social world that art incorporates and reconfigures. Morrison's novel offers a fleeting, evanescent vision of reconciliation, of women working through the painful past to a point in which they are no longer haunted. The conclusion of the book also provides an image of resurrection, an image of the convent women appearing in the afterlife. Yet the blissful image of these women rejoicing and dancing must be juxtaposed to the persistence of an unreconciled world, exemplified by the violence perpetrated on them by the men of Ruby. This moment of satisfaction, in other words, is disrupted by realities and conditions that will always thwart the actualization of paradise, realities that are produced in part because of this desire for a reconciled community and world. This broken-promise motif reappears in the final scene as the reader is introduced to the image of the female goddess Piedade, an allusion to African-Brazilian traditions such as Candomblé. In this scene, Piedade holds and comforts a younger woman (the younger woman lies on Piedade's lap), thereby resembling the famous image of Jesus's dead body lying on Mary's lap after the crucifixion. As Udono Erika emphasizes, Connie first introduces Piedade in one of her tales. Yet in this earlier story, Piedade is identified with emeralds, gold, and ruby while in the final scene, she is surrounded by trash and broken objects (her fingers are similarly described as ruined, which perhaps alludes to the manual labor endured by women of color).[106] The introduction of a female goddess exposes and contests the conflation of patriarchy and divinity within many religious traditions as well as the analogous founding-father motif that accompanies the nation's origin stories. At the same time, by ending with an image of a "ruined" goddess Morrison suggests that redemption is a broken possibility. Like Benjamin, Morrison seems to imply that redemption has something to do with rescuing the ruins and shards produced by our social formations but also that redemption, or a better set of possibilities, entails a difficult willingness to acknowledge that our narratives and imagined identities are wounded, torn, and vulnerable. For my purposes, I underscore the fact that the image and the consoling song of Piedade are juxtaposed to "sea trash gleams," "discarded bottle caps near a broken sandal," and a "small dead radio." I also reiterate Piedade's ambivalence, her initial identification with rubies and emeralds and her torn experience at the end of the novel. Perhaps Morrison is suggesting that the experience of beauty,

enjoyment, intimacy, and happiness and the memory of and sensitivity to the broken and discarded have to be held together, in difficult tension. Discovering beauty, meaning, and value occurs through a difficult openness to the fractured quality of existence, a quality that perpetually upsets the presumption that these desired ideals could ever be grasped or possessed in their fullness. And perhaps it is precisely within this tension and amid the accumulated ruins, shards, and waste that we might create and discover a different kind of place, nation, and earth, that our bodies might "shoulder the endless work . . . down here in paradise."[107]

I take it that the alternative community of dislocated women in Morrison's novel opens up space to reimagine what it means to cohabit space and territory with others. In opposition to the ostensible solidity and stability provided by certain kinds of privileged identities (like Americanness, national pride, maleness, whiteness, authentic blackness) and narratives that bowdlerize the unsettling qualities of life and history, the gathering of women in the convent gestures toward the possibility of developing and cultivating bonds and relationships marked by receptivity and vulnerability to the broken quality of social life and human coexistence. This includes, among other things, an awareness of unavoidable human shortcomings and limitations. Even our highest efforts to live and coexist peaceably with others involve damaging and being damaged by others. Many of us, for all kinds of understandable reasons, devise ways to shield ourselves from these damages insofar as these features of our lifeworlds threaten to undo our sense of coherence, stability, and home. While there is an understandable human desire to become "settled," to establish a stable place in the world, Morrison's work suggests that a more compassionate, generous world requires a willingness to be unsettled, figuratively dislocated, and removed from comfort zones. At the same time, this flashing possibility of becoming more compassionate and receptive selves always emerges in the fray of conditions, arrangements, collectives, and realities that constrain, mutilate, and flatten more promising lines of flight. This is why Morrison's novel can only gesture toward and descry this potential for a better world, more generous selves, a wounded opening toward others. The hope of relating to violence, history, and others without the consolations provided by assuring and protective expressions of self and communal existence, is a hope draped in black. And our capacity to develop and embody this opaque hope depends in part on how we contemplate, diagnose, and in-

habit the space between the post- and racial, a space marked by tension-filled memories, tangled relationships, and unexplored possibilities.

By reading Obama's speeches and writings alongside Morrison's novel, the aim of this chapter was to reexamine the idea of the postracial and to situate this idea against broader notions of progress and national exceptionalism. We might say that the stronger and weaker senses of the postracial represent alternative ways of imagining and remembering the fraught relationships among race, nation, gender, and other identity formations. They represent two different logics and different ways of relating to history, trauma, and others. The stronger sense of the postracial, occasionally heard in Obama's rhetoric, deploys the strivings and achievements of black people to buttress the image of America as an exceptional, supreme nation. While this stronger sense of the postracial might acknowledge that racism still exists, it often uses images and events of the recent past to assure people that the nation is on the path of progress and that strong attachments to the nation (our common project) will eventually reconcile past and present conflicts. The weaker sense of the postracial acknowledges changes in how race is imagined, performed, and experienced; it also underscores how racism and racial difference are always being mediated and reexpressed, how the line between acceptable and unacceptable loss gets redrawn and reimagined. According to this alternative logic, national exceptionalism, America's supremacy, and the American difference are ideals and strategies that justify and render acceptable the erasure and suppression of the nation's internal and external others. I have suggested in this chapter that the strong, triumphant sense of the postracial either minimizes the trauma of race and nation-building or displaces this trauma. This process allows us, for instance, to accuse other nations and communities of being cruel and violent while Americans are imagined as tolerant and free, a distinction that contributes to the general consent to American empire. I have also argued, with the help of Morrison, that a better world, a more generous world, will involve a greater awareness of how our attachments and identifications contribute to forgetfulness, displacement, and relocation of violence and death. A better, more melancholic hope entails a difficult willingness to allow the traumas of nation-building and racial difference to unsettle and interrupt our sense of stability, achievement, and the coherence of self and collective identity.

Conclusion

In the preface to the fiftieth anniversary edition of *The Souls of Black Folk*, Du Bois makes a prescient comment about the future of the "color line" and the shifting significance of race. After informing the reader about the increasing relevance of Marx and Freud for his thinking about racial matters, he writes,

> I still think today as yesterday that the color line is the great problem of this century. But today I see more clearly than yesterday that back of the problem of race and color, lies a greater problem which both obscures and implements it: and that is the fact that so many civilized persons are willing to live in comfort even if the price of this is poverty, ignorance, and disease of their fellowman; that to maintain this privilege men have waged war until today war tends to become universal and continuous, and the excuse for this war continues largely to be color and race.[1]

Here Du Bois warns the reader that race will continue to be a divisive factor while admitting that race points beyond itself. Racial difference,

as Du Bois suggests, is used, manipulated, and implemented to maintain class hierarchies and to justify unequal distributions of wealth, knowledge, and health. This does not necessarily mean that race is reducible to class but that racial difference points to and articulates related material conditions and inequities; racial inequality is intertwined with and often indicative of different levels of access to capital. In addition to the racial and class connections, Du Bois makes a subtle critique of the idea of civilization in this passage. Similar to his arguments in "The Souls of White Folk," Du Bois claims that there is a cost to civilization (and progress); the other side of civilization consists of hunger, deprivation, and loss. And these conditions persist in part because privileged subjects are comfortable with the state of things, indifferent to the suffering that the civilizing process requires. Finally, Du Bois suggests that the accumulation of power, privilege, and capital relies on the capacity to wage war. While wars and invasions may be the result of material interests, these violent projects are justified, according to Du Bois, through the language of race. Racial difference, in other words, continues to excuse and make acceptable certain kinds of death and loss.

This passage is relevant to contemporary discussions about race, politics, and black American progress. As I read Du Bois here, he is saying that the color line must be understood and examined in relationship to other, associated concepts and realities, such as class, nation, empire, war, and the tragic dimensions of civilization and progress. His diagnosis therefore dovetails with the second sense of the postracial discussed in the final chapter of this book. Race is informed, inflected, and mediated by its other; it is attached to and destabilized by overlapping arrangements, narratives, modes of power, and identities. While this might sound messy and complicated, it does accord with Du Bois's claim in *Dusk of Dawn* that race might not be a coherent concept but rather a "group of contradictory forces, facts, and tendencies."[2] Affirming the messiness and instability of race not only compels us to examine the broader constellation that race forms a part of but to unhinge race from the white-black binary reinforced by the language of the color line. Of course this binary still resonates, especially in the American context, but it also obscures other permutations of race and racial difference within the modern world. In his poignant essay "The Negro and the Warsaw Ghetto" (1952), Du Bois acknowledges the limitations of reducing race to the color line. After witnessing and contemplating the devastating conditions of Jews in Poland, Du Bois talks

about acquiring an "enlarged view" of the strivings of black people and the idea of race more generally. He writes, "The race problem in which I was interested cut across lines of color and physique and belief and status and was a matter of cultural patterns, perverted teaching, and human hate and prejudice, which reached all sorts of people and caused endless evil to all men."[3] According to Du Bois, racism, a mechanism that has harmed Jews in a manner that is both similar to and different from its pernicious effects on black bodies, signifies broader human tendencies and inclinations such as hatred, disgust, perversion, and evil.

While expressions and conceptions of race might shift and change across time and space, one condition that seems to consistently follow, accompany, and haunt race is death—or perhaps the denial of death. Recall Du Bois's claim that race is employed to excuse or justify war. Although he does not expound on this claim, he suggests that racial difference can function to make privileged communities and nations comfortable with the deaths and losses of people of color. According to this logic, because some people are less advanced, civilized, or democratic than others, their lives are, as Butler astutely points out, less grievable, less worthy of being mourned. Because racism, as Foucault and Butler argue, enables us to make distinctions between a livable and unlivable life, acceptable and unacceptable suffering, it is often expressed and mediated by national attachments, patriotism, exceptionalism, and anxieties about "abnormal" religious practices. Morrison's *Paradise*, as discussed in the final chapter of this book, begins to address these fraught intersections. The notion of racial progress, an idiom that often emboldens national projects and triumphant narratives, obscures the ways race (mediated by other factors and tendencies) operates to justify or deny death and its various intimations—loss, exclusion, silencing, repression, hunger, and so forth.[4]

A couple of contemporary examples might be helpful. At a town meeting during the 2008 presidential race, John McCain assuaged his audience's concerns and fears about the possibility of an Obama victory.[5] After reassuring a gentleman at the meeting that Obama is a decent man, McCain offered the microphone to an elderly woman who expressed her distrust of the future president. She confessed that her distrust was motivated by a suspicion that Obama is an Arab. McCain quickly shook his head, implicitly acknowledging that the woman had received some wrong information. He rejoined in a civil manner, reassuring the woman and the audience that Obama is "a decent family man and citizen." On the one hand, McCain

should be applauded for refusing to exploit the paranoia around Obama's citizenship, middle name, and supposed ties to Islam. On the other hand, McCain's rejoinder attempts to defuse the woman's suspicion by making a tacit distinction between "decent family man and citizen" and the threatening Arab other. Obama can be accepted, recognized, and trusted as a good citizen by severing any connections or affiliations with the Arab. The Arab in this case is the Other, against whom Obama's goodness, citizenship, and decency is defined and established. This interaction between McCain and his apprehensive supporters anticipated much of the rhetoric by some of Obama's more extreme detractors on the Right (Birthers and Tea Party members). For some of these critics, Obama does not belong in the office of the presidency because of his hidden "Muslim identity," his uncertain citizenship status, his ties to Indonesia and Kenya, and of course his socialist leanings. While McCain avoided making these connections at the town meeting, his response still assumed that the Arab is a subject position or identity opposed to American citizenship and respectability. In order for Obama to be recognized as a decent subject, a threatening outside must be imagined or at least implicitly accepted. As just mentioned, some of the Tea Party activists refused to grant Obama admission into this space of citizenship and recognition. In both cases, in McCain's endeavor to distinguish Obama from the threatening Other and in the Tea Party's attempt to associate Obama with this threatening Other, the Arab Muslim is perceived as a harmful persona and identity. Race is therefore displaced and mediated by anti-Muslim and anti-Arab sentiments and expressions of resentment. If progress makes it less acceptable than in earlier periods to denounce Obama on the basis of his blackness, this is because there are other, related narratives, tropes, and subject positions that are available to kindle fear, disgust, and cruelty. The language of racial progress downplays these instances of (displaced) racial exclusion.

Responses to George Zimmerman's acquittal in the Trayvon Martin case provide another occasion to think about the intersections of race, progress, and loss. Within twenty-four hours of the controversial verdict, the rock musician Ted Nugent celebrated the court's decision, claiming that Zimmerman had the right to defend himself against a violent, threatening, young, black male. He claims:

All thinking people are very relieved that George Zimmerman was found not guilty by the intelligent, justice-driven women of the jury,

in spite of the façade presented by the prosecution and forced by the threat of racism by everyone from President Obama, to Eric Holder, the New Black Panther gangstas, NAACP, excuse makers of every stripe and even the governor of Florida, but still this innocent man who simply defended his life from a violent, life-threatening, bloodying, head-and-face slamming attack by an enraged black man-child has so wrongly paid an inexplicable price financially and emotionally. But George Zimmerman and his entire family, innocent of any wrongdoing, have lost everything and will be in debt for a long, long time for having to fight the trumped-up charges that he "profiled" and/or set out to murder the poor, helpless, dope-smoking, dope-peddling, gangsta wannabe, Skittles hoodie boy.[6]

What I find striking about this excerpt from Nugent is the litany of accusatory catch phrases: "Violent, life-threatening, enraged, bloodying, dope-smoking, and dope-peddling, gangsta." Because Trayvon Martin exclusively embodied these traits, his death, murder, loss is justified, made sense of, and absolved. But to put it differently, Nugent suggests, in his incendiary response to the verdict, that even though Martin was the pursued body, the one being followed and chased by an armed subject, the real victim is Zimmerman. The killing is justified because Trayvon Martin is a predator and Zimmerman, in response to this threat, was standing his ground, protecting his neighborhood, defending his very being and existence. There is apparently no room for ambiguity; one person occupies the position of both victim and protector; the other is consigned to the position of predator, gangsta, attacker, and a general threat to the well-being of good, decent citizens. Notice that when Nugent uses the terms "poor and helpless" to describe Trayvon, he does this with sarcasm. Also notice how he refers to those who are relieved and assured by the verdict as "thinking people" and "intelligent," as if rationality and justice belong to those who endorse and celebrate Zimmerman's courageous act.

What is also striking and disturbing about Nugent's diatribe is the unequivocal coldness and indifference toward Trayvon Martin and his family. While he shows compassion and concern for Zimmerman's family, for the emotional and financial strain that they have incurred throughout the trial, he expresses no lament for the Martins' loss; the death of a black male in this case is not the occasion for mourning, grief, or remorse. By alluding to Martin as a predator and attacker, a subject position that renders Martin's

life and death ungrievable, Nugent conjures up the black buck persona that D. W. Griffith employed in *The Birth of a Nation*. While the thug or gangsta is not the same image or persona as the black buck, there are troubling affinities between the two, including the shared quality of framing and marking the black male body as violent, threatening, and not worthy of life. Martin's aggressive, menacing identity excuses and justifies an act of violence—or defense—against him; his identity as the thug makes him the aggressor even in his death and erasure. Interestingly, Nugent suggests that Holder and Obama are gangstas as well, thereby placing these officials in the same category as Trayvon Martin. But this association should not deceive us into thinking that Nugent's diatribe is merely an expression of racism or an aversion to black people. His cruel depiction of Trayvon underscores the fact that certain expressions of blackness, especially those associated with working-class blacks or black youth influenced by hip hop and street culture, are denigrated, stigmatized, and feared by the broader culture. While this predicament thwarts fantasies of and yearnings for a postracial society, it also indicates that the line between acceptable and unacceptable expressions of race involves a consideration of class, gender, regimes of surveillance, and the pervasive desire to tame and monitor the movements of suspicious bodies. (Recall that Zimmerman's initial suspicion of Martin was spurred because Martin was just walking around aimlessly and up to no good.)[7] The fact that so many people, across racial lines, responded to the death of Trayvon Martin by urging black youth to dress differently and behave more respectably in public indicates the long-standing attempt to confront racial inequality by accepting and promoting values and norms associated with middle-class propriety. While Nugent's harangue disavows the disruptive quality of Martin's death in the name of justice (he got what he deserved), many advocates for the deceased Martin respond to the problem of the threatening black male body by drawing on the traditional model of uplift and respectability. Both sides try to make sense of and respond to Martin's death and the conditions that enabled it in a manner that minimizes the shock, absurdity, and tragic quality of the event (not to mention the way in which the shock and absurdity have become all too normal). Both sides cling to familiar, reassuring narratives that minimize how Trayvon Martin's encounter with George Zimmerman reflects systemic racial violence, violence that is embedded in modern arrangements and practices.

In this book, I have argued that a hope draped in black, a hope made possible by melancholy, remembrance, and the contemplation of suffering and loss, is more promising than progress and its cognates for thinking about and reimagining black people's diverse strivings and the modern legacy of race more broadly. The language and logic of progress, even in its best and more inspiring permutations, resonates with, shapes, and emboldens desires for a harmonious, tension-free social world. These desires are all too human, understandable, and perhaps unavoidable. At the same time, attachments to progress and longings for a coherent, reconciled world, longings that mark race-talk as divisive or that betray an eagerness to move beyond race, diminish our capacity to remember and be affected by conflict, violence, death, and loss. Clinging to the proverbial symbol of America or a strong version of the postracial idea renders us less attuned to the ways these images both produce and justify everyday forms of anguish. A different set of possibilities, I have argued, open up when we think hope and melancholy together, when vulnerability to the suffering of others becomes a site for a different kind of future and imaginary. In order to sketch what this opaque possibility looks like, I have examined black literature, literary expressions of music, film, and critical theory. By examining these different domains, I have demonstrated how the work of sorrow, the breaks and cuts of literary jazz, the cuts, images, and sounds of film, and the fictional reimagination of race, gender, and national belonging can challenge, or at least expose, tendencies to forget, repress, displace, or explain away the tragic dimensions of race, sociality, and human coexistence.

Certainly questions and concerns remain. For one, it might seem counterintuitive to trouble progressive narratives and longings at a time when hope, optimism, and resilience are needed in the face of wars, ecological disaster, economic crises, and so forth. In other words, people do not need to be reminded of the tragic quality of life. In the spirit of Richard Rorty, people need inspiring and encouraging stories, stories that remind us of historical achievements and moments when people intervened into and changed the state of things. While this is a valid concern, it is not necessarily incompatible with the themes and arguments put forth here. A commitment to change, even radical change, relies to some extent on reexamining the narratives, symbols, and imaginaries that keep us attached to the order of things. It requires selves to think about the relationship

between micropractices and macroprocesses, between everyday habits, dispositions, sensibilities, and affective structures, on the one hand, and arrangements of power on the other. In other words, any radical intervention into the state of things entails changes and transformations in how selves remember, contemplate, experience the world, and see and hear suffering. Structural change must include practices, activities, and modes of being that cultivate heightened levels of vulnerability and attunement to the broken, dissonant features of lifeworlds and social arrangements, to bodies, communities, struggles, and conditions that disconcert our sense of achievement, coherence, and complacency. Therefore, in response to Rorty's important concerns, I contend that receptivity, remembrance, being unsettled, troubling violent narratives and images of solidarity, and risking self-coherence and stability are occasions for and sources of inspiration, or a certain kind of inspiration. In line with this Rortyean concern, one might argue that melancholy, contemplation, and the deconstruction of narratives are merely critical dispositions and strategies that lack a constructive component. In other words, I have not offered a determinate vision or alternative to the state of things. The work of the negative, to be taken seriously, must ultimately generate something affirmative, substantive, practical, and well-defined. These kinds of qualms, usually directed at the so-called poststructuralists, miss the fact that troubling, destabilizing, and undoing well-entrenched narratives and assumptions does do something; it does many things, in fact. It opens up spaces for contestation, tarrying, revision, and reimagination. Leaving the constructive moment indeterminate does not necessarily mean a retreat on practical matters or an unwillingness to imagine a different kind of world; the indeterminate moment with regard to reconstructing the world is an ethical and political strategy that acknowledges and registers the violence involved in well-intentioned endeavors to envision, project, and bring into being a well-defined alternative to the order of things. Similarly, the language of vulnerability and receptivity, which many commentators merely associate with passivity and a refusal to be engaged in the messy, contingent world, draws attention to the underside of overconfident notions of self, agency, and action. These are notions of the self or collective identity characterized by desires to control, determine, and manage the proverbial Other, to assimilate, eliminate, or both assimilate and eliminate that which is opaque, dissonant, and unwieldy.

Yet this study does make explicit contributions to and interventions into difficult discussions about race, religion, remembrance, and collective strivings for a more just and generous world. This contribution includes an irreverent notion of black piety, the ambivalence of recognition, the ethics of remembering against the grain, and a playful embrace of the tragic quality of existence.

An irreverent notion of black piety—piety here alluding to a general awareness of human contingency and dependence on others as well as the specific ways in which an author like Du Bois acknowledges the historical doings and sufferings that make his existence possible—both draws from and parts way with conventional strands of black religious thought. While black religious thought is fluid and heterogeneous, most people inside and outside of the academy conflate black religion with the black church and with black Protestantism more specifically. As philosopher of religion William David Hart points out, "the standard narrative of black religion" assumes that "Christianity in general and its institutional manifestation as church is the template for understanding what Black Religion is."[8] This conflation historically privileges the church as the "womb" of black cultural life, downplaying alternative religious traditions that black people have participated in, constructed, and reimagined. In addition, the black religion–black church reduction tends to make a rigid distinction between church and world, sacred and profane, religion and culture. This neglects how spaces and practices outside of the church, and outside of religious institutions, provide resources that help black people narrate, make sense of, and even perform the complexities and vicissitudes of life. These practices and resources, like jazz, blues, hip hop, and literature, trouble conventional distinctions between the sacred and profane. A kind of piety or fidelity (remember that religion stems from a Latin term that means "to bind") to black cultural legacies is often expressed through remembrance, mourning, gratitude, and reinterpretation.

But as Hart admonishes, with particular reference to Du Bois, black piety is frequently intertwined with essentialized notions of blackness. In other words, certain kinds of qualities and behaviors are imagined as necessary markers of blackness. To be faithful to black people, one has to accept normative conceptions of being black, widely recognized ways of remembering black history, and uncritical appeals to tradition, iconic leadership, and so forth. To resist this temptation, Hart suggests that pious

dispositions must be accompanied by impiety. As much as we show gratitude and acknowledge our debts to those who came before us, we also have the responsibility to critique, reinterpret, and even reject some of our ancestor's commitments. In addition, we might say that while piety is usually associated with gratitude toward what we have been given, black piety is also marked by an awareness of those traumas and losses that will always remain opaque and irretrievable. These are experiences that Morrison warns cannot be "passed on," that cannot be ignored, but at the same time cannot be recuperated by traditional narratives and discourses. Even the legible goods and resources that get passed down bear the marks of conflict and erasure. An idea or practice that might be an empowering gift for some black selves, might be ponderous and oppressive for others. Therefore, black piety must contemplate the often disavowed relationship between gift and theft. It must confront the fissures and cuts in black experience that, among other effects, work against totalizing notions of blackness and racial identity. Finally, I suggest that we think of black piety as a piety of the opaque, to riff on Charles Long's designation.[9] A piety of the opaque demands a melancholic attunement to exclusions and erasures that make progress and social advancement possible, to the blind spots and silences that indicate the limitations of discourse, visibility, and recognition. (Our lives and existence depend on the losses and sufferings of anonymous others.) While redemption, wholeness, and liberation have often been the end goals of black religious strivings, this melancholy piety draws attention to how these kinds of strivings further stigmatize and devalue bodies, both within and outside the black community, that signify ambivalence, contradiction, and diremption.

Black piety, on my reading, demonstrates how recognition, especially in the context of black people's strivings, is a fraught idea and goal. It is very difficult to think about political resistance without the Hegel-inspired struggle for recognition, discussed in chapter 1. This struggle does not simply express an abstract desire to be affirmed and respected as a human being or citizen (as important as this is); it also expresses a more concrete and practical desire for goods, resources, and capital to be redistributed and expanded. This redistribution of goods, and respect, is certainly important, valuable, and necessary. But recognition harbors a neglected underside. In order for the excluded to be included, to be recognized as citizens and protected by laws, the excluded must accede to the norms and terms of the political and social order. Or perhaps this is too one-sided. As

the tradition of black freedom struggles show us, the demand for equality and inclusion often entails a transformation of the dominant norms and rules, a reconfiguration of democracy and social coexistence. Yet any order or social arrangement defines itself against some Other, some set of qualities and practices that present a threat to that order. Expanding the sphere of recognition to formerly excluded groups does not necessarily eliminate the space of the threatening Other; it simply, or not so simply, shifts and redistributes the line between acceptable subject or citizen and menacing Other. Some examples help clarify what I am getting at here. Establishments cannot legally prohibit black bodies from entering their spaces (although occasionally instances to the contrary flash up) but they can proscribe certain kinds of clothing and dress associated with racialized and working-class identities. Signs that used to read "no blacks allowed" have been replaced by signs that read "no Timberlands, work boots, baggy clothing, or white T-shirts permitted." I am obviously not suggesting that all or only black people wear these kinds of clothing. I am suggesting that this contemporary ban replaces one form of exclusion with another, more subtle form of exclusion that is informed by race, class, and gender anxieties. Another example pertains to gender dynamics in hip hop culture. Within the past three decades, a disproportionate amount of black men with respect to black women have found a way to be "recognized" and affirmed within hip hop culture. Yet as many commentators have shown, this recognition often requires rap artists to perform exaggerated versions of black masculine identity, a performance that generates both fascination and fear. The money, power, and respect that male artists have been able to accumulate typically require an acceptance and exaggeration of troubling, but pervasive, gender norms and expectations, especially the treatment of women as useful objects of pleasure or a threat to masculine power. Recognition and the acquisition of wealth and capital, as important as this process might be, always comes with a cost; it requires subjects to consent to terms and conditions that are harmful to some community or identity. Riffing on Du Bois, we might say that progress and recognition are necessarily ugly. Riffing on Ellison, we might say that making some people's struggles more visible entails rendering other struggles relatively invisible. This is not always because we are intentionally cruel and inhumane but because we are always finite and human. This predicament does not mean that we should forgo these strivings for recognition but that these strivings should be informed by a heightened awareness of the violence involved in

well-intentioned endeavors to make the world more inclusive (or the violent quality of the institutions, practices, and arrangements that provide protection and recognition to formerly excluded selves and communities, but at the expense of others).

Like recognition, remembrance is enabled by a complicated set of activities, processes, and practices. As both an individual and collective process, remembrance is shaped, informed, and made possible by cultural narratives, symbols, and practices. Remembrance is closely linked to piety since piety tends to regulate how and what we remember. As Morrison and Benjamin especially suggest, many of our cultural narratives and attachments work to erase the "tradition of the oppressed" or threaten to assimilate this legacy for the sake of order and stability. Remembering against the grain enables us to not only seize images, events, and ideas from the past but to cut, challenge, and undo narratives that justify, redeem, and make us comfortable with suffering and loss. While melancholic hope challenges the eagerness to get over the painful dimensions of the past, it also resists forms of nostalgia about the past. Melancholy and nostalgia are sometimes difficult to distinguish.[10] Both are ways of being attached to loss. Yet in my analysis, there is a crucial difference. Nostalgia, as demonstrated in a film like *The Birth of a Nation*, marks a longing for a lost time, state, or place marked by completeness and plentitude; it imagines some harmonious state that exists before some fall or decline. Contemporary narratives about hip hop that imagine a golden era before the commercialization of this musical genre exemplify nostalgic longings. Discussions in black communities about the good old days when black people were unified, when blacks had effective and courageous leaders, and when the youth respected their elders also betray this inclination toward nostalgia. Melancholy, on my reading, works in a different direction. Instead of wishing for some past (or future) wholeness, melancholic hope exposes how this all-too-human desire for wholeness and unity obscures the breaks, cuts, and wounds of history and human existence. It cultivates a difficult attunement to the ruins and remains that cannot be fully integrated into unifying narratives and projects (but that are also the products of these unifying projects). Instead of trying to recover a more complete and happy past, melancholic hope imagines a tension-filled interaction between the past and present. It is inspired by Ellison's jazzlike sense of time in which the present is never coherent or seamless but always disjointed and marked by competing rhythms, temporalities, and modes of being. This

dissonant understanding of time and history opens up novel ways of reading the relationship between past and present—against the grain of prevailing narratives and practices of remembrance.

At the same time, I acknowledge that forgetfulness is both inevitable and necessary. One always has to tread lightly when talking about the capacity and need to forget. On the one hand, this is a marker of our finitude. Events inevitably become repressed as we move on and history continues to take place. Even if selves don't forget past incidents and realities (both pleasurable and painful), they don't relate to these incidents in the same way over time. Leaving certain dimensions of the past behind us is probably necessary in order to create new and more promising ways of living together. On the other hand, I acknowledge that the need to forget is often an onus placed on those who have been injured and persecuted. As Adorno puts it, in reference to Germans working through the trauma and guilt of the Holocaust, "The attitude that everything should be forgotten and forgiven, which would be proper for those who suffered injustice, is practiced by those . . . who committed the injustice."[11] In addition, the pressure placed on us to move on and leave the past behind assumes that we have complete control over this process. As Morrison's novels suggest, there are facets of the past that haunt us because they cannot be easily handled, fixed, and resolved. The past remains alive, or in a state between life and death, in part because traumas take time to be made sense of, to be worked through, and to be incorporated into memory and language. Therefore, forgetfulness is both necessary and a quality that should generate suspicion. Adorno sums up this tension well: "One wants to break free of the past: rightly because nothing at all can live in its shadow, and because there will be no end to the terror as long as guilt and violence are repaid with guilt and violence; wrongly, because the past that one would like to evade is still very much alive."[12]

Melancholic hope acknowledges inescapable tensions and conflicts when it comes to recognition, remembrance, and the legacy of racial difference. This is not because of an inclination to equivocate or a desire to confuse the reader but because ultimately I am naming—with fear and trembling—the broken, tragic quality of human existence. A difficult, but playful, embrace of the tragic is clearly indebted to Ellison's notion of the tragic-comic, an idea that he introduces in his well-known definition of the blues. But closer to home, my ludic understanding of the tragic is a riff on Cornel West's tragic-comic sensibilities. West often interprets black

people's struggles, their "doings and sufferings," according to three broader frames—American history, modern life, and the tragic-comic quality of being human.[13] This tragic-comic trope underscores the inevitability of death, loss, and suffering in a culture and species that often tries to hide from its mortality. At the same time, for West, this sensibility acknowledges the importance and value of producing and "passing down" cultural resources that enable us to cope, endure, resist, make the world a little better during our short detour on earth, and ultimately prepare for death. Some might worry that the particularity of black people's doings and strivings might get lost or erased by using such a broad category like the tragic-comic to frame these experiences. This does not have to be the case. One can take seriously the particularity of racial formations and struggles while also acknowledging how these modern realities reflect, refract, and signify broader human tendencies and predicaments (while also prompting us to reimagine and alter our understanding of the human).

The tragic-comic sensibility, articulated by West, is appropriate. Life is messy. The world might be our home, but it is a broken home. Selves are thrown into existence, into traditions, cultures, and legacies of oppression and struggle that are always under way.[14] Communities nurture and cultivate selves but they also injure and mutilate selves; communities provide sustenance and life for their members but this life is often predicated on the alienation and death of others. We are taught by the social world to desire certain things, including material objects, power, recognition, love, intimacy, friendship, transcendence, and so forth. But our desires clash with those of others; the fulfillment of my desire requires other desires to remain unsatisfied. My pleasure comes at the expense of someone else's misery and anguish. My well-intentioned attempts to help others and change the state of things often repeat and introduce troubling relationships and forms of power. Even as I recognize these all-too-human predicaments, I inhabit a social world in which recognition and self-preservation require me to act as if I am coherent, composed, assured, and intact. In other words, my success as a self in this world requires me to distance and separate myself from its broken features, a prerequisite that includes the belief that this broken quality can be fixed or resolved. To accentuate the language of tragedy and brokenness does not imply that some of our undesirable relationships and arrangements cannot be changed or remedied. History shows us that there is always room to tinker, improvise, experiment, create, and contest social constraints that prevent wider human

flourishing. In addition, to reduce the world to its tragic features is not the same thing as affirming its inescapability; the reduction doesn't make room for anything else and downplays the importance of laughter, pleasure, change, hope, and intimacy. The affirmation suggests that the more pleasurable aspects of life always carry the trace of the tragic, broken quality of existence.

Perhaps this play between pleasure and suffering, or hope and anguish, is where we should end—and begin. And perhaps the trope of the cut used in literary jazz is a fitting sound for this interplay. Recall that the cut within literary jazz signifies both a wound and an opening. It suggests that better horizons and possibilities might be enabled and opened by a heightened and more vulnerable awareness of the wounds and damages that mark our social worlds. A more generous and promising world, according to this view, relies on an opening toward, rather than attempts to escape from, the fractured quality of social life. Through this difficult vulnerability, this bitter earth might not be so bitter after all.

NOTES

1. John McCain, "Complete Text of John McCain's Concession Speech," November 4, 2008, accessed July 30, 2012, http://latimesblogs.latimes.com/washington/2008/11/john-mccain.html.
2. Booker T. Washington's influence and legacy are very complicated and beyond the scope of this project. I am simply interested in how McCain's reference to the conservative black leader fits into McCain's speech, how it compels a certain way of imagining the nation's racial history. I talk more about Du Bois's relationship to Washington in chapter 2.
3. NBC News transcript, "Decision 2008," quoted in Tim Wise, *Between Barack and a Hard Place: Racism and White Denial in the Age of Obama* (San Francisco: City Lights Books, 2009), 26.
4. Quoted in Matthew Hughey, "Measuring Racial Progress in America: The Tangled Path," in *The Obamas and a (Post) Racial America?*, edited by Gregory S. Parks and Matthew W. Hughey (Oxford: Oxford University Press, 2011), 19.
5. Hughey, "Measuring Racial Progress in America," 19.
6. Victor Anderson has provided a powerful articulation of the problems and dangers associated with this tendency to identify successful, heroic individuals within the black community as representative of the race as a whole. For Anderson, this is

an example of essentializing blackness and assumes a unified black experience. See Victor Anderson, *Beyond Ontological Blackness: An Essay on African American Religious and Cultural Criticism* (New York: Continuum, 1995).

7. Here, for instance, I am thinking about Eduardo Bonilla-Silva's claim that postracial rhetoric is the newest expression of colorblind racism. See his *Racism without Racists: Color-Blind Racism and Inequality in Contemporary America* (Lanham, MD: Rowman and Littlefield, 2010).

8. Barack Obama, "Obama Trayvon Martin Speech Transcript: President Comments on George Zimmerman Verdict," July 19, 2013, accessed October 9, 2015, http://www.huffingtonpost.com/2013/07/19/obama-trayvon-martin-speech-transcript_n_3624884.html.

9. Barack Obama, "President Obama's BET Interview," December 8, 2014, accessed October 9, 2015, https://www.youtube.com/watch?v=KJ4cszNCRTo.

10. For a treatment of Obama's teleological vision, his commitment to human progress, and his indebtedness to previous presidents and activists, see Richard Leeman, *The Teleological Discourse of Barack Obama* (Lanham, MD: Rowman and Littlefield, 2012).

11. This is a central theme in the anthology *The Obamas and a (Post) Racial America?*

12. Du Bois, *Darkwater: Voices from within the Veil* (Mineola, NY: Dover, 1999), 19.

13. Du Bois, *Darkwater*, 27.

14. Here I am making a distinction similar to the one that Robert Gooding-Williams makes between intrinsic and extrinsic theories of white supremacy. The latter interpretation sees white supremacy and the reproduction of racial hierarchies as a deviation from modern practices and norms while the former sees them as constitutive. See Robert Gooding-Williams, *In the Shadow of Du Bois: Afro-modern Political Thought in America* (Cambridge, MA: Harvard University Press, 2009), 15–16; also see Charles Mills, *The Racial Contract* (Ithaca, NY: Cornell University Press, 1997).

15. See Kevin Gaines, *Uplifting the Race: Black Leadership, Politics, and Culture in the Twentieth Century* (Chapel Hill: University of North Carolina Press, 1996).

16. See Shamoon Zamir's *Dark Voices: W. E. B. Du Bois and American Thought, 1888–1903* (Chicago: University of Chicago Press, 1995), chapter 4.

17. I am thinking particularly of Hegel's famous text, *Phenomenology of Spirit*, translated by A. V. Miller (Oxford: Oxford University Press, 1977). *Spirit* is a complicated term that has, according to recent Hegel scholarship, been misunderstood by most readers of Hegel. Whereas many have assumed that Hegel's Spirit is a metaphysical, ethereal category, recent commentators have suggested that Spirit constitutes a set of "down to earth" social practices characterized by antiauthoritarianism, norm-governed freedom, mutual recognition, and the exchange of reasons among coparticipants. See, for instance, Terry Pinkard, *The Sociality of Reason* (Cambridge: Cambridge University Press, 1996), 1–19.

18. Georg Wilhelm Friedrich Hegel, *The Philosophy of History*, translated by J. Sibree (New York: Dover, 1956), 99.

19. See Hegel, *Elements of the Philosophy of Right*, edited by Allen Wood (Cambridge: Cambridge University Press, 1991), 376.

20. For a very helpful essay on the relationship between Hegel's philosophy and colonization, see Tsenay Serequeberhan, "The Idea of Colonialism in Hegel's Philosophy of Right," *International Philosophical Quarterly* 29, no. 3 (September 1989): 301–18. For a more nuanced reading of Hegel's relationship to colonization, see Susan Buck-Morss, *Hegel, Haiti, and Universal History* (Pittsburgh: University of Pittsburgh Press, 2009). According to Buck-Morss, the famous section in the *Phenomenology* on the master-slave relationship was actually inspired by the Haitian Revolution. Although she claims that Hegel was sympathetic to the struggles of black slaves in the early part of his career, she accuses Hegel for the conservative shift made in the later part of his career, a shift signified by claims about Africa's insignificance to history. See especially pages 65–75.
21. See, for instance, Du Bois, "The Conservation of Races," in *The Idea of Race*, edited by Robert Bernasconi and Tommy Lott (Indianapolis: Hackett, 2000), 108–17.
22. See, for instance, *The Marx-Engels Reader*, edited by Robert C. Tucker (New York: W. W. Norton, 1978), 469–500.
23. See, for instance, *The Marx-Engels Reader*, 435–36.
24. *The Marx-Engels Reader*, 435.
25. To some extent, Marx adopts Hegel's advanced-backward binary even though he is very attuned to the violence enacted against "backward nations." For a discussion of how Marx and Engels adopt Hegel's notion of "backwardness" with regard to non-European groups, and how this notion buttresses their endorsement of colonialism, see Jorge Larrain, "Classical Political Economists and Marx on Colonialism and 'Backward' Nations," *World Development* 19, no. 2 (1991): 225–43. For a discussion of the ambiguous implications of Marx's universal conception of history, see Dipesh Chakrabarty, *Provincializing Europe: Postcolonial Thought and Historical Difference* (Princeton, NJ: Princeton University Press, 2000).
26. Ellison, *Shadow and Act* (New York: Quality Paperback, 1994), 253.
27. Ellison, *Shadow and Act*, 43–44.
28. For a similar concern about this more "conservative" side of Ellison's thought, see Roderick Ferguson, *Aberrations in Black: Toward a Queer Color of Critique* (Minneapolis: University of Minnesota Press, 2004), 66–72.
29. See Bercovitch, *The American Jeremiad* (Madison: University of Wisconsin Press, 1978), 3–30.
30. This is somewhat complicated since Bercovitch acknowledges that the jeremiad tradition has a dark side, a side that includes condemnation and castigation when the chosen nation, America, fails to fulfill its obligation. In other words, the idea of chosenness can lead to triumphant visions of nationhood as well as a critical disposition toward that nation when it refuses to live up to the ideals of the nation. As Bercovitch points out, eminent critics of America (Emerson, Thoreau, Melville) may have put forth severe critiques of America—greed, corruption, wastefulness—but these critiques were often inspired by an idealized conception of America. See Bercovitch, *The American Jeremiad*, 176–210.
31. Bercovitch, *The American Jeremiad*, 17. But of course it has to deny divisiveness because it often creates conflict and division, as I describe below.

32. Ellison, *Shadow and Act*, 250.

33. See Benjamin, "On the Concept of History," in *Walter Benjamin: Selected Writings* vol. 4, edited by Howard Eiland and Michael Jennings (Cambridge, MA: Harvard University Press, 2003), 392.

34. Benjamin, "On the Concept of History," 391. Here I am very indebted to Shoshana Felman's reading of Benjamin. She suggests that the "deceptive continuity" of history silences the oppressed, deprives them of a voice (while they are living and after death). See Felman, *The Juridical Unconscious: Trials and Traumas in the Twentieth Century* (Cambridge, MA: Harvard University Press, 2002), 28–34.

35. This narrative was made very explicit during the inauguration ceremonies in January, 2009.

36. Theodor Adorno, "Progress," in *Critical Models: Interventions and Catchwords*, translated by Henry Pickford (New York: Columbia University Press, 1999), 143–44.

37. I acknowledge that I am conflating the terms *black* and *black American*. Due to my limited expertise, the focus of this book is on black writers and authors who have operated primarily in the American context (Du Bois would of course be an exception here). At the same time, I acknowledge that blackness as a modern category of identification and subject position extends beyond the United States and the Americas.

38. See MacIntyre, *Whose Justice? Which Rationality?* (Notre Dame, IN: University of Notre Dame Press, 1989), 12.

39. For a discussion of the different debates around what constitutes black literature (what distinguishes it from other literary forms), see *African American Literary Criticism, 1773 to 2000*, edited by Hazel Arnette Ervin (New York: Twayne, 1999), introduction. For a very different perspective, one that rejects the notion of African American literature as a valid, unified discourse after 1965, see Kenneth Warren, *What Was African American Literature?* (Cambridge, MA: Harvard University Press, 2011).

40. See, for instance, Judith Butler, *Precarious Life: The Powers of Mourning and Violence* (New York: Verso, 2004); Anne Cheng, *The Melancholy of Race: Psychoanalysis, Assimilation, and Hidden Grief* (New York: Oxford University Press, 2001); David Eng and David Kazanjian, *Loss: The Politics of Mourning* (Berkeley: University of California Press, 2003); David Kim, *Melancholic Freedom: Agency and the Spirit of Politics* (Oxford: Oxford University Press, 2007); Antonio Viego, *Dead Subjects: Toward a Politics of Loss in Latino Studies* (Durham, NC: Duke University Press, 2007).

41. Sigmund Freud, "Mourning and Melancholia," *The Standard Edition of the Complete Psychological Works of Sigmund Freud Vol XIV*, translated by James Strachey (London: Hogarth, 1957), 243.

42. Freud, "Mourning and Melancholia," 249.

43. Freud, "Mourning and Melancholia," 246.

44. Like most distinctions in Freud's corpus, it is deconstructed and destabilized throughout the essay.

45. Butler, *Precarious Life*, 21.

46. See Eng and Kazanjian, *Loss: The Politics of Mourning*, introduction.

47. Eng and Kazanjian, *Loss: The Politics of Mourning*, 4.

48. Cheng, *The Melancholy of Race*, 4.

49. Cheng, *The Melancholy of Race*, 10.

50. Cheng, *The Melancholy of Race*, 20.

51. Karla Holloway, *Passed On: African American Mourning Stories* (Durham, NC: Duke University Press, 2002).

52. Here Cheng is indebted to the Saidiya Hartman's argument about the excessive and opaque quality of sorrow songs. See Saidiya Hartman, *Scenes of Subjection: Terror, Slavery, and Self-Making in Nineteenth-Century America* (Oxford: Oxford University Press, 1997), 35–36.

53. Here I am indebted to Jonathan Flatley's description of melancholy as a mode of being, mood, and temperament in *Affective Mapping: Melancholia and the Politics of Modernism* (Cambridge, MA: Harvard University Press, 2008).

54. It is unfortunate that the first generation of the Frankfurt School (especially Adorno and Horkheimer) is typically portrayed as pessimistic with regard to the possibility of social change and transformation. I would suggest that this is the result of a misreading of texts like *Dialectic of Enlightenment* and a consequence of Habermas's highly influential reading of his predecessors. According to Habermas, authors like Adorno and Horkheimer proffer a critique of the modern world that is so totalizing and complete that they must locate hope and possibility in an irrational, aesthetic realm. See, for instance, Jürgen Habermas, "The Entwinement of Myth and Enlightenment: Re-Reading Dialectic of Enlightenment," *New German Critique* 26 (spring–summer 1982): 13–30. Like many other commentators before me, I hope to contribute to alternative readings of the first generation.

55. See Adorno, *Aesthetic Theory*, translated by Robert Hullot-Kentor (Minneapolis: University of Minnesota Press, 1997), 135.

56. See West, *The American Evasion of Philosophy: A Genealogy of Pragmatism* (Madison: University of Wisconsin Press, 1989).

57. See Paul Gilroy, *The Black Atlantic: Modernity and Double-Consciousness* (Cambridge, MA: Harvard University Press, 1993).

58. Adorno develops this notion of a constellation in *Negative Dialectics*, translated by E. B. Ashton (New York: Continuum, 1973), 162–66. He is borrowing from and reinterpreting Benjamin's definition of the constellation in *The Origin of German Tragic Drama*, translated by John Osborne (London: Verso, 1985), 34.

59. See C. L. R. James, "Black Studies and the Contemporary Student," in *The C. L. R. James Reader*, edited by Anna Grimshaw (Cambridge, MA: Blackwell, 1992), 397. For a recent elaboration on this particular point, see Alexander Weheliye, *Habeus Viscus: Racializing Assemblages, Biopolitics, and Black Feminist Theories of the Human* (Durham, NC: Duke University Press, 2014), 17–18.

60. See Sylvia Wynter, "Unsettling the Coloniality of Being/Power/Truth/Freedom: Towards the Human, After Man, Its Overrepresentation—an Argument," *CR: The New Centennial Review* 3, no. 3 (2003): 257–337.

61. Ralph Ellison, *Invisible Man* (New York: Signet Classics, 1952), 8.

62. I acknowledge that there have been many different sites, texts, and contexts where the idea of racial progress and advancement gets produced, reinforced, displayed, and performed. Here one might think of photographs from the nineteenth and

early twentieth century of black leaders and figures that were designed to display and capture the promise of progress and uplift. See, for instance, *Pictures and Progress: Early Photography and the Making of African American Identity*, edited by Maurice Wallace and Shawn Michelle Smith (Durham, NC: Duke University Press, 2012).

63. This view is expressed by scholars like Anthony Appiah and Naomi Zack. See, for instance, Appiah's "The Uncompleted Argument: Du Bois and the Illusion of Race," in *The Idea of Race*, edited by Robert Bernasconi and Tommy Lott (Indianapolis: Hackett Publishing, 2000), 118–35. Also see Naomi Zack, *Race and Mixed Race* (Philadelphia: Temple University Press, 1994).

64. See, for instance, Stuart Hall, "What Is the 'Black' in Black Popular Culture?" *Social Justice* 20 (spring–summer 1993): 104–15. For another, related theory of racial formation as a socially constituted process, see Michael Omi and Howard Winant, "Selections from *Racial Formation in the United States*," in *The Idea of Race*, edited by Robert Bernasconi and Tommy Lott (Indianapolis: Hackett, 2000), 181–212.

65. See Crenshaw, "Mapping the Margins: Intersectionality, Identity Politics, and Violence against Women of Color," *Stanford Law Review* 43 (1993): 1241–99.

66. See Pinn, "Handlin' My Business: Exploring Rap's Humanist Sensibilities," in *Noise and Spirit: The Religious and Spiritual Sensibilities of Rap Music*, edited by Anthony Pinn (New York: New York University Press, 2003), 85–104.

67. On this issue of the usefulness of race as a category that helps us to frame and respond to social conflicts, see Omi and Winant, "Selections from *Racial Formation in the United States*." Also see Paul Taylor, "Pragmatism and Race," in *Pragmatism and the Problem of Race*, edited by Bill Lawson and Donald Koch (Bloomington: Indiana University Press, 2004), 162–76.

CHAPTER ONE *Unreconciled Strivings*

1. I am intentionally using hyperbole here. I am not necessarily saying that Du Bois is the founding father of African American Studies. I certainly don't want to make an argument about origins or progenitors, even if Du Bois is often treated as such. I think it is safer to say that many of the stories and accounts that we provide about black people, black history, and black intellectual traditions tend to privilege and rely heavily on Du Bois's texts and ideas. To be sure, there is some concern about how Du Bois is invoked within contemporary discourses. For a critique directed at the ahistorical use of Du Bois's ideas within African American Studies, see Adolph Reed, *W. E. B. Du Bois and American Political Thought: Fabianism and the Color Line* (New York: Oxford University Press, 1997). I deal with Reed's concerns in chapter 2. For a different, yet related, critique directed at how Du Bois is invoked to imagine the black intellectual in ways that reinforce gender exclusions and hierarchies, see Hazel Carby, *Race Men* (Cambridge, MA: Harvard University Press, 1998), 9–41. I also respond to Harby's critique in chapter 2.

2. See, for instance, Lawrie Balfour's recent use of Du Bois to think about substantive racial equality and the cultural amnesia in our supposedly postracial world in *Democracy's Reconstruction: Thinking Politically with W. E. B. Du Bois* (New York:

Oxford University Press, 2011). For a powerful account of how Du Bois can help us reimagine the relationship between religion and democracy, see Terrence Johnson, *Tragic Soul-Life: W. E. B. Du Bois and the Moral Crisis Facing American Democracy* (New York: Oxford University Press, 2012).

3. See Johnson, *Tragic Soul-Life*, 39–41.

4. W. E. B. Du Bois, "The Talented Tenth," in *The Negro Problem* (Amherst, NY: Humanity Books, 2003), 33–75.

5. Du Bois's elitism has of course been the object of much discussion. For a helpful examination of Du Bois's understanding of the civilizing mission of elite blacks, see Reed, *W. E. B. Du Bois and American Political Thought*, 43–70. Also see Robert Gooding-Williams, *In the Shadow of Du Bois: Afro-modern Political Thought in America* (Cambridge, MA: Harvard University Press, 2009), 130–61. For a nuanced reading of Du Bois's elitism, a reading that tracks the changes in his thought with respect to the masses (and their relationship to black leaders), see Joy James, *Transcending the Talented Tenth: Black Leaders and American Intellectuals* (New York: Routledge, 1996).

6. Cornel West, "Black Strivings in a Twilight Civilization," in *The Cornel West Reader* (New York: Basic Civitas Books, 1999), 89. Although I think West is right to remind us that Du Bois was a child of his age, I think he overextends his argument by claiming that Du Bois does not wrestle with evil and tragedy. And although I am sympathetic to West's concerns about conceptions of humanity that deny or downplay the tragic, I think he too easily dismisses the melancholic tenor of his predecessor's thought. For a different reading of Du Bois's engagement with tragedy and evil, see Terrence Johnson, "'My Soul Wants Something New': Democratic Dreams behind the Veil," in *The Souls of W. E. B. Du Bois: New Essays and Reflections*, edited by Edward Blum and Jason Young (Macon, GA: Mercer University Press, 2009), 110–34. Also see Shamoon Zamir, *Dark Voices: W. E. B. Du Bois and American Thought, 1888–1903* (Chicago: University of Chicago Press, 1995).

7. My argument here is very much indebted to Zamir's reading of Du Bois and his relationship to proponents of American progress and exceptionalism.

8. Balfour, *Democracy's Reconstruction*, 7.

9. W. E. B. Du Bois, *The Souls of Black Folk* (New York: Dover, 1994), 1. Notice how the term *delicacy* can have many meanings here. Delicacy can refer to tact, refinement, and sympathy but it can also suggest weakness, flimsiness, and frailty. Is this opening sentence to "Our Spiritual Strivings" a potential critique of liberal notions of civility, politeness, and so forth?

10. Du Bois, *The Souls of Black Folk*, 2.

11. Du Bois, *The Souls of Black* Folk, 2. "Tasteless sycophancy" may refer to complacent assimilationists like Booker T. Washington, whereas those who "distrust everything white" might align themselves with black-nationalist, separatist movements. Throughout much of his early life, DuBois eschewed both temptations.

12. Du Bois, *The Souls of Black Folk*, 2.

13. For a very powerful elaboration on the significance of the "double" in Du Bois's thought, see Nahum Chandler, *X—The Problem of the Negro as a Problem for Thought* (New York: Fordham University Press, 2013).

14. Hortense Spillers, "Mama's Baby, Papa's Maybe: An American Grammar Book," *Black, White, and in Color: Essays on American Literature and Culture* (Chicago: The University of Chicago Press, 2003), 206.

15. Du Bois, *The Souls of Black Folk*, 2–3.

16. See Zamir, *Dark Voices*, 113–53. Of course Hegel is not the only author that Du Bois draws from to develop his notion of double-consciousness. As others have pointed out, he is indebted to his mentor, William James, who advanced a notion of the divided self or soul. See Zamir, *Dark Voices*, 153–68. It is important, for Zamir, that Du Bois part ways with both Hegel and James, a parting that has everything to do with the significance of black suffering and strivings within Du Bois's imagination and sphere of concern. For a very different understanding of Du Bois's notion of double-consciousness, see Reed, *W. E. B. Du Bois and American Political Thought*, 91–125.

17. Charles Taylor, *Hegel* (Cambridge: Cambridge University Press, 1975), 119.

18. See Hegel, *The Phenomenology of Spirit*, translated by A. V. Miller (Oxford: Oxford University Press, 1977), 111–19.

19. See Buck-Morss, *Hegel, Haiti, and Universal History*, 21–75.

20. Hegel, *The Phenomenology of Spirit*, 113.

21. Hegel, *The Phenomenology of Spirit*, 113.

22. See Honneth, *The Struggle for Recognition: The Moral Grammar of Social Conflicts*, translated by Joel Anderson (Cambridge, MA: MIT Press, 1999).

23. For an in-depth analysis of Hegel's notion of reconciliation, see Michael Hardimon, *Hegel's Social Philosophy: The Project of Reconciliation* (Cambridge: Cambridge University Press, 1994).

24. See Louis Althusser, "Ideology and Ideological State Apparatuses," in *Lenin and Philosophy and Other Essays*, translated by Ben Brewster (New York: Monthly Review Press, 2001), 85–126. For a critical response to the idea that recognition is merely the way in which ideology operates and consolidates itself, see Honneth, "Recognition as Ideology," in *Recognition and Power: Axel Honneth and the Tradition of Critical Social Theory*, edited by Bert Van Den Brink and David Owen (Cambridge: Cambridge University Press, 2007), 323–47.

25. Zamir, *Dark Voices*, 124.

26. Du Bois, *The Souls of Black Folk*, 3.

27. Du Bois, *The Souls of Black Folk*, 7.

28. Zamir, *Dark Voices*, 126. Shannon Mariotti offers a helpful reading of the relationship between the Veil and the gift of second sight. See Mariotti, "On the Passing of the First Born: Emerson's 'Focal Distancing,' Du Bois' 'Second Sight,' and Disruptive Particularity," *Political Theory* 37, no. 3 (2009): 351–74. Also see Balfour, *Democracy's Reconstruction*, 6–7.

29. Du Bois, *The Souls of Black Folk*, 4.

30. Du Bois, *The Souls of Black Folk*, 31.

31. Du Bois, *The Souls of Black Folk*, 7.

32. For a powerful analysis of this endeavor, see Eric Porter's reading of Du Bois and *Souls* in *What Is This Thing Called Jazz?: African American Musicians as Artists, Critics,*

and *Activists* (Berkeley: University of California Press, 2002), 3–5. Also see Paul Allen Anderson, *Deep River: Music and Memory in Harlem Renaissance Thought* (Durham, NC: Duke University Press, 2001), 13–57. Hazel Carby makes a similar claim in *Race Men*, 87–89.

33. See, for instance, Ellison's critical response to Leroi Jones in *Shadow and Act* (New York: Quality Paperback, 1964), 247–58. For Ellison, it is safe to say that mainstream American culture is always already blackened. I deal with Ellison's jazzlike vision of American culture in chapter 2.

34. Arnold Rampersad, *The Art and Imagination of W. E. B. Du Bois* (Cambridge, MA: Harvard University Press, 1990), 71.

35. Anderson, *Deep River*, 30.

36. Du Bois, *The Souls of Black Folk*, 7.

37. Here I am implicitly drawing on Jacques Derrida's notion of the supplement (and his broader understanding of the play of signs and the deferral of meaning), which signifies not only an addition and accretion of meaning but also substitution and subtraction. See Derrida, *Of Grammatology*, translated by Gayatri Spivak (Baltimore: Johns Hopkins University Press, 1997), 141–64.

38. See Eric Sundquist, *To Wake the Nations: Race in the Making of American Literature* (Cambridge, MA: Harvard University Press, 1993), 457–539.

39. Theodor Adorno, *Negative Dialectics*, translated by E. B. Ashton (New York: Continuum, 1973), 5.

40. Frederick Douglass, "Narrative of the Life of Frederick Douglass," in *Slave Narratives*, edited by William L. Andrews and Henry Louis Gates Jr. (New York: Library of America, 2000), 289–90.

41. Fred Moten, *In the Break: The Aesthetics of the Black Radical Tradition* (Minneapolis: University of Minneapolis Press, 2003), 20–21.

42. Du Bois, *The Souls of Black Folk*, 155.

43. Du Bois, *The Souls of Black Folk*, 157.

44. Du Bois, *The Souls of Black Folk*, 157.

45. James Baldwin, "Many Thousands Gone," *The Price of the Ticket* (New York: St. Martins, 1985), 65.

46. Saidiya Hartman, *Scenes of Subjection: Terror, Slavery, and Self-Making in Nineteenth-Century America* (New York: Oxford University Press, 1997), 35–36.

47. Du Bois, *The Souls of Black Folk*, 162.

48. Du Bois, *The Souls of Black Folk*, 162.

49. Du Bois, *The Souls of Black Folk*, 163.

50. For a definitive account of the influence of Exodus on antebellum black America, see Eddie Glaude, *Exodus!: Religion, Race, and Nation in Nineteenth-Century Black America* (Chicago: University of Chicago Press, 2000). I will deal with the underside of Exodus narrative in chapter 5.

51. Du Bois, *The Souls of Black Folk*, 162.

52. See Anthony Pinn, *Why, Lord?: Suffering and Evil in Black Theology* (New York: Continuum, 1995), 21–38.

53. Du Bois, *The Souls of Black Folk*, 120.

54. Du Bois, *The Souls of Black Folk*, 116.

55. Karl Marx, "Contribution to the Critique of Hegel's *Philosophy of Right*," *The Marx-Engels Reader*, 54.

56. For an earlier essay that locates Du Bois within the black prophetic tradition, see Manning Marable, "The Black Faith of W. E. B Du Bois," in *Black Leadership* (New York: Columbia University Press, 1998), 59–74. For more recent studies of Du Bois's religious imagination, see Edward Blum, *W. E. B. Du Bois: American Prophet* (Philadelphia: University of Pennsylvania Press, 2007); Jonathon Kahn, *Divine Discontent: The Religious Imagination of W. E. B. Du Bois* (Oxford: Oxford University Press, 2009). Also see Terrence Johnson's *Tragic Soul-Life*.

57. For an account of the relationship between transcendence and immanence in slave practices and beliefs, see Al Raboteau's *Slave Religion: The "Invisible Institution" in the South* (Oxford: Oxford University Press, 2004), 317–18.

58. Du Bois, *The Souls of Black Folk*, 157, 158.

59. See Freud, "Mourning and Melancholia."

60. Du Bois, *The Souls of Black Folk*, 155.

61. Adorno, *Aesthetic Theory*, 117.

62. This idea is implicit throughout Adorno's corpus. But it might be most powerfully and famously articulated in *Minima Moralia*. To mention Adorno within the context of black music is complicated considering his infamous and widely misunderstood critique of jazz. I deal with Adorno's critique of jazz at the end of chapter 3.

63. Anthony Pinn, "Making a World with a Beat: Musical Expression's Relationship to Religious Identity and Experience," in *Noise and Spirit: The Religious and Spiritual Sensibilities of Rap Music*, edited by Anthony Pinn (New York: New York University Press, 2003), 3.

64. Pinn, "Making a World with a Beat," 3.

65. See Alexander Weheliye, *Phonographies: Grooves in Sonic Afro-Modernity* (Durham, NC: Duke University Press, 2005), 73–74.

66. Benjamin, "On the Concept of History," 390.

67. Benjamin, "On the Concept of History," 394.

68. Du Bois, *The Souls of Black Folk*, 159.

69. Du Bois, *The Souls of Black Folk*, 157. It is important to point out that the minstrel tradition is potentially more complicated than Du Bois suggests. Some scholars have underscored the ways blackface minstrelsy demonstrates both fascination with and aversion to black culture, both love and dispossession. See, for instance, Eric Lott, *Love and Theft: Blackface Minstrelsy and the Making of the Working Class* (New York: Oxford University Press, 1993).

70. This emphasis on authenticity in the context of black musical production is famously developed and expanded by Leroi Jones in his well-known text *Blues People* (New York: Morrow Quill Books, 1963). Jones argues that the history of black American music has been marked by a recurring clash between authentic expression (typically associated with the blues and other musical forms that are vocal, emotive, and that allow for spontaneity and improvisation) and prepackaged music designed to entertain wide audiences. The second type, which includes big

band jazz and swing for Jones, is regulated by the desire to appeal to mainstream America and to generate profit. It bears the heavy imprint of commodification and therefore devalues what constitutes black music—spontaneity, creativity, and improvisation. When black music is mainstreamed, according to Jones, it ceases to be characterized by a visceral cry or moan, thereby obscuring black people's unique relationship to America. In this mainstreaming process, something vital about black music is lost or taken away.

71. See, for instance, Robert Gooding-Williams, *In the Shadow of Du Bois*, 13–15. Also see Paul Allen Anderson, *Deep River*, 22–29.

72. Anderson, *Deep River*, 28.

73. On this point, see Anderson, *Deep River*, 28–29. Du Bois of course develops a more nuanced conception of race and racial identity in later texts like *Dusk of Dawn*.

74. See Jon Cruz, *Culture on the Margins: The Black Spiritual and the Rise of the American Cultural Interpretation* (Princeton, NJ: Princeton University Press, 1999).

75. Shamoon Zamir makes a similar point about Du Bois's refusal to assimilate the tragic in his reading of the sorrow songs. See Zamir, *Dark Voices*, 199.

76. Throughout Zamir's book on Du Bois, he draws from Horkheimer's famous critique of American pragmatism in *Eclipse of Reason* and suggests that Du Bois actually distances himself from this tradition by emphasizing the importance of contemplation and reflection (activity is balanced by receptivity). Whereas the pragmatists, according to Horkheimer and Zamir, underestimate the importance of remembrance, Zamir's Du Bois shows the ethical and political implications of recollection. I am not convinced by Zamir's reductive reading of pragmatism but I do follow his inclination to underscore the significance of remembrance, contemplation, and even nostalgia in Du Bois's thought.

CHAPTER TWO *Unhopeful but Not Hopeless*

1. I am indebted to my conversations with Bill Hart on this issue.

2. Reed, *W. E. B. Du Bois and American Political Thought*, 130.

3. See Robert Stepto, *From behind the Veil: A Study of Afro-American Narrative* (Chicago: University of Illinois Press, 1991), 164–67.

4. There are many reasons typically offered to explain Du Bois's isolation from black folk. One has to do with class and regional differences; another related factor involves Du Bois's elitism with respect to the masses of black folk. Yet in my view these explanations often overlook the ways alienation and loneliness are general features of human existence, especially in the modern world.

5. Du Bois, *The Souls of Black Folk*, 37.

6. Du Bois, *The Souls of Black Folk*, 37–38.

7. Du Bois, *The Souls of Black Folk*, 39.

8. Du Bois, *The Souls of Black Folk*, 38.

9. Du Bois, *The Souls of Black Folk*, 41.

10. This is of course potentially a problem insofar as Du Bois downplays difference in favor of identity. This is one of the concerns that Carby articulates in *Race Men*.

11. Du Bois, *The Souls of Black Folk*, 39.

12. Du Bois, *The Souls of Black Folk*, 43.

13. See Gooding-Williams, *In the Shadow of Du Bois*, 94–95.

14. Gooding-Williams, *In the Shadow of Du Bois*, 94.

15. Walter Benjamin, *The Origin of German Tragic Drama*, translated by John Osborne (London: Verso, 1977), 177–78.

16. Shannon Mariotti, "On the Passing of the First Born: Emerson's 'Focal Distancing,' Du Bois' 'Second Sight,' and Disruptive Particularity," *Political Theory* 37, no. 3 (2009): 351–74.

17. Adorno, *Negative Dialectics*, 203.

18. Du Bois, *The Souls of Black Folk*, 45.

19. Carby, *Race Men*, 10.

20. Carby, *Race Men*, 39.

21. Carby, *Race Men*, 19. Carby also offers a provocative reading of Du Bois's essay on Atlanta and the use of gendered language to describe the space of this city.

22. Carby, *Race Men*, 20.

23. This is an argument made persuasively throughout Johnson's text, *Tragic Soul-Life*.

24. See Adorno and Horkheimer, *Dialectic of Enlightenment*, chapter 1. These themes have also been developed by authors like Georges Bataille and, more recently, Lee Edelman.

25. Du Bois, *The Souls of Black Folk*, 143.

26. Arnold Rampersad, *The Art and Imagination of W. E. B. Du Bois* (Cambridge, MA: Harvard University Press, 1990), 71.

27. Rampersad, *The Art and Imagination of W. E. B. Du Bois*, 75.

28. Du Bois, *The Souls of Black Folk*, 146.

29. For a brilliant reading of this scene that resembles mine but that goes in more detail, see Gooding-Williams, *In the Shadow of Du Bois*, 115–25.

30. Du Bois, *The Souls of Black Folk*, 146.

31. Du Bois, *The Souls of Black Folk*, 146.

32. This is somewhat complicated because John tries to reimmerse himself in the Southern community.

33. See Gooding-Williams, *In the Shadow of Du Bois*, 115–19. According to this author, the description of John in this short story resembles Du Bois's description of Alexander Crummell in the preceding chapter.

34. Du Bois, *The Souls of Black Folk*, 144–45.

35. Carby, *Race Men*, 25.

36. Carby, *Race Men*, 25. Again, I think Carby is right on here. Yet as I describe below, I don't think she pays enough attention to John's final act, his plunge into the sea.

37. Du Bois, *The Souls of Black Folk*, 152.

38. It is important to note that John looks at this white man with a sense of pity. It is almost as if the tragedy is redirected away from the victim toward the persecutor.

39. Du Bois, *The Souls of Black Folk*, 153.

40. Gooding-Williams, *In the Shadow of Du Bois*, 124.

41. See Jonathan Kahn, *Divine Discontent: The Religious Imagination of W. E. B. Du Bois* (Oxford: Oxford University Press, 2009), 123–26.

42. Kahn, *Divine Discontent*, 123.

43. Kahn, *Divine Discontent*, 122.

44. For my project, however, I privilege authors who have contested and challenged notions of agency. See Andrea Sun Mee Jones and Josh Dubler, *Bang! Thud: World Spirit from a Texas School Book Depository* (New York: Autraumatron, 2006); Judith Butler, *The Psychic Life of Power* (Stanford, CA: Stanford University Press, 1997); David Kim, *Melancholic Freedom* (New York: Oxford University Press, 2007); and Saba Mahmood, *Politics of Piety: The Islamic Revival and the Feminist Subject* (Princeton, NJ: Princeton University Press, 2005).

45. Romand Coles has written powerfully about how the Kantian tradition assumes a self that is coherent and stable, qualities that rely on not receiving from radical others. See Coles, *Rethinking Generosity: Critical Theory and the Politics of Caritas* (Ithaca, NY: Cornell University Press, 1997), 24–74.

46. Gay Wilentz, "Civilizations Underneath: African Heritage as Cultural Discourse in Toni Morrison's *Song of Solomon*," in *Toni Morrison's Fiction: Contemporary Criticism*, edited by David Middleton (New York: Garland, 2000), 112.

47. Du Bois, *The Souls of Black Folk*, 128.

48. Du Bois, *The Souls of Black Folk*, 128.

49. Du Bois, *The Souls of Black Folk*, 130.

50. Du Bois, *The Souls of Black Folk*, 130.

51. Du Bois, *The Souls of Black Folk*, 130.

52. Gooding-Williams, *In the Shadow of Du Bois*, 17. Gooding-Williams's argument is based on the assumption that Du Bois treated white supremacy as extrinsically related to America's norms and ideals. In other words, the racial ordering of modernity is not an intrinsic quality of the standards, norms, and practices of liberal democracy but a deviation from these practices. Here Gooding-Williams adopts the distinction that Charles Mills makes between "normative" and "anomaly" theories of white supremacy, arguing that Du Bois adopts the latter. He therefore does not emphasize the importance of transforming the basic arrangements of American democracy and modernity more broadly. For a very different reading of Du Bois's political vision, see Balfour's *Democracy's Reconstruction*. According to Balfour, white supremacy and racial injustice are, for Du Bois, fundamental features of modern life, not simply deviations.

53. Gooding-Williams offers a different reading of Du Bois in a recent article comparing Du Bois's autobiography (*Dusk of Dawn*) with that of Barack Obama (*Dreams of My Father*). See Gooding-Williams, "Autobiography, Political Hope, Racial Hope," *Du Bois Review* 11, no. 1 (spring 2014): 159–75. In this article, Gooding-Williams argues that while Obama's autobiography opens up the possibility of transcending race by finding a common ground, Du Bois links the elimination of racial domination with a "long siege."

54. Reed, *W. E. B. Du Bois and American Political Thought*, 127.

55. See Reed, *W. E. B. Du Bois and American Political Thought*, 163–78.

56. Reed, *W. E. B. Du Bois and American Political Thought*, 125.

57. Here I am very indebted to my conversations with Kent Brintnall and his reading of Georges Bataille. Brintnall uses Bataille in his work to undercut redemptive narratives of male suffering in everyday culture including action films. These redemptive narratives use the suffering body to ultimately recuperate fantasies of wholeness or being a unified subject. See Kent Brintnall, *Ecce Homo: The Male-Body-In-Pain as Redemptive Figure* (Chicago: University of Chicago Press, 2011).

58. Edward Said makes this link between a sense of unease and critical consciousness in *Representations of the Intellectual* (New York: Vintage, 1994).

59. See, for instance, Adolph Reed, *Class Notes: Posing as Politics and Other Thoughts on the American Scene* (New York: New Press, 2001).

60. See, for instance, Jacques Rancière, *The Politics of Aesthetics*, translated by Gabriel Rockhill (New York: Continuum, 2006) for an expanded notion of the aesthetic.

61. Du Bois, "Criteria of Negro Art," in *The Portable Harlem Renaissance Reader*, edited by David Levering Lewis (New York: Penguin, 1994), 103.

62. Du Bois, "Criteria of Negro Art," 103. For an interesting essay that shows how Du Bois actually mediates between the purists and the propagandists, see Eric Watts King, "Cultivating a Black Public Voice: W. E. B. Du Bois and the 'Criteria of Negro Art,'" *Rhetoric and Public Affairs* 4, no. 2 (summer 2001): 181–201.

63. Adorno, *Aesthetic Theory*, translated by Robert Hullot-Kentor (Minneapolis: University of Minnesota Press), 135.

64. Adorno, *Aesthetic Theory*, 237.

65. Adorno and Horkheimer, *Dialectic of Enlightenment*, 103.

66. See Marcuse, *An Essay on Liberation* (Boston: Beacon, 1969), 3–48.

CHAPTER THREE *Hearing the Breaks and Cuts of History*

1. I acknowledge that the term *jazz* is complicated and that there has never been consensus around what jazz is and who or what should be included in this elusive category. On this issue, see Scott DeVeaux, "Constructing the Jazz Tradition: Jazz Historiography," *Black American Literature Forum* 25, no. 3 (autumn 1991): 525–60. In this chapter, I am primarily concerned with literary uses of jazz or how Ellison and Morrison use jazz tropes to dislodge progressive accounts of history. On this distinction between jazz as such and literary jazz, see Jürgen E. Grandt, *Kinds of Blue: The Jazz Aesthetic in African American Narrative* (Columbus: Ohio State University Press, 2004), xiii.

2. See Grandt, *Kinds of Blue*, ix–xix.

3. For a discussion of the storytelling dimension of jazz music, see Walton Muyumba, *The Shadow and the Act: Black Intellectual Practice, Jazz Improvisation, and Philosophical Pragmatism* (Chicago: University of Chicago Press, 2009), 18.

4. Grandt, *Kinds of Blue*, xiii.

5. In her masterful interpretation of the aesthetics of hip hop, Imani Perry offers an expanded reading of the call-and-response tradition (within jazz, blues, hip hop).

For Perry, this trope does not just refer to the relationship between entertainer and audience. It also refers to the ways black artists and writers "respond to," reinterpret, and riff on traditional styles and discourses. Call and response, in other words, connotes intertextuality and dependence on tradition. See Perry, *Prophets of the Hood: Politics and Poetics in Hip Hop* (Durham, NC: Duke University Press, 2004), 33–37.

6. On the use of swing time within black literature, see Grandt, *Kinds of Blue*, 22–42.

7. Muyumba, *The Shadow and the Act*, 16.

8. Ralph Ellison, *Shadow and Act* (New York: Quality Paperback, 1994), 234.

9. See, for instance, Judith Butler, "Performative Acts and Gender Constitution: An Essay in Phenomenology and Feminist Theory," in *Theatre Journal* 40, no. 4 (December 1988): 519–31. Also see Butler, *Excitable Speech* (New York: Routledge, 1997), 127–64. I acknowledge that Butler underscores more than Ellison does the ways norms operate as a mode of subjection.

10. In addition to Burns's film and Muyumba's book, I am thinking of Beth Eddy's *The Rites of Identity: The Religious Naturalism and Cultural Criticism of Kenneth Burke and Ralph Ellison* (Princeton, NJ: Princeton University Press, 2003) and collections like *The Jazz Cadence of American Culture*, edited by Robert O'Meally (New York: Columbia University Press, 1998).

11. Farah Jasmine Griffin, *"Who Set You Flowin'?": The African American Migration Narrative* (New York: Oxford University Press, 1995), 3.

12. Cornel West, *Keeping Faith: Philosophy and Race in America* (New York: Routledge, 1993), xiii.

13. See Burke, "Ralph Ellison's Trueblooded *Bildungsroman*," in *Ralph Ellison's* Invisible Man: *A Casebook*, edited by John Callahan (Oxford: Oxford University Press, 2004), 65–79.

14. Burke, "Ralph Ellison's Trueblooded *Bildungsroman*," 67.

15. On this notion of authorial control, see, for instance, Robert Stepto, "Literacy and Hibernation: Ralph Ellison's *Invisible Man*," in *Ralph Ellison's* Invisible Man: *Modern Critical Interpretations*, edited by Harold Bloom (Philadelphia: Chelsea House, 1999), 41–43.

16. Burke, "Ralph Ellison's Trueblooded *Bildungsroman*," 67.

17. Ellison, *Invisible Man*, 6.

18. Grandt, *Kinds of Blue*, 39.

19. See especially Mircea Eliade's *Myth of the Eternal Return* (Princeton, NJ: Princeton University Press, 2005). I am thinking especially of the section on the "terror of history," pages 139–62.

20. See James Snead, "On Repetition in Black Culture," *Black American Literature Forum* 15, no. 4 (winter 1981): 146–54.

21. Ellison, *Invisible Man*, 8. For one of the more insightful readings of this passage, see Romand Coles, "Democracy, Theology, and the Question of Excess: A Review of Jeffrey Stout's *Democracy and Tradition*," *Modern Theology* 21, no. 2 (April 2005): 314–15.

22. Romand Coles, "Democracy, Theology, and the Question of Excess: A Review of Jeffrey Stout's *Democracy and Tradition*," 6.

23. Romand Coles, "Democracy, Theology, and the Question of Excess," 8.

24. See, for instance, Ellison's essay "On Bird, Bird-Watching, and Jazz," in *Living with Music: Ralph Ellison's Jazz Writings*, edited by Robert G. O'Meally (New York: Modern Library), 69.

25. See James Harding, "Adorno, Ellison, and the Critique of Jazz," in *Adorno and "A Writing of the Ruins"* (Albany: SUNY Press, 1997), 110–11. According to Harding, Ellison is somewhere between the beboppers and Louis Armstrong. Although he borrows from bebop's insistence on antistructure and dissonance (as opposed to Armstrong's diatonic, teleological style), he also appreciates certain aspects of Armstrong's role as musician and entertainer.

26. Beth Eddy offers a powerful reading of Ellison's refusal to reject Armstrong even though he shares the beboppers' concerns about minstrel entertainment. By disowning Armstrong, the bebop generation actually turns Armstrong into a scapegoat or victim. See Eddy, *The Rites of Identity*, 121–24.

27. Ellison, "On Bird, Bird-Watching, and Jazz," 69.

28. Ellison makes this claim especially in his discussion of Dizzy Gillespie. See "On Bird, Bird-Watching, and Jazz," 70.

29. Robert O'Meally, introduction to *Living with Music*, xxii. Certainly the relationship between jazz and blues is complicated. In this chapter, I adopt Ted Gioia's description of the relationship between jazz and blues as intimate bedfellows. See Gioia, *History of Jazz* (Oxford: Oxford University Press, 1998), 20.

30. O'Meally, introduction to *Living with Music*, xxiv.

31. Ellison, *Shadow and Act*, 78.

32. Ellison, *Shadow and Act*, 94.

33. Albert Murray suggests this play between lament and festivity in his text *Stomping the Blues* (Cambridge, MA: De Capo, 1989).

34. Horace Porter, *Jazz Country: Ralph Ellison in America* (Iowa City: University of Iowa Press, 2001), 74.

35. Fred Moten, *In the Break*, 67.

36. Ellison, *Shadow and Act*, 296–97.

37. Ellison, *Shadow and Act*, 297.

38. Danielle Allen, "Ralph Ellison on the Tragi-Comedy of Citizenship," in *Ralph Ellison and the Raft of Hope*, edited by Lucas Morel (Lexington: University Press of Kentucky, 2004), 37.

39. Eddy, *The Rites of Identity*, 129.

40. Ellison, *Going to the Territory* (New York: Vintage Books, 1986), 59. For a helpful reading of this passage, see Eddy, *The Rites of Identity*, 129.

41. Ellison, *Invisible Man*, 307.

42. Ellison, *Invisible Man*, 282.

43. Ellison, *Invisible Man*, 290–91.

44. Ellison, *Invisible Man*, 4–5.

45. See Butler, *Psychic Life of Power*, 28–29. Also see my discussion of recognition in chapter 1.

46. Kim Benston, "Controlling the Dialectical Deacon: The Critique of Historicism in *Invisible Man*," *Delta* 18 (1984): 92.

47. Ellison, *Invisible Man*, 309.

48. Ellison, *Invisible Man*, 306.

49. Ellison, *Invisible Man*, 306.

50. What do I mean by anonymous others? This is my way of suggesting that we are indebted to bodies, selves, and communities that often go unrecognized— people who make our clothes, gather the fruits and vegetables that we consume, people who endure deprivation and lack while others live abundantly.

51. Eddy, *The Rites of Identity*, 106.

52. See Eddy, *The Rites of Identity*, 103–5.

53. Ellison, *Invisible Man*, 16.

54. Ellison, *Invisible Man*, 16.

55. Ellison, *Invisible Man*, 335.

56. Ellison, *Invisible Man*, 389.

57. Ellison, *Invisible Man*, 392.

58. See Fanon, *Black Skin, White Masks*, translated by Charles Lam Markmann (New York: Grove, 1967), 133–40. But we must be careful here. Both Ellison and Fanon claimed that racial identity should not prevent an acknowledgment of something like a common humanity, or in Fanon's case, a new humanity.

59. Ellison, *Going to the Territory*, 56.

60. Ellison, *Invisible Man*, 502–3.

61. See Allen, "Ralph Ellison on the Tragi-Comedy of Politics," 46–51.

62. Allen, "Ralph Ellison on the Tragi-Comedy of Politics," 45.

63. For a very insightful reading of Brother Clifton's death that resembles my interpretation, see Weheliye, *Phonographies*, 74–82.

64. Ellison, *Invisible Man*, 439.

65. Ellison, *Invisible Man*, 441.

66. Benjamin, "On the Concept of History," 391.

67. Ellison, *Invisible Man*, 443.

68. Ellison, *Invisible Man*, 441.

69. Adorno and Horkheimer, *Dialectic of Enlightenment*, 25.

70. Adorno, *Minima Moralia*, 151.

71. According to Barbara Foley, *Invisible Man*'s critique of American democratic liberalism fades as the novel progresses (after his encounter with Norton, the paternalistic trustee who represents and endorses Emersonian philosophy). On the other hand, the novel's depiction of the Brotherhood, according to Foley, indicates Ellison's growing disillusionment with American communism. See Foley, *Wrestling with the Left: The Making of Ralph Ellison's* Invisible Man (Durham, NC: Duke University Press, 2010).

72. On the relationship between Ellison's geographical upbringing and his sense of possibility, see *Shadow and Act*, 3–23.

73. Ellison, *Going to the Territory*, 4.

74. Ellison, *Going to the Territory*, 5.

75. Ellison, *Going to the Territory*, 7–8.

76. Ellison, *Going to the Territory*, 11.

77. Ellison, *Going to the Territory*, 7.

78. Ellison, *Going to the Territory*, 15. For an illuminating reading of the significance of the railroad station within American vernacular in general and black American culture in particular (especially concerning the blues), see Houston Baker, *Blues, Ideology, and Afro-American Literature: A Vernacular Theory* (Chicago: University of Chicago Press, 1984), 7–14. According to Baker, the railway juncture signals the transient crossing and intersection of arrivals and departures. "Polymorphous and multidirectional, scene of arrivals and departures, place betwixt and between, the juncture is the way-station of the blues" (7). For Baker, many of the sounds that constitute blues music are mimetically related to the sounds of trains crossing track junctures—"rattling gondolas, clattering flatbeds, quilling whistles, clanging bells, rumbling boxcars, and other railroad sounds" (8).

79. See especially Adorno, *Negative Dialectics*, 149.

80. Ellison, *Going to the Territory*, 12.

81. Ellison, *Going to the Territory*, 20.

82. Ellison, *Going to the Territory*, 20–21. Emphases mine.

83. Ellison, *Going to the Territory*, 38.

84. Here I am responding to modernist accounts of jazz that focus on the heroic quality of jazz musicians, their ability to create meaning and make something beautiful against a backdrop of violence, racism, and social chaos. On this modernist reading of jazz, see George Lipsitz, "Songs of the Unsung: The Darby Hicks History of Jazz," in *Uptown Conversation: The New Jazz Studies*, edited by Robert O'Meally, Brent Edwards, Farah Jasmine Griffin (New York: Columbia University Press, 2004), 9–26. In response to Ken Burns's controversial film *Jazz*, which adopts a modernist framework to tell the story of jazz in America, Lipsitz warns that this framework, among other problems, leads the narrators in the film to identify racism and white supremacy as "little more than a dramatic background for the emergence of individuals who turn adversity into aesthetic perfection through their art." According to Lipsitz, racism is read and interpreted in the film as an obstacle rather than a "constitutive force."

85. Ellison, *Going to the Territory*, 124.

86. Ellison, *Going to the Territory*, 124.

87. Ellison, *Shadow and Act*, 250.

88. Ellison, *Invisible Man*, 17

89. Ellison, *Invisible Man*, 19.

90. Muyumba, *The Shadow and the Act*, 61.

91. Muyumba, *The Shadow and the Act*, 62.

92. Ellison, *Invisible Man*, 23.

93. Ellison, *Shadow and Act*, 127.

94. Ellison actually suggests this in his response to Irving Howe's critique of him and Baldwin. See Ellison, *Shadow and Act*, 109.

95. Moten, *In the Break*, 69.

96. See Claudia Tate, "Notes on the Invisible Women in Ralph Ellison's *Invisible Man*," in *Modern Critical Interpretations*, 81–91. To be sure, Tate does suggest that we have to "look closer" at the women in the novel to discover their complexity.

97. Toni Morrison, *Jazz* (New York: Plume, 1992), 111.

98. J. Brooks Bouson, *Quiet as It's Kept: Shame, Trauma, and Race in the Novels of Toni Morrison* (Albany: SUNY Press, 2000), 179.

99. Griffin, *"Who Set You Flowin?,"* 4–5.

100. My argument here is very much indebted to Roberta Rubenstein. See her "Singing the Blues/Reclaiming Jazz: Toni Morrison and Cultural Mourning," *Mosaic* 31, no. 2 (June 1998): 147–63. For Rubenstein the categories of loss and mourning refer not only to injuries and wounds embodied by African Americans but also to the appropriation of black culture by other groups (or the loss of black cultural resources). Although these notions of loss are related, I am more interested in the first sense. For a similar argument about Morrison's reappropriating jazz and situating it within the everyday life of blacks, see Griffin, *"Who Set You Flowin?,"* 184–99.

101. Morrison, *Jazz*, 32–33.

102. This is an interesting move considering Ellison's concern that once jazz migrated up North and became bebop, it became too rigid and disconnected from dancing, folk practices, bodily movements, and so forth. On Ellison's critique of bebop, see O'Meally, *Living with Music*, xxviii–xxix.

103. Morrison, *Jazz*, 33. It is important that Morrison uses semicolons here to make the reader experience the length of time involved in the development and movement of the massive wave. I am indebted to Jeff Stout for pointing this out to me.

104. Alain Locke, "The New Negro," in *The New Negro: Voices of the Harlem Renaissance*, edited by Alain Locke (New York: Touchstone, 1997), 6. I am indebted to my conversations with Professor Wallace Best on this issue. His work on the Harlem Renaissance helped me think about the importance of memory or re-remembering within this period of black cultural production.

105. Alain Locke, "The New Negro," 6.

106. For a brilliant analysis of this relationship between music and cultural memory, see Guthrie Ramsey Jr., *Race Music: Black Cultures from BeBop to Hip Hop* (Berkeley: University of California Press, 2003), 1–43. According to Ramsey, music and memory are mutually constitutive. Music, he suggests, is connected to specific cultural contexts or what he calls sites, or theaters, of memory such as the church or a house party. For a brief discussion of Morrison's work, see pages 30–32 of Ramsey's text.

107. Morrison, *Jazz*, 53–54.

108. Morrison, *Jazz*, 56–57.

109. Barbara Williams Lewis, "The Function of Jazz in Toni Morrison's *Jazz*," in *Toni Morrison's Fiction: Contemporary Criticism* (New York: Garland, 2000), 273.

110. See Gioia, *The History of Jazz*, 98.

111. Lewis, "The Function of Jazz in Toni Morrison's *Jazz*," 276.

112. Lewis, "The Function of Jazz in Toni Morrison's *Jazz*," 276.

113. Morrison, *Jazz*, 51.

114. Morrison, *Jazz*, 53.

115. Morrison, *Jazz*, 22–23.

116. Morrison, *Jazz*, 107.

117. Morrison, *Jazz*, 102.

118. Morrison, *Jazz*, 101.

119. Morrison, *Jazz*, 124.

120. Morrison, *Jazz*, 130.

121. See Phillip Page, "Traces of Derrida in Toni Morrison's *Jazz*," *African American Review* 29, no. 1 (1995): 57. My reading of the play of presence and absence in Joe's life and its connection to Joe's last name is highly indebted to Page's essay. He gives a brilliant reading of the Derridean themes—particularly the idea of the trace and the critique of logocentrism—that are prevalent in Morrison's *Jazz*.

122. For a beautiful description of the losses and disappointments that shape and constitute the subject (including the incestuous desires that must be repressed in order for the child to survive), see Freud, "The Dissolution of the Oedipus Complex," in *The Freud Reader*, edited by Peter Gay (New York: W. W. Norton, 1989), 661–66.

123. See Luce Irigaray, *An Ethics of Sexual Difference*, translated by Carolyn Burke and Gillian Gill (Ithaca, NY: Cornell University Press, 1984), 5–19.

124. Porter, *What Is This Thing Called Jazz?*, 32.

125. See Carby, "It Jus Be's That Way Sometime: The Sexual Politics of Women's Blues," in *The Jazz Cadence of American Culture*, edited by Robert O'Meally (New York: Columbia University Press, 1998), 469–82.

126. See Cohen, *The Boundaries of Blackness: AIDS and the Breakdown of Black Politics* (Chicago: University of Chicago Press, 1999), 8–9, 14–15.

127. Morrison, *Jazz*, 220.

128. Adorno, "The Form of the Phonograph Record," in *Essays on Music*, 279. In this essay, Adorno offers a powerful, dialectical reading of the effects of the phonograph record. At times, he does suggest that the record signifies the reification of artistic activity. Yet he also claims that the record creates a new relationship between music and writing; a record for Adorno is a script that needs to be read and interpreted. He even calls phonograph records "missives whose formulations capture the sounds of creation" and whose message is yet to come.

129. See, for instance, Phillip Page, "Traces of Derrida in Toni Morrison's *Jazz*," 60–64. According to Page, the narrator in the beginning of the novel commits the logocentric error, the idea that she alone knows the story and that she has privileged access to the truth. As the story develops, she corrects some of her judgments and perceptions of the characters. She realizes that the characters and their stories are more complicated and unpredictable than her narrative can account for. According to Barbara Williams Lewis, the narrator discovers that she is being written while she writes, that she is an open book that the reader is confronted with. See Lewis, "The Function of Jazz in Toni Morrison's *Jazz*," 278.

130. Morrison, *Jazz*, 220–21.

131. Morrison, *Jazz*, 227.

132. Morrison, *Jazz*, 113.

133. Ellison, *Going to the Territory*, 193.

134. Ellison, *Going to the Territory*, 192.

135. Ellison, *Going to the Territory*, 112.

136. Consonance or harmony among the various musical elements is not bad per se for Adorno. As we will see, the problem for him is how the harmony emerges. His concern is whether the harmony or consonance is imposed on the musical materials or whether it emerges within and from the musical materials. The former tendency is bad while the latter is good.

137. Adorno, "Perennial Fashion-Jazz," in *Prisms*, translated by Samuel and Shierry Weber (Cambridge, MA: MIT Press, 1983), 122.

138. Adorno, "Perennial Fashion-Jazz," 123.

139. As many commentators have pointed out, Adorno is simply wrong when he claims that much of jazz's content is made up of popular, mainstream tunes. See for instance, Theodore Gracyk, "Adorno, Jazz, and the Aesthetics of Popular Music," *Musical Quarterly* 76, no. 4 (winter 1992): 532–34. Gracyk points out that musicians like Louis Armstrong often "dispensed with popular song" and deviated from "popular mainstream standards." Even when jazz musicians appropriated popular songs, they often transformed the original tune. Gracyk mentions Charlie Parker as a musician who mastered this art of transformation. Also see Ulrich Schonherr, "Adorno and Jazz: Reflections on a Failed Encounter," *Telos* 87 (spring 1991): 95. Schonherr mentions Coltrane's remaking of Richard Rodgers's "My Favorite Things" as a successful transformation from kitsch to serious, avant-garde art.

140. Adorno, "Perennial Fashion-Jazz," 125.

141. Adorno, "On Jazz," in *Essays on Music* (Berkeley: University of California Press, 2002), 477.

142. See Adorno, "Perennial Fashion-Jazz," 122.

143. Adorno, "Perennial Fashion-Jazz," 122. It is important to note that Adorno attributes this idea to a European *Weltanschauung* rather than to dominant American perspectives on jazz.

144. Adorno, "On Jazz," 477.

145. It is interesting to compare Adorno writing here with the work of someone like Amiri Baraka, one of the prominent members of the Blacks Arts Movement. In his famous *Blues People* (New York: Morrow Quill, 1963), Baraka makes a rigid distinction between Negro music and American culture. Whereas the latter tends to produce conformity, the former is the expression of authentic desire. Negro music is therefore the direct, unmediated expression of black people's pain, suffering, joy, and sorrow. When black music deviates from this authentic expression, it becomes more susceptible to commodification, which Baraka associates with mainstream American culture. Although Adorno seems to resist this rigid binary between spontaneity and commodification when it comes to jazz, he can be accused of assuming that a free and spontaneous form of music (unhindered by the rigid rules of the society) is possible. He also can be interpreted as suggesting that although the unruly aspects of jazz have been absorbed by the culture industry, these unruly aspects are still associated with the music and culture of Africa. See Lee Brown's discussion in "Afropurism," in "Adorno's Critique of Popular Culture: The Case of Jazz Music," *Journal of Aesthetic Education* 26, no. 1 (spring 1992): 26–29.

146. For a helpful account of the different cultures that contributed to American jazz and blues (especially as it developed in New Orleans), see Ted Gioia, *The History of Jazz*, 3–12. Gioia focuses on the French, Spanish, and African elements that contributed to the development of New Orleans jazz.

147. Adorno, "Perennial Fashion-Jazz," 122. This doesn't mean that we cannot speak of black music or that we cannot talk about jazz as being a genre of black music; it simply means that the boundaries between black music and other types of music are fluid and porous. What we consider black culture or black music (as a heuristic category or as a category that is helpful in bringing various practices, desires, conditions, and styles into focus) always exists in a set of complex, shifting relationships with other cultures and ways of living.

148. Adorno, "On Jazz," 477–78.

149. James Harding, "Adorno, Ellison, and the Critique of Jazz," *Cultural Critique* 31 (autumn 1995): 136–37. Of course many African Americans have been hip to the ways the entertainment industry uses and exploits black people, reducing them to clowns and minstrels.

150. Harding, "Adorno, Ellison, and the Critique of Jazz," 137. For Ellison's interpretation of the "grotesque and unacceptable" comedy associated with the tradition of minstrelsy, see Ellison, *Shadow and Act*, 45–59. For a seminal text on the complex function of minstrelsy in American culture, see Eric Lott, *Love and Theft: Blackface Minstrelsy and the American Working Class* (New York: Oxford University Press, 1993). According to Lott, this tradition of minstrelsy betrays both a fascination with and an aversion to black culture, black bodies, and so forth.

151. See, for instance, Frederic Jameson, *Late Marxism: Adorno, or the Persistence of the Dialectic* (London: Verso, 1996), 141. Also see Tom Levin, "For the Record: Adorno on Music in the Age of Its Technological Reproducibility," *October* 55 (winter 1990): 23.

152. Bourdieu is much more complicated on the relationship between structure and agency than Butler suggests in *Excitable Speech*. On this issue, see Sean McCloud, "The Possibilities of Change in a World of Constraint: Individual and Social Transformation in the Work of Pierre Bourdieu," *Bulletin for the Study of Religion* 41, no. 1 (February 2012): 2–8.

CHAPTER FOUR *Reel Progress*

1. For a concise articulation of this relationship between visual representation and racial recognition, see, for instance, Miles White, *Jim Crow to Jay-Z: Race, Rap, and the Performance of Masculinity* (Chicago: University of Illinois Press, 2011), 14–15.

2. On this issue, see Carole Henderson, "'King Kong Ain't Got Sh** On Me': Allegories, Anxieties, and the Performance of Race in Mass Media," *Journal of Popular Culture* 43, no. 6 (2010): 1207–21. Also see James Snead's classic essay, "Spectatorship and Capture in King Kong: The Guilty Look," in *White Screens, Black Images: Hollywood from the Dark Side*, edited by Colin McCabe and Cornel West (New York: Routledge, 1994), 1–27.

3. See Henderson, "'King Kong Ain't Got Sh** On Me,'" 1211–13. Also see Mia Mask, *Divas on Screen: Black Women in American Film* (Urbana: University of Illinois Press, 2009), 221–32.

4. On this particular critique of the film, see Adolph Reed's essay "*Django Unchained* or *The Help*: How Cultural Politics Is Worse than No Politics at All, and Why," February 25, 2015, accessed July 30, 2013, http://nonsite.org/feature/django-unchained -or-the-help-how-cultural-politics-is-worse-than-no-politics-at-all-and-why.

5. Bogle, *Toms, Coons, Mulattoes, Mammies, and Bucks: An Interpretive History of Blacks in American Films* (New York: Contiuum, 2001), 3.

6. Bogle, *Toms, Coons, Mulattoes, Mammies, and Bucks*, 18. For a very different understanding of how blacks have contested and challenged these negative images and types, see Thomas Cripps, "Race Movies as Voices of the Black Bourgeoisie: *The Scar of Shame*," in *Representing Blackness: Issues in Film and Video*, edited by Valerie Smith (New Brunswick, NJ: Rutgers University Press, 1997), 47–59.

7. See Valerie Smith, introduction to *Representing Blackness*, 1–5. Also see James Snead's very important critique of concentration on positive and negative images in black film studies in Snead, *White Screens, Black Images*, 1–4.

8. Snead, *White Screens, Black Images*, 4.

9. Ed Guerrero, *Framing Blackness: The African American Image in Film* (Philadelphia: Temple University Press, 1993), 2.

10. For Althusser's notion of ideology, see Althusser, "Ideology and Ideological State Apparatuses."

11. Guerrero, *Framing Blackness*, 6.

12. Guerrero, *Framing Blackness*, 6.

13. See Adorno, "Notes on Kafka," in *Prisms*, translated by Samuel and Shierry Weber (Cambridge, MA: MIT Press, 1967), 257.

14. See hooks, *Black Looks: Race and Representation* (Cambridge, MA: South End Press, 1992), 115.

15. See Laura Mulvey, "Visual Pleasure and Narrative Cinema," *Screen* 16, no. 3 (autumn 1975): 6–18.

16. hooks, *Black Looks*, 128. Here hooks is responding to the limitations in Manthia Diawara's essay "Black Spectatorship: Problems of Identification and Resistance," in *Black American Cinema*, edited by Manthia Diawara (New York: Routledge, 1993), 211–20. In this essay, Diawara is concerned about the ways black male identification with typical protagonists on screen requires a kind of denial of their humanity (he offers *The Color Purple* as an example). While he uses the phrase *resisting spectator* to describe the critical response to misrepresentations of black male identity, hooks contends that this is too reactive and passive. For her, black women's ways of looking differently involve creation and invention as well as resistance. I don't think Diawara would disagree with hooks's point here. Hooks also seems to make a distinction between resistance and critique that she does not elaborate on and explain.

17. See *The Bakhtin Reader: Selected Writings of Bakhtin, Medvedev, and Voloshinov*, edited by Pam Morris (London: Arnold, 1994), 74–77.

18. It is important to acknowledge that Adorno and Benjamin had long, back-and-forth debates about art, aesthetics, commodification, mediation, and so forth. I will not be engaging these differences here. For a snippet of this debate, see Adorno et al., *Aesthetics and Politics* (New York: Verso, 2007), 100–141.

19. Benjamin, "The Work of Art in the Age of Mechanical Reproduction," in *Illuminations*, translated by Harry Zohn, edited by Hannah Arendt (New York: Schocken Books, 1973), 217–42.

20. Benjamin, "The Work of Art in the Age of Mechanical Reproduction," 223.

21. Benjamin, "The Work of Art in the Age of Mechanical Reproduction," 236.

22. Benjamin, "The Work of Art in the Age of Mechanical Reproduction," 222.

23. Adorno and Horkheimer, *Dialectic of Enlightenment*, 94.

24. Adorno and Horkheimer, *Dialectic of Enlightenment*, 98–99.

25. Adorno and Horkheimer, *Dialectic of Enlightenment*, 115–16.

26. Adorno, "Transparencies on Film," *New German Critique*, no. 24/25 (autumn, 1981– winter 1982): 201.

27. Adorno discusses montage as an unconventional cinematic strategy with critical potential in "Transparencies on Film."

28. See Linda Williams, *Playing the Race Card: Melodramas of Black and White from Uncle Tom to O. J. Simpson* (Princeton, NJ: Princeton University Press, 2001), 107.

29. Bogle, *Toms, Coons, Mulattoes, Mammies, and Bucks*, 15.

30. See Cripps, "Race Movies as Voices of the Black Bourgeoisie," 47–59.

31. On this issue and how it relates to the emergence of Sidney Poitier as a box office star, see Guerrero, *Framing Blackness*, 69–79.

32. James Baldwin, *The Devil Finds Work* (New York: Vintage International, 1976), 71–79.

33. See Glen Harris and Anthony Toplin, "*Guess Who's Coming to Dinner?*: A Clash of Interpretations Regarding Stanley Kramer's Film on the Subject of Interracial Marriage," *Journal of Popular Culture* 40, no. 4 (2007): 704–5.

34. See Baldwin, *The Devil Finds Work*, 72.

35. Harris and Toplin, "*Guess Who's Coming to Dinner?*" 705.

36. Stanley Kramer, *Guess Who's Coming to Dinner*, Columbia Pictures, 1967, DVD.

37. For a reading of the similarities between the Mammy characters in *Birth* and *Guess*, see Baldwin, *The Devil Finds Work*, 74.

38. Harris and Toplin, "*Guess Who's Coming to Dinner*," 702–3.

39. For an insightful reading of this scene, see Andrea Levine, "Sidney Poitier's Civil Rights: Mystique of White Womanhood in *Guess Who's Coming to Dinner* and *In the Heat of the Night*," *American Literature* 73, no. 2 (June 2001): 374–75.

40. Here I am thinking with Hans Gadamer, who introduces the term *horizon* in his magnum opus, *Truth and Method* (New York: Continuum, 1993), 300–307. As I take it, a horizon is defined by the historically constituted prejudices, assumptions, and presuppositions that both constrain and enable our ability to make sense of the world. A horizon registers what we can and cannot see or understand.

41. See, for instance, Nietzsche's "On the Uses and Disadvantages of History for Life," in *Untimely Meditations*, translated by R. J. Hollingdale, edited by Daniel Breazeale, 57–124.

42. Harris and Toplin, "*Guess Who's Coming to Dinner?*" 708.

43. See Levine, "Sidney Poitier's Civil Rights," 374–75.

44. Guerrero, *Framing Blackness*, 76.

45. Guerrero, *Framing Blackness*, 77.

46. Levine, "Sidney Poitier's Civil Rights," 374.

47. The language of (irreconcilable) antagonism in the context of racial difference, film, and representation is underscored and developed in Frank Wilderson III, *Red, White, and Black: Cinema and the Structure of U.S. Antagonisms* (Durham, NC: Duke University Press, 2010).

48. For an insightful account of how the blaxploitation genre emerged in relationship to black power movements, see Guerrero, *Framing Blackness*, 69–111.

49. For a discussion of the limitations of this blaxploitation genre, see Guerrero, *Framing Blackness*, 86–111.

50. Massood, "An Aesthetic Appropriate to Conditions," *Wide Angle* 21, no. 4 (October 1999): 23.

51. Dana Stevens, "Black Sheep: A Legendary Film from 1977 Gets Its Due," March 30, 2007, accessed August 27, 2013, http://www.slate.com/articles/arts/movies/2007/03/black_sheep.html?nav=tap3.

52. On the soundtrack of the film, see Inez Hedges, "Signifyin and Intertextuality: *Killer of Sheep* and Black Independent Film," *Socialism and Democracy* 21, no. 2 (July 2007): 140–41.

53. See David James, "Toward a Geo-Cinematic Hermeneutics: Representations of Los Angeles in Non-Industrial Cinema—*Killer of Sheep* and *Water and Power*," *Wide Angle* 20, no. 3 (1998): 34.

54. See Nathan Grant, "Innocence and Ambiguity in the Films of Charles Burnett," in Smith, *Representing Blackness*, 138.

55. Grant, "Innocence and Ambiguity in the Films of Charles Burnett," 138.

56. On this shift and replacement, see Grant, "Innocence and Ambiguity in the Films of Charles Burnett," 138.

57. On this point, see Grant, "Innocence and Ambiguity in the Films of Charles Burnett," 139.

58. Grant, "Innocence and Ambiguity in the Films of Charles Burnett," 139.

59. Massood, "An Aesthetic Appropriate to Conditions," 30.

60. I am indebted to Inez Hedges's description of this shot. See Hedges, "Signifyin and Intertextuality," 138.

61. Stevens, "Black Sheep."

62. Adorno and Horkheimer, *Dialectic of Enlightenment*, 28–29.

63. Grant, "Innocence and Ambiguity in the Films of Charles Burnett," 141.

64. This is a term that I am borrowing from Lee Edelman's *No Future: Queer Theory and the Death Drive* (Durham, NC: Duke University Press, 2004). I realize that I am using it slightly differently than he does.

65. Grant, "Innocence and Ambiguity in the Films of Charles Burnett," 144.

66. On this issue, see S. Craig Watkins, *Representing: Hip Hop Culture and the Production of Black Cinema* (Chicago: University of Chicago Press, 1998), 196–231.

67. Watkins, *Representing*, 204.

68. Here I am indebted to Gwendolyn Pough's reading of the film in *Check It while I Wreck It: Black Womanhood, Hip-Hop Culture, and the Public Sphere* (Boston: Northeastern University Press, 2004), 154–61.

69. See Collins, *Black Feminist Thought: Knowledge, Consciousness, and the Politics of Empowerment* (New York: Routledge, 1990), 225–30.

70. Gangsta rap is a genre and expression of hip hop (characterized by harsh sounds and lyrics, hypermasculine rebellion, occasional glorification of violence, attunement to the conditions and practices that reproduce inequality in American cities) that is often misunderstood and simplified by critics. For a nuanced and insightful reading of this artistic response in the late 1980s and early 1990s to ongoing race and class inequalities, see Robin Kelley, *Race Rebels: Culture, Politics, and the Black Working Class* (New York: Free Press, 1996), 183–227.

71. See Watkins, *Representing*, on this point about confinement and isolation. For an analysis of how ghetto action films both adopt and resist conventional Hollywood formats, see Guerrero, *Framing Blackness*, 180–90.

72. On the connection between a film like *Boyz n the Hood* and the L.A. rebellion, see Guerrero, *Framing Blackness*, 186.

73. Pough, *Check It while I Wreck It*, 130.

74. See Watkins, *Representing*, 218–26 for an articulation of this limitation in the film's argument and the way in which the focus on the strong father motif dovetails with conservative, culture of poverty arguments.

75. Pough, *Check It while I Wreck It*, 157.

76. Tucker, *The Marx-Engels Reader*, 432.

77. Here I am indebted to Jennifer Nash's arguments and interventions in discussions about the representation of black women in visual culture. See Nash, *The Black Body in Ecstasy: Reading Race, Reading Pornography* (Durham, NC: Duke University Press, 2014).

78. See Tricia Rose, *Black Noise: Rap Music and Black Culture in Contemporary America* (Middleton, CT: Wesleyan University Press, 1994), 21–61.

79. See Higginbotham, "African-American Women's History and the Metalanguage of Race," *Signs* 17, no. 2 (winter 1992): 273–74.

80. See Halberstam, *Female Masculinity* (Durham, NC: Duke University Press, 1998), 29. For a recent interpretation of Halberstam's attempt to extricate the performance of masculinity from the exclusive possession of men, one that places her work in the context of black lesbians on screen, see Mark Anthony Neal, *Looking for Leroy: Illegible Black Masculinities* (New York: New York University Press, 2013), 90–92. For a reading of Cleo's character that exclusively focuses on the stereotypical dimensions, see Patricia Hill Collins, *Black Sexual Politics: African Americans, Gender, and the New Racism* (New York: Routledge, 2005), 271–72.

81. Halberstam, *Female Masculinity*, 229–30.

1. Paul Taylor, "Post-Black, Old-Black," *African American Review* 41, no. 4 (2007): 626. Taylor expands this argument in a more recent article, "Taking Postracialism Seriously: From Movement Mythology to Racial Formation," *Du Bois Review* 11, no. 1 (spring 2014): 9–25. In this more recent article, Taylor argues that we should make a distinction between the simplistic forms of postracial rhetoric (which argue that racism is a thing of the past) and the more subtle articulations of the postracial idea that underscore changes and shifts in the racial order and the possibility of a racially just future.

2. I am indebted to my conversations with Kent Brintnall on this issue.

3. See Singh, *Black Is a Country: Race and the Unfinished Struggle of Democracy* (Cambridge, MA: Harvard University Press, 2005).

4. See Chris Matthews's response to the presidential address at "Matthews: 'I forgot he was black tonight for an hour,'" *Politico*, January 27, 2010, accessed October 18, 2015, http://www.politico.com/blogs/michaelcalderone/0110/Matthews_I_forgot _he_was_black_tonight_for_an_hour.html.

5. This becomes even more complicated when we consider his biracial identity and the nation's inability to establish a legitimate subject position for biracial subjects.

6. Think, for instance, of the insightful scene in Spike Lee's *Do the Right Thing* (Universal Pictures, 1989) when John Turturro's character, Pino, tells Spike Lee's character, Mookie, that celebrities like Michael Jackson and Michael Jordan are "black, but not black" or "black, but more than black." Black bodies, in other words, are under the burden of transcending their racial particularity and becoming more than black, a burden that assumes a conflation between whiteness and universality. On how black is typically imagined as particularizing while whiteness is associated with everything and nothing (because whiteness has been established as normal and natural), see Fred Dyer, "White," in *Film and Theory: An Anthology*, edited by Robert Stam and Toby Miller (Malden, MA: Blackwell, 2000), 733–51.

7. My argument is highly indebted to Jasbir Puar's powerful analysis of the relationship between race, gender, and sexuality in *Terrorist Assemblages: Homonationalism in Queer Times* (Durham, NC: Duke University Press, 2007). Puar investigates how gays have been incorporated into the fold of the nation-state in ways that affirm American exceptionalism and reinforce and justify racism, anti-Arab resentment, and so forth. For Puar, American exceptionalism combines singularity and teleology, making American ways of life unique and the universal end that humanity should strive after and emulate. See especially pages 1–11. In many ways, Puar is employing arguments made by Amy Kaplan in her insightful article "Violent Belongings and the Question of Empire Today: Presidential Address to the American Studies Association," *American Quarterly* 56, no. 1 (March 2004): 1–18.

8. Barack Obama, *The Audacity of Hope: Thoughts on Reclaiming the American Dream* (New York: Three Rivers Press, 2006), 235.

9. On Obama's use of teleological, unifying language, see Leeman, *The Teleological Discourse of Barack Obama*. I discuss Leeman's argument in more detail below.

10. See Balibar, "The Nation Form: History and Ideology," in *Race Critical Theories: Text and Context*, edited by Philomena Essed and David Theo Goldberg (Malden, MA: Blackwell, 2002), 220–30.

11. Obama, *The Audacity of Hope*, 228.

12. Obama, *The Audacity of Hope*, 228.

13. Obama, *The Audacity of Hope*, 233.

14. Obama, *The Audacity of Hope*, 228, 230.

15. See Klein, *The Shock Doctrine: The Rise of Disaster Capitalism* (New York: Metropolitan Books, 2007).

16. Obama, *The Audacity of Hope*, 233.

17. See Robert Terrill, "Unity and Duality in Barack Obama's 'A More Perfect Union,'" *Quarterly Journal of Speech* 95, no. 4 (November 2009): 363–86. For a different way of thinking about the relationship between Du Bois and Obama, see Gooding-Williams, "Autobiography, Political Hope, Racial Hope," *Du Bois Review* 11, no. 1 (spring 2014): 159–75.

18. Here Obama is referring to misinterpretations of his Democratic National Convention speech in 2004, in which he proclaimed that there is "one" America.

19. Obama, *The Audacity of Hope*, 232.

20. Obama, *The Audacity of Hope*, 232.

21. See Behdad, *A Forgetful Nation: On Immigration and Cultural Identity in the United States* (Durham, NC: Duke University Press, 2005).

22. Noelle McAfee, "Obama's Call for a More Perfect Union," *Contemporary Pragmatism* 8, no. 2 (December 2011): 66.

23. See Adolph Reed, "Obama No," *The Progressive*, May 2008, accessed June 2, 2013, http://progressive.org/mag_reed0508.

24. See Barack Obama, "A More Perfect Union," March 18, 2008, accessed June 4, 2013, https://my.barackobama.com/page/content/hisownwords.

25. Obama, "A More Perfect Union."

26. Obama, "A More Perfect Union."

27. Obama, "A More Perfect Union."

28. Terrill, "Unity and Duality in Barack Obama's 'A More Perfect Union.'"

29. Obama, "A More Perfect Union."

30. These critics of Hegel are also very much indebted to Hegel. I am thinking particularly of authors like Adorno, Butler, Kristeva, and Fanon, authors who have troubled the framework of mutual recognition, a troubling that I associated with Du Bois's *The Souls of Black Folk* in chapter 1.

31. Here I am deeply influenced by Puar's arguments and reflections in *Terrorist Assemblages*.

32. Obama, "A More Perfect Union." For now, I will overlook the fact that many of the images and sounds of Wright's sermons were taken out of context by the media.

33. Leeman, *The Teleological Discourse of Barack Obama*, 45.

34. See Honig, *Political Theory and the Displacement of Politics* (Ithaca, NY: Cornell University Press, 1993).

35. See Adorno, *Negative Dialectics*, 149.

36. McAfee, "Obama's Call for a More Perfect Union," 63.

37. I imagine that this increase has been politically necessary since many people on the right have accused Obama of not being committed to American exceptionalism.

38. See Barack Obama, "President Obama's Speech at the MLK Memorial Dedication," October 16, 2011, accessed June 8, 2013, http://thegrio.com/2011/10/16/text-obama -mlk-memorial-speech.

39. Obama, "President Obama's Speech at the MLK Memorial Dedication."

40. Obama, "President Obama's Speech at the MLK Memorial Dedication."

41. Obama, "President Obama's Speech at the MLK Memorial Dedication."

42. Obama, "President Obama's Speech at the MLK Memorial Dedication."

43. See Benjamin, "On the Concept of History," 391. Here I am not suggesting that Obama interprets King incorrectly. I assume that there are multiple ways to interpret and appropriate King's legacy. History is always a field of struggle and contestation. I am simply pointing out how certain ways of interpreting and incorporating King can place severe constraints on our ability to appropriate his ideas and practices in creative and radical ways.

44. One can find this theme in many of the speeches and essays in *A Testament of Hope: The Essential Writings and Speeches of Martin Luther King, Jr.*, edited by James M. Washington (New York: HarperCollins, 1986).

45. Here I am thinking of Baldwin's collection of essays *The Price of the Ticket: Collected Nonfiction, 1948–1965* (New York: St. Martin's, 1985). Baldwin's title is of course inspired by the conversation between Ivan and Alyosha Karamazov on the problem of evil in *The Brothers Karamazov*.

46. See Bercovitch, *The American Jeremiad*, 176–210. For a brilliant discussion of how Douglass, Du Bois, and King all express complicated relationships to this "idea of America" and the notion of a unique American telos, see Leeman, *The Teleological Discourse of Barack Obama*, 199–241.

47. See Sheldon Wolin, *The Presence of the Past: Essays on the State and the Constitution* (Baltimore: Johns Hopkins University Press, 1989), 82.

48. Wolin, *The Presence of the Past*, 83.

49. See, for instance, James Kloppenberg, *Reading Obama: Dreams, Hope, and the American Political Tradition* (Princeton, NJ: Princeton University Press, 2010). See also Bart Schultz, "Obama's Political Philosophy: Pragmatism, Philosophy, and the University of Chicago," *Philosophy of the Social Sciences* 39, no. 2 (June 2009): 127–73. Also see the articles in the special issue on Obama and pragmatism in *Contemporary Pragmatism* 8, no. 2 (December 2011).

50. Rorty, *Achieving Our Country* (Cambridge, MA: Harvard University, 1998), 3.

51. Rorty, *Achieving Our Country*, 20–21.

52. Rorty, *Achieving Our Country*, 22.

53. For an insightful account of the relationship between violence and receptivity or nonreceptivity toward recalcitrant others, see Romand Coles, *Rethinking*

Generosity: Critical Theory and the Politics of Caritas (Ithaca, NY: Cornell University Press, 1997).

54. I acknowledge that these terms are charged, contested, and not always clear. For now, I am not interested in the complexity of terms like *secular* or the *sacred*. I am simply interested in the residual theological components of the "idea of America."

55. Bercovitch, *American Jeremiad*, 176.

56. Rorty, *Achieving Our Country*, 12.

57. Schultz, "Obama's Political Philosophy," 141.

58. To some extent, we are all guilty of doing this. We all use and employ authors in ways that further and advance our goals. This will always involve eliminating elements of those authors that don't fit within our schemes and goals. At the same time, we can become more aware of the different kinds of effects and implications of this intractable obstacle.

59. See James Baldwin, *The Fire Next Time* (New York: Vintage, 1993), 91.

60. Baldwin, *The Fire Next Time*, 98.

61. See George Shulman, *American Prophecy: Race and Redemption in American Political Culture* (Minneapolis: University of Minnesota Press, 2008), 175–226.

62. Morrison, *Paradise* (New York: Plume, 1997), 4.

63. On the relationship between paradise and exclusion, see J. Bouson, *Quiet as It's Kept: Shame, Trauma, and Race in the Novels of Toni Morrison* (Albany, NY: SUNY Press, 2000), 192.

64. Peter Widdowson, "The American Dream Refashioned: History, Politics, and Gender in Toni Morrison's *Paradise*," *Journal of American Studies* 35, no. 2 (August 2001): 318.

65. Rorty makes this point in the first chapter of *Achieving Our Country*.

66. Morrison, *Paradise*, 13.

67. Morrison, *Paradise*, 13.

68. Morrison, *Paradise*, 189.

69. See Katrine Dalsgard, "The One All-Black Town Worth the Pain: (African) American Exceptionalism, Historical Narration, and the Critique of Nationhood in Toni Morrison's *Paradise*," *African American Review* 35, no. 2 (2001): 233–48. According to Dalsgard, Morrison breaks free from this exceptionalist narrative, an argument that I will develop in this section of the chapter.

70. The phrase *black nationalism* has different meanings and connotations. Wahneema Lubiano offers an insightful definition of the phrase in her essay, "Standing in for the State: Black Nationalism and 'Writing' the Black Subject," in *Is It Nation Time?: Contemporary Essays on Black Power and Black Nationalism*, edited by Eddie Glaude (Chicago: University of Chicago Press, 2002). She writes: "Black nationalism in its broadest sense is a sign, an analytic, describing a range of historically manifested ideas about black American possibilities that include any or all of the following: racial solidarity, cultural specificity, religious, economic, and political separatism (this last has been articulated both as a possibility within and outside of U.S. territorial boundaries)" (157). I take it that there are strong forms of black nationalism (associated with people like Marcus Garvey and the UNIA movement) which

call for the complete separation of blacks and whites, that desire separate territory and land for black people. There are also modes of cultural nationalism (associated with figures like Ron Karenga) that affirm and celebrate the distinct cultural achievements, rituals, and practices associated with black people without desiring separate land or territory outside of the United States. And then there are also subtle, taken-for-granted forms of black nationalism (indebted but not reducible to the former two) that assume black people have a shared history, destiny, and set of experiences. Because of this shared life, black selves have special obligations to others in their community. For the dangers involved in black nationalism and racial chauvinism see Wilson Moses, *The Golden Age of Black Nationalism, 1850–1925* (Hamden, CT: Archon Books, 1978). For a more nuanced approach to the complexities and varieties of black nationalism, see the essays in *Is It Nation Time?*

71. See Glaude, *Exodus!*

72. It is important that Glaude focuses on the antebellum expressions of black nationalism in opposition to Wilson Moses's concentration on postbellum articulations of black nationalism. According to Glaude, Moses misses a period in the 1830s and 1840s when race-talk by black Americans did not include the language of biology or essentialism but was a more fluid, unstable, and pragmatic concept. See Glaude, *Exodus!*, 13–15.

73. The underside of the exodus narrative is the source of Edward Said's response to Michael Walzer's *Exodus and Revolution* (New York: Basic Books, 1985). For a reprinting of the exchange between Walzer and Said, see William D. Hart, *Edward Said and the Religious Effects of Culture* (Cambridge: Cambridge University Press, 2000), 176–99.

74. See Lubiano, "Standing in for the State." Also see her "Black Nationalism and Black Common Sense: Policing Ourselves," in *The House that Race Built* (New York: Pantheon Books, 1997), 232–52.

75. See Morrison, *Paradise*, 302–3.

76. Bouson, *Quiet as It's Kept*, 199.

77. Morrison, *Paradise*, 8.

78. Morrison, *Paradise*, 199.

79. Morrison, *Paradise*, 16.

80. Morrison, *Paradise*, 59–60.

81. Morrison, *Paradise*, 201–2.

82. Because, during the silence, the women upstairs are at least heard, although of course they are not part of the conciliatory meeting.

83. Morrison, *Paradise*, 102.

84. Morrison, *Paradise*, 113.

85. Bouson, *Quiet as It's Kept*, 203. In addition to Arnette, Sweetie also goes to the Convent after not leaving her house for six years (because she has been tending to her damaged children). As Bouson points out, instead of dealing with her desire to flee her home and instead of confronting the need for reprieve and healing, she tells her husband, Jeff, that the women "snatched" her.

86. Bouson, *Quiet as It's Kept*, 203.

87. Réne Girard, *Violence and the Sacred*, translated by Patrick Gregory (Baltimore: Johns Hopkins University Press, 1977), 4. Also see Girard, "Mimesis and Violence," in *The Girard Reader* (New York: Crossroad, 1996), 9–19. Girard's work is helpful but limited for understanding the relationship between reconciliation of conflict (between members of a community) and the deflection of violence toward other members or nonmembers.

88. Girard, "Mimesis and Violence," 12.

89. Morrison, *Paradise*, 159.

90. Morrison, *Paradise*, 9–10.

91. Morrison, *Paradise*, 277.

92. Morrison, *Paradise*, 277.

93. Behdad, *A Forgetful Nation*, 13.

94. See Wendy Brown, *Walled States, Waning Sovereignty* (New York: Zone Books, 2010).

95. See Anna Mulrine, "This Side of 'Paradise': Toni Morrison Defends Herself from Criticism of Her New Novel," *US News and World Report*, January 19, 1998.

96. Foucault, *Society Must Be Defended: Lectures at the College De France, 1975–1976* (New York: Picador, 1997), 256.

97. I discuss the concept as it pertains to Du Bois's thought in chapter 1.

98. On this idea of being a member of both dominant groups and subordinate groups, see Patricia Hill Collins, *Black Feminist Thought: Knowledge, Consciousness, and the Politics of Empowerment* (New York: Routledge, 1990), 230.

99. See, for instance, Gloria Anzaldúa, "Now Let Us Shift . . . the Path of Conocimiento . . . Inner Work, Public Acts," in *This Bridge We Call Home: Radical Visions for Transformation*, edited by Gloria Anzaldúa and Analouise Keating (New York: Routledge, 2002), 546–47. This theme is also implicitly developed in *Borderlands/ La Frontera* (San Francisco: Aunt Lute Books, 1999).

100. On this issue, see Shirley Ann Stave, "Jazz and Paradise: Pivotal Moments in Black History," in *The Cambridge Companion to Toni Morrison*, edited by Justine Tally (Cambridge: Cambridge University Press, 2007), 72.

101. Erica Edwards, *Charisma and the Fictions of Black Leadership* (Minneapolis: University of Minnesota Press, 2012), 182.

102. Edwards offers a beautiful analysis of this. See Edwards, *Charisma*, 182–83.

103. Channette Romero, "Creating the Beloved Community: Religion, Race, and Nation in Toni Morrison's *Paradise*," *African American Review* 39, no. 3 (2005): 415–30. There are several relevant aspects of this healing scene that Romero illumines but that space and time do not allow me to discuss. For instance, Connie fuses healing rituals derived from Candomblé (remember she is from Brazil) with Catholic practices. Here Morrison is subtly disrupting the tendency to privilege Christianity as the consummate religion, a tendency that we find in Hegel as well as in the typical narratives about American and African American history, experience, and social life. Here she is also reminding us of how the unfamiliar and foreign ("pagan" religious influences) are inscribed in what we consider to be familiar and everyday, home.

104. Morrison, *Paradise*, 283.

105. Morrison, *Paradise*, 265.
106. See Udono Erika, "Toni Morrison and Tradition of Christianity," *Nanzan Review of American Studies* 29 (2007): 189–90.
107. Morrison, *Paradise*, 318. According to Peter Widdowson, there are two alternative, yet related, possibilities that the conclusion of the novel offers for a different kind of future. The one future, what he calls the "realistic" possibility, is exemplified by Billie Delia leaving Ruby and acquiring a job in a nearby town. Widdowson compares Billie to Denver, the haunted daughter in Morrison's *Beloved*, who expressed a form of hopeful agency by leaving the house on Bluestone Road. The second alternative of a different future, what Widdowson calls the "magical" possibility, is suggested both by the disappearance of the women's bodies and by the final scene in which the women experience an ecstatic, beatific vision of the female goddess Piedade. According to Widdowson, Billie's agency indicates the "true message" or at least the more practical and relevant message. I concur with the thrust of Widdowson's bipartite reading of the alternative future that Morrison gestures toward at the end of the novel. Yet I want to supplement his account a bit and insert some tensions. First, Billie Delia is somewhat of a convenient character to select insofar as she is the one who escapes Ruby, the one who literally leaves home. But leaving home can also be read as a figurative movement, as a process of leaving one's region of comfort, as a mode of engaging the strange and unsettling qualities within one's familiar, everyday routines and rhythms. It can refer to the unsettling of our mundane frameworks of meaning through an engagement with the opaque, edge-residing dimensions of our social worlds. This broader conception of leaving home brings into focus other members of Ruby, such as Reverend Misner, who decides to stay in Ruby despite the town's all-too-human flaws, and Deek, who, at the end of the text, begins the process of confession and mourning in light of his participation in the murder of the convent women.

CONCLUSION

1. Du Bois, "Preface to the Jubilee Edition of *The Souls of Black Folk* (1953)," *Monthly Review* 55, no. 6 (November 2003): 41.
2. Du Bois, *Dusk of Dawn: An Essay toward an Autobiography of a Race Concept* (New York: Schocken Books, 1968), 133.
3. Du Bois, "The Negro and the Warsaw Ghetto," in *The Oxford W. E. B. Du Bois Reader*, edited by Eric J. Sundquist (New York: Oxford University Press, 1996), 472.
4. Here I am indebted to Foucault's point that the right to kill certain bodies does not simply refer to murder but to exposing these bodies to death or increasing the risk of death. See Foucault, *Society Must Be Defended*, 256.
5. See "McCain Counters Obama 'Arab' Question," October 11, 2008, accessed October 18, 2015, https://www.youtube.com/watch?v=jrnRU3ocIH4.
6. See Doug Marquardt, "Today's Stupid Conservative Quotes," *All Things Democrat*, July 16, 2013, accessed October 18, 2015, http://www.allthingsdemocrat.com/2013/07/todays-stupid-conservative-quotes-19/.

7. For a brilliant essay on how black males are frequently subject to the "normative gaze" and always "suspect," even before a crime, see William David Hart, "Dead Black Man, Just Walking," in *Pursuing Trayvon Martin: Historical Contexts and Contemporary Manifestations of Racial Dynamics* (New York: Lexington Books, 2013), 91–101.

8. William David Hart, *Afro-Eccentricity: Beyond the Standard Narrative of the Black Church* (New York: Palgrave MacMillan, 2011), 2.

9. See Long's *Significations: Signs, Symbols, and Images in the Interpretation of Religion* (Aurora, CO: Davies Group, 1995), 207–9.

10. On this issue, see Wendy Brown, "Resisting Left Melancholia," in *Loss: The Politics of Mourning*, ed. David Eng and David Kazanjian (Berkeley: University of California Press, 2003), 458–65.

11. Adorno, "The Meaning of Working through the Past," in *Critical Models: Interventions and Catchwords* (New York: Columbia University Press, 1998), 89.

12. Adorno, "The Meaning of Working through the Past," 89.

13. See, for instance, West's essay "To Be Human, Modern, and American," in *The Cornel West Reader* (New York: Basic Civitas Books, 1999), xv–xx.

14. I acknowledge the Heideggerian influence on my language here.

SELECT BIBLIOGRAPHY

Adorno, Theodor. *Aesthetic Theory*. Translated by Robert Hullot-Kentor. Minneapolis: University of Minnesota Press, 1997.

Adorno, Theodor. *Critical Models: Interventions and Catchwords*. Translated by Henry Pickford. New York: Columbia University Press, 1998.

Adorno, Theodor. *The Culture Industry*. Edited by J. M. Bernstein. New York: Routledge, 2001.

Adorno, Theodor. *Minima Moralia*. Translated by E. F. N. Jephcott. New York: Verso, 1978.

Adorno, Theodor. *Negative Dialectics*. Translated by E. B. Ashton. New York: Continuum, 1973.

Adorno, Theodor. *Prisms*. Translated by Samuel Weber and Sherry Weber. Cambridge, MA: MIT Press, 1983.

Adorno, Theodor, and Max Horkheimer. *Dialectic of Enlightenment: Philosophical Fragments*. Translated by Edmund Jephcott. Stanford, CA: Stanford University Press, 2002.

Allen, Danielle. "Ralph Ellison on the Tragi-Comedy of Politics." In *Ralph Ellison and the Raft of Hope*, edited by Lucas Morel, 37–57. Lexington: University Press of Kentucky, 2004.

Anderson, Paul Allen. *Deep River: Music and Memory in Harlem Renaissance Thought*. Durham, NC: Duke University Press, 2001.

Anzaldúa, Gloria. *Borderlands/La Frontera*. San Francisco: Aunt Lute Books, 1987.

Baker, Houston. *Blues, Ideology, and Afro-American Literature: A Vernacular Theory*. Chicago: University of Chicago Press, 1984.

Baldwin, James. *The Devil Finds Work*. New York: Vintage, 1976.

Baldwin, James. *The Fire Next Time*. New York: Vintage, 1963.

Baldwin, James. *The Price of the Ticket: Collected Nonfiction, 1948–1985*. New York: St. Martins Press, 1985.

Balfour, Lawrie. *Democracy's Reconstruction: Thinking Politically with W. E. B. Du Bois*. New York: Oxford University Press, 2011.

Balibar, Étienne. "The Nation Form: History and Ideology." In *Race Critical Theories: Text and Context*, edited by Philomena Essed and David Theo Goldberg, 220–30. Malden, MA: Blackwell, 2002.

Benhabib, Seyla. *Critique, Norm, and Utopia: A Study of the Foundations of Critical Theory*. New York: Colombia University Press, 1986.

Benjamin, Walter. *Illuminations*. Edited by Hannah Arendt Translated by Harry Zohn. New York: Schocken Books, 1969.

Benjamin, Walter. "On the Concept of History." In *Walter Benjamin: Selected Writings*, vol. 4, edited by Howard Eiland and Michael Jennings, 389–400. Cambridge, MA: Harvard University Press, 2003.

Benjamin, Walter. *The Origin of German Tragic Drama*. Translated by John Osbourne. New York: Verso, 2003.

Benston, Kim. "Controlling the Dialectical Deacon: The Critique of Historicism in Invisible Man." *Delta* 18 (1984): 89–103.

Bergson, Henri. *Matter and Memory*. Translated by Nancy Margaret Paul and W. Scott Palmer. Edinburgh: Riverside, 1911.

Berkovitch, Sacvan. *The American Jeremiad*. Madison: University of Wisconsin Press, 1978.

Bernasconi, Robert, and Tommy Lott, eds. *The Idea of Race*. Indianapolis: Hackett, 2000.

Bernstein, J. M. *Adorno: Disenchantment and Ethics*. Cambridge: Cambridge University Press, 2001.

Bloch, Ernst. *The Principle of Hope*. Translated by Neville Plaice, Stephen Plaice, and Paul Knight. Cambridge, MA: MIT Press, 1986.

Blum, Edward. *W. E. B. Du Bois: American Prophet*. Philadelphia: University of Pennsylvania Press, 2007.

Bogle, Donald. *Toms, Coons, Mulattoes, Mammies, and Bucks: An Interpretive History of Blacks in American Films*. New York: Continuum, 2001.

Botwinick, Areyah, and William Connolly, eds. *Democracy and Vision: Sheldon Wolin and the Vicissitudes of the Political*. Princeton, NJ: Princeton University Press, 2001.

Bouson, J. Brooks. *Quiet as It's Kept: Shame, Trauma, and Race in the Novels of Toni Morrison*. Albany: SUNY Press, 2000.

Brintnall, Kent. *Ecce Homo: The Male-Body-In-Pain as Redemptive Figure*. Chicago: University of Chicago Press, 2011.

Brown, Lee. "Adorno's Critique of Popular Music: The Case of Jazz Music." *Journal of Aesthetic Education* 26, no. 1 (1992): 17–31.

Buck-Morss, Susan. *Hegel, Haiti, and Universal History*. Pittsburgh: University of Pittsburgh Press, 2009.

Burke, Kenneth. "Ralph Ellison's Trueblooded *Bildungsroman*." In *Ralph Ellison's* Invisible Man: *A Casebook*, edited by John Callahan, 65–79. Oxford: Oxford University Press, 2004.

Burnett, Charles, director. *Killer of Sheep*. Milestone Films, 1978. DVD.

Butler, Judith. *Precarious Life: The Powers of Mourning and Violence*. London: Verso, 2004.

Butler, Judith. *The Psychic Life of Power: Theories in Subjection*. Stanford, CA: Stanford University Press, 1997.

Carby, Hazel. *Race Men*. Cambridge, MA: Harvard University Press, 1998.

Cheng, Anne. *The Melancholy of Race: Psychoanalysis, Assimilation, and Hidden Grief*. New York: Oxford University Press, 2001.

Coles, Romand. *Rethinking Generosity: Critical Theory and the Politics of Caritas*. Ithaca, NY: Cornell University Press, 1997.

Collins, Patricia Hill. *Black Feminist Thought: Knowledge, Consciousness, and the Politics of Empowerment*. New York: Routledge, 1990.

Cone, James. *The Spirituals and the Blues*. Maryknoll, NY: Orbis, 1992.

Conner, Marc, ed. *The Aesthetics of Toni Morrison: Speaking the Unspeakable*. Jackson: University Press of Mississippi, 2000.

Crenshaw, Kimberlé. "Mapping the Margins: Intersectionality, Identity Politics, and Violence against Women of Color." *Stanford Law Review* 43 (1993): 1241–99.

Cruz, Jon. *Culture on the Margins: The Black Spiritual and the Rise of American Cultural Interpretation*. Princeton, NJ: Princeton University Press, 1999.

Dalsgard, Katrine. "The One All-Black Town Worth the Pain: (African) American Exceptionalism, Historical Narration, and the Critique of Nationhood in Toni Morrison's *Paradise*." *African American Review* 35, no. 2 (2001): 233–48.

Davis, Angela. *Blues Legacies and Black Feminism: Gertrude Ma Rainey, Bessie Smith, and Billie Holiday*. New York: Vintage, 1999.

Dewey, John. *Art as Experience*. New York: Pedigree Books, 1980.

Derrida, Jacques. *Specters of Marx: The State of the Debt, the Work of Mourning, and the New International*. Translated by Peggy Kamuf. New York: Routledge, 1994.

Derrida, Jacques. *The Work of Mourning*. Edited by Pascale-Anne Brault and Michael Naas. Chicago: University of Chicago Press, 2001.

Du Bois, W. E. B. *Black Reconstruction in America, 1860–1880*. New York: Free Press, 1998.

Du Bois, W. E. B. "Criteria of Negro Art." In *The Portable Harlem Renaissance Reader*, edited by David Levering Lewis, 100–105. New York: Penguin, 1994.

Du Bois, W. E. B. *Darkwater: Voices from within the Veil*. Mineola, NY: Dover, 1999.

Du Bois, W. E. B. *Dusk of Dawn: An Essay toward an Autobiography of a Race Concept*. New York: Schocken Books, 1968.

Du Bois, W. E. B. "The Negro and the Warsaw Ghetto." In *The Oxford W. E. B. Du Bois Reader*, edited by Eric J. Sundquist, 469–473. New York: Oxford University Press, 1996.

Du Bois, W. E. B. *The Souls of Black Folk*. New York: Dover, 1994.

Eddy, Beth. *The Rites of Identity: The Religious Naturalism and Cultural Criticism of Kenneth Burke and Ralph Ellison*. Princeton, NJ: Princeton University Press, 2003.

Edelman, Lee. *No Future: Queer Theory and the Death Drive*. Durham, NC: Duke University Press, 2004.

Ellison, Ralph. *Going to the Territory*. New York: Vintage Books, 1986.

Ellison, Ralph. *Invisible Man*. New York: Signet Classics, 1952.

Ellison, Ralph. *Shadow and Act*. New York: Quality Paperback, 1994.

Eng, David, and David Kazanjian, eds. *Loss: The Politics of Mourning*. Berkeley: University of California Press, 2003.

Ervin, Hazel Arnette, ed. *African American Literary Criticism, 1773–2000*. New York: Twayne, 1999.

Fanon, Frantz. *Black Skin, White Masks*. Translated by Charles Lam Markmann. New York: Grove, 1967.

Felman, Shoshana. *The Juridical Unconscious: Trials and Traumas in the Twentieth Century*. Cambridge, MA: Harvard University Press, 2002.

Ferguson, Roderick. *Aberrations in Black: Toward a Queer Color Critique*. Minneapolis: University of Minnesota Press, 2004.

Flatley, Jeff. *Affective Mapping: Melancholia and the Politics of Modernism*. Cambridge, MA: Harvard University Press, 2008.

Foucault, Michel. *Language, Counter-Memory, Practice*. Edited by Donald Bouchard. Ithaca, NY: Cornell University Press, 1977.

Foucault, Michel. *Society Must Be Defended: Lectures at the College of France, 1975–1976*. Translated by David Macey. New York: Picador, 2003.

Freud, Sigmund. *Beyond the Pleasure Principle*. Translated by James Strachey. New York: W. W. Norton, 1961.

Freud, Sigmund. "Mourning and Melancholia." In *The Standard Edition of the Complete Psychological Works of Sigmund Freud Vol. XIV*, translated by James Strachey, 243–58. London: Hogarth, 1957.

Fultz, Lucille. *Toni Morrison: Playing with Difference*. Chicago: University of Illinois Press, 2003.

Gates, Henry Louis. *Signifying Monkey: A Theory of African American Literary Criticism*. New York: Oxford University Press, 1989.

Gilroy, Paul. *The Black Atlantic: Modernity and Double-Consciousness*. Cambridge, MA: Harvard University Press, 1993.

Gioia, Ted. *The History of Jazz*. New York: Oxford University Press, 1997.

Glaude, Eddie. *Exodus!: Religion, Race, and Nation in Early Nineteenth-Century Black America*. Chicago: University of Chicago Press, 2000.

Glaude, Eddie. *In a Shade of Blue: Pragmatism and the Politics of Black America*. Chicago: University of Chicago Press, 2007.

Goodchild, Philip. *Capitalism and Religion: The Price of Piety*. London: Routledge, 2002.

Gooding-Williams, Robert. "Autobiography, Political Hope, Racial Hope." *Du Bois Review* 11, no. 1 (spring 2014): 159–75.

Gooding-Williams, Robert. *In the Shadow of Du Bois: Afro-modern Political Thought in America*. Cambridge, MA: Harvard University Press, 2009.

Gooding-Williams, Robert, and Charles Mills. "Race in a 'Postracial' Epoch." *Du Bois Review* 11, no. 1 (spring 2014): 1–8.

Gordon, Lewis. "Of Tragedy and Blues in an Age of Decadence: Thoughts on Nietzsche and African America." In *Critical Affinities: Nietzsche and African American Thought*, edited by Jacqueline Scott, 75–97. Albany: SUNY Press, 2006.

Grandt, Jürgen. *Kinds of Blue: The Jazz Aesthetic in African American Narrative*. Columbus: Ohio State University Press, 2004.

Gray, F. Gary, director. *Set It Off*. New Line Cinema, 1996. DVD.

Griffin, Farah Jasmine. *"Who Set You Flowin?": The African American Migration Narrative*. New York: Oxford University Press, 1995.

Griffith, D. W., director. *The Birth of a Nation*. Epoch Producing Company, 1915.

Grimshaw, Anna, editor. *The C. L. R. James Reader*. Cambridge, MA: Blackwell, 1992.

Guerrero, Ed. *Framing Blackness: The African American Image on Film*. Philadelphia: Temple University Press, 1993.

Habermas, Jürgen. *Moral Consciousness and Communicative Action*. Translated by Christian Lenhardt and Shierry Weber Nicholsen. Cambridge, MA: MIT Press, 1990.

Habermas, Jürgen. *The Philosophical Discourse of Modernity*. Translated by Frederick Lawrence. Cambridge, MA: MIT Press, 1987.

Hall, Stuart. "What Is the 'Black' in Black Popular Culture?," *Social Justice* 20 (spring–summer 1993): 104–15.

Hardimon, Michael. *Hegel's Social Philosophy: The Project of Reconciliation*. Cambridge: Cambridge University Press, 1994.

Harding, James. "Adorno, Ellison, and the Critique of Jazz." *Cultural Critique* 31 (autumn 1995): 129–58.

Harris, Glen, and Anthony Toplin. *"Guess Who's Coming to Dinner?*: A Clash of Interpretations Regarding Stanley Kramer's Film on the Subject of Interracial Marriage." *Journal of Popular Culture* 40, no. 4 (2007): 700–713.

Hart, William D. "Three Rival Narratives of Black Religion." In *A Companion to African-American Studies*, edited by Lewis Gordon and Jane Gordon, 476–93. Malden, MA: Blackwell, 2006.

Hartman, Saidiya. *Scenes of Subjection: Terror, Slavery, and Self-Making in Nineteenth-Century America*. Oxford: Oxford University Press, 1997.

Hauerwas, Stanley, and Romand Coles. *Christianity, Democracy, and the Radical Ordinary: Conversations between a Radical Democrat and a Christian*. Eugene, OR: Cascade Books, 2008.

Hegel, G. W. F. *Elements of the Philosophy of Right*. Edited by Allen Wood. Cambridge: Cambridge University Press, 1991.

Hegel, G. W. F. *The Phenomenology of Spirit*. Translated by A. V. Miller. Oxford: Oxford University Press, 1977.

Held, David. *Introduction to Critical Theory: Horkheimer to Habermas*. Berkeley: University of California Press, 1980.

Hirsch, Marianne. "The Generation of Postmemory." *Poetics Today* 29, no. 1 (spring 2008): 103–28.

Holloway, Karla. *Passed On: African American Mourning Stories*. Durham, NC: Duke University Press, 2002.

Hollywood, Amy. *Sensible Ecstasy: Mysticism, Sexual Difference, and the Demands of History*. Chicago: University of Chicago Press, 2002.

Honneth, Axel. *The Struggle for Recognition: The Moral Grammar of Social Conflicts*. Translated by Joel Anderson. Cambridge, MA: MIT Press, 1999.

hooks, bell. *Black Looks: Race and Representation*. Cambridge, MA: South End Press, 1992.

Huyssen, Andreas. *Twilight Memories: Marking Time in a Culture of Amnesia*. New York: Routledge, 1994.

Irigaray, Luce. *An Ethics of Sexual Difference*. Translated by Carolyn Burke and Gillian Gill. Ithaca, NY: Cornel University Press, 1984.

James, Robin. *Resilience and Melancholy: Pop Music, Feminism, Neoliberalism*. Hampshire, UK: Zero Books, 2015.

Jameson, Fredric. *Late Marxism: Adorno, or the Persistence of the Dialectic*. London: Verso, 1996.

Jameson, Fredric. *Marxism and Form*. Princeton, NJ: Princeton University Press, 1971.

Jay, Martin. *Adorno*. Cambridge, MA: Harvard University Press, 1984.

Jay, Martin. *The Dialectical Imagination: A History of the Frankfurt School and the Institute of Social Research, 1923–1950*. Berkeley: University of California Press, 1973.

Jay, Martin. *Marxism and Totality: The Adventures of a Concept from Lukács to Habermas*. Berkeley: University of California Press, 1984.

Johnson, Terrence. *Tragic Soul-Life: W. E. B. Du Bois and the Moral Crisis Facing American Democracy*. New York: Oxford University Press, 2012.

Jones, Leroi. *Blues People*. New York: Morrow Quill, 1963.

Kahn, Jonathan. *Divine Discontent: The Religious Imagination of W. E. B. Du Bois*. Oxford: Oxford University Press, 2009.

Kierkegaard, Søren. *Fear and Trembling*. Edited by Howard and Edna Hong. Princeton, NJ: Princeton University Press, 1983.

Kim, David. *Melancholic Freedom: Agency and the Spirit of Politics*. Oxford: Oxford University Press, 2007.

Kramer, Stanley. *Guess Who's Coming to Dinner*. Columbia Pictures, 1967. DVD.

Leeman, Richard. *The Teleological Discourse of Barack Obama*. Lanham, MD: Rowman and Littlefield, 2010.

Levine, Andrea. "Sidney Poitier's Civil Rights: Mystique of White Womanhood in *Guess Who's Coming to Dinner* and *In the Heat of the Night*." *American Literature* 73, no. 2 (June 2001): 365–86.

Lewis, Barbara Williams. "The Function of Jazz in Toni Morrison's *Jazz*." In *Toni Morrison's Fiction: Contemporary Criticism*, edited by David Middleton, 271–82. New York: Garland, 2000.

Love, Heather. *Feeling Backward: Loss and the Politics of Queer History*. Cambridge, MA: Harvard University Press, 2009.

Lubiano, Wahneema. "Black Nationalism and Black Common Sense." In *The House that Race Built: Black Americans, U.S. Terrain*, edited by Wahneema Lubiano, 232–52. New York: Pantheon, 1997.

Mahmood, Saba. *Politics of Piety: The Islamic Renewal and the Feminist Subject.* Princeton, NJ: Princeton University Press, 2005.

Marcuse, Herbert. *The Aesthetic Dimension: Toward a Critique of Marxist Aesthetics.* Boston: Beacon, 1978.

Marcuse, Herbert. *An Essay on Liberation.* Boston: Beacon, 1969.

Margalit, Avishai. *The Ethics of Memory.* Cambridge, MA: Harvard University Press, 2002.

Massood, Paula. "An Aesthetic Appropriate to Conditions: *Killer of Sheep,* Neo-Realism, and the Documentary Impulse." *Wide Angle* 21, no. 4 (October 1999): 20–41.

McAfee, Noelle. "Obama's Call for a More Perfect Union." *Contemporary Pragmatism* 8, no. 2 (December 2011): 57–67.

McCarthy, Thomas, and David Hoy. *Critical Theory.* Oxford: Blackwell, 1994.

Meeks, Kathleen. *Toni Morrison's* Beloved *and the Apotropaic Imagination.* Columbia: University of Missouri Press, 2002.

Mendieta, Eduardo, ed. *The Frankfurt School on Religion.* New York: Routledge, 2005.

Morrison, Toni. *Beloved.* New York: Plume, 1987.

Morrison, Toni. "Home." In *The House that Race Built: Black Americans, U.S. Terrain,* edited by Wahneema Lubiano, 3–12. New York: Pantheon, 1997.

Morrison, Toni. *Jazz.* New York: Plume, 1992.

Morrison, Toni. *Paradise.* New York: Plume, 1997.

Morrison, Toni. *Playing in the Dark: Whiteness and the Literary Imagination.* New York: Vintage Books, 1992.

Morrison, Toni. "Sites of Memory." In *Inventing the Truth: The Art and Craft of Memoir,* edited by William Zinsser, 183–200. New York: Mariner Books, 1998.

Morrison, Toni. "Unspeakable Things Unspoken: The Afro-American Presence in American Literature." *Michigan Quarterly* 28, no. 1 (1989): 1–34.

Moten, Fred. *In the Break: The Aesthetics of the Black Radical Tradition.* Minneapolis: University of Minnesota Press, 2003.

Muñoz, Jose. *Cruising Utopia: The Then and There of Queer Futurity.* New York: NYU Press, 2009.

Murray, Albert. *Stomping the Blues.* Cambridge, MA: De Capo, 1989.

Muyumba, Walton. *The Shadow and the Act: Black Intellectual Practice, Jazz Improvisation, and Philosophical Pragmatism.* Chicago: University of Chicago Press, 2009.

Nietzsche, Friedrich. *The Genealogy of Morals.* Edited by Walter Kaufmann. New York: Vintage Books, 1989.

Nietzsche, Friedrich. *Untimely Meditations.* Edited by Daniel Breazeale. Cambridge: Cambridge University Press, 1997.

Nusbaum, Martha, and Joshua Cohen. *For Love of Country?* Boston: Beacon, 2002.

Obama, Barack. *The Audacity of Hope: Thoughts on Reclaiming the American Dream.* New York: Three Rivers Press, 2006.

Obama, Barack. "A More Perfect Union." In *The Speech: Race and Barack Obama's "A More Perfect Union Speech,"* edited by T. Denean Sharpley-Whiting, 237–52. New York: Bloomsbury, 2009.

O'Meally, Robert. *The Jazz Cadence of American Culture*. New York: Columbia University Press, 1998.

Page, Phillip. "Traces of Derrida in Toni Morrison's *Jazz*." *African American Review* 29, no. 1 (1995): 55–66.

Phelan, Shane. "Interpretation and Domination: Adorno and the Habermas-Lyotard Debate." *Polity* 25, no. 4 (1993): 597–616.

Pinn, Anthony. "Making the World with a Beat: Musical Expression's Relationship to Religious Identity and Experience." In *Noise and Spirit: The Religious and Spiritual Sensibilities of Rap Music*, edited by Anthony Pinn, 1–25. New York: NYU Press, 2003.

Pinn, Anthony. *Why, Lord?: Suffering and Evil in Black Theology*. New York: Continuum, 1995.

Porter, Eric. *What Is This Thing Called Jazz?: African American Musicians as Artists, Critics, and Activists*. Berkeley: University of California Press, 2002.

Porter, Horace. *Jazz Country: Ralph Ellison in America*. Iowa City: University of Iowa Press, 2001.

Pough, Gwendolyn. *Check It While I Wreck It: Black Womanhood, Hip-Hop Culture, and the Public Sphere*. Boston: Northeastern University Press, 2004.

Puar, Jasbir. *Terrorist Assemblages: Homonationalism in Queer Times*. Durham, NC: Duke University Press, 2007.

Rampersad, Arnold. *The Art and Imagination of W. E. B. Du Bois*. Cambridge, MA: Harvard University Press, 1990.

Rancière, Jacques. *The Politics of Aesthetics*. Translated by Gabriel Rockhill. New York: Continuum, 2006.

Reed, Adolph. *W. E. B. Du Bois and American Political Thought: Fabianism and the Color Line*. New York: Oxford University Press, 1997.

Romero, Channette. "Creating the Beloved Community: Religion, Race, and Nation in Toni Morrison's *Paradise*." *African-American Review* 39, no. 3 (2005): 415–30.

Rorty, Richard. *Achieving Our Country: Leftist Thought in the Twentieth Century*. Cambridge, MA: Harvard University Press, 1998.

Rorty, Richard. *Contingency, Irony, and Solidarity*. Cambridge: Cambridge University Press, 1989.

Rorty, Richard. *Philosophy and Social Hope*. London: Penguin Books, 1999.

Rose, Gillian. *The Melancholy Science: An Introduction to the Thought of Theodor W. Adorno*. London: MacMillan, 1978.

Rose, Gillian. *Mourning Becomes the Law: Philosophy and Representation*. Cambridge: Cambridge University Press, 1996.

Schreiber, Evelyn. *Race, Trauma, and Home in the Novels of Toni Morrison*. Baton Rouge: Louisiana State University Press, 2010.

Scott, David. *Conscripts of Modernity: The Tragedy of Colonial Enlightenment*. Durham, NC: Duke University Press, 2004.

Shulman, George. *American Prophecy: Race and Redemption in American Political Culture*. Minneapolis: University of Minnesota Press, 2008.

Smith, Valerie, ed. *Representing Blackness: Issues in Film and Video*. New Brunswick, NJ: Rutgers Press, 1997.

Snead, James. *White Screens, Black Images: Hollywood from the Dark Side*. Edited by Colin MacCabe and Cornel West. New York: Routledge, 1994.

Spencer, Jon. *Protest and Praise: Sacred Music of Black Religion*. Minneapolis: Ausburg, 1990.

Spillers, Hortense. *Black, White, and in Color: Essays on American Literature and Culture*. Chicago: University of Chicago Press, 2003.

Stepto, Robert. *From behind the Veil: A Study of Afro-American Narrative*. Chicago: University of Illinois Press, 1991.

Stout, Jeff. *Democracy and Tradition*. Princeton, NJ: Princeton University Press, 2004.

Sundquist, Eric. *To Wake the Nations: Race in the Making of American Literature*. Cambridge, MA: Harvard University Press, 1993.

Tally, Justine, ed. *The Cambridge Companion to Toni Morrison*. Cambridge: Cambridge University Press, 2007.

Taylor, Paul. "Post-Black, Old Black." *African-American Review* 41, no. 4 (2007): 625–40.

Taylor, Paul. "Pragmatism and Race." In *Pragmatism and the Problem of Race*, edited by Donald Koch and Bill Lawson, 162–76. Bloomington: Indiana University Press, 2004.

Taylor, Paul. "Taking Postracialism Seriously: From Movement Mythology to Racial Formation." *Du Bois Review* 11, no. 1 (spring 2014): 9–25.

Terrill, Robert. "Unity and Duality in Barack Obama's 'A More Perfect Union.'" *Quarterly Journal of Speech* 95, no. 4 (November 2009): 363–86.

Tucker, Robert, ed. *The Marx-Engels Reader*. New York: W. W. Norton, 1978.

Viego, Antonio. *Dead Subjects: Toward a Politics of Loss in Latino Studies*. Durham, NC: Duke University Press, 2007.

Volf, Miraslov. *The End of Memory: Remembering Rightly in a Violent World*. Grand Rapids, MI: Eerdmans, 2006.

Warren, Kenneth. *What Was African American Literature?* Cambridge, MA: Harvard University Press, 2011.

Watkins, S. Craig. *Representing: Hip Hop Culture and the Production of Black Cinema*. Chicago: University of Chicago Press, 1998.

Weheliye, Alexander. *Phonographies: Grooves in Sonic Afro-Modernity*. Durham, NC: Duke University Press, 2005.

Wellmer, Albrecht. *The Persistence of Modernity: Essays on Aesthetics, Ethics, and Postmodernism*. Translated by David Midgley. Cambridge, MA: MIT Press, 1991.

West, Cornel. "Black Strivings in a Twilight Civilization." In *The Cornel West Reader*, 87–118. New York: Basic Civitas Books, 1999.

West, Cornel. *Keeping Faith: Philosophy and Race in America*. New York: Routledge, 1993.

West, Cornel. *Prophesy Deliverance: An Afro-American Revolutionary Christianity*. Louisville, KY: Westminster John Knox Press, 2002.

Widdowson, Peter. "The American Dream Refashioned: History, Politics, and Gender in Morrison's *Paradise*." *Journal of American Studies* 35 (2001): 313–35.

Wilderson, Frank, III. *Red, White, and Black: Cinema and the Structure of U.S. Antagonisms*. Durham, NC: Duke University Press, 2010.

Williams, Linda. *Playing the Race Card: Melodramas of Black and White from Uncle Tom to O. J. Simpson*. Princeton, NJ: Princeton University Press, 2001.

Wise, Tim. *Between Barack and a Hard Place: Racism and White Denial in the Age of Obama.* San Francisco: City Lights Books, 2009.

Wolin, Richard. *Walter Benjamin: An Aesthetic of Redemption.* New York: Columbia University Press, 1984.

Wolin, Sheldon. *The Presence of the Past: Essays on the State and the Constitution.* Baltimore: Johns Hopkins University Press, 1989.

Wynter, Sylvia. "Unsettling the Coloniality of Being/Power/Truth/Freedom: Towards the Human, After Man, Its Overrepresentation—an Argument." CR: *The New Centennial Review* 3, no. 3 (2003): 257–337.

Zamir, Shamoon. *Dark Voices: W. E. B. Du Bois and American Thought, 1888–1903.* Chicago: University of Chicago Press, 1995.

Zuidervaart, Lambert. *Adorno's Aesthetic Theory: The Redemption of Illusion.* Cambridge, MA: MIT Press, 1991.

INDEX

Addams, Jane, 78

Adorno, Theodor, 14–15, 21–22, 62, 177, 220; on alienation, 82; on artworks, 81–82, 106; on conceptual constellations, 23, 163; critique of Hegel by, 22; critique of jazz by, 21, 26, 130–35, 273n139; on culture industry, 131–33, 135, 146–47; on domination, 179; on Holocaust, 249; on identity, 62, 64–65, 109; on melancholy, 25, 50; on the negative, 42, 173, 195; on pain, 49–50; on progress, 42; works: *Aesthetic Theory*, 232–33; *Dialectic of Enlightenment*, 64–65, 168–69, 257n54; "Form of the Phonograph Record," 127, 272n128; *Minima Moralia*, 262n62

African American Studies, 258n1

AIDS, 159

alienation, 9, 20, 250, 263n4; Adorno on, 82; Du Bois on, 34, 42, 54, 58–59, 64–70, 76–78; Ellison on, 91, 95, 98, 109–10; in *Killer of Sheep*, 139, 164, 166–72; in *Set It Off*, 139, 180, 185–86

Allen, Danielle, 97, 111

Althusser, Louis, 39, 141–42

American dream, 174, 185, 195, 197, 208

American exceptionalism, 203, 205, 213, 235; Behdad on, 196; Bercovitch on, 216, 255n30; Ellison on, 12; immigrants and, 222; LGBT communities and, 279n7; McCain on, 2; Morrison on, 213; Obama on, 27, 195–96, 204–5; Puar on, 190; Whitman on, 210; Zamir on, 39–40

American Indians. *See* Native Americans

Anderson, Paul Allen, 41, 53

Anderson, Victor, 253n6

anti-Semitism, 22, 238–39

Anzaldúa, Gloria, 230

Appiah, Anthony, 258n63

Armstrong, Louis, 86, 171, 273n139; Adorno and, 133; Burnett and, 163, 171; Ellison

Armstrong, Louis (*continued*)
and, 92–94, 101, 268n25; minstrel tradition and, 93–94, 101, 268n26

Baker, Houston, 77, 79–80, 109, 270n78
Bakhtin, Mikhail, 144
Baldwin, James, 45–46, 86, 205; on *Guess Who's Coming to Dinner*, 149, 150, 159; jazz and, 88; Rorty and, 211–12
Balfour, Lawrie, 33, 258n2, 265n52
Balibar, Étienne, 192
Baraka, Amiri, 88, 262n70
Bataille, Georges, 266n57
bebop music, 93–94, 101, 268nn25–26, 271n102. *See also* jazz
Beckett, Samuel, 23
Behdad, Ali, 196, 222
Benjamin, Walter, 21–22, 98, 105; on film techniques, 145–46; on jazz, 25; on liberation, 100; on melancholy, 25; on memories, 205; on ruins, 61–62, 146, 233; works: "On the Concept of History," 13–14, 51; *Origin of German Tragic Drama*, 61–62; "The Work of Art in the Age of Mechanical Reproduction," 144–46
Benston, Kim, 99
Bercovitch, Sacvan, 205, 210–11; on American exceptionalism, 216, 255n30; *The American Jeremiad*, 12–13, 24
Berry, Halle, 138, 140
Berry, Wendell, 3
Best, Wallace, 271n104
Birth of a Nation (film), 26; banning of, 149; *Guess Who's Coming to Dinner* and, 148, 159, 160; nostalgia in, 159, 248; stereotypes in, 140, 152, 242
Bismarck, Otto von, 9
black literary and aesthetic tradition, 16–17, 24–25, 82–83, 245, 273n145
Black Lives Matter movement, ix
black nationalism, 91, 107, 216–17, 226, 282n70; antebellum expressions of, 283n72; Du Bois on, 259n11; Nation of Islam and, 211
blaxploitation films, 161–62, 175
blues music, 17, 245; Baraka on, 273n145; in Burnett, 163, 164, 166–68, 170–72;

in Ellison, 17, 94–96, 105–7, 134–35; in Morrison, 17, 94–95, 105–7; women singers of, 126. *See also* jazz
Blum, Edward, 48
Bogle, Donald, 140–41, 149
Bonilla-Silva, Eduardo, 254n7
Bourdieu, Pierre, 135, 274n152
Bouson, J. Brooks, 115, 218, 283n85
Boyz n the Hood (film), 173, 175–76, 183
Brintnall, Kent, 266n57, 279n2
Brown, Wendy, 223
Buck-Morss, Susan, 37, 255n20
Burke, Kenneth, 90, 91, 100
Burnett, Charles, 17, 26, 139, 162–74; blues music and, 163, 164, 166–68, 170–72; civil rights movement and, 163, 174; Guerrero on, 162
Burns, Ken, 88, 270n84
Butler, Judith, 72, 113, 239, 280n30; on Bourdieu, 135, 274n152; on Freud, 18–19; on norms, 88, 267n9; on performing roles, 102; on recognition, 99

Candomblé, 233, 284n103
Carby, Hazel, 63–65, 69, 126, 264n36
Carlin, George, 129
Chekov, Anton, 23
Cheng, Anne, 19–20, 257n52
civilizing mission, 13, 211
civil rights movement, 14, 16, 139; Burnett and, 163, 174; Kramer and, 161; Obama on, 197, 204
Cohen, Cathy, 127
Coles, Romand, 265n45
Collins, Patricia Hill, 174, 226
Coltrane, John, 23, 273n139
consciousness, false, 142. *See also* double-consciousness
The Cosby Show (television program), 141
Crenshaw, Kimberlé, 28
Cripps, Thomas, 149
Cruz, Jon, 54

Dalsgard, Katrine, 216, 282n69
Dash, Julie, 142, 162
Declaration of Independence, 121, 215

Deleuze, Gilles, 92, 230

Derrida, Jacques, 25, 124, 261n37; Page and, 272n121, 272n129

Dewey, John, 22, 203, 209, 210

Diawara, Manthia, 275n16

Django Unchained (film), 138

double-consciousness, 9, 33–42, 66, 87; false consciousness and, 142; Hegel and, 260n16; Obama on, 195; racial essentialism and, 78–79; white supremacists and, 137

Douglass, Frederick, 43–44, 76–77

Du Bois, Burghardt Gomer, 73–75, 80

Du Bois, W. E. B., 3, 7–10, 31–55, 81, 228; anti-Semitism and, 238–39; Benjamin and, 22, 51; on Bismarck, 9; on black nationalism, 259n11; on color line, 9, 237–38; on double-consciousness, 33–42, 66, 78–79, 87; elitism of, 32, 259n5, 263n2; Ellison and, 14, 16, 41; on gender, 63–65; Hegel and, 9–10, 22, 24, 36–37; on Jim Crow laws, 7, 16, 33, 48, 76; Marx and, 8, 237; on melancholy, 17, 46, 57, 64, 259n6; on minstrel songs, 53; on piety, 245; on racial progress, 9–10, 32, 59–65, 76–77, 80, 238; Reed on, 57–58; rural teaching experiences of, 58–64; on sorrow songs, 17, 24, 40–48, 52–54, 57, 83, 85, 100, 172; on wage versus slave labor, 8; Booker T. Washington and, 3, 61, 63–64; on white supremacists, 32, 35, 50, 52, 76–77, 137, 265n52; works: "Criteria of Negro Art," 81; *Dusk of Dawn*, 238; "The Negro and the Warsaw Ghetto," 238–39; "Of the Coming of John," 65–75, 89, 90, 264n33; "Of Our Spiritual Strivings," 33–42; "On the Meaning of Progress," 58–65; "On the Passing of the First Born," 73–75, 80; *The Souls of Black Folk*, 17, 24–25, 31–55, 57–83, 237–38; "The Souls of White Folk," 7, 9, 238

Dunbar, Paul, 165

Eddy, Beth, 97, 100–101, 107, 110, 111

Edwards, Erica, 231

Eliade, Mircea, 92

Elise, Kimberly, 178

Ellington, Duke, 133

Ellison, Ralph, 7, 10–14, 193, 247; Armstrong and, 92–94, 101, 268nn25–26; on artist's function, 145; Benjamin and, 21–22, 51; blues music and, 17, 94–96, 105–7, 134–35; Butler and, 267n9; Cheng on, 19–20; Du Bois and, 14, 16, 41; jazz and, 25–26, 83, 88–89, 91–96, 107, 110–14; on laughter, 129, 133; Marxism and, 11–12, 25, 89, 91, 97–99, 103–4, 107, 269n71; on master narratives, 96–107; on piety, 100–101; Booker T. Washington and, 100; Richard Wright and, 95; women characters of, 270n96; works: "Harlem Is Nowhere," 96–97; *Invisible Man*, 25–26, 88–107; "The Little Man at Chehaw Station," 107–11, 212

Emerson, Ralph Waldo, 13, 22, 193, 255n30

Eng, David, 19, 23

Erika, Udono, 233

exceptionalism. *See* American exceptionalism

exodus narratives, 46–57, 216–17, 261n50, 283n73

Fanon, Frantz, 103, 162, 269n58, 280n30

Faulkner, William, 198

Felman, Shoshana, 256n34

Ferguson (MO) police protests, ix, 4

Flatley, Jonathan, 21, 257n53

Foley, Barbara, 269n71

Foucault, Michel, 207–8, 225, 239, 285n4

Fox, Vivica, 176

Foxx, Jamie, 138

Frankfurt School, 13, 21–27. *See also individual writers*

Freud, Sigmund, 19, 49, 96, 111, 237; on desire, 124, 167; on melancholy, 18–19, 124–25; on mourning, 18–19, 124–25

Gaines, Kevin, 8

gangsta rap, 175, 278n70

Garvey, Marcus, 282n70

Gates, Henry Louis, 77, 79–80

gender, 179, 184, 247; cinematic representations of, 142–44, 162, 164, 176; Du Bois and, 63–65; Ellison and, 270n96;

gender (*continued*)
 intersectionality of, 76, 148, 160–61, 180, 226–27; Irigaray on, 125; jazz and, 90, 125–26; Morrison and, 90
genocide, 15, 249
Gerima, Haile, 162
Gillespie, Dizzy, 93, 268n28
Gilroy, Paul, 23
Gioia, Ted, 121, 268n29
Girard, René, 221–22, 284n87
Giuliani, Rudolph, 4
Glaude, Eddie, 46, 216–17, 283n72
Goethe, Johann von, 90
Golden, Thelma, 188
Gooding-Williams, Robert, 61, 69, 71–73, 80; on Douglass, 76–77; on Obama, 265n53; on white supremacists, 76–77, 254n14, 265n52
gospel music, 53
Gracyk, Theodore, 273n139
Gramsci, Antonio, 23
Grandt, Jürgen, 86, 91–92
Grant, Nathan, 164, 166, 170
Gray, F. Gary, 26, 139–40, 174–86
Great Migration. *See* migration narratives
Griffith, D. W., 26, 140, 148, 159, 160, 242
Griffith, Farah Jasmine, 89
Guerrero, Ed, 141–42, 144, 157–59, 162
Guess Who's Coming to Dinner (film), 26, 139, 143, 147–61, 186, 189; Baldwin on, 149, 150, 159; Burnett and, 162–63, 172–73; Guerrero on, 157–59; Harris on, 150–52; Reed on, 197

Habermas, Jürgen, 257n54
Haitian Revolution, 37, 255n20
Halberstam, Judith, 184
Hall, Stuart, 28
Hardimon, Michael, 39
Harding, James, 93–94, 133
Harlem Renaissance, 89, 118–19
Harris, Glen, 150–52
Hart, William David, 245–46, 263n1, 286n7
Hartman, Saidiya, 46, 257n52
Hawaii, 40, 150

Hedges, Inez, 168
Hegel, G. W. F., 99, 132, 255n25, 280n30; Adorno on, 22; on *Aufheben*, 36–37, 199; double-consciousness and, 260n16; Du Bois and, 9–10, 22, 24, 36–37; on master-slave relationship, 33, 37–38, 255n20; Obama and, 199; *The Phenomenology of Spirit*, 37–38, 254n17; on reconciliation, 38–39; Rorty and, 209–10, 212
Heidegger, Martin, 207–8
Herder, Johann, 53
Higginbotham, Evelyn, 183
hip hop music, 181–82, 242, 245; gangsta rap and, 175, 278n70; Perry on, 267n5; Pinn on, 50
HIV disease, 159
Holder, Eric, 241, 242
Holloway, Karla, 20
Holocaust, 15, 249
Honig, Bonnie, 201
Honneth, Axel, 38
hooks, bell (Gloria Watkins), 142–44, 147, 275n16
hope, 21, 238–39; melancholy and, 6–7, 15, 17, 74, 243, 248–50; mourning and, 202–4; Obama on, 27, 190–96; optimism and, 5–6, 211, 213; piety and, 154; Rorty on, 208, 212–13; sorrow-filled, 171
Horkheimer, Max, 64–65, 168–69, 257n54, 263n76
Hughes, Langston, 86
Hurricane Katrina, 193–94

identity, 78, 87–88, 179, 184; Adorno on, 62, 64–65, 109; authenticity and, 141; Ellison on, 12, 92, 94; Fanon on, 103, 269n58
interracial marriage. *See* marriage, interracial
Irigaray, Luce, 125
Islam. *See* Muslims

James, C. L. R., 24
James, David, 163
James, William, 48
Jameson, Fredric, 133
jazz, 12, 17, 245; Adorno's critique of, 21, 26, 130–35, 273n139; African elements in, 132;

Amiri Baraka on, 88, 262n70; bebop and, 93–94, 268nn25–26, 271n102; Benjamin on, 25; Ellison and, 25–26, 83, 88–89, 91–96, 107, 110–14; gender and, 90, 125–26; literary uses of, 86, 89–92, 107, 134–35, 248–49, 251; Morrison and, 17, 25–26, 83, 88–89, 113, 127, 134–35; Porter on, 125–26; as problematic term, 266n1; techniques of, 85–88, 121–22, 130–31, 251

jeremiad tradition, 24, 210–11, 255n30

Jim Crow laws, 198; Du Bois on, 7, 16, 33, 48, 76

Johnson, Terrence, 32, 42

Jones, Leroi, 88, 262n70

Kafka, Franz, 96

Kahn, Jonathan, 48–49, 71–73

Kant, Immanuel, 72, 265n45

Karenga, Ron, 283n70

Kazanjian, David, 19, 23

Kierkegaard, Søren, 96

Killer of Sheep (film), 26, 139, 162–74, 186; *Guess Who's Coming to Dinner* and, 162–63, 172–73

Kim, David, 72

King, Martin Luther, Jr., 14, 173; legacy of, 204–6, 281n43

Klein, Naomi, 194

Kramer, Stanley, 26, 139, 147–61

Ku Klux Klan, 40; in *Birth of a Nation*, 148, 159; Locke on, 118, 119. *See also* white supremacists

Latinos, 160, 187, 190, 227–28, 230

laughter, 128–29

Lee, Spike, 17, 142, 279n6

Leeman, Richard, 191–92, 200–201

Levin, Tom, 133

Levine, Andrea, 157, 158

Lewis, Barbara Williams, 121

LGBT communities, 7; AIDS crisis in, 159; American exceptionalism and, 279n7

Lipsitz, George, 270n84

Locke, Alain, 24, 118–19

Long, Charles, 246

Loving v. Virginia (1967), 26, 149

Lubiano, Wahneema, 217, 282n70

lynching, 7–8, 36, 112, 116, 142; in *Birth of a Nation*, 148; in "Of the Coming of John," 66, 70–73

MacIntyre, Alasdair, 16

Malraux, André, 96

Marable, Manning, 48

Marcuse, Herbert, 83

Mariotti, Shannon, 62

marriage, interracial, 139, 148, 153–56; legality of, 26, 149, 150

Martin, Trayvon, 5, 240–42

Marxism, 96, 141, 178–79, 210, 255n25; class struggle and, 37; Du Bois and, 8, 237; Ellison and, 11–12, 25, 89, 91, 97–99, 103–4, 107, 269n71; religion and, 47, 147

Massood, Paula, 165, 166

master-slave relationship, 33, 37–38, 255n20

Matthews, Chris, 188–90

McAfee, Noelle, 196, 202–3

McCain, John, 239–40; on American exceptionalism, 2; concession speech of, 1–3, 6, 14, 174

McKinley, William, 13

melancholy, 16–21, 212; Adorno on, 25, 50; Benjamin on, 25; Cheng on, 19–20, 257n52; cinematic, 137–40; definitions of, 17–18; Douglass on, 44; Du Bois on, 17, 46, 57, 64, 259n6; Flatley on, 21, 257n53; Freud on, 18–19, 124–25; Holloway on, 20; hope and, 6–7, 15, 17, 74, 243, 248–50. *See also* mourning

Melville, Herman, 255n30

memory, 33, 243, 248; Benjamin on, 205; forgetfulness and, 189, 206, 210; nostalgia and, 159, 185, 248; shame and, 208–9, 212, 218

Menace II Society, 173, 175

Micheaux, Oscar, 142

Middle Passage, 15, 36, 50, 73, 89. *See also* slavery

migration narratives, 25, 89, 115–19, 126, 215–16

Mills, Charles, 265n52

minstrel tradition, 53, 133, 262n69; Armstrong and, 93–94, 101, 268n26; scholarship on, 274n150

Monster's Ball (film), 138, 140

Morrison, Toni, 7, 23, 181, 246, 249; on American exceptionalism, 213; Benjamin and, 22; blues music and, 17, 94–95, 105–7; gender and, 90; jazz and, 17, 25–26, 83, 88–89, 113, 127, 134–35; on laughter, 128–29; Obama's speeches and, 227, 231, 235; on redemption, 233; works: *Beloved*, 115, 285n107; *Jazz*, 25–26, 88–89, 112, 114–30, 214; *A Mercy*, 227; *Paradise*, 27, 191, 213–35; "Recitatif," 227; *Song of Solomon*, 73

Moses, Wilson, 283n72

Moten, Fred, 44, 95–96, 114

"Motherless Child" (song), 50

mourning, 203, 245; Butler on, 18–19; Freud on, 18–19, 124–25; Holloway on, 20; hope and, 202–4. *See also* melancholy

Muhammad, Elijah, 211

Mulrine, Anna, 224

Mulvey, Laura, 142–43

Muslims, 28, 160, 187, 190, 211, 227–28, 240

Muyumba, Walton, 87, 88, 112

My Brother's Wedding (film), 173

NAACP, 149, 241

Nag Hammadi, 121

narratives, 58, 69; exodus, 46–57, 216–17, 261n50, 283n73; master, 96–107; migration, 25, 89, 115–19, 126, 215–16

Nation of Islam, 211. *See also* black nationalism

Native Americans, 210, 223, 230–31; dislocation of, 55, 159; genocide of, 15; Marx on, 11; storytelling traditions among, 40; uplift paradigm for, 7

naturalism, religious, 48

Nelson, Kadir, 182

Nietzsche, Friedrich, 75, 155

nostalgia, 159, 185, 248. *See also* memory

Nugent, Ted, 240–42

Obama, Barack: on American exceptionalism, 27, 195–96, 204–5; *The Audacity of Hope*, 190–96; on double-consciousness, 195; Giuliani on, 4; Gooding-Williams on, 265n53; on Martin Luther King, 204–6, 281n43; Matthews on, 188–90; McCain on, 1–3, 6, 14, 239–40; "A More Perfect Union" speech, 196–204; Morrison's novels and, 227, 231, 235; on Rosa Parks, 192–93; on racial progress, 5–6, 14, 27, 194–98, 209; on Jeremiah Wright, 196, 199–203, 212; on Zimmerman verdict, 5–6

O'Meally, Robert, 94–95

optimism. *See* hope

Page, Phillip, 124, 272n121, 272n129

Parker, Charlie, 86, 93, 94, 273n139

Parks, Rosa, 192–93

Perry, Imani, 267n5

Petry, Ann, 86

Philippines, 13, 40

Picasso, Pablo, 81–82

piety, 172, 245–46, 248; Ellison on, 100–101; hope and, 154

Pinkett, Jada, 177

Pinn, Anthony, 28, 47, 50

Poitier, Sidney, 143, 148–49, 152–53, 156, 173, 189

police biases, 5, 149

Porter, Eric, 125–26

Porter, Horace, 95

postracial concept, 187–92, 235, 238; ambiguity of, 224–29, 241; Morrison on, 214; Paul Taylor on, 226

Pough, Gwendolyn, 175, 178, 278n68

pragmatism, 22–23, 42, 203, 207, 210, 263n76

progress, racial, 8, 19, 126, 213, 257n62; ambivalence of, 7–21, 159; Du Bois on, 9–10, 32, 59–65, 76–77, 80, 238; in films, 149, 173, 176, 177, 182–85; Obama on, 5–6, 14, 27, 194–96, 209; underside of, 61, 162, 190, 195–96

Pryor, Richard, 129

Puar, Jasbir, 190, 279n7

race, 28, 140–48; essentialist notions of, 41, 54, 76–79, 228, 245; Foucault on,

225, 239; gender and, 148, 160–61, 180, 226–27; intersectionality of, 76, 139, 141, 161, 179, 238; police biases of, 5, 149; stereotypes of, 140, 152, 184, 242. *See also* Veil; white supremacists

Rainey, Ma, 126

Rampersad, Arnold, 41, 66, 67

Ramsey, Guthrie, Jr., 271n106

rap music, 175, 182, 278n79

Reagan, Ronald, 159, 174

Reed, Adolph, 25, 57–58, 77–83, 197; on African American Studies, 258n1; Rorty and, 207

Robeson, Paul, 163, 164, 168

Romero, Channette, 232, 284n103

Roosevelt, Franklin D., 156

Roosevelt, Theodore, 2

Rorty, Richard, 191, 207–13, 243–44; *Achieving Our Country*, 207, 211–12, 218; on Baldwin, 211–12; on Hegel, 209–10, 212; on hope, 208, 212–13; on Whitman, 209, 210, 212

Rose, Tricia, 182

Rubenstein, Roberta, 271n100

Rwanda genocide, 15

Said, Edward, 266n58

Santayana, George, 48

Sartre, Jean-Paul, 96, 103

scapegoat effect, 97, 221–22

Schultz, Bart, 211

Set It Off (film), 26, 139–40, 174–86

shame, 208–9, 212, 218

sharecropping, 60, 123

Shulman, George S., 213

Singh, Nikhil, 188

Singleton, John, 173, 175–76

slavery, 148; Hegel on, 33, 37–38, 255n20; Middle Passage and, 15, 36, 50, 73, 89; wage labor versus, 8

Smith, Bessie, 86, 126

Smith, Valerie, 141

Smith, Will, 4

Snead, James, 92, 141

sorrow songs (spirituals), 32, 46; Cheng on, 20; Douglass on, 43–44; Du Bois on, 17,

24, 40–48, 52–54, 57, 83, 85, 100, 172; Pinn on, 50

Spillers, Hortense, 36

stand-your-ground law, 5

Stepto, Robert, 58, 69

stereotypes, racial, 140, 152, 184, 242

Stevens, Dana, 163

Stout, Jeff, 271n103

Sundquist, Eric, 42

Tarantino, Quentin, 138

Tate, Claudia, 114, 270n96

Taylor, Charles, 36, 72, 211

Taylor, Paul, 188, 226, 228

Tea Party movement, 28, 240

Terrill, Robert, 195, 198, 202

Thoreau, Henry David, 255n30

Thornton, Billy Bob, 138

Toplin, Robert, 156, 157

tragic-comic, 249–51

Training Day (film), 138, 140, 143

Tuskegee Institute, 61

uncanniness (*Unheimlichkeit*), 34, 44–45, 50, 110, 145

Van Der Zee, James, 115

Veil, racial, 9, 58–61, 77, 165; in "Of Coming of John," 66, 67, 69; in "Of Our Spiritual Strivings," 35; in "Of the Passing of the First Born," 74–75

Wagner, Richard, 67–68, 74

Walderson, Frank, III, 277n47

Washington, Booker T., 2–3, 58, 78, 80, 100

Washington, Denzel, 138, 140, 143

Washington, Dinah, 163, 166–67, 170, 171

Watkins, Craig, 173, 175

Watts riots, 26, 165, 172–74

Weheliye, Alexander, 51

Wells, Ida B., 3

West, Cornel, 22–23, 89, 249–50, 259n6

Whitehead, Alfred North, 31

Whiteman, Paul, 133

white supremacists, 16, 116, 270n84; in *Birth of a Nation*, 159; Douglass on, 76; Du Bois

white supremacists (*continued*)
on, 32, 35, 50, 52, 76–77, 137, 265n52;
Glaude on, 217; Gooding-Williams on,
76–77, 254n14, 265n52; Ku Klux Klan
and, 40, 118, 119, 148, 159; Morrison on,
214, 225–26; in *Set It Off*, 179. *See also*
race
Whitman, Walt, 13, 209, 210, 212
Widdowson, Peter, 215, 285n107
Wilentz, Gay, 73
Will, George, 4

Williams, Linda, 148
Wolin, Sheldon, 206
Wright, Jeremiah, 196, 199–203, 212
Wright, Richard, 95, 211
Wynter, Sylvia, 24

Zack, Naomi, 258n63
Zamir, Shamoon: on American exceptional-
ism, 39–40; on Du Bois, 9, 36, 42, 54,
259n7; on pragmatism, 263n76
Zimmerman, George, 5, 240–42